NEW BALANCE ATHLETIC SHOE, INC., is pleased to join the Museum of Fine Arts, Boston, in welcoming you to this one-of-a-kind exhibition. In the beautiful Torf Gallery, you will be taken back to antiquity as you walk among ancient works of art that tell a fascinating and historical story of the ancient Greek games. As you are transported back two thousand years to when the games were associated with Greek gods, images of the modern games will be juxtaposed on video monitors to convey both the similarities and differences of Olympic competition then and now.

Supporting this exhibition is a natural fit for New Balance, as it celebrates athletics—our heritage—and recognizes the everyday athlete who is serious about his or her sport. Ancient or modern, these athletes are heroes of their times. They struggle through adverse conditions, strive to meet personal goals, achieve high performance, and triumph in competition.

On behalf of our associates around the world, we are pleased to sponsor this unique presentation of objects and artifacts from the MFA's world-class collection and on loan from other institutions. We hope you enjoy the story of the Olympics as it is told here.

ANNE DAVIS
Executive Vice President Administration

JAMES S. DAVIS
Chairman & Chief Executive Officer

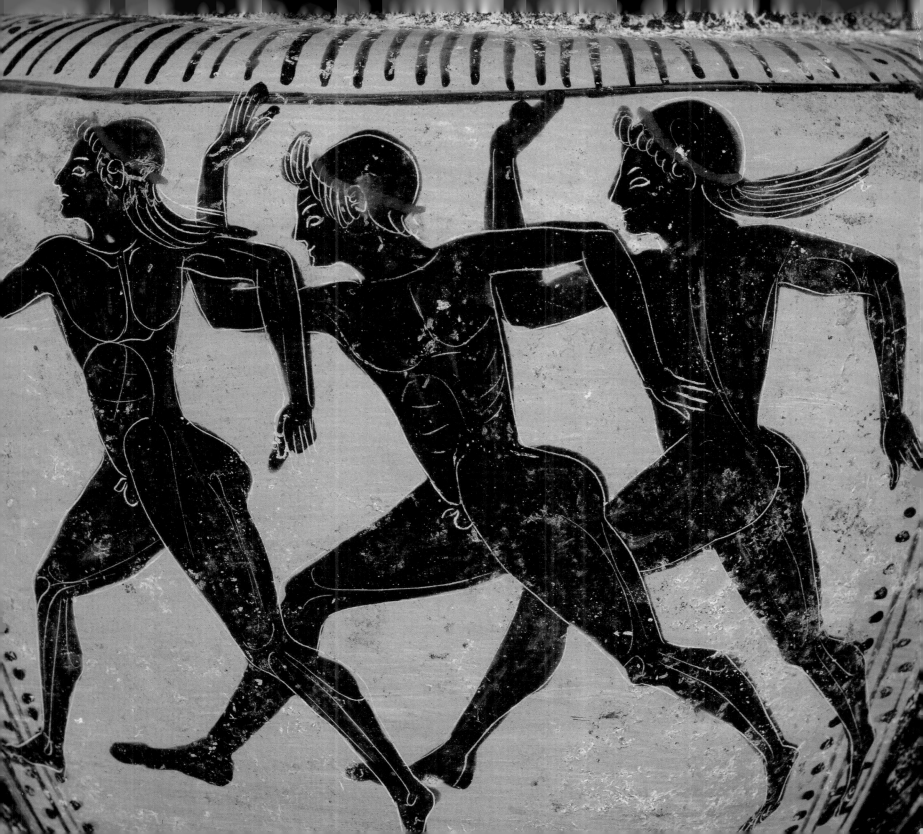

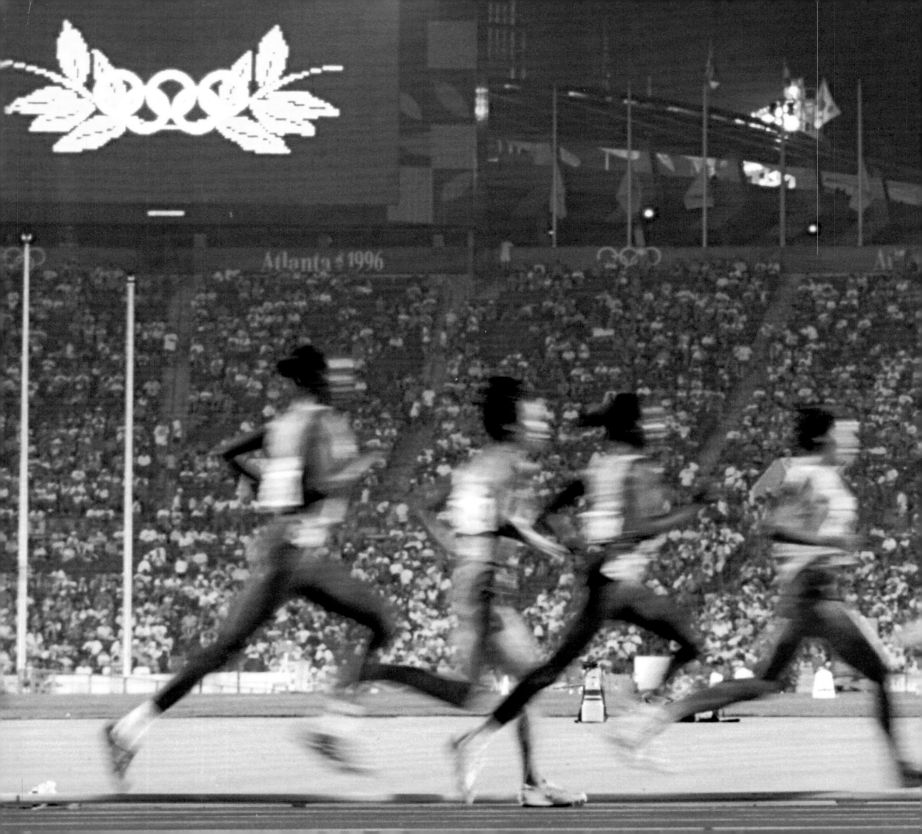

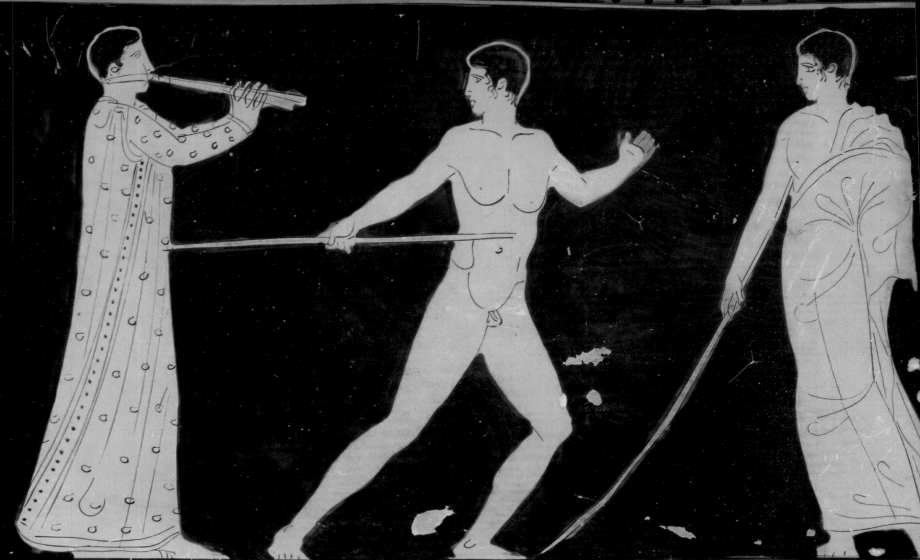

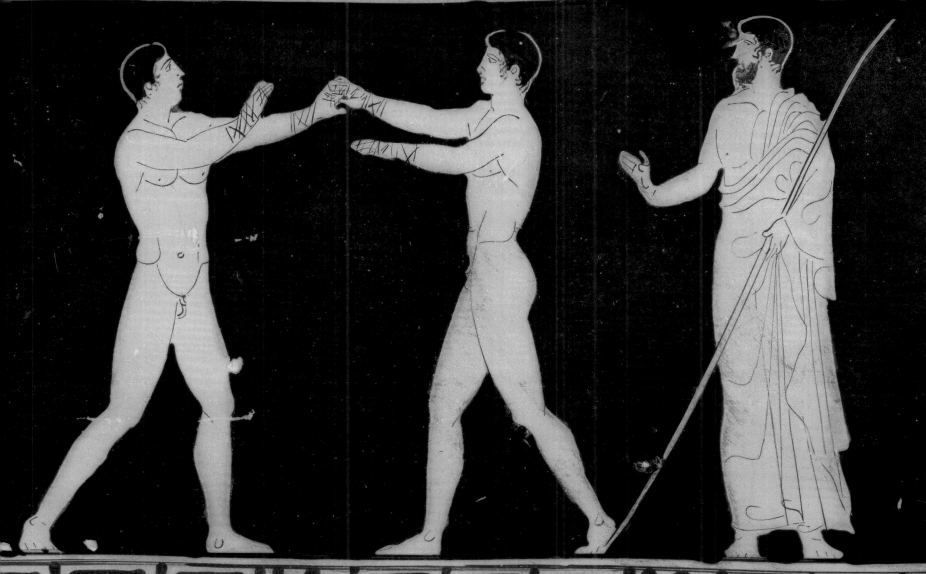

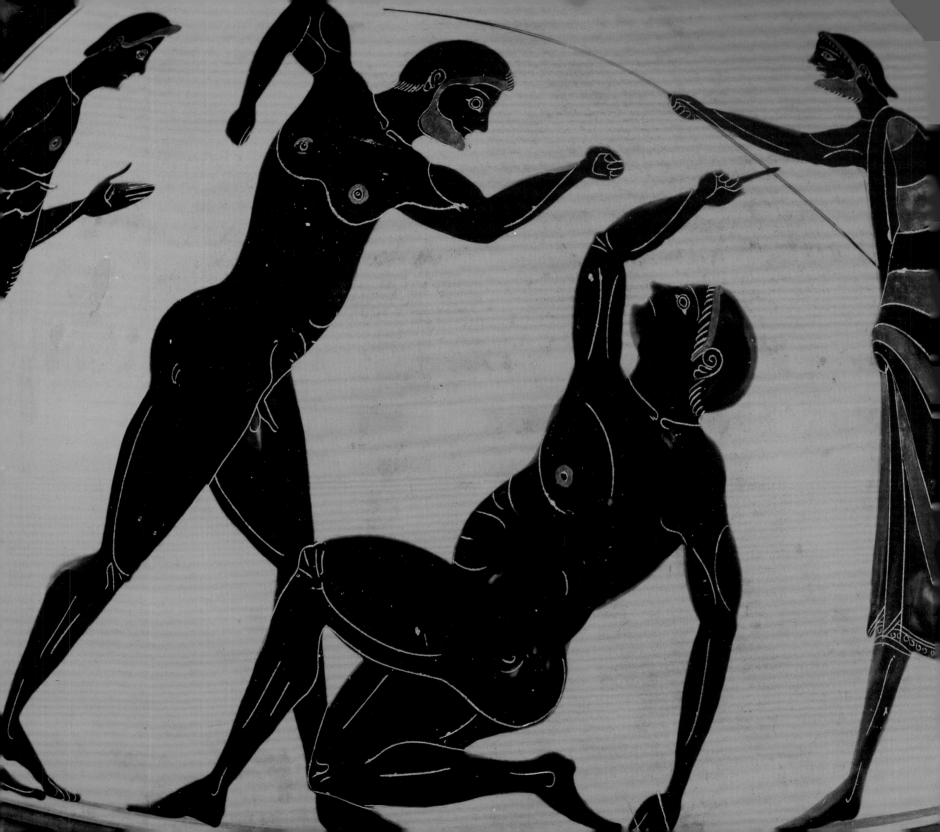

Games for the Gods

THE GREEK ATHLETE AND THE OLYMPIC SPIRIT

John J. Herrmann, Jr., and Christine Kondoleon

With a foreword by Bill Littlefield

MFA PUBLICATIONS

a division of the Museum of Fine Arts, Boston

MFA PUBLICATIONS
a division of the Museum of Fine Arts, Boston
465 Huntington Avenue
Boston, Massachusetts 02115
www.mfa-publications.org

This book was published in conjunction with the exhibition "Games for the Gods: The Greek Athlete and the Olympic Spirit," organized by the Museum of Fine Arts, Boston, from July 21, 2004, to November 28, 2004.

 Generous support for the exhibition was provided by New Balance Athletic Shoe, Inc.

The publication of *Games for the Gods: The Greek Athlete and the Olympic Spirit* was made possible with generous support from the Thomas Anthony Pappas Charitable Foundation, Inc.

For a complete listing of MFA Publications, please contact the publisher at the address on the left, or call 617 369 3438.

Front cover: Large basin with wrestlers on its rim, early 5th century B.C. (cat. no. 55, detail)
Back cover: John Huet, *Going to the Mat, Los Angeles, 1999,* © John Huet 1999
All photographs of works in the MFA's collections are by the Photo Studios, Museum of Fine Arts, Boston. Additional credits are noted in the checklist.

The term "Olympic" is used with permission of the United States Olympic Committee.

Designed and produced by Cynthia Rockwell Randall
Edited by Sarah E. McGaughey
Printed and bound by Graphicom, Verona, Italy

Trade distribution:
D.A.P. / Distributed Art Publishers
155 Sixth Avenue, 2nd floor
New York, New York 10013
Tel. 212 627 1999 Fax 212 627 9484

FIRST EDITION
Printed in Italy
This book was printed on acid-free paper.

There is a time when men welcome the winds, and a time when they welcome the waters of heaven, the rain-laden daughters of the cloud. But, when anyone is victorious by aid of toil, then it is that honey-voiced odes are a foundation for future fame, even a faithful witness to noble exploits.

—Pindar *Olympian Ode* 11.1–7

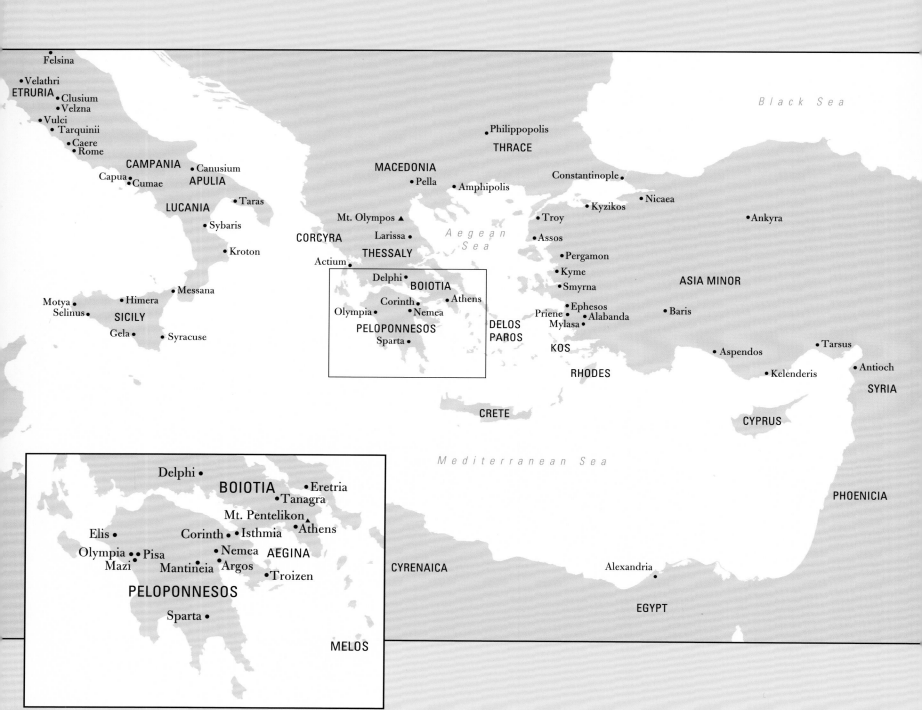

Felsina

Velathri
ETRURIA Clusium
 Velzna
Vulci
Tarquinii
Caere
Rome
 CAMPANIA Canusium
 Capua
 Cumae APULIA
 LUCANIA Taras
 Sybaris
 Kroton
Motya Himera Messana
Selinus
 SICILY
 Gela Syracuse

MACEDONIA
 Pella Amphipolis

THRACE
 Philippopolis

Black Sea

Constantinople
 Nicaea
 Kyzikos
 Troy Ankyra
 Assos
 Pergamon
 Kyme
 Smyrna ASIA MINOR
Priene Ephesos
 Alabanda Baris
Mylasa

Aegean
Sea

Mt. Olympos ▲
 Larissa
CORCYRA
 THESSALY
Actium
 Delphi
 BOIOTIA
 Corinth Athens
Olympia Nemea
PELOPONNESOS
 Sparta

DELOS
PAROS

KOS

RHODES

Tarsus
Kelenderis Antioch
SYRIA

CRETE

CYPRUS

Mediterranean Sea

PHOENICIA

CYRENAICA

Alexandria

EGYPT

Delphi

BOIOTIA Eretria
 Tanagra
 Mt. Pentelikon ▲
 Athens
Elis Corinth Isthmia
Olympia Pisa Nemea AEGINA
Mazi Mantineia Argos
 Troizen
PELOPONNESOS

Sparta

MELOS

CONTENTS

DIRECTOR'S FOREWORD

EVERY FOUR YEARS THE WORLD'S attention is focused on the summer Olympic Games, wherever they may be staged. This year the location of the games in Athens calls special attention to the ancient Greek inspiration that lies at the games' roots, and the ancient remains in Athens, Olympia, and other sites in Greece will shed a fascinating light on those origins. Much light can also be shed by the rich Classical collections in the United States in general and the Museum of Fine Arts, Boston, in particular. The diverse holdings of the MFA have been drawn on for the first major American exhibition dedicated to Greek athletics. Important loans have also come from private collections and our sister institutions around the country.

While ancient Greek culture colored their presentation of athletics, sports are essentially timeless in their basic appeal. For ancient artists, athletes in action and in repose were sources for images of human beauty. Modern photographers have recorded athletes in a very similar spirit, and the Museum has taken pleasure in juxtaposing ancient and modern images of some of the same "Greek" athletic events.

Thanks are due to the curators, John J. Herrmann, Jr., and Christine Kondoleon, who were ably assisted by numerous members of the Museum's staff. Bill Littlefield has vividly brought a slice of modern Olympic experience to the project. We are very grateful to the many museums and private collectors who have generously lent to this exhibition. In these times of heightened concern about provenance issues, the Museum has vigorously investigated the modern history of all objects on display and has determined that all loans meet the same standards the Museum sets for its own collection.

Finally, we are appreciative of the generous support that helped the exhibition and this book meet their ambitious goals. A large debt of gratitude is owed to New Balance Athletic Shoe, Inc., especially Jim and Anne Davis, which through its corporate sponsorship provided the means to transport works of art great and small from coast to coast and to present both audiovisual information and a worthy installation for the exhibition. The Thomas Anthony Pappas Charitable Foundation, Inc., supported the publication of this richly illustrated book.

Nothing can recapture the excitement of the moment of competition and the thrill of victory—or the pain of exhaustion and defeat—that sports provide. Ancient Greek, Etruscan, and Roman artists—as well as modern photographers—have, however, been able to create images drawn from athletic competition and use them to charm, challenge, and excite. We hope that this exhibition and book will communicate how attractive and fascinating the artistic expression of athletics can be.

MALCOLM ROGERS
Ann and Graham Gund Director

ACKNOWLEDGMENTS

IN THE PAST THREE YEARS OF preparations for this exhibition there have been many individuals who embraced the concept of celebrating the return of the Olympics to Athens with an exhibition featuring the important and extensive collections at the Museum of Fine Arts, Boston. We are especially indebted to director Malcolm Rogers for his challenging vision of giving a contemporary dimension to ancient athletics. To enrich the MFA holdings we called upon many museums to part with their athletic treasures in this Olympic year, a time when such works will receive heightened attention. Our deep gratitude goes to colleagues at the following museums: Addison Gallery of American Art (Allison Kemmerer); Arthur M. Sackler Museum, Harvard University Art Museums (Amy Brauer, Karen Manning, and David Gordon Mitten); The Cleveland Museum of Art (Michael Bennett); The Detroit Institute of Arts (William Peck); Hood Museum of Art, Dartmouth College (Katherine Hart); Kimball Art Museum (Timothy Potts); Los Angeles County Museum of Art (Nancy Thomas); The Metropolitan Museum of Art (Seán Hemingway, Joan Mertens, and Carlos Picon); Michael C. Carlos Museum, Emory University (Jasper Gaunt); Princeton University Art Museum (Michael Padgett); and The Walters Art Museum (Gary Vikan). Private collectors have also been generous. Peter and Widgie Aldrich; the Centre Island Collection; the Estate of Arthur S. Dewing; the Estate of Donald Upham and Rosamund U. Hunter; the Estate of Emily Townsend Vermeule; Shelby White and her husband, the late Leon Levy, and their curator, Jennifer Chi; Nicolas Zoullas; and other lenders who wish to remain anonymous have helped us put together this rich and comprehensive display.

We extend our gratitude to New Balance Athletic Shoe, Inc., the exhibition's corporate sponsor, for supporting the exhibition and also to the New Balance Foundation for supporting related youth educational programs. Jim Davis, Anne Davis, and Katherine Shepard deserve special acknowledgment for their efforts. The videos in the exhibition were imaginatively conceived and produced by Pagano Media, especially Joe Pagano, Bari Boyer, and Matt Thayer. Our search for contemporary photographers was aided by Karen Haas and Anne Havinga at the MFA, as well as by Blake Fitch at the Griffin Museum of Photography and Mark Rykoff at *Time Canada*. Photographers Lou Jones and John Huet were most generous with their time and imagery. For their support and enthusiasm in all matters civic and Hellenic, heartfelt thanks are due to Maria Anagnastopoulos of the Greek Institute; George Behrakis; Konstantin Bikas, Greek Consul General; Arthur Dukakis; former Governor Michael Dukakis; and Professor Evangelos Venizelos, Greek Minister of Culture. We are indebted to former Ambassador Loucas Tsilas and Amalia Cosmetatou of the Alexander S. Onassis Benefit Foundation for their support of an educational program. We are also grateful to an anonymous foundation for its support of educational programs related to the exhibition.

We are especially grateful to the Thomas Anthony Pappas Charitable Foundation, Inc., who generously provided funding for this catalogue. The research, writing, and production of the catalogue were aided by many colleagues who offered information and advice. The authors are indebted to Annewies van den Hoek for the review and translations of the Greek inscriptions; in many cases, she corrected and improved our understanding of

the texts and the objects that carry them. We benefited from many discussions with Cornelius Vermeule, who playfully and usefully shared his knowledge of athletic objects, ancient and modern. For scholarly advice and ideas we thank Shelagh Hadley, Stephen Miller, Gregory Nagy, Jenifer Neils, David Romano, and Judith Swaddling.

Many individuals at the MFA contributed to the successful realization of this project. We would especially like to acknowledge the key people who have devoted much time to this exhibition. At the top of the list is our dedicated research assistant, Lisa Buboltz, who handled a vast array of tasks at every stage of the preparations, especially for the catalogue; she was assisted by Brenda Breed and Rebecca Reed. Mary Comstock meticulously researched the provenances of objects from the MFA. Laura Gadbery provided archaeological advice. The quality of this book was dramatically enhanced by the photography of Greg Heins and David Mathews, with media coordinator Nicole Crawford. The objects were carefully treated by a team of conservators (particularly Lisa Ellis, Susanne Gänsicke, Ingrid Neuman, Kent Severson, Kim Simpson, Carol Snow, and Nina Vinogradskaya) under the able direction of Abigail Hykin. Keith Crippen provided the installation design. Registrar Jill Kennedy-Kernohan handled the loan requirements. In Museum Learning and Public Programs, we are grateful to Barbara Martin, Adina Sabghir, Gilian Shallcross, and Lois Solomon. We recognize the able coordination of the exhibition process by Katie Getchell and Jennifer Bose, and in External Relations the fundraising and other efforts of William McAvoy, Desne Crossley, and Jennifer Cooper, assisted by Melinda Hallisey and Margaret Sheehan. In

Public Relations and Marketing, we thank Dawn Griffin, Kelly Gifford, Jennifer Standley, Jennifer Weissman, and Janet O'Donoghue. The publication was produced under the direction of Mark Polizzotti, with the meticulous attention of editor Sarah McGaughey and the skillful eye of designer Cynthia Randall, assisted by interns Kristin Caulfield and Deblina Chakraborty.

JOHN J. HERRMANN, JR.
CHRISTINE KONDOLEON

Games for the Gods

THE GREEK ATHLETE AND THE OLYMPIC SPIRIT

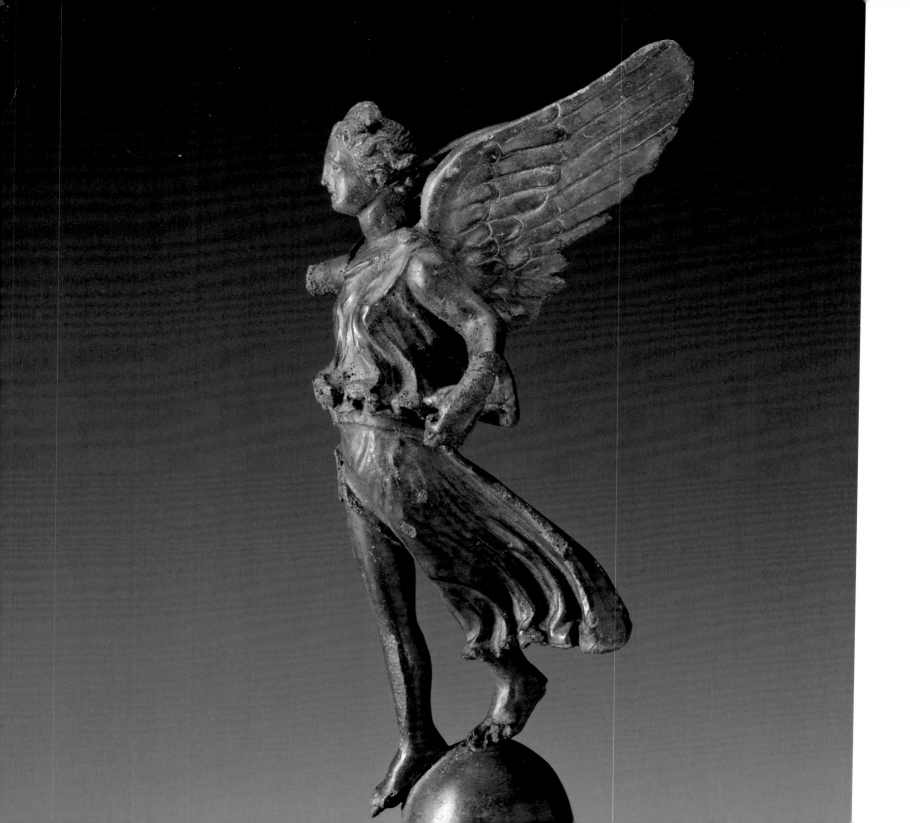

The media makes more of the pressure than the players feel. I love playing against the top players in the world.
—Kristine Lilly, *member of the U.S. Olympic soccer team that won gold in 1996 and silver in 2000*

You don't have to be the best in the world to win in the Olympics. You just have to be the best on that day.
—Jimmy Pedro, *winner of a bronze medal in judo in 1996*

You make it what you want it to be. I know that winning meant opportunities that otherwise never would have been given to me.
—Joan Benoit Samuelson, *1984 Olympic marathon champion*

Several Olympians who are in the middle of their season with the WUSA's Boston Breakers soccer team sit shivering in T-shirts and shorts in the enthusiastically air-conditioned room beside the Boston University hockey rink. They've just come from practice on a pitch composed of a type of artificial grass that is pretty good at imitating the real thing when a soccer ball hits it, and brilliant at absorbing the day's ninety-degree heat, then transferring it to the players through the soles of their shoes. Their thermostats must be at the breaking point, but the players are ready for questions.

Kristine Lilly, the midfielder who has played in more international soccer matches for her country than any other player of either gender or any nationality, smiles when she's asked if she had dreams of participating in the Olympics when she was a child. "I would watch the Olympics and dream about winning a medal as a gymnast," she says, shrugging. "It was a dream. I couldn't do a back walkover. Besides, I couldn't imagine competing in an individual sport, because I use my teammates so much. I'm amazed at what the individual athletes can do. If things go wrong, they have to fix it themselves."

The conversation highlights how much the Olympic Games have changed since their invention in ancient Greece. Back in those days, women had limited options for participation. Married women couldn't compete in sports at all; they couldn't even watch. Unmarried girls could race against each other in lesser venues than the Olympics—perhaps in part to showcase their attractions for prospective husbands. But the assumption of main event status by female athletes from Nadia Comaneci and Katarina Witt to Kristine Lilly and Joan Benoit Samuelson is a modern development.

Aside from which, team sports didn't exist in ancient times, so Lilly would have been on her own. Ball games didn't exist either, at least not officially. Male athletes competed as individuals in track and field events, boxing, wrestling, and horse races. Kids may have played with balls as a pastime, but soccer had not been imagined—for men or women.

Even when Kristine Lilly was growing up, not so long ago, her Olympic dream had to be about something other than women's soccer, which didn't become an Olympic sport until the accomplished midfielder was too old to be content with dreams and just the right age to lead her team to a gold medal in Atlanta in 1996. But some dreams persist. When asked what she'd like to do in the games if she wasn't one of the world's best soccer

< The ancients personified Victory as a draped, winged female (cat. no. 141).

3

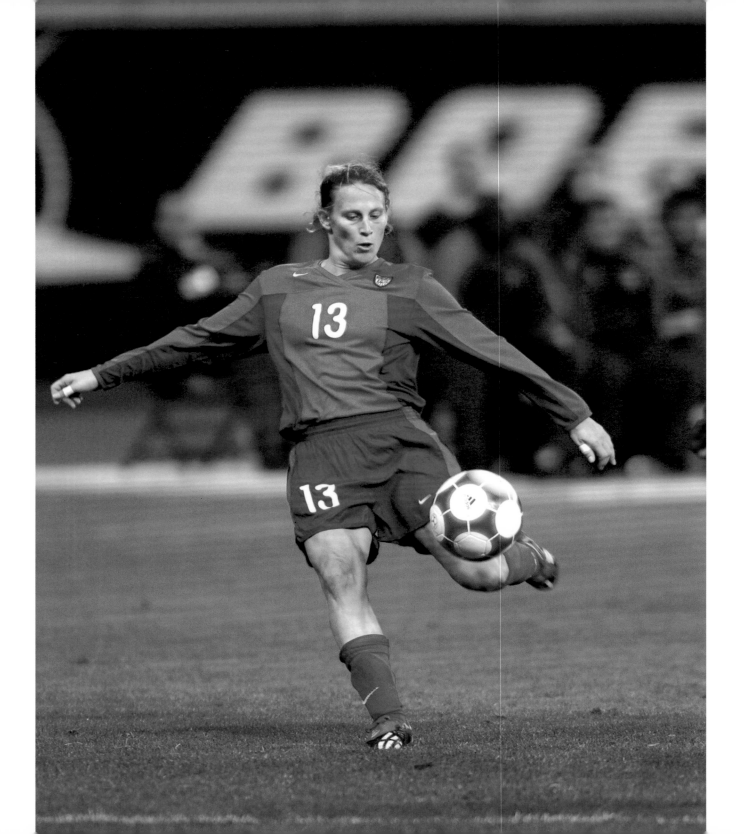

players, Lilly still says, "I'd be a gymnast." At which point Lilly's teammate Kate Sobrero chimes in, "I'd play Ping-Pong, because I don't want to have to run around and work so hard the next time around."

For fans of women's team sports, the Olympic Games are better than they've ever been. Women play not only soccer but basketball and softball at the summer games. In the winter games they play ice hockey. Gone are the days when little girls would only dream of being princess-skaters or pixie-gymnasts, and big girls were out of luck unless they were shot-putters.

But for others, the contemporary Olympic spectacle is a diminished thing. "It's changed for the worse," Wilbert "Skeeter" McClure recently told me. "It's too big now, and with the cheating and all, it doesn't bode well."

Actually, the modern Olympics don't hold exclusive rights to cheating. The ancient games were intensely competitive. A victory could bring fame, wealth, and glory for the champion's hometown, even a lifetime of free dinners and other perks. Corruption was rampant: judges were bribed, competitors were paid off, nations formed alliances. We didn't invent athletic scandals.

McClure's Olympic triumph came in 1960. At the age of twenty-one, the Ohio native traveled to Rome and boxed as a light middleweight. Track star Wilma Rudolph and an unassuming eighteen-year-old teammate of McClure's named Cassius Clay got the attention, but Skeeter McClure's medal was as gold as theirs were.

McClure—who finished college after those Olympics, boxed professionally for a time, and eventually earned a Ph.D. in psychology—recalls that his first shock as an Olympian came when, as he and his teammates watched, the referees began holding up the arms of the wrong boxers. "We saw some of those bouts, and we all talked about how political it was," he says. "The best fighters didn't necessarily win. It was the height of the Cold War."

Asked if he had entertained childhood dreams about being an Olympian, McClure said dreaming had nothing to do with it. "The Olympics was just another hurdle. I figured I'd go over there and do the best I could. But I don't think anybody dreamed about it. It

wasn't a big thing. There wasn't as much hullabaloo in the 1940s and 1950s, and there wasn't much TV. Nobody in Toledo talked about it that much."

For McClure, there wasn't a lot of hullabaloo after the games either. His professional career was disappointing, at least to him, and, though he has served as a boxing commissioner in Massachusetts and still attends bouts from time to time, he's unlikely to be ringside in Athens. "You're a gold medalist, and now you can't get tickets to Olympic events," he told me. "You have to pay your own way."

John Thomas won't be in Athens either. As a teenager, he competed as a high jumper in the 1960 games, winning a bronze medal, which, he learned, was dross. Thomas had been favored to win gold; when he didn't, as he put it recently, the kindest of his critics asked, "What happened?" Those less inclined to compassion called him "a quitter, a man with no heart." After those games Thomas said, "People only like winners. They don't give credit to a man for trying. American spectators are frustrated athletes. In the champions, they see what they'd like to be. In the loser, they see what they actually are, and they treat him with scorn."

Was it any different in the early days of the Olympics? We're told that for the ancient Greeks, only first place counted; second- and third-place finishers were simply losers. Adoring fans showered victors with ribbons, palm branches, and gifts, just as today we shower them with tokens of affection like flowers and teddy bears, but silver and bronze weren't even categories back then.

Thomas made the team again in 1964 and won a silver medal in Tokyo, finishing second to the Russian Valery Brumel. To their great credit, they became friends and had their picture taken together despite the tension between their nations and the inclination of many to understand the games as a symbolic battle between ideologies. Looking back, Thomas calls the 1964 games "the last really honest Olympics," because now even the track athletes are "professionals running for prize money."

The Olympic ideal of amateurism that Thomas alludes to wasn't practiced systematically in ancient times, either. Athletes were professionals who competed in a circuit of games throughout

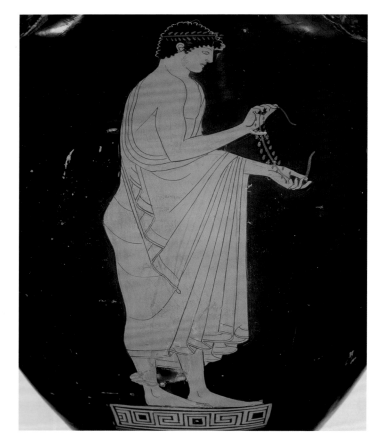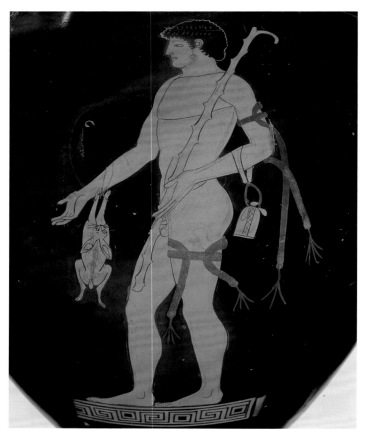

An admirer (left) offers a wreath to an athlete who is already loaded with prizes and gifts (cat. no. 149, two views).

the Greek world. Part of the mystical attraction of the Greek Olympics was that the athletes were competing for tokens rather than treasure, but the most successful of them could be sure their patrons would reward them with the aforementioned perks: cash, free meals, even verses ensuring their immortality. Today the spoils include sponsorships and lucrative opportunities to sell everything from breakfast cereal to pain relievers. "Immortality" comes in the form of TV spots and media celebrity.

Certainly the greatest change in how the Olympics are perceived has come from the influence of TV on the contemporary games. Television pays for the games and buys the right to decide not only what we'll see but whom we'll love. As athletes like John Thomas recognize, the up-close, personal, and shameless presentations of the chosen sometimes have very little to do with the athlete as competitor, and everything to do with the Olympian as TV star.

"TV wants the spectacular, whether it's good or bad," Thomas commented recently. "TV kind of taints the sport. It's about the good, the bad, and the ugly. TV says, 'Hey, the person over there has blond hair and blue eyes.'"

"Were you the good, the bad, or the ugly?" I asked him.

He smiles. "I'd put myself in the good," he says. It's a reconciliation with his Olympic experience that has taken some time.

Jimmy Pedro is still looking for reconciliation. The six-time judo world champion has competed in three Olympics, but his greatest thrill came in making the team for the 1992 games in Barcelona. "I was ecstatic," he remembers. "I was definitely overwhelmed by it all. All the free clothes, the feeling of being part of the best team in the world, it was terrific. But after losing, after not medaling, I was devastated. I was empty, depressed. I wondered if I'd just wasted my time. I was only twenty-one, but I had high expectations."

In 1996 Pedro won a bronze medal. In 2000 he traveled to Sydney as a five-time world champion and overwhelming favorite, but won nothing, which explains why he decided to try to qualify for the Athens games.

"It's unfinished business," he told me. "I would not be competing if I'd won gold at any of the previous Olympics. In the 1999 World Championships, I even beat a Russian to win the gold, so my childhood dream was fulfilled. And I would have been ready to retire after Sydney, but then I said to myself, 'I'm still young enough, and it's the one thing I haven't accomplished in my career, the one thing I haven't succeeded at.'" As in the early days, there's something magical about the Olympics. They have a prestige that no other tournament can match—not the World Championships today, nor any of the other "crown games" in Greek times.

If many Olympians feel short-changed because they don't win gold—or because they don't win anything—at least they've experienced the satisfaction of making the team. To that extent, their struggles have paid off. Most athletes who pursue the dream of making the Olympics have only scars and mixed memories for their efforts. Four years after she spent a year trying to qualify for the 2000 games, rower Sara Field shakes her head at what she endured to keep competing. "Lots of rowers break ribs," she told

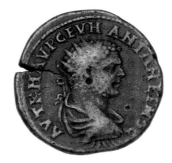

A vessel, a palm branch, and a bulky crown on the reverse of this coin are athletic prizes (cat. no. 144).

me. "There's a strain on the back muscles that causes them to bunch up, get fatigued, and pull at the cartilage. You get cracked ribs and stress fractures."

To keep practicing, some of the rowers at the Olympic Training Center in San Diego in the year before the Sydney games, Field among them, needed treatments that may strike many non-Olympians as grotesque, if not medieval. "The doctor would lean you over," Field told me, "then dig his fingers into your ribs and pull against them, separate them, so that you could make it through practice. We were practicing three times a day, and at some points I was having that treatment every day."

Field, tall and strong, works as a Web designer now, but still looks as if she could slip into a scull and compete at the highest level. She is frank about the pain she and others at the center came to regard as routine. "In your time off," she recalled, "you wanted to have ice on everything. On one of those days, my mom came to visit, and I was strapping ice bags all over my torso. I asked her to grab one end of the ace bandage to help me strap on the ice, and she started crying. It kind of made me realize how ridiculous it was, but I didn't quit. I felt I shouldn't quit until I'd gone as far as I could go."

The process of choosing who'd be in the boat in Sydney made failing to make the cut even more painful. Sara Field joyfully competed as a member of the U.S. National Team for four

years, but she found the Olympic Camp frustrating. "You never knew if something you said at dinner, or something somebody said about you, was counting for or against you. And the coach liked it that way. He wanted you to feel that everything counted. So there was always speculation: 'Why is this person in the boat? Or why isn't that person in the boat?'

"I used to wish I had a different sport, where the choosing might not have been so arbitrary. Rowing is good when you get to the Olympics, but there are so many elements to getting there."

Today, as in the ancient games, "arbitrary" comes into it even for athletes who don't have to depend on a coach's decision, or at least it feels that way to some of those athletes. Of her triumph in the marathon at the 1984 games in Los Angeles, Joan Benoit Samuelson told me, "I never thought I'd win. It was Greta

[Waitz]'s medal, but everything clicked that day. A day earlier, an hour earlier, it might have been a different result. You can run a race a million times in your head, and then go out and blow it."

Like Kristine Lilly, Samuelson had dreams of competing as an Olympian when she was a child. But in those dreams, she was a skier. "I never thought it would be running," she says now. "I wanted to be like Jean-Claude Killy, Billy Kidd, or Nancy Greene from Canada. Skiing was one of the few sports that gave girls the opportunity to compete. Now it's totally different. I don't know what I'd do now. Maybe today I'd be a soccer player."

Joan Benoit Samuelson, like Skeeter McClure and John Thomas, is not entirely happy with the games as we see them today. "The commercialization and the drama in the ads are hard to take," she told me. Unlike most of her fellow gold medalists, Samuelson still practices the trade that made her famous. Running is part of who she is. And sometimes when she runs, she recalls the running she did twenty years ago. "Some days I think, 'How'd I do it?'" she told me. "On other days, I think I could go out and run that same race again."

One of the constants we can point to through the history of the Olympic Games is our admiration for competitors like Samuelson, Lilly, and the rest. The least imaginative among us may be upset, baffled, even angry when our champions do not finish first, but we admire these athletes' physical prowess and their commitment. We envy their passion. That the ancient Greeks were similarly moved is evident in the sculptures and paintings in this book.

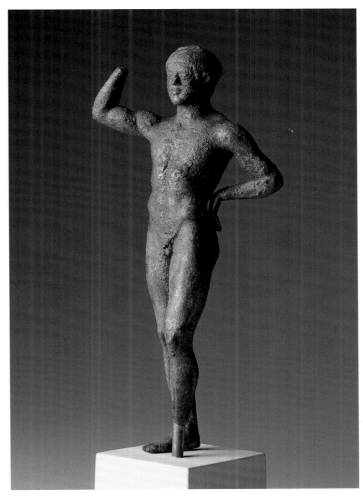

This athlete is probably crowning himself with a prize wreath (cat. no. 157).

This foreword is based on interviews with Kristine Lilly and Kate Sobrero (Boston University, July 29, 2003), Jimmy Pedro (phone interview, September 3, 2003), Joan Benoit Samuelson (phone interview, September 3, 2003), Wilbert "Skeeter" McClure (phone interview, August 15, 2003), John Thomas (Roxbury Community College, August 19, 2003), and Sara Field (Boston University, August 22, 2003), and on John Thomas's comments in *The Complete Book of the Summer Olympics*, ed. David Wallechinsky (New York: Overlook Press, 2000).

Bill Littlefield hosts NPR's *Only a Game*, produced at WBUR in Boston. His books include *Fall Classics: The Best Writing About the World Series' First 100 Years* (ed.) and two novels, *The Circus in the Woods* and *Prospect*.

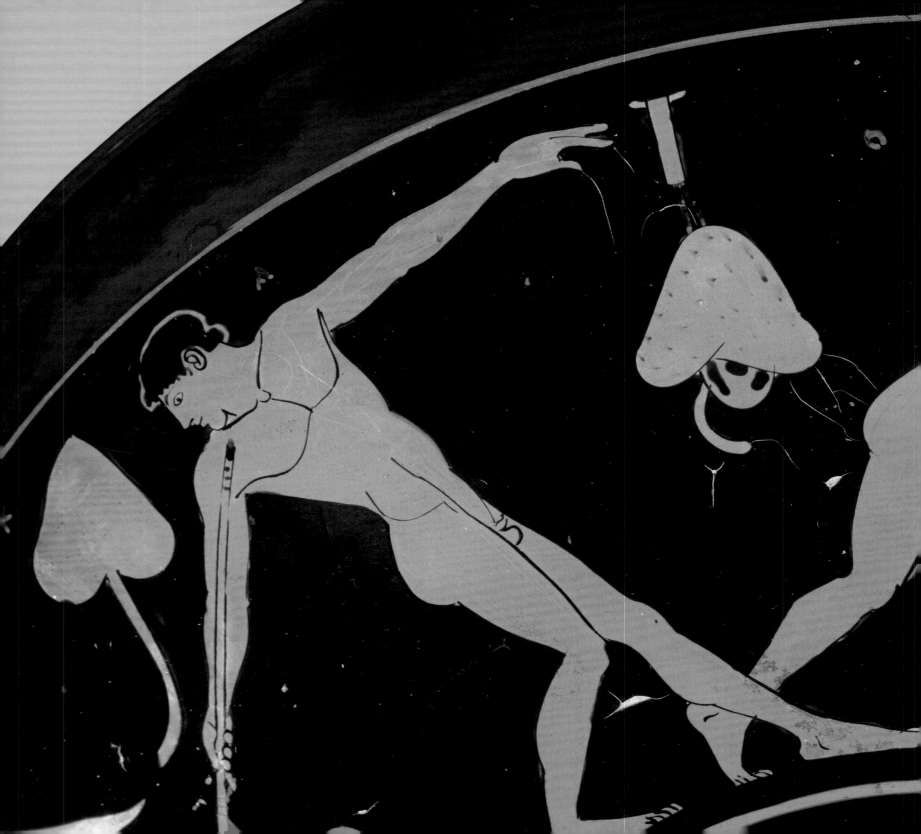

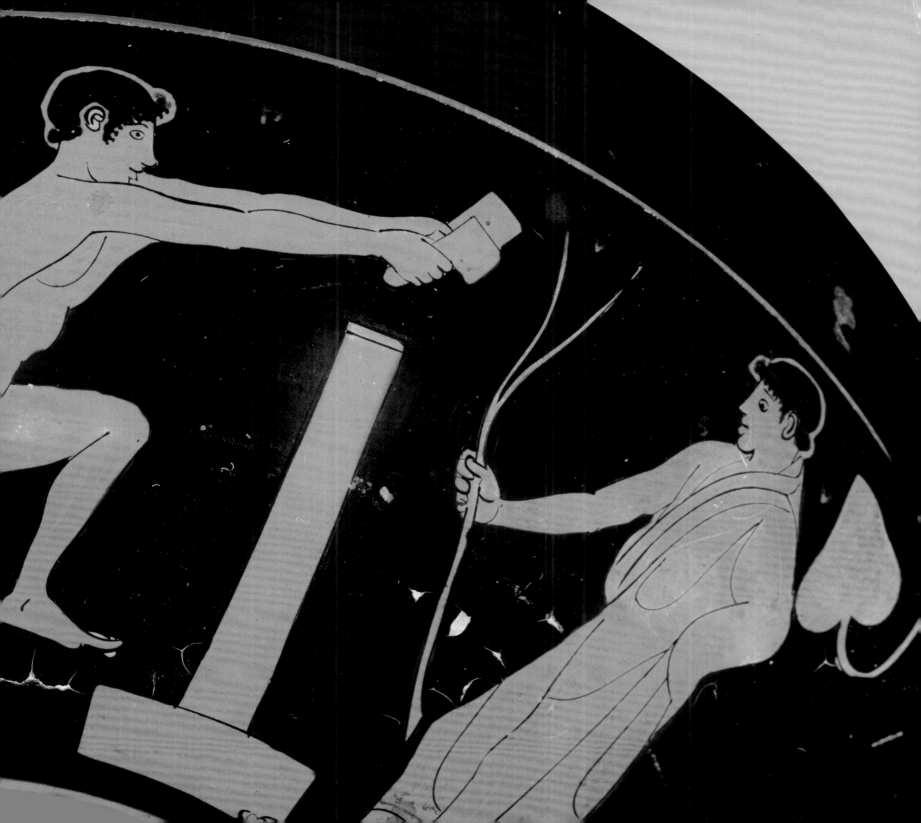

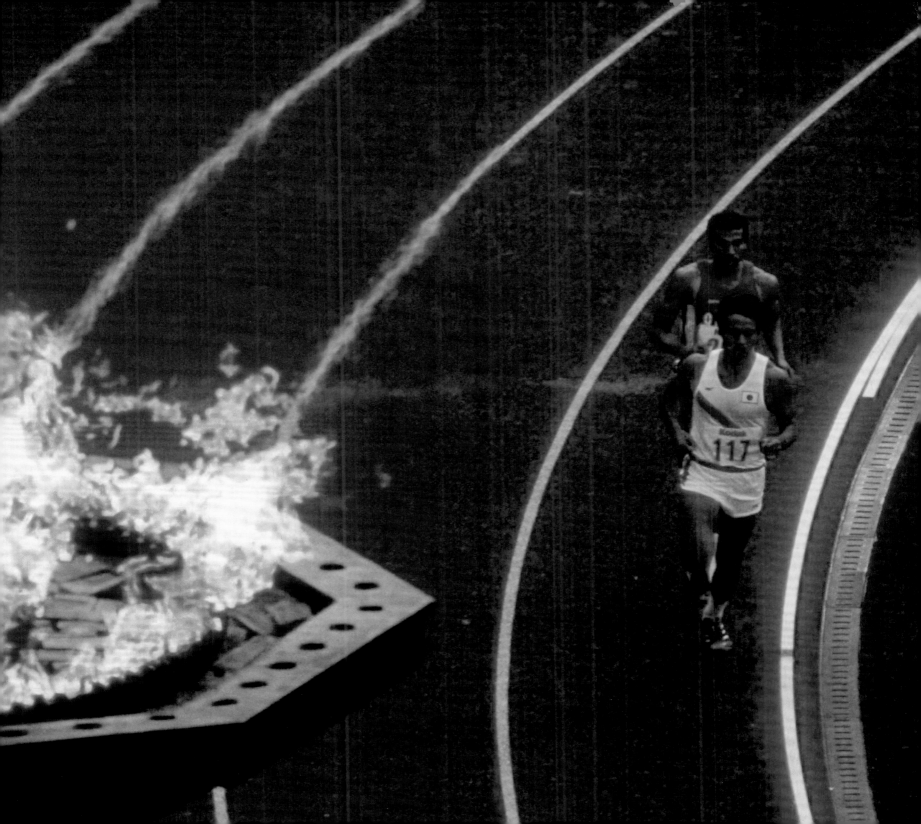

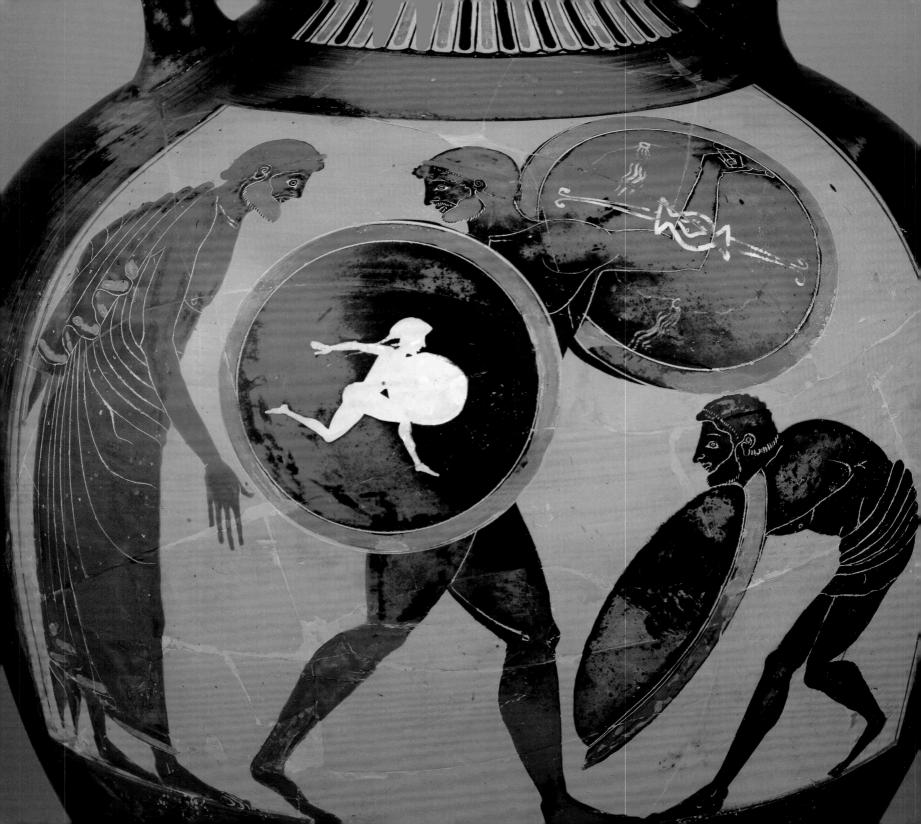

Good heavens, Mardonius, what kind of men are these that you have pitted us against? It is not for money they contend but for glory of achievement!

— Herodotus *Histories* 8.26.3

The modern Olympic Games are an amazing phenomenon, a flourishing international tradition modeled on an athletic ritual that ceased more than a millennium and a half ago. The difficulty promoters have experienced in making soccer, the world's most popular sport, take root fully in the United States only puts the magnitude of the Olympic achievement in greater relief. When the French nobleman and educator Baron Pierre de Coubertin realized his dream by organizing the first modern Olympic Games in Athens in 1896, he was working in a climate of romanticism about ancient Greek and Roman culture (then defined as "Classical") that no longer prevails in today's multicultural world. Coubertin succeeded in linking competitive physical activities to pageantry, internationalism, peace, ethics, and, not least, excitement over new discoveries about ancient civilization.[1] The idealization of Greek sports that prevailed in this environment led to the wholesale takeover of Greek terminology for modern athletics—usually in Latinized form. The very word "athletics" is Greek in origin: *athlos*, meaning "contest for a prize," led to *athletica* in Latin. "Stadium" is identical in Latin and English and comes from the Greek *stadion*; "gymnasium" is the Latin adaptation of *gymnasion*; and so on.

Similarly, many Olympic events, especially those of track and field, were consciously revived from Greek antiquity. Wrestling, boxing, and footraces are perhaps natural events, since they are found in many unrelated cultures throughout the world and throughout time. The field events of jumping and throwing the javelin and the discus, however, are the result of learned neoclassic revival. Combined events, such as the pentathlon ("five contests"), were also taken up directly from ancient Greece. Relay races and the custom of having runners bring fire from Olympia to inaugurate each edition of the modern Olympic Games were probably inspired by the torch relay race between different tribes at athletic festivals in several ancient cities, including Athens, Corinth, and Amphipolis. The four-year interval between modern Olympics likewise repeats the ancient timing; then, as now, the games were held during the hottest part of the year. And, as in antiquity, intrinsically valuable prizes are not given at the Olympics; the winners receive only a symbolic wreath of leaves and, in modern times, a medal.

Even the Olympic Truce, when warfare was stopped to permit all Greeks to participate in the festival at Olympia, has been an example for modern times. Although the Olympics were suspended during both World Wars, they survived several less widespread conflicts during the Cold War, and the ideal of peace is written into the Olympic Charter. In spite of interruptions and the dissipation of the climate of Classical revival that led to their birth, the Olympic Games have endured for 108 years, and the magnitude of the Olympic phenomenon has only grown. The desire to be the best and the admiration for the Olympic champion are sentiments that unite ancient and modern athletes and their audiences. The excitement of competition and unabashed regard for highly trained, beautifully fit human beings at the peak of their physical powers were pleasures for ancient, just as they are for modern, spectators.

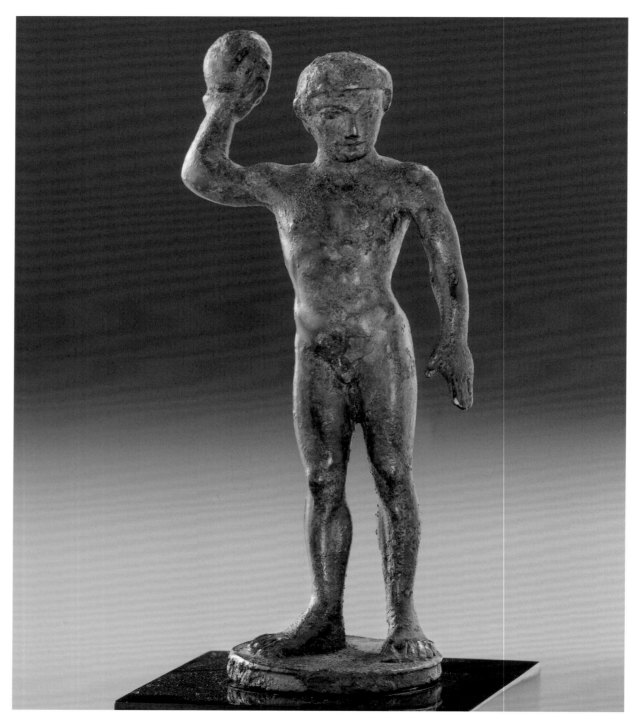

Ancient and modern artists alike celebrate athletic prowess. This athlete lifts a sizable, ball-like weight with one hand (cat. no. 102).

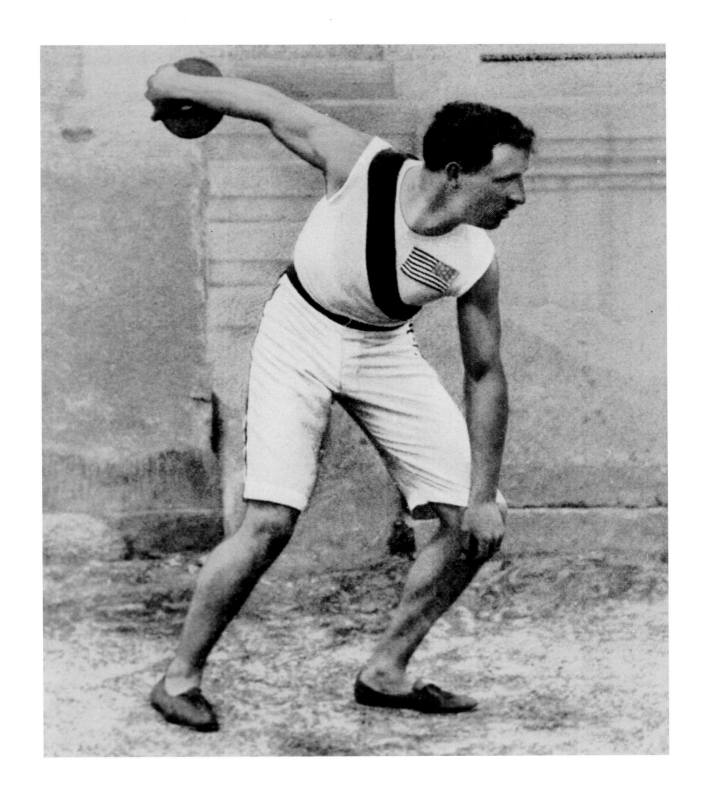

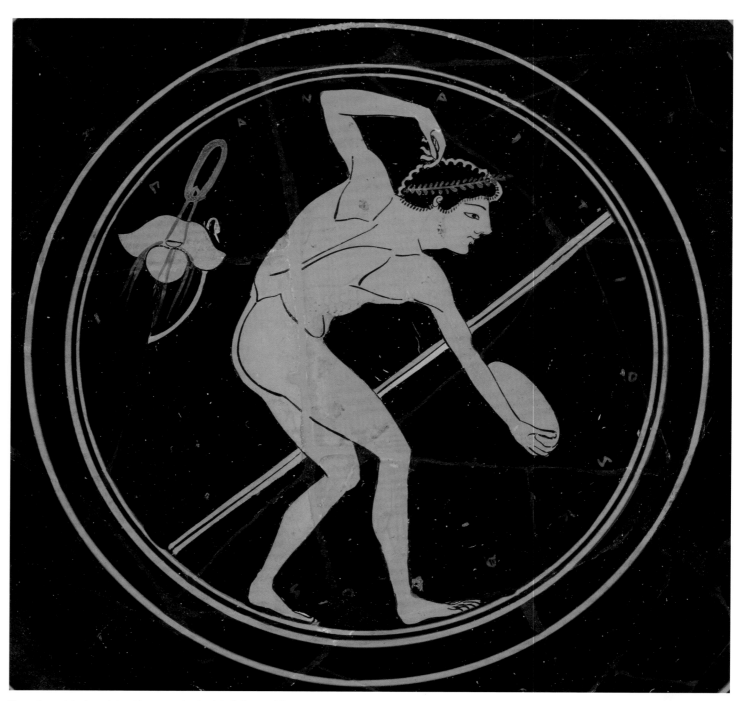

The motion and physique of the athlete are explored artistically (cat. no. 39).

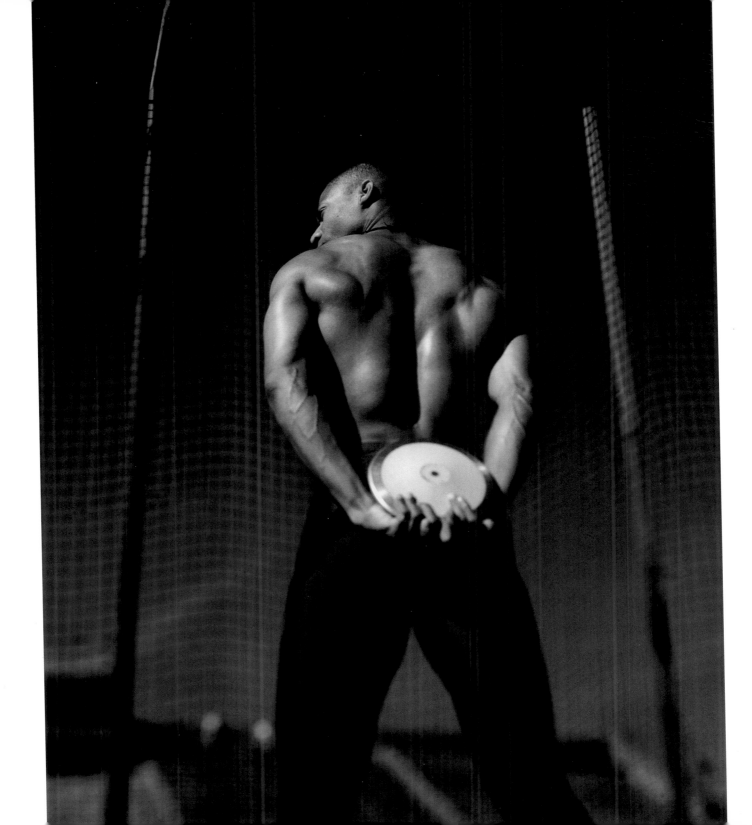

Putting ancient and modern athletics side by side can produce a sense of pleasure at the similarities that forge a bond across the millennia, but the comparison can also produce a jolt of alienation. Ancient athletics have a very different look and feel from modern sports. In spite of the many cultural parallels and revivals in the fields of government, philosophy, and art, the ancient and modern worlds are quite different, and only by adapting ancient traditions to modern aspirations and political and social structures could Greek-based athletics gain their present hold on the world. Alien social and religious structures, in particular, intrude into the games of antiquity in ways that are fairly incompatible with almost any twenty-first-century culture, from post-Protestant northern Europe to fundamentalist Islam. All athletics are harsher and sweatier than they seem from the distant grandstand, and Greek athletics are strange and problematic in their own special way.

The ancient Olympics had a stature and a celebrity much like today's games, but they were not alone as "international" athletic festivals for track and field events. They were the most prestigious and oldest of such tournaments, having been founded, according to tradition, in 776 B.C., toward the end of the Greek "Dark Ages," but they generated numerous imitators and derivatives. In the sixth century B.C. three other athletic festivals were instituted or reorganized on the Olympic model: the Pythian Games at Delphi in central Greece, the Isthmian Games at the Isthmus of Corinth, and the Nemean Games at Nemea. These competitions took place either every two or every four years, and their prizes were also wreaths or crowns of leaves sacred to a god. The Olympics towered over the others in prestige, yet the four formed a circuit of "crown games" that had something of the character of a modern athletic conference.

The absence of valuable prizes in these tournaments has always been a source of amazement. In antiquity it impressed the "barbarians" (that is, non-Greeks) enormously. As a commander of the invading Persian army put it in 480 B.C.: "Good heavens, Mardonius, what kind of men are these that you have pitted us against? It is not for money they contend but for glory of achievement!"[2] While the official prizes were symbolic at the crown games, there were collateral ways for winners to profit from their victories. An inscription from the first half of the sixth century B.C. testifies that the athlete Kleombrotas dedicated one-tenth of his Olympic winnings to Athena, the chief goddess of his hometown in southern Italy.[3] Hometown pride in victors at the crown games could also produce very substantial perks. The Athenian legislator Solon had five hundred drachmas paid to every victor from his home city. An Athenian law from 430 B.C. guaranteed winners free meals at state expense for life.[4]

The now-abandoned modern ideal that an Olympian must be a complete amateur was inspired in part by the ancient crown games, and in both cases elitism was involved. Only the wealthy could dispose of the money and time necessary to train for competition at the highest level in contests for which there was no monetary reward. Initially the aristocracy, who styled themselves as the beautiful and noble (*kaloi kagathoi*), were dominant. Amateurism, however, was neither systematically practiced nor preached in antiquity. The enthusiasm for athletics in the sixth century B.C. led to the founding or reorganization of many additional festivals that offered intrinsically valuable prizes, whether money or precious commodities. Most notable were the major Panathenaic Games in Athens, founded in 566 and reorganized in 561 B.C. In Athens the prizes were large jars of precious olive oil. Other festivals awarded commodities such as woolen fabrics, and valuable silver or bronze vases were popular as trophies (fig. 1).[5]

The sporting mania spread far beyond the boundaries of Greece itself. From the fifth century B.C. onward athletic festivals sprang up in Greek or heavily Hellenized cities in Italy, Asia Minor, and Cyrenaica (modern Libya). Although these games may have been called "Nemean" or "Isthmian," they lacked the prestige of the crown games they imitated and presumably had to provide substantial incentives to attract athletic talent.[6] Mourning and funerals offered almost limitless opportunities for more tournaments. The Greeks and the cultures surrounding them cele-

brated their war dead and local heroes of the past with sports events, and the heirs of the very rich and pretentious staged private funeral games.[7] Several of the objects in this book, in fact, have a connection with this kind of commemorative event. As a result of the proliferation of tournaments, Greek athletes could pass from one set of games to the next throughout the years, with winners basking in adulation and collecting hefty prizes and desirable collateral perks. Stories were told of great wealth accumulated by major winners. Theagenes from the northern Greek island of Thasos in the fifth century B.C., for example, was able to pay off immense and rather arbitrary Olympic fines.[8]

Greek athletics soon spread to the surrounding non-Greek, or "barbarian," world as well. The Etruscans in north-central Italy took up Greek sports in the fifth century B.C., as is made clear by numerous statuettes of nude athletes with discus, javelin, or jumping weights and tomb frescoes representing these typically "Greek" events.[9] Greek athletics made a great leap to the east in the second half of the fourth century B.C. Through the conquests of Philip II of Macedon and his son Alexander the Great, Greek culture, with its athletics, intruded into the Thracian world in the southern Balkans and spread throughout the Persian Empire, extending from Asia Minor and Egypt through modern Afghanistan and Pakistan.[10] A Hellenic gymnasion has, in fact, been excavated at Ai Khanoum in Afghanistan. Philip himself was strongly attached to the Olympic Games, where his horses and chariots won, as commemorated on his coinage (cat. nos. 78 and 92, p. 114). His admission to the Olympic Games was of great political and ideological importance, since it validated his claim to be a Greek rather than a barbarian, as some of his adversaries to the south called him. After they conquered Greece, Philip and Alexander rather arrogantly erected a templelike triumphal monument at Olympia, complete with gold and ivory statues of themselves and members of their family.

Even after Rome conquered the kingdoms of Alexander's successors, the process of athletic Hellenization continued in the Balkans and Asia. Visual manifestation of the spread of athletics

Fig. 1. This water jar, a prize from games at Mylasa in Asia Minor, depicts Zeus in the form of an eagle abducting Ganymede.

can be followed in local coinages of the Roman Empire. Cities publicized themselves and their festivals with athletic imagery. Particularly vivid examples are provided by the large bronze coins of Philippopolis in Thrace (modern Plovdiv, Bulgaria) during the first half of the third century A.D. (cat. nos. 53, 60, and 144, pp. 88, 98, and 7). The coinage celebrated the city's own Pythian Games, named in honor of their model, the festival of Apollo the python slayer at Delphi. These Greek-style games, it should be noted, always remained clearly distinct from the characteristic Roman entertainments of beast hunts and gladiatorial combats to the death.

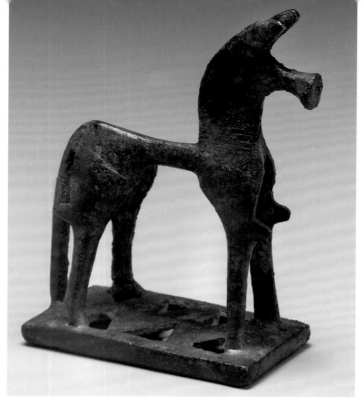

Statuettes of horses were common dedications at Greek sanctuaries (cat. no. 16).

The role played by religion and piety was a distinctive feature of Greek athletic festivals.[11] These festivals were linked to celebrations in honor of the principal god of a city-state and/or to a local hero. This connection is made explicit on Panathenaic amphorae, where the athletic event occupies one side and Athens's principal goddess, Athena, is depicted on the other. Even minor festivals took over this model; one vase presented to a victor by the city of Mylasa, near the west coast of Asia Minor, was, according to its inscription, a prize from the games of Zenoposeidon, a local god who combined Zeus and Poseidon (fig. 1).[12] Some events, such as the torch race, originated as part of religious ceremonies. The races usually involved carrying the flame from one altar to another of a god or hero associated with fire or light, such as Apollo, Eros, Hephaistos, or Prometheus.[13] Divine intervention was considered a major factor in the outcome of athletic contests. In Homer, gods give extra rushes of adrenaline to their favorites and harass the competition with accidents.[14] The chief god was believed to decide the results of competitions at his or her festival. Winning the Olympic wreath in antiquity signified the favor of Zeus, and it could have political consequences. Spartan kings, for example, wanted to have an Olympic victor at their side in battle.[15] Modern fans may offer private prayers for their favorite team, but there is no such systemic belief in the efficacy of divine intervention.

The full spectrum of events at the ancient Olympic Games was significantly different and much narrower than it is today. In the eighth century B.C., the limitations were extreme. During their first half-century the games reputedly consisted of only one footrace for the length of the stadium, approximately 180 meters (200 yards). The winner was the toast of Greece, and the following four-year period was named after him. In the 720s two longer races were added: a double length of the stadium and a long-distance race. In 708 B.C. wrestling and the pentathlon appeared on the Olympic program. In 688 B.C. another combat sport, boxing, was added.

Events alien to our Olympics made their appearance in the course of the seventh century B.C. Horse racing and four-horse chariot racing became the most popular attractions at Olympia, and over the span of several centuries variations were added and, in some cases, later dropped: races of mares, two-horse chariots, mule-chariots, and foal-chariots. The popularity of horse races may have been an offshoot of the widespread admiration of these animals in early Greek society: ceramic and bronze horses were the favorite votive gifts at most sanctuaries, Olympia included, from the tenth through the seventh centuries B.C. (cat. no. 16).[16] Chariot races, furthermore, provided more pageantry than human races, and, as in car racing today, there was a constant possibility of spectacular accidents, which were on occasion commemorated in art and coinage (cat. no. 90, p. 118). The perils of the sport were customarily attributed to demonic intervention rather than to Zeus himself. Other Greek-style athletic festivals of antiquity offered still more novel equestrian races, which included pairs of

horses with one rider who would change horses on the fly, or one horse with a rider who would dismount and complete the race on foot.[17]

Still other events foreign to the modern Olympic Games were added in the following centuries. The *pankration* joined the program in 648 B.C. This no-holds-barred fighting was a mixture of wrestling and boxing that had more in common with today's professional wrestling than with any current Olympic event. The *hoplitodromos*, a race in armor, made its appearance in 520 B.C. This event was perhaps intended to strengthen the link between military service and athletics and to justify the social utility of sport. Strikingly unathletic were the competitions between trumpeters and heralds that were added to the Olympics in the early fourth century B.C. Again, pageantry and a sense of social utility may have been the motives for their inclusion. Male beauty contests were added in some athletic festivals, particularly in Athens and Elis. Although no details are known, size and strength and thus some kind of athletic prowess were important criteria, but there also seems to have been some effort to rate the interior qualities of the competitor.[18] These contests could have offered rare opportunities for subjective factors to be considered in the outcome.

The most dramatic limitation by today's standards is the absence of team events in the ancient Olympics. All competitions were for individuals. Some Greek athletic festivals, however, incorporated team competitions at the margins. As already mentioned, Athens held a relay torch race between its various tribes. Boat races, pitting crews of oarsmen against one another, are thought to have been part of the Isthmian Games since heroic times. From at least the fourth century B.C. onward, they formed part of various festivals at Athens, Hermione on the north coast of the Peloponnesos, and Actium on the west coast of Greece.[19] Several Athenian reliefs of the second century A.D. show crews of victorious rowers (cat. no. 162).[20] Boats on coins from the island of Corcyra (modern Corfu) probably celebrate victories in nearby Actium, and an example from Roman times shows a rather impure mixture of rowing and sailing (cat. no. 24). A boat with a victorious crew crowned with wreaths on an Apulian plate could represent victors either in southeastern Italy or across the strait in Actium (fig. 2).

Ball playing, the great passion of the modern world of sports, was apparently not included in any ancient athletic festival, although as a form of recreation it was popular with girls as well as boys and young men.[21] The ceramic ball illustrated in this book (cat. no. 46, pp. 34 and 82) was a girl's toy and was meant to be suspended by a cord. Women on southern Italian vases from the fourth century B.C. are occasionally shown dangling such ornamental balls.[22] Individuals would juggle multiple balls, and small groups would play catch, with one who dropped the ball having to carry another on his back as a penalty. A famous marble relief in Athens from the early fifth century B.C. shows what seems to be a game of field hockey, and another shows a kind of volleyball without a net between teams of three youths. Inflatable balls were probably unknown (although there is some disagreement about this), and even stuffed balls were objects of relative luxury. These technical and economic factors may have contributed to the absence of ball games from organized competitions. Team ball games may have been primarily pastimes for privileged youths at gymnasia. Only at Sparta—always an exception—were ball games between teams of great importance in training and ritual. In fact, Spartan youths entering manhood were called "ballplayers."[23]

The lack of today's sophisticated technology may, at least in part, explain some radically different rules and procedures in antiquity. Athletes were divided into age classes rather than weight classes, perhaps because human body weight would have been hard to determine accurately. However, the weights of small objects such as coins could be measured rather precisely, and in the absence of drivers' licenses and passports age would also have been hard to establish reliably. Men and boys had their own events at the Olympics, and elsewhere age groups might have been broken down further into three groups: boys, youths, and men. Not surprisingly, the heavyweights in each age group of the combat sports (boxing, wrestling, and pankration) usually rose to

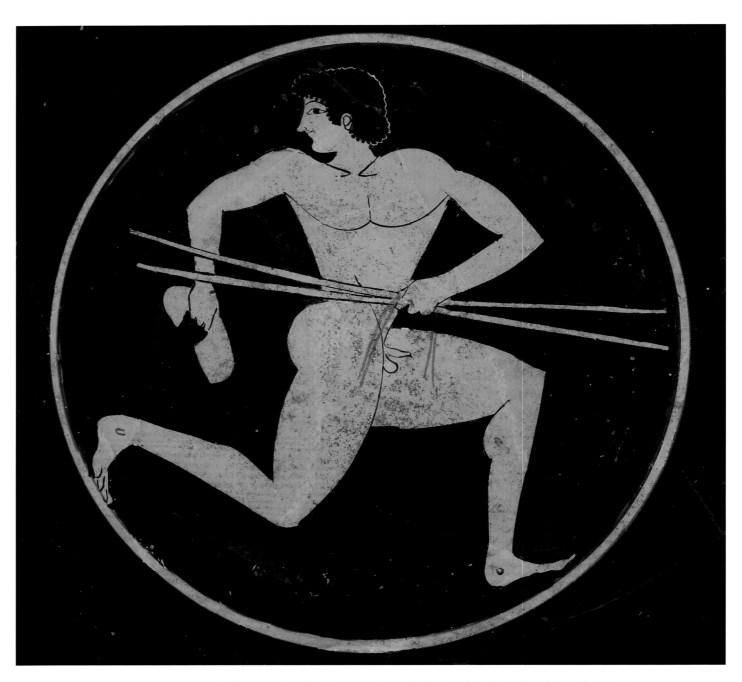

Pentathletes competed in long jump, javelin, discus, a short footrace, and wrestling. Here, a pentathlete carries javelins and a weight used in the long jump (cat. no. 40).

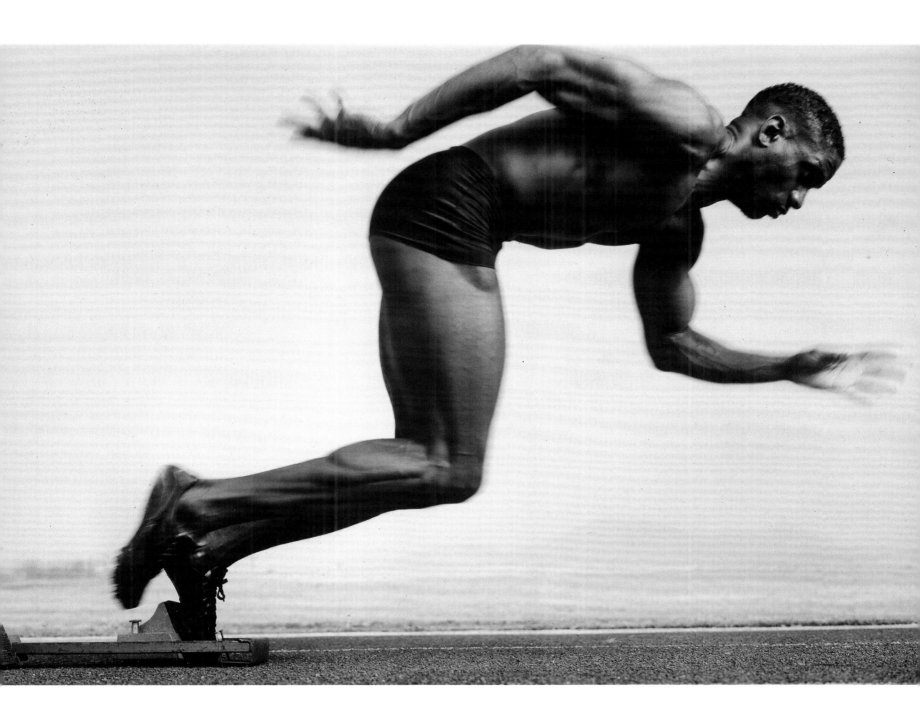

the top. Probably for this reason they were called the "heavy" events. Record performances did not matter, since there were no fixed standards for equipment. In a survey of fifteen ancient Greek bronze discuses, all were of different weights and diameters, and the largest weighed four times the smallest.[24] Speed records could not be established since races could not be timed with any precision. Beyond individual victories, only multiple victories on the circuit of crown games could create the aura of a super champion. The ultimate achievement was to win at all four games and become a *periodonikes*, the equivalent of a modern grand-slam winner in tennis or golf.

What might be called the Olympic trials took on a strangely legalistic, controlling, and punitive character in antiquity. Competitors had to reside at Olympia or in Elis for weeks or months and undergo training according to regulations and standards set by the city's judges. Late arrival led to disqualification, and tardiness was carefully investigated. One disqualified athlete who claimed he was delayed by bad weather proved to have been picking up cash prizes at some lesser games in Ionia (along the coast of Asia Minor).[25] The judges classified athletes by age group and presumably weeded out weak performers. The qualifying process could evidently be so severe that only one athlete might show up at the official games and collect his wreath without contest.[26] Perhaps these individuals proved themselves so superior in training that no one wanted to confront the pain and/or humiliation of competing against them publicly.

At the games themselves, corruption and pressure on the judges seem to have flourished. At the entrance to the stadium at Olympia was a series of statues of Zeus set up from the fines imposed on athletes—usually for bribery. Since no monetary prizes were offered at Olympia, money under the table could have an especially powerful effect. On one occasion, two judges were fined for some sort of collusion.[27] Unfortunately, we do not have any proceedings of the review board or confessions by the scheming judges, as in the case of the secret agreement between the French and Russian figure-skating judges in the 2002 winter Olympics in Salt Lake City.

Competitiveness was even more extreme in antiquity than it is nowadays. Statements by celebrated modern professional coaches to the effect that winning is all that matters have become famous (for example, Vince Lombardi's dictum, "There is only one place in my game, and that's first place"). But this is not modern Olympic doctrine, where the mantra is that the important thing is to have participated, nor does it prevail in modern sports in general. In antiquity, however, the principle "winner takes all" was institutionalized. Only first place counted at the ancient Olympics and the other crown games; second- and third-place finishers were just losers. The exclusive focus on winning led to a procedure for the ancient pentathlon that seems unfair and disappointing to our way of thinking. If one contestant won the first three events, he became the winner of the pentathlon, and the remaining two events were cancelled.[28] The pentathlon, however, did pose a problem for the deep thinkers about ancient sport. An athlete who was not the top in any one specialty (that is, a loser) could still win the pentathlon and in a sense be the best athlete of all.[29] Winning was not everything in some lesser, local festivals; the Panathenaia, for example, awarded second prizes, which were worth one-fifth of the first prize.[30]

Unfamiliar to the modern Olympics is the level of brutality permitted in the ancient games. There were virtually no victories by decision in combat sports. Referees did not intervene to save badly battered fighters. Boxing and freestyle fighting (pankration) went on until one contestant gave up or was knocked unconscious. Boxing gloves were vicious weapons rather than protective devices. Blood flowed freely and disfiguring injuries were the normal badge of the boxer. Killing an opponent went too far; the homicide was disqualified. However, the gallantry, even the poetic beauty, of fighting to the death was highly appreciated. "Victory or death" was a slogan as current in Greek sport as in Greek warfare. Today's attitudes to mortal injuries in sport could hardly be more different.[31] Well beyond the pale of the brutality in the crown games, moreover, were bloody Spartan athletics. These contests—for Spartans only—included enduring flogging and battles on an island in which one team would drive another into the water. Those who died were honored with statues.[32]

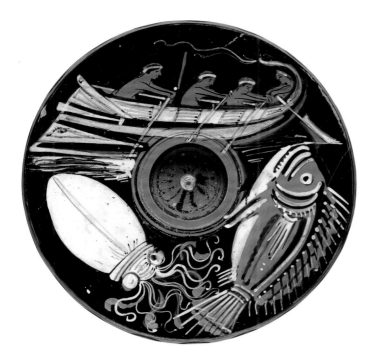

Fig. 2. This plate depicts a victorious boat crew with marine creatures.

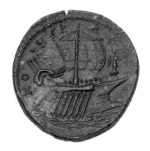

Victors of boat races are commemorated on this coin (cat. no. 24) and marble stele (cat. no. 162).

The ancient Greek rule books seem to have passed over many tactics we would consider the worst sort of dirty fighting. There appears to have been no objection to kicks or punches to the genitals, shown in several vase paintings and perhaps on a coin (cat. no. 61, p. 98).[33] The absence of this taboo is made explicit in a wrestling handbook from Egypt: the trainer enjoins one of his pupils to "catch hold of him [his opponent] by the testicles."[34] Choking, scratching, and kicking were acceptable in pankration.[35] Biting may have been forbidden, but it apparently went on without terminating the match. When biters were reproached or ridiculed, they replied that they bit like lions, not women.[36] Eye gouging was, however, uniformly inadmissible. Rule breakers were lashed by the referee, rather than disqualified—as one can see in vase paintings, where trainers and/or referees equipped with long sticks frequently flank athletes. In some

cases, these supervisors seem to prod the athletes lightly, like trainers, but at times they apparently lash offenders vigorously.[37] The lack of a point system left few other options for discipline. Fines and exclusion from the games seem to have been imposed for bribery, fixes, or political offenses by city-states, but not for mere dirty fighting.

AESTHETICS AND GENDER

Most foreign to the modern mentality is the nudity associated with Greek athletics. Throughout most of antiquity, men and boys probably engaged in Greek-type sports without clothing. Only charioteers were dressed, wearing a long tunic. The building where athletic training took place came to be known as the "gymnasium," from the Greek word *gymnos*, or "nude." Why and how early the costume of nudity originated is essentially lost in the mists of time.[38] Homer (about 800 B.C.) was fully aware of the vulnerability and unattractiveness of most naked people, yet he also had a purely aesthetic appreciation of fit, young male bodies. He expresses this combination of revulsion, pity, and admiration in the contemplation of the corpses of young and old warriors on a battlefield.[39] There is, however, no hint of nudity in his accounts of athletic competitions. Some ancient authors place the origin of athletic nudity at the Olympic Games in 720 B.C. The idea is not implausible, given the many statuettes of nude male gods and warriors of about that time known from Olympia and other sites.[40] The practical reason given by tradition for the beginning of nudity in sports, however, is generally regarded as spurious: a runner supposedly won because he dropped his loincloth. Nudity was compulsory at Olympia, not a matter of choice dictated by functionality. Plato and Thucydides, writing at the end of the fifth and the first half of the fourth centuries B.C., said that the custom of nakedness originated on Crete and then was taken up in Sparta, before becoming generally practiced throughout the Greek world.[41]

Given the practicality of protection and support for the male genitals, scholars have claimed that nudity was limited—perhaps practiced only by boy athletes.[42] The textual and visual record is

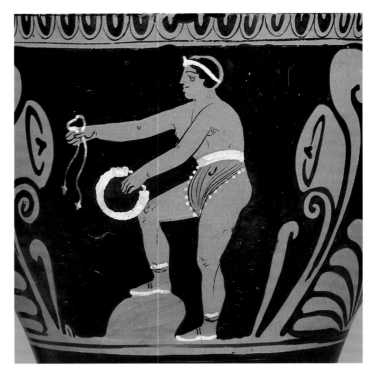

This modest southern Italian athlete wears a loincloth (cat. no. 151).

so overwhelmingly in favor of complete athletic nudity, however, that this view is not generally maintained. Athletic nakedness evidently developed and flourished in the environment of sexual separation, military training, and social competitiveness associated with Greek athletics. Since most games took place at religious sites, nudity has been speculatively linked to age-group initiations. The ideal of the good-looking, successful athlete became firmly connected with elite groups who wanted to present themselves as beautiful minds in beautiful bodies.[43]

These doctrines were usually reserved for males. Naked women engaged in athletics were regarded as laughable—but strangely fascinating. There was no belief in the therapeutic value of nudity for one and all, as nowadays[44]—except in Sparta, where girls also competed, danced, and paraded nude.[45] Nudity, male or

female, continued to be regarded as ridiculous or immoral by surrounding cultures, and the Greeks were well aware of the barbarians' negative attitudes toward this aspect of their culture. Even in heavily Hellenized areas of Italy, athletes with all the trappings of Greek victors (headbands, wreaths, and ribbons) might wear loincloths or shorts, as on a cup produced at Capua in Campania (cat. no. 151).

The Greeks had very distinct ideas of the body beautiful. The massively bulging muscles—especially of the upper body—favored by today's bodybuilders don't appear in Greek art. In Archaic times powerful thighs, which could be the legacy of much walking in a mountainous land, are quite common (cat. no. 40, p. 24). Archaic vase painters show fighters in heavy events with rather thick proportions and at times give them the bulky bellies of some modern professional wrestlers and heavyweight boxers (cat. no. 64, p. 90). These are not, however, the favored physical types in the art of the late sixth and the fifth centuries B.C. Combat sports may have been the most exciting for spectators, but the physical type favored aesthetically was that of the all-around athlete who competed in the pentathlon. In addition, the beauty of adolescence was frequently praised by Greek writers and idealized by Greek artists. In fifth-century art, athletes usually have light builds and seem to be juveniles. Many of the boxers and *pankratists* on vases are slender and have small penises and minimal body hair (cat. no. 66, p. 101). They seem to be boys (that is, in the youngest weight class) who have not yet developed specialized physiques and have not suffered the disfiguring injuries of older, seasoned champions.

In Athenian vase painting victorious athletes are shown on Panathenaic prize amphorae and on some imitation Panathenaics, but most athletic representations are on equipment for drinking parties. These cups, bowls, and plates focus on practice in the gymnasion and *palaistra* (the wrestling ground). This realm of art can wander off into the contemplation of good-looking local youths cleaning up, loitering, or just horsing around (fig. 3). On one plate (cat. no. 44) Xenophon and Dorotheos are apparently engaged in nothing more than a teasing dispute over a discus.

Dorotheos makes a request, and Xenophon pokes at him and holds the disk back. Apparently in the everyday life of a Greek city, champions were not the only recipients of flattering attention.

This kind of presentation of athletes not engaged in serious competition can also move into the realm of homoerotic relationships.[46] Drinking cups are covered with inscriptions praising the best-looking boys of the day such as "so-and-so is good looking" (*kalos*) or more generically "the boy is good looking" (*ho pais kalos*). There is a voyeuristic side to such works. To some degree it was built into the system, since an older male athlete was expected to mentor a boy—an official relationship entered into ideally with the approval of the boy's father. The older man was officially called the "lover" (*erastes*) and the boy was the "beloved" (*eromenos*). Since proper Greek women were kept hidden away at home as much as possible, and since Greek male citizens did not marry until they were about thirty, idealism, affection, and love had ample opportunity to develop among companions in the gymnasia.

The public sanction of homoerotic relationships in Greek athletics was a far cry from today's world, in which gay professional athletes often stay in the closet and very few reveal their orientation even after their playing days are over.[47] The meaning of "homosexuality," however, was far different in antiquity than it is today. Greek homoeroticism by no means represented an exclusive attraction to one's own sex. Instead, it was an institution underpinning a patriarchal system that enabled an adult male minority to dominate not only females but also minors, slaves, barbarians, and (ideally) rival Greek city-states. Boys were minors who, by obliging and learning from their privileged mentors, attained excellence and achieved a high place in the hierarchy.[48]

Women generally had a subordinate and obscure share in Greek athletic culture. This derived naturally from the second-class status that they held in ancient society—especially Athenian society, about which we know the most. Respectable females—that is, the daughters of male citizens—were seen primarily as bearers of legitimate offspring and as domestic economic resources. To insure these goals women were to venture outside

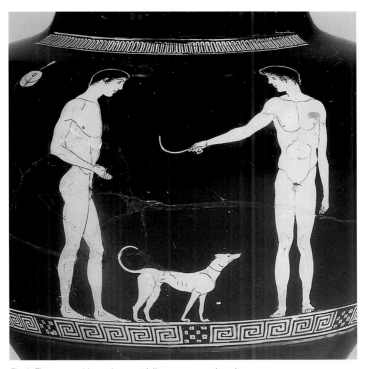

Fig. 3. These two athletes share a strigil, or scraper, as they clean up.

in honor of Artemis. At Olympia girl racers wore short tunics with only one shoulder strap, leaving one maidenly breast bare. This was, in fact, cross-dressing, since this costume was that worn by male workmen. Runners at other Greek sites apparently wore tunics with short skirts and short sleeves.[52] Footraces for girls also took place among the Etruscans in central Italy. A vase painting[53] and a figure carved in an intaglio (cat. no. 135) make it clear that, in the early days at least, Etruscan girls raced fully dressed. The girl in the intaglio runs with a branch of foliage, which was either the palm, a symbol of victory, or some plant sacred to the divinity to which the athletic festival was dedicated.

Female athletic nudity is best documented in Sparta, where up to a point boys and girls received similar, highly competitive training. The training for young females included all of the events of the pentathlon, and they even competed with the boys in wrestling. Their gymnastic training seems to have been a preparation for and terminated by marriage, which took place around the age of eighteen, and it succeeded in giving them a reputation for firm bodies, good looks, and loose morals from early times onward. Helen of Troy, after all, was a Spartan.[54] How complete

their homes as rarely as possible and to be married early, ideally around age fourteen.[49] In the athletic realm, other forms of social hierarchy mitigated this system of subordination and obscurity. Married women might own horses and be celebrated for the victories of their animals, charioteers, and riders.[50] Actual athletic competitions for females were widespread, but they were normally open only to girls—that is, unmarried women—in various age groups, and the only events were footraces. Such races were staged as part of festivals of Hera at Olympia and Nemea, and like males, the female winners had the right to set up a statue or painting of themselves. Races for girls took place at many other festivals as well.[51] During the festival at Brauron near Athens, which may not have been fully public, the girls at times raced in the nude and at times in short tunics as part of a prenuptial ritual

An Etruscan girl lifts the hem of her skirt as she races (cat. no. 135).

< Xenophon and Dorotheos converse during their discus practice (cat. no. 44).

31

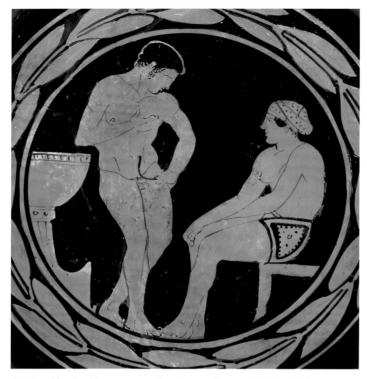

A male and female athlete converse as they clean up after exercise (cat. no. 132).

rated with wrestlers that could have belonged to an athletic complex (cat. no. 55, p. 94). Images such as this are customarily taken as representations of the mythical heroine Atalanta, famed for her masculine athletic prowess; she hunted with the hero Meleager and wrestled with the hero Peleus.[56] However, the images also evoke gymnastic activity at Sparta: "I marvel at the many rules of your palaistra, O Sparta, but even more at the blessings of your gymnasium for girls, since a naked girl may take part in the well-known games amidst men as they wrestle."[57] An ancient viewer could have looked at the coeducational locker room in the drinking cup either way—as mythology or as everyday Spartan life.

The Spartan tradition of girl athletes exercising in the nude like men and boys attracted some artistic attention in the Athenian and even the Etruscan worlds. The focus was on the most titillating aspect of female athletics to male eyes: cleaning up after exercise (cat. no. 131, p. 135). The interest may have been more than artistic. While the girls shown cleaning their bodies with scrapers in these works of art could have been the famous Spartan girls, it is also possible that they reflect homegrown girl athletes.[58] The lean, hard Etruscan girl (cat. no. 133) certainly looks like a highly trained female competitor, not an Etruscan love goddess. The artist must have had a very athletic girl available locally to use as a model.

Throughout most of the Greek world, the palaistra, the gymnasion, and the stadium were highly masculine territory. Married women were barred from viewing the Olympic Games and presumably most other athletic festivals. Unmarried girls could, however, be spectators at male competitions, just as they could participate in their own games. A girl named Myrrhine must have been a great fan of male athletics: her ceramic ball is inscribed with praise of an athlete[59] and decorated with scenes of gymnasion life, ranging from athletes training for the pentathlon to pederastic solicitation (cat. no. 46). A somewhat enigmatic group of Athenian and southern Italian vases of the late fifth and fourth centuries B.C. show nude athletes and fully dressed females mingling in rustic settings, which could be gymnasia located in open

their nudity was remains somewhat uncertain. It seems clear that on certain occasions—perhaps in major festivals—female runners may have worn some clothing, including short tunics. They may well have worn shorts in gymnastic practices. Bronze mirror handles in the form of a female athlete clad in body-hugging shorts probably represent Spartan girls (cat. no. 134).[55] These girls look as slim as male runners, but far from being the result of ignorance of female anatomy, as has at times been claimed, their elongated proportions and reduced body fat could well be the result of intense training. Attic vase painters showed a girl in shorts cleaning up with a male athlete beside a *louterion,* or washbasin (cat. no. 132). The basin is shaped much like a bronze louterion deco-

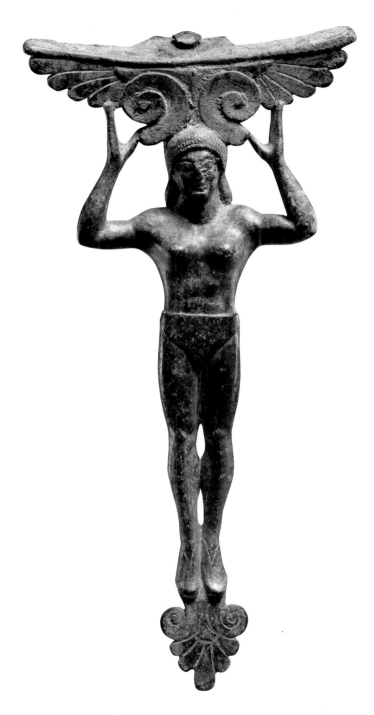

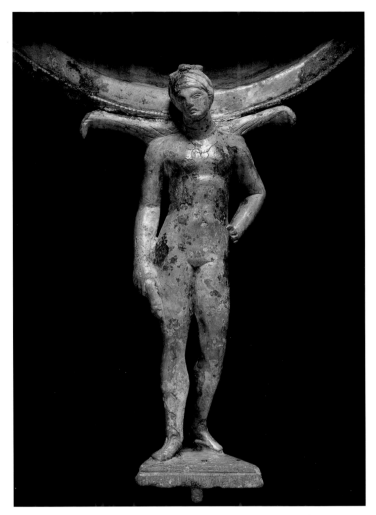

∧ This Etruscan girl carries a strigil, a common attribute of athletes (cat. no. 133).

< This girl, who wears shorts and soft shoes, is probably a Spartan (cat. no. 134).

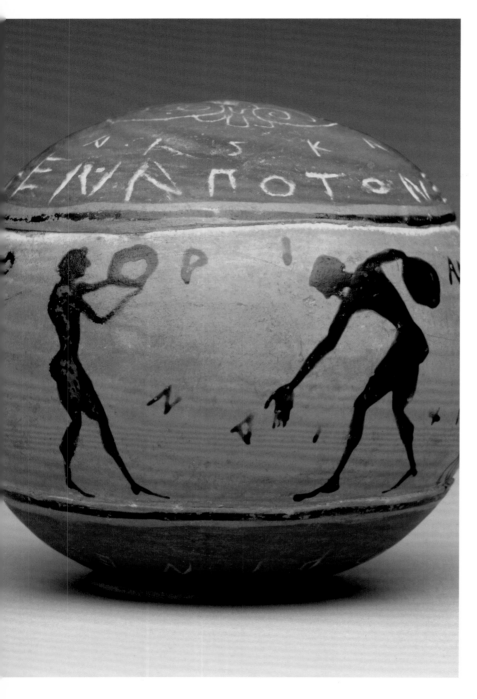

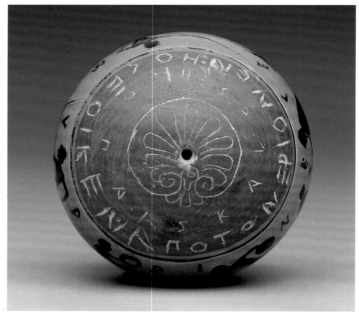

fields at the edge of the city (cat. no. 136). Eros, the god of love, is often present, and gifts are exchanged. These admiring female spectators do not seem to be courtesans, who were solicited rather than solicitors in Greek art, nor even "groupies" engaged in hot and risky pursuit of star athletes. Instead, this male-female interaction probably reflects a kind of marriage-market situation. In spite of the general inclination of male citizens to keep their female family members at home, the vases suggest that quite properly attired girls came out to the sports fields, followed the action, and made discreet advances to their favorite male athletes. The male nudity appears to have been accepted as normal athletic costume. Marriage would have been the intended outcome of this kind of courtship, apparently initiated by the girls.[60]

This ceramic ball, decorated with athletic scenes and inscriptions praising a good-looking boy, belonged to a girl named Myrrhine (cat. no. 46, two views).

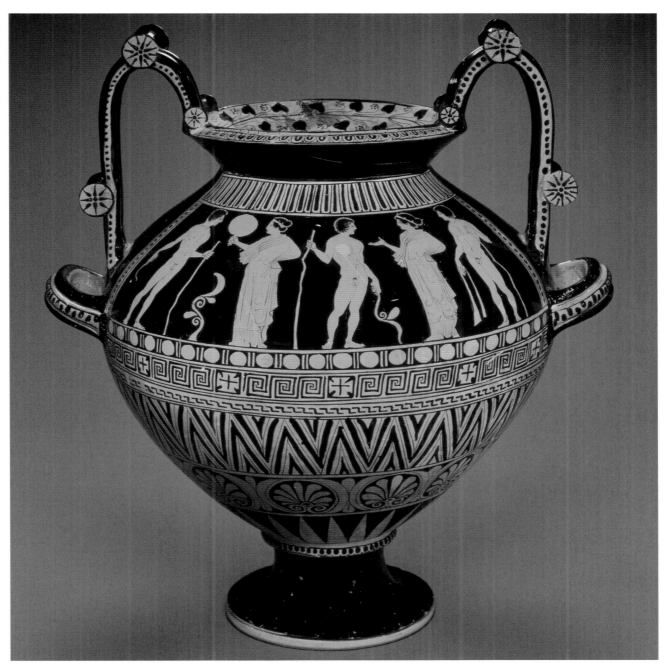

Female admirers converse with male athletes (cat. no. 136).

Private funerary games could in principle take place anywhere, but we know very little about the staging of such events. Festivals in great cities, such as the Panathenaia in Athens, were implanted rather uncomfortably in the civic center through most of the Classical period, until stadia began to be built in more convenient suburban locations.[61] The main public sports events, the crown games, were staged at isolated shrines—Delphi, Isthmia, Nemea, and Olympia—that had little independent existence apart from their roles as places of pilgrimage, worship, oracles, and athletics. All were governed and managed by nearby powerful cities. Within the region of Elis, the cities of Pisa and Elis vied for control of Olympia. The city of Elis, some thirty-five kilometers (twenty-two miles) away from Olympia, gained dominance from the fifth century B.C. onward. There are few traces of constructions from the early days of the games at Olympia. In the Geometric period, the ninth and eighth centuries B.C., Olympia may have been little more than a running track and a sacred area, the Altis, composed of a grove of trees and an ash altar where oracular sayings were pronounced.[62]

Excavation and chance finds in the neighborhood of Olympia have turned up a multitude of votive gifts in terracotta and bronze from this period (cat. no. 16, p. 22). The gifts reveal that Zeus was the embodiment of the battle power of the northwestern Greek tribes, the Aitolians, who moved into this part of the Peloponnesos during the Dark Ages. In the earliest images Zeus wears a helmet to embody this warrior aspect (cat. no. 7, p. 50). By the sixth century he had been reconfigured to become the more universal Greek sky god armed with the thunderbolt, but he remained the bringer of victory in both warfare and athletics (cat. no. 8).[63] Many votive gifts continued to have a military character and represented a share of the booty taken in war (cat. no. 15, p. 64). In the seventh century B.C. the sons of Kypselos, tyrant of Corinth, expressed their gratitude to Zeus for his favor in warfare with particular splendor, commissioning a lavish gold libation bowl (cat. no. 14, p. 51). The family of Kypselos also donated a cedar chest covered with mythological tales inlaid in gold and ivory, known from a description by Pausanias, in gratitude for Kypselos's escape from danger as a baby.[64]

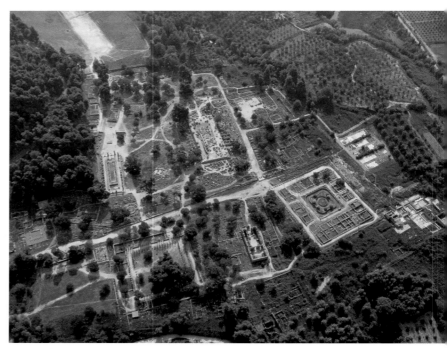

Fig. 4. This aerial view shows the archaeological site at Olympia.

The earliest substantial buildings at Olympia (fig. 4) date from the seventh century B.C., when the site was roughly leveled and a first stone temple of Hera (and Zeus) was built.[65] From Classical through Roman times Olympia basically comprised the sacred enclosure of the Altis, filled with temples, altars, statues, and smaller sacred enclosures for heroes (fig. 5). Small, temple-like treasuries celebrating military victories attributed to the influence of Olympian Zeus were built by Greek city-states, mostly located in southern Italy, Sicily, or other even more distant regions. This religious nucleus was surrounded by sports facilities and arrangements for visitors—baths, a few houses, and "hotels" for functionaries, athletes, and the elite. Mixed into this zone surrounding the Altis were administrative buildings, including a town council house where winning athletes were banqueted at public expense. A few altars and shrines appeared outside the Altis, and some especially ancient shrines were located on top of

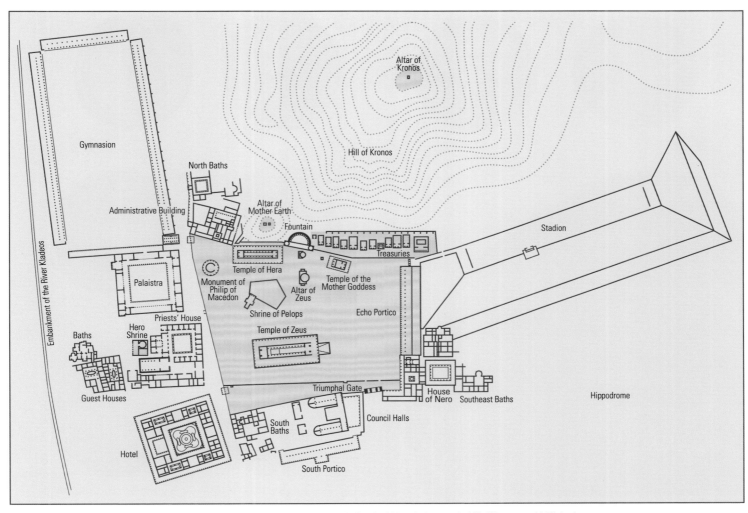

Fig. 5. This plan illustrates the layout of Olympia during the Roman period. Sacred areas, including the Altis and altars on the hill of Kronos, are highlighted.

the hill of Kronos, father of Zeus and Hera, which overlooked the Altis. The vast majority of the spectators at the games must have camped in tents or under the stars, but the multitude of wells excavated at the site offer testimony to the thirst of the crowds.

Dependent though they may have been politically, Olympia and Delphi managed to be artistic forces through the various sculptors and craftsmen creating monuments there. The Temple of Zeus at Olympia enclosed the colossal gold and ivory figure of the god by the Athenian sculptor Pheidias, which was reflected in a multitude of later works (cat. nos. 6, p. 52, and 8–9). Although Pheidias and many other artists were called in for specific commissions, Olympia had its own mints that produced a small but

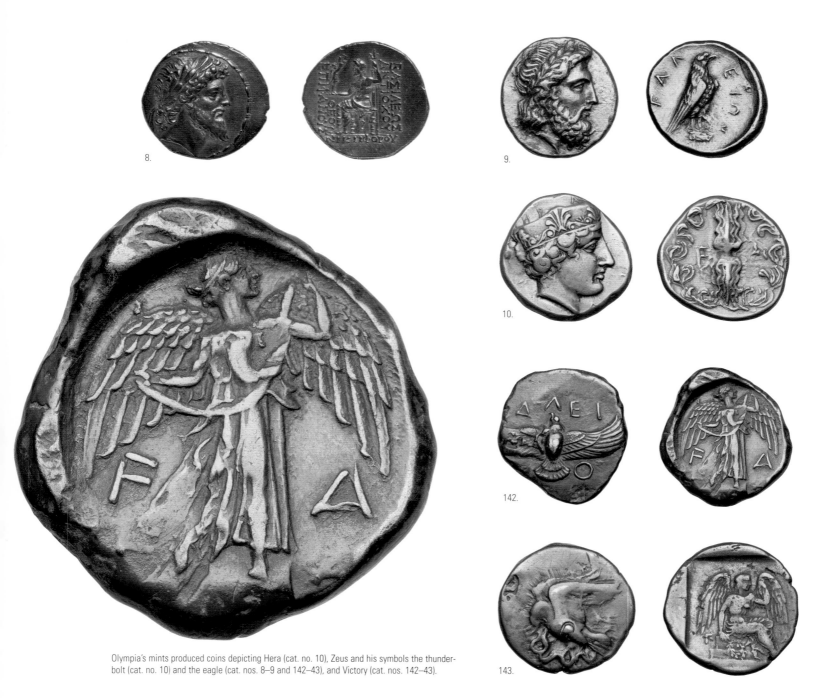

8.

9.

10.

142.

143.

Olympia's mints produced coins depicting Hera (cat. no. 10), Zeus and his symbols the thunder-bolt (cat. no. 10) and the eagle (cat. nos. 8–9 and 142–43), and Victory (cat. nos. 142–43).

ever-changing series of high-quality coins in the fifth and fourth centuries B.C.[66] One mint was based in or at the Temple of Hera and produced coinage bearing the head of that goddess (cat. no. 10). Another was in the Temple of Zeus and emphasized the dominant male divinity and his symbols—particularly the eagle killing a snake (cat. nos. 142–43). A favorite theme of this mint was Victory, or Nike, with ribbons and wreaths for athletic victors (cat. nos. 142–43).

The female side of the divine spectrum was surprisingly well represented at Olympia. Temples and altars to goddesses such as Meter, the mother of the gods, Gaia, mother earth, and Eileithyia, the birth goddess, were religious relics of the Bronze Age and a time before the site was taken over by the Aitolians and became strongly colored by Zeus and his athletic festival. Hera herself, though wife of Zeus, probably continued an earlier cult of a goddess. Artemis, the huntress, was also popular, honored at eight altars in the Altis and in other sites in the countryside nearby (cat. no. 11).[67] The nymphs and the heroine Hippodameia were venerated, and they must have been important for the prenuptial rites that were bound up with the races for girls at the festival of Hera.

While Greek athletics continued to flourish under Roman hegemony, there was also resistance to their spread in Italy. Romans had never approved of Greek athletics, and in a certain sense they regarded them as a waste of time and an opportunity for indolence. Long sessions in the gymnasion or palaistra could clearly involve a great deal of talking and lounging around. In the Republican period (the fifth to the first centuries B.C.) Romans shared the Etruscans' enthusiasm for horse racing of all kinds and perhaps for boxing. Greek-style games might have been staged to celebrate great victories or major funerals. The prizes must have been very attractive, because on such occasions athletes could be sucked away from the Olympic Games. Gymnastic training for the young, however, was frowned upon.[68] The principle business of the Roman state was warfare. While Greeks could argue that sports were good preparation for war, the Romans argued that actual military service was even better, and for all the military obligations of the Greek soldier, Roman obligations were greater. Pederasty was also regarded as a negative side effect of Greek

gymnastic customs. The Romans preferred to waste their time watching the blood sports of gladiatorial combat and wild-beast hunting. In the Imperial period, however, gymnastic contests took hold in Rome. Greek athletic competitions were held in temporary stadia under Caesar and Augustus in the third quarter of the first century B.C. The emperors Nero (A.D. 54–68) and Domitian (A.D. 81–97) instituted full-blown and heavily criticized imitations of the Olympic Games. Domitian built a permanent stadium for Greek-style athletics in Rome, whose layout survives in Piazza Navona.[69]

The tranquillity of the Classical Mediterranean world under the *pax romana* was severely shaken around the middle of the third century A.D., when Germanic barbarians broke through the northern frontiers and the newly founded Sassanian Persian Empire smashed through Rome's eastern defenses. Greece was hit very hard. The Herulians, a tribe from southern Russia, ravaged the peninsula, and Olympia must have been one of their intended targets. About A.D. 267 a fortification wall of blocks hastily stripped from nearby buildings was erected around a small part of the site, anchored by the Temple of Zeus, and valuable metalwork was moved inside.[70] The treasures apparently survived the Herulian raids, but the games would never again be the same. Around the year 300 earthquakes and floods accelerated the deterioration, even though the Temple of Zeus was repaired.

In the fourth century Christianity became the official religion of the empire, and with it came new attitudes. In Christian eyes the great traditional games were indelibly tainted by their association with pagan religion. Zeus, Hera, Apollo, and Eros were considered demons, and their worship was idolatry. By the end of the fourth century the pressure to shut down the games had its intended effect. The last ancient Olympic Games were held probably about A.D. 390, since the Emperor Theodosius banned all pagan cults in 393. Eventually a Christian church was built in one of the few suitable standing structures at Olympia, but this initiative does not seem to have been accompanied by an effort to refound the games on a "decontaminated" or exorcised basis.

Greek athletics could, however, continue on more neutral ground. Athletes went on appearing in performances of every

kind. After the fifth century athletes may have supplanted gladiators altogether. Christian writers, moreover, did not feel obliged to oppose gymnastic training. They even admired some athletic virtues, often referring to martyrs and ascetics metaphorically as athletes.[71] In the largest stadia, however, the most popular events were the chariot races. The competitive edge came from the rabid partisanship of two great sporting clubs—the Greens and the Blues. Their popularity extended throughout the Roman Empire, and within individual cities their rivalry led to hooliganism and, at times, mob violence. To some extent, this situation is comparable to modern cities with two professional teams competing in the same league, such as the Clippers and the Lakers in Los Angeles, and Torino and Juventus in Turin, Italy. In any case, continuing waves of barbarian invasion and the concomitant crises and impoverishment led to the fading away of chariot racing, even in Constantinople, its last stronghold, some time in the Middle Ages.

The sporting spirit does not die out, however, and later in the Middle Ages forms of competition grew up on new, more overtly geographic bases. As in today's sports leagues, town would face off against town or district would set its champion against district. Horse races such as the Palio in Siena pitted riders from the various regions of the city against one another. The Palio also stimulated competition among those with no hope of winning by awarding a booby prize: a pig for the district whose rider finished last. A particularly fertile innovation was "mob football," where whole villages would battle to move a ball over a goal line. This may have been the ancestor of most modern team games.

Curiosity about Greek athletics emerged in the Renaissance, and deepening interest in Classical civilization nourished Olympic nostalgia thereafter. Revivals of the Olympic Games appeared in England in the seventeenth century, and numerous Olympic Games were staged in Europe and the United States in the eighteenth and nineteenth centuries.[72] It took Coubertin's sweeping vision in the 1890s, however, to firmly launch the modern Olympics on their spectacular international course.

< Artemis, the huntress, was the goddess of wild nature and of health, a prime concern of every athlete. (cat. no. 11).

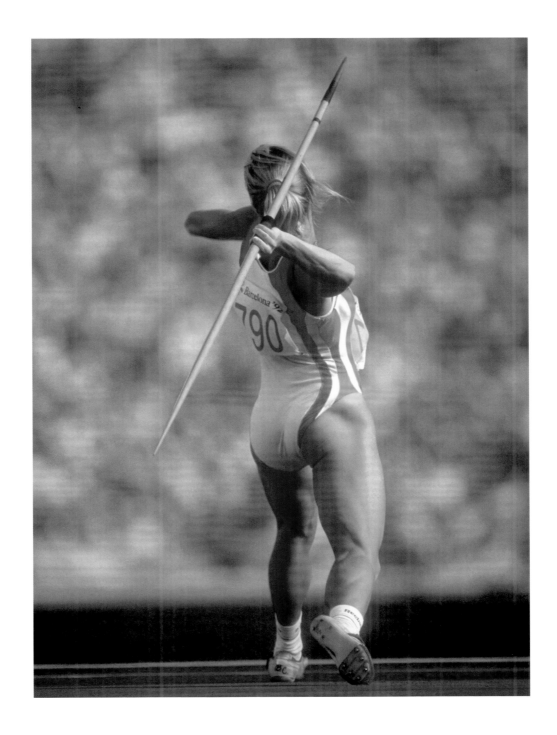

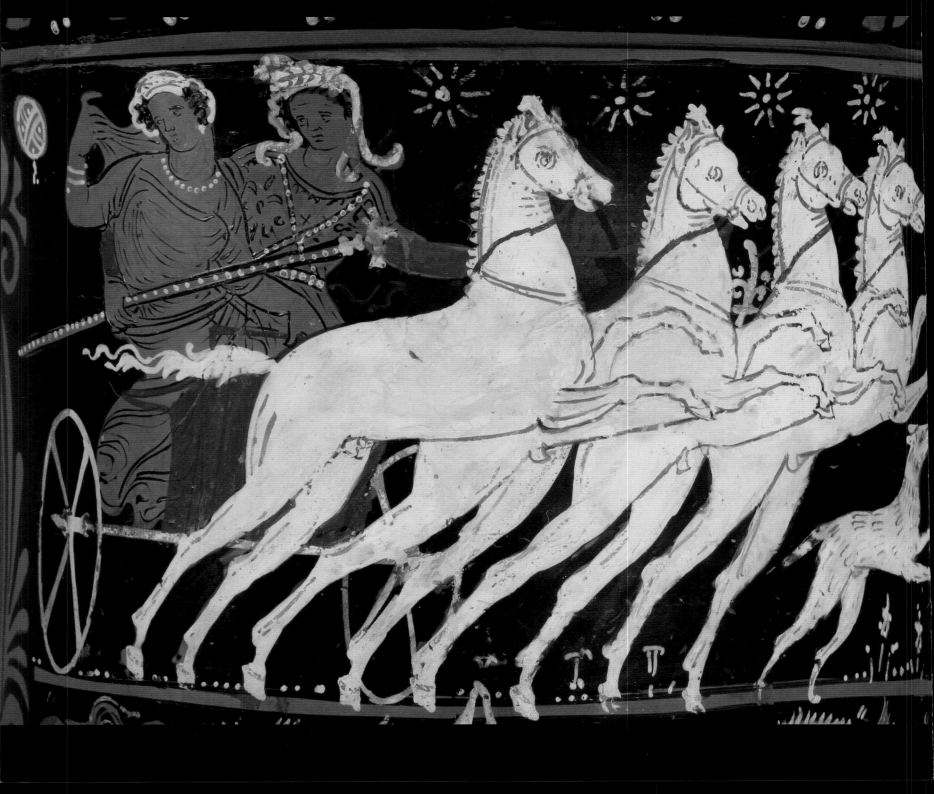

THE ORIGINS OF THE GAMES

He saw that the festival at Olympia was beloved and admired by all men, and it was there that the Greeks made display of wealth and strength of body and training, and both that the athletes were envied and that the cities of the victors became renowned.
— Isokrates *The Team of Horses* 32–33

The origins of the Olympic Games are much debated. Physical contests among men are illustrated in artworks and writings from the earliest times: wall paintings in Crete depict bull leaping, coins from Larissa show bull wrestling, vessels from the Greek Bronze Age display belt wrestling and chariot racing (cat. no. 1). All of these reflect the possible Bronze Age roots of the Olympic events. But the contests we are most familiar with from ancient Greek culture find their earliest expression in Homer. Book 23 of the *Iliad* (written about 800 B.C.) describes the funeral games, with their footraces, archery contests, chariot races, boxing, and wrestling matches, that were held outside the walls of Troy in commemoration of the dead hero Patroklos. The repeated recitations of these famous verses by lyric poets establish such events as the predominant cultural model. In these games, honor was inextricably bound with physical prowess. Athletic competitions thus played a vital role in allowing the living to honor the dead. Indeed, the founding legends of the four great Panhellenic festivals—the Olympic, Pythian, Isthmian, and Nemean—are all rooted in death and propitiation of the gods.

Other evidence supports this connection between Greek athletics and funeral rituals. The association is vividly made on a red-figured askos of the early fifth century B.C. (cat. no. 47). A bearded half-figure with helmet, shield, and spear stands behind a tumulus, or grave mound, on which hang javelins, jumping weights, a discus, and two victor's fillets. The figure could represent the dead hero Patroklos at his grave or a privileged Athenian; in either case, the sports equipment of the pentathlete was surely included to honor a deceased hero. The inscriptions on several marble discuses from the vicinity around Athens use an archaic Greek word for tomb or burial mound, *erion* (cat. no. 43, p. 89), which reinforces the impression that athletic events were an aspect of Greek funerals. Often the tomb of a local hero was located near the athletic festival site where games were held in his honor. The stringent preparations for the Olympic Games—namely a thirty-day period of seclusion, fasting, and sexual abstinence—as well as the stripping naked for athletics underline the ritual aspects of the games. The events seemingly also played the role of a rite of passage in Greek society. Contestants were usually divided into age classes. At Olympia there were only two age classes, but at other games there were three: the *paides*, or young boys of about twelve years of age; the beardless youths up to eighteen years old, called the *ageneioi* or *epheboi*; and the men, or *andres*, who were typically shown bearded.

The four original competitive festivals made up the Panhellenic *periodos*, or circuit games, and were held in honor of the gods sacred to the respective sites of the games. In central Greece, the Pythian Games were celebrated every four summers beginning in 582 B.C. at the oracular shrine of Apollo at Delphi. The Isthmian Games at Poseidon's sanctuary on the Isthmus of Corinth, in the Peloponnesos, were held every two years in

< Pelops and his bride Hippodameia ride together in his chariot (cat. no. 4).

43

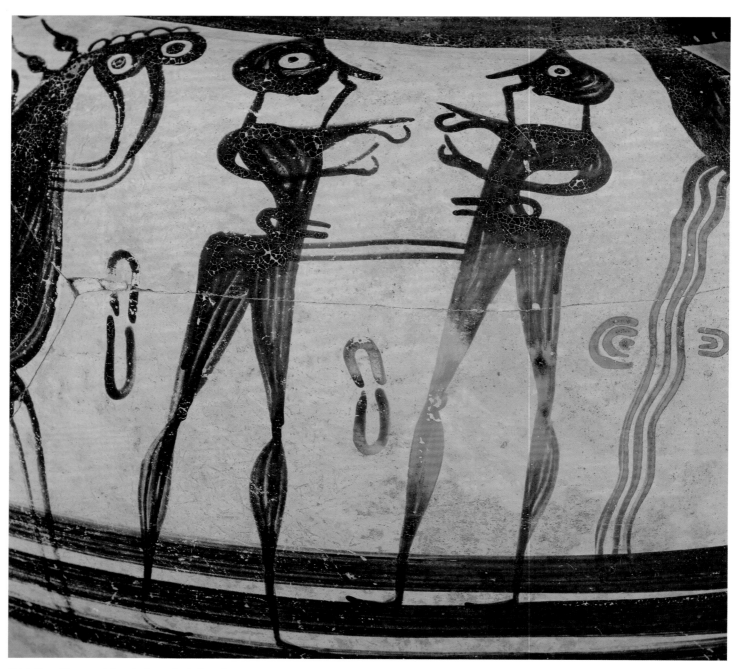

This belt wrestling scene is from the Bronze Age (cat. no. 1).

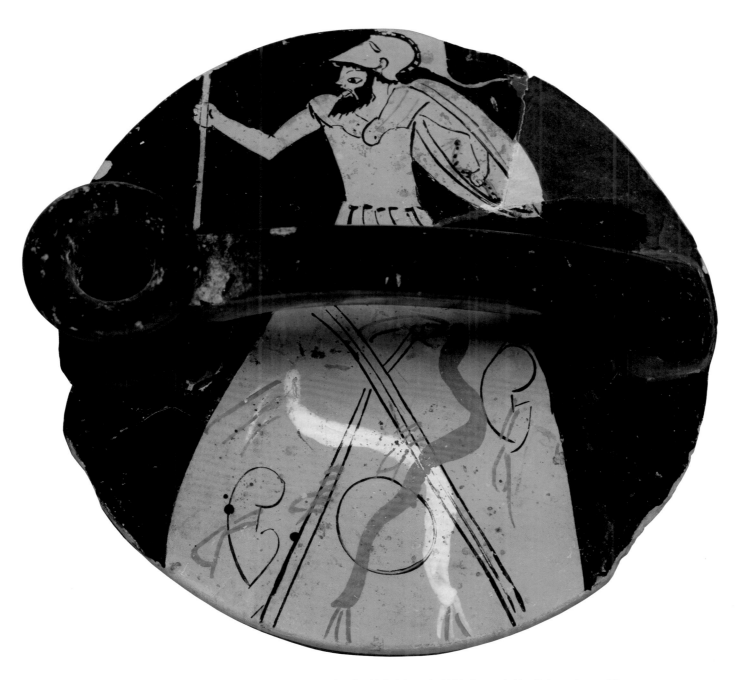

A spirit of a deceased warrior and pentathlete rises from his burial mound, which is decorated with athletic gear (cat. no. 47).

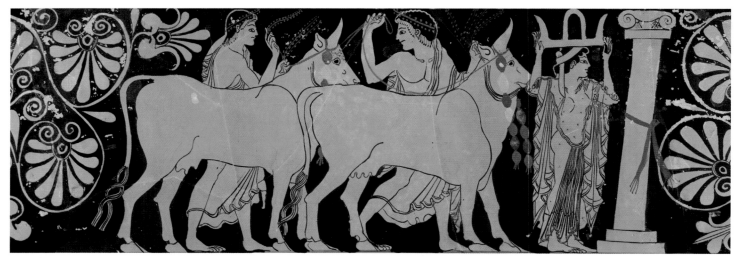

A girl carrying a sacred basket leads a religious procession that will end with the sacrifice of the cows (cat. no. 19).

spring or summer beginning in 581 B.C. Starting in 573 B.C. the Nemean Games honoring Zeus were staged every other September at Nemea in the northeastern Peloponnesos; these games later moved to Argos. The oldest and most prestigious games began in 776 B.C. in honor of Zeus and were held for five days at the hottest time of the summer, about mid-July to mid-August (at the second full moon after the summer solstice) of every fourth year at Olympia, in the region of Elis in northwestern Peloponnesos. Sport and religion shaped the calendar of ancient life, so that time was tied to the cycles of the festivals. Many similar games were subsequently initiated at various cities, until there were scores of local festivals featuring athletic competitions during the Greek and Roman periods.

Probably the best known of these local versions is the major Panathenaic festival that was held in Athens every fourth year starting in 566 B.C. Sometime during July of that year all the people of Athens—both men and women—assembled to pay tribute to their patron goddess, Athena. The festival probably lasted about a week. Athletic events were modeled on the Olympic Games, but Athens made some interesting additions, such as a torch race (cat. no. 23), a male beauty contest, a rich program of music and theater, and a regatta at Piraeus. The light craft used in boat racing can be seen in a southern Italian plate (fig. 2, p. 27). All of this was accompanied by rituals and processions in homage to Athena. Vase painters captured various stages of this communal spectacle, such as the parade of festooned oxen preceded by girls bearing sacred baskets (cat. no. 19). The culmination was a procession through the city to present a richly woven robe, or *peplos*, to the colossal cult statue by Pheidias housed in the Parthenon on the Acropolis. Although the Pheidian masterpiece is now lost, the Athena Parthenos seen in this book is believed to echo its appearance (cat. no. 18).

The start of each Olympic Games was a call for peace; three heralds donning olive wreaths were sent out from Elis, the city responsible for the sanctuary and its festivals, to announce the date and invite every Greek state to participate. Because this initiated the Olympic Truce, which provided a hiatus to the constant warring among city-states, these heralds were called the

> This statue is an ancient Roman replica of Pheidias's cult image of Athena Parthenos (cat. no. 18).

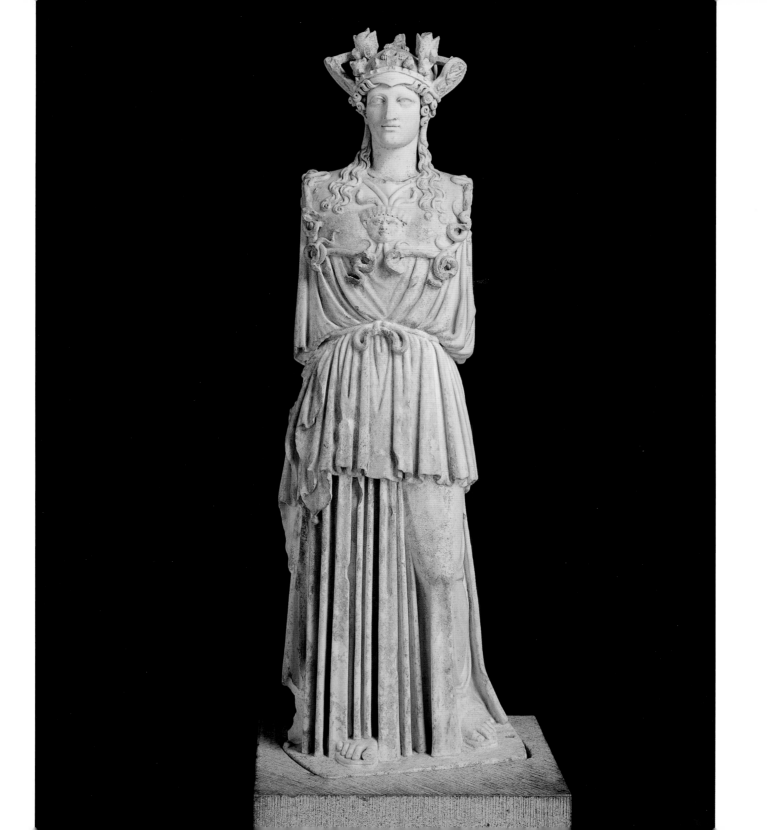

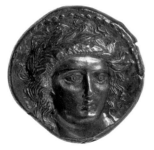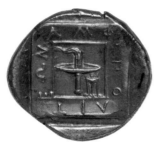

A torch and a prize tripod convey the idea of a torch race in the limited space available on this coin (cat. no. 23).

spondophoroi, or truce bearers. Thus the games functioned not only as a rite of passage for young male adults and a means of honoring the gods but also as a promotion of communal sentiment that resulted in a temporary Panhellenism. The events and their victors reflected the culture and values of early Greek society, and the male contestants were the physical embodiment of the idealized heroes and gods believed to be the founders of the games. The historical details emerge from a variety of literary sources ranging in date from contemporary accounts to Byzantine commentators. Consequently, the etiology of the games varies depending on which ancient sources are used. Even the most canonical of the myths for Olympia, the chariot race of Pelops, survives in several versions.

| PELOPS AND OLYMPIA

Within the Altis there is also a sacred enclosure consecrated to Pelops, whom the Eleans as much prefer in honor above the heroes of Olympia as they prefer Zeus over the other gods.

—Pausanias *Description of Greece* 5.13.1

The topography of the Peloponnesos forms the heartland of the Greek games, as it is the location of three of the sites of the Panhellenic circuit. Pelops, for whom the Peloponnesos is named, was the hero worshiped at Olympia. He was to the region what Theseus was to Athens, founding father and mythic hero.

His cult site was a grave mound called the Pelopion located near the Altar of Zeus in the sacred olive grove, or Altis, at Olympia. The ancient historian Pausanias, who visited the cities and sanctuaries of Greece in the second century of our era, reported that the shoulder blade of Pelops was exhibited as a sacred relic in the city of Elis.[1] Control of the Olympic sanctuary and preeminent domain over the Pelopion was contested among cities in the region until the Eleans (the people of Elis) defeated their neighbors, the Pisans, in 470 B.C. The spoils of that victory paid for the great Temple of Zeus at Olympia, with its shining marble sculptures, once colorfully painted.

The significance of Pelops to the region and the games was firmly established for the first time on the east pediment of the Temple of Zeus. There, facing into the sanctuary of Olympia and toward the racetrack, the mythic drama of the hero Pelops was carved in life-size figures. King Oinomaos of Pisa had a daughter, Hippodameia, who was of marrying age. Eager to keep her to himself, Oinomaos challenged suitors to chariot races for her hand. As Oinomaos had unfair advantages, the suitors always lost and were killed. When Pelops arrived in Pisa from his homeland in Asia Minor, Hippodameia fell in love with him and conspired to sabotage her father's chariot by exchanging the metal linchpins for those made of wax. According to Sophocles, the king's charioteer Myrtilos, also in love with Hippodameia, agreed to betray his king. Pelops won her hand and the rule of the kingdom when her father was killed in the chariot crash. In another version Pindar claims that Poseidon gave Pelops a chariot with winged horses in order for him to win. Through these local legends Pelops was said to have founded the chariot-race events at Olympia. The fact that Pelops used a trick to win did not diminish him as a victor. Greek heroes were not necessarily virtuous; they used cunning, as in the case of Odysseus, as well as great strength, as in the case of Herakles, to achieve their goals.

Most works of art representing the story of Pelops depict the action of the chariot race (cat. nos. 4, p. 42, and 5). The east pediment, in contrast, portrays the moment before the race when the

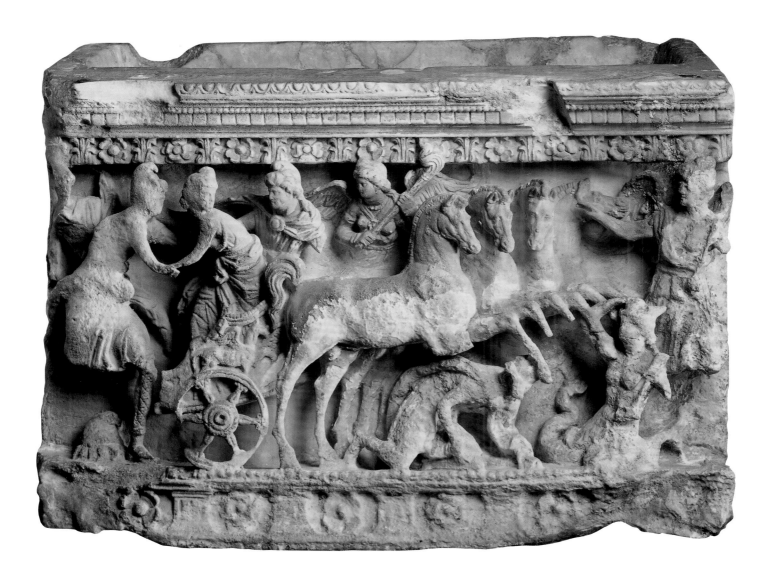

Hippodameia is helped down from the chariot driven by Pelops; the body of her father, King Oinomaos, lies trampled below the horses (cat. no. 5).

participants are offering sacrifices and oaths to Zeus, who looms large and austere at the center. Two pendant chariot teams flank the pedimental group, guaranteeing recognition of the drama. Scholars interpret Zeus as inclined toward Pelops, who is the only completely nude figure. The east pediment thus projects the Elean desire to make the local hero a king who rules by divine right and who, like the Olympian athletes, stands for achievement and excellence. The Eleans commissioned it both to announce the special status of Pelops to all visitors to Olympia and to advance their own political goals. It is this mix of politics, religion, myth, and art that informs our study of the origins of the Greek games.[2]

| ZEUS

Of all the images of Zeus, the Zeus in the bouleutarion [at Olympia] is the one most likely to strike terror into the hearts of sinners. This Zeus is surnamed Horkios ["of the Oath"], and he holds a thunderbolt in each hand. Beside this statue it is established for the athletes, their fathers and brothers, and their trainers to swear an oath on slices of the flesh of wild boars that they will do nothing evil against the Olympic Games. The athletes in the men's category also swear that they have adhered strictly to their training for ten successive months.

—Pausanias *Description of Greece* 5.24.9

The veneration of Pelops is second only to Zeus, who dominated the sacred topography and rituals of Olympia. As Pausanias reports it, the Olympic festival began with solemn promises to follow the regulations and rules of the games, made in the presence of an imposing statue of Zeus. Athletes and their families burned incense and twigs of olive and made libations of wine to give thanks and swear vows. Toward the middle of the festival great sacrifices of one hundred oxen were made at the Altar of Zeus, whereupon the smoke of the burnt offerings went heavenward to the gods, and the roasted meats were enjoyed in a public banquet.

This statuette of Zeus and his wife Hera may have been a votive object (cat. no. 7).

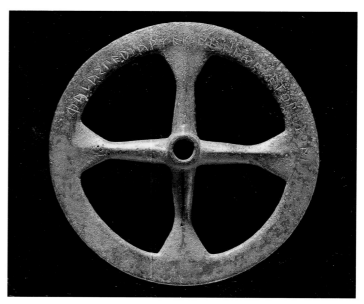

A charioteer probably dedicated this miniature chariot wheel (cat. no. 17).

Only the wealthiest of Greeks could afford such a valuable gift as this golden bowl, dedicated at Olympia by the rulers of Corinth (cat. no. 14).

Monumental and miniature statues were dedicated in the sanctuaries of Zeus and the other gods, and the dedicatory formula was at times inscribed on the sculpture itself. Frequently the sculpture would focus on the athlete's piety by showing him pouring out a libation (cat. no. 12). This gesture reflects the swearing of oaths on the first day of the athletic festival.[3] Athletes also showed piety by dedicating the prize they won or the gear they used (jumping weights, discus, and so on) to their god.[4] Precious gifts such as the rare golden bowl inscribed from Kypselos, tyrant of Corinth (cat. no. 14), were offered to Zeus by the elite. Modest objects such as a bronze chariot wheel (cat. no. 17), probably offered by the charioteer rather than the owner of the team, were more typically found in the sanctuary area.

Access to the Sanctuary of Zeus and permission to offer sac-

> This athlete originally held a libation bowl in his right hand and perhaps a victory palm or a pitcher in his left (cat. no. 12).

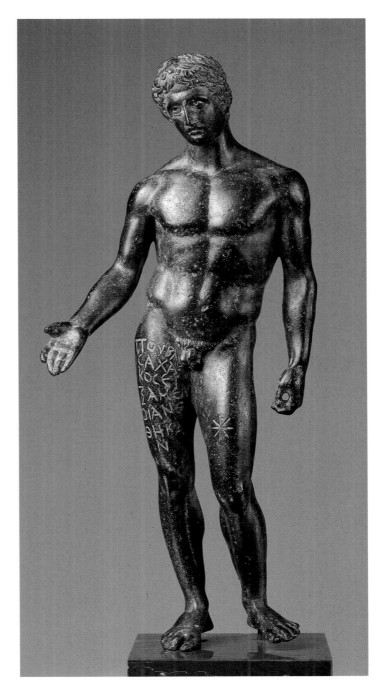

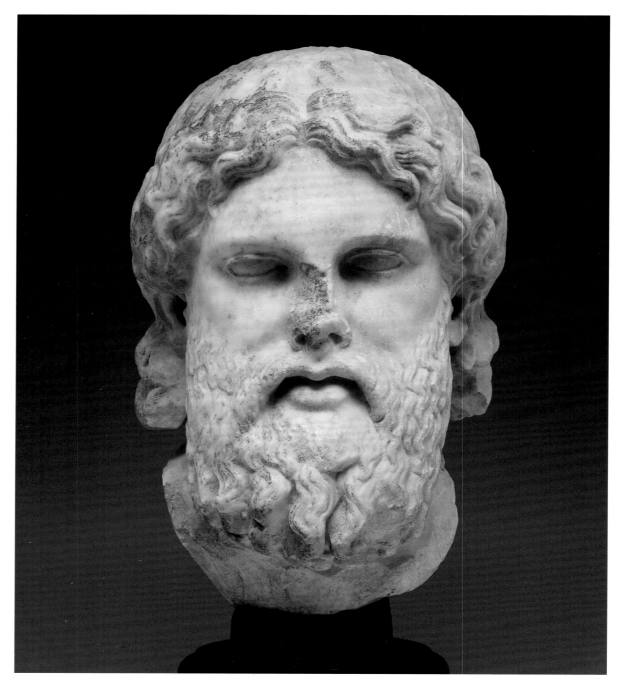

This head is believed to be a close copy of Pheidias's colossal statue of Zeus at Olympia (cat. no. 6).

rifice were the privilege of the Eleans, who could wield this power to political advantage. Thucydides reports that in the summer of 420 B.C., the Spartans were excluded from the Sanctuary of Zeus and from competing in the games, ostensibly because they had refused to pay a fine imposed by the Eleans. The Olympic authorities, fearing that the Spartans would force their way in, called upon two thousand guards from friendly Argos and Mantinea, as well as Athenian cavalry, to protect the sanctuary. These actions could well stem from the fact that Elis had recently signed a treaty with Athens, Argos, and Mantinea against the Spartans.[5] Such incidents bring to mind occasions in recent times when politics have influenced Olympic participation: in 1964, for example, South Africa was barred from the Tokyo Olympics because of its apartheid policies.

The presence of Zeus at Olympia was monumental, in the shape of a gold and ivory statue some thirteen meters (forty-two feet seven inches) high made about 438 B.C. by the sculptor Pheidias for Zeus's temple. Recognized as one of the seven wonders of the ancient world, the colossal statue was carted off to Constantinople in the fourth century, where it tragically fell victim to fire a century later. Its likeness is believed to be captured in a marble head of Zeus from southwest Asia Minor (cat. no. 6). The father of all gods fixes us with a gaze imbued with a dual nature—an Olympian loftiness and a human sensitivity.

∧ Herakles uses his bare hands to choke the Nemean lion to death (cat. no. 3).

| HERAKLES

And Time, in passing onward, clearly told the plain story, how Herakles divided the spoils that were the gift of war, and offered sacrifice, and how he ordained the four years' festival along with the first Olympic Games and with contests for victors.

—Pindar *Olympian Ode* 10.55–59

The bridge between Zeus and man was physically made through the agency of his mortal son, the superhero Herakles (cat. no. 2). Probably the best contemporary source on the Greek athletes is the poet Pindar, who was commissioned to write dozens of epinicians, or victory songs, in honor of the victors at the Panhellenic games during the first half of the fifth century B.C. It is Pindar, perhaps out of pride for a fellow Theban, who promotes Herakles as the founder of the Olympic Games in honor of his father Zeus.[6] Herakles won immortality by performing twelve difficult labors called *athloi*, or contests, at the demand of Zeus's wife Hera. His manly prowess, what the Greeks called *arete*, set the model for achieving immortality, and his deeds were the inspiration for generations of athletes. Herakles's first and most often illustrated labor, the killing of the Nemean lion, was one of six adventures that took place in the Peloponnesos (cat. no. 3). King Eurystheus of Mycenae demanded that Herakles bring him the skin of an especially fierce lion that was terrorizing

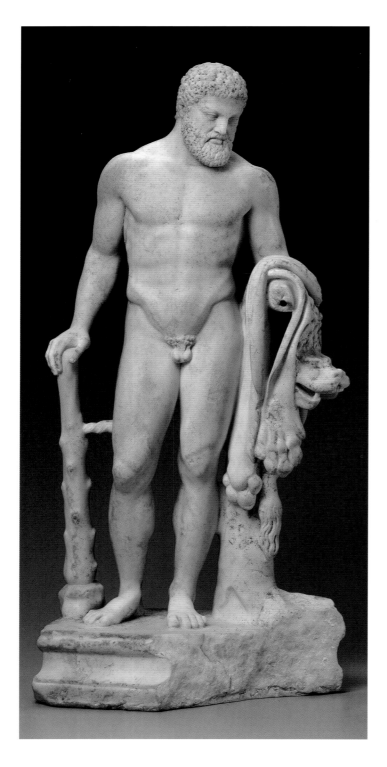

the people in the hills around Nemea. When Herakles located the beast he soon realized his arrows would not defeat it, so he ran after it with his club. He finally cornered it in a cave, whereupon he took the lion in his arms and held it until the beast choked to death. His athleticism was emphasized by artists, who often showed him wrestling the lion in poses that correspond to those of professional wrestlers. The contest between Herakles and the lion was considered the founding event of the crown games of Nemea.

The carved metopes from the Temple of Zeus at Olympia present the canonical version of Herakles's labors.[7] In the first metope he appears as a beardless youth, a nude athlete, with the dead lion at his feet. Because many of his labors took the form of wrestling matches, such as the struggles with the serpents and with Achelous, Antaios, and Eryx, Greek wrestlers were visually cued by the carvers of the Olympian metopes to associate themselves with the hero Herakles. Herakles is even credited with physically laying out the precinct of the games. For his twelfth labor he had to clean out the stables belonging to King Augeias of Elis. To accomplish this he diverted the nearby Alpheios and Peneios rivers, key topographic features of the sanctuary of Olympia. According to the tenth Olympian, which Pindar wrote for a victor of the boys' boxing match in the Olympics of 476 B.C., Herakles took his revenge on the deceitful king Augeias and destroyed Elis with the river. He then "measured out a sacred precinct for his father most mighty; he fenced in the Altis and set it apart in the open, and he made the surrounding plain a resting place for banqueting."[8] Herakles is represented in the Olympian metope assigned to this labor as a bearded nude with an athletic physique.

The great temple metopes superimpose Herakles onto the landscape of Olympia. They link him directly to the sanctuary and the contests, and they parallel his physical exertions with those of the athletes by presenting him in heroic nudity. Herakles is a bridge between the divine and the human. As such, he is a mythic paradigm for the attainment of immortality through victory, the bringer of fame and *kleos*, or glory. By defeating beasts and barbaric opponents, Herakles also represents a civilizing force and promoter of Greek culture.

< A heroic model for all athletes, Herakles holds the skin of the lion he defeated (cat. no. 2).

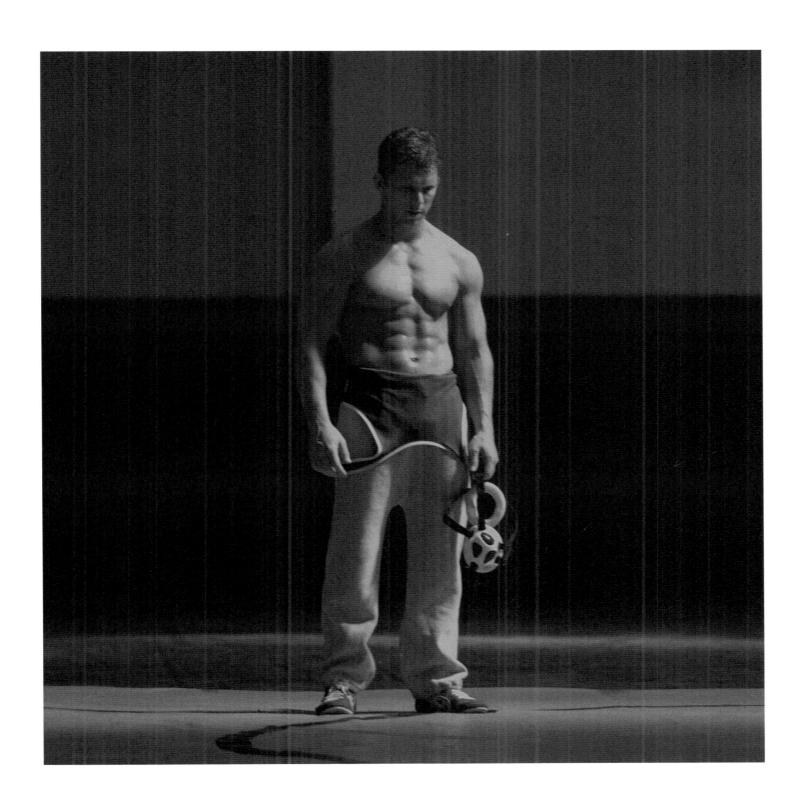

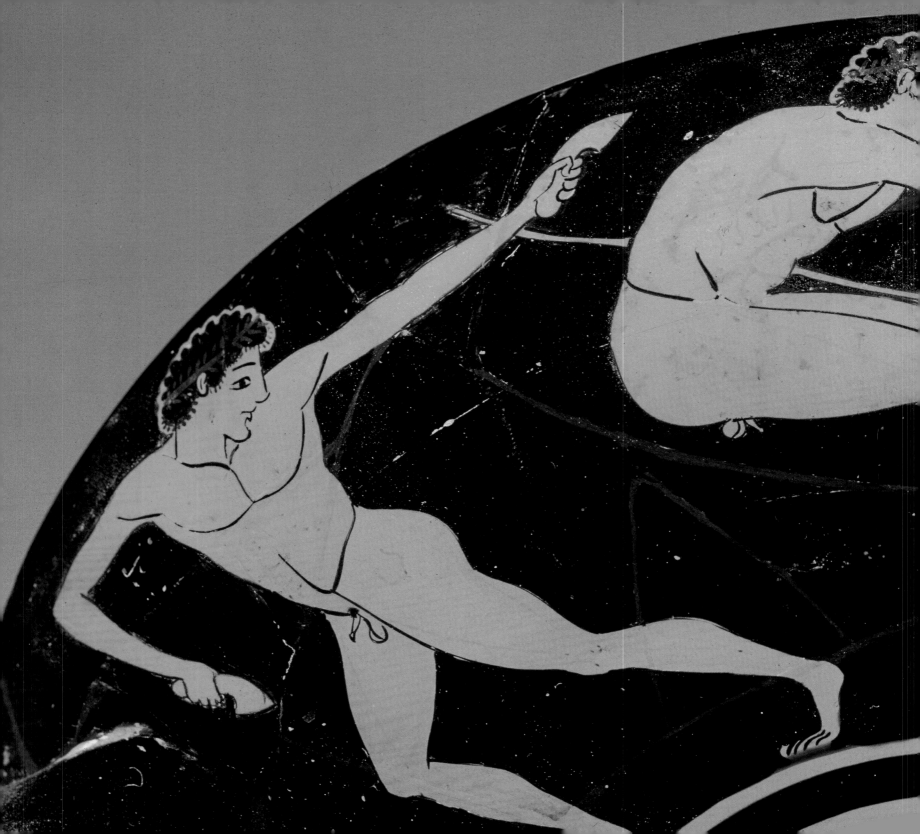

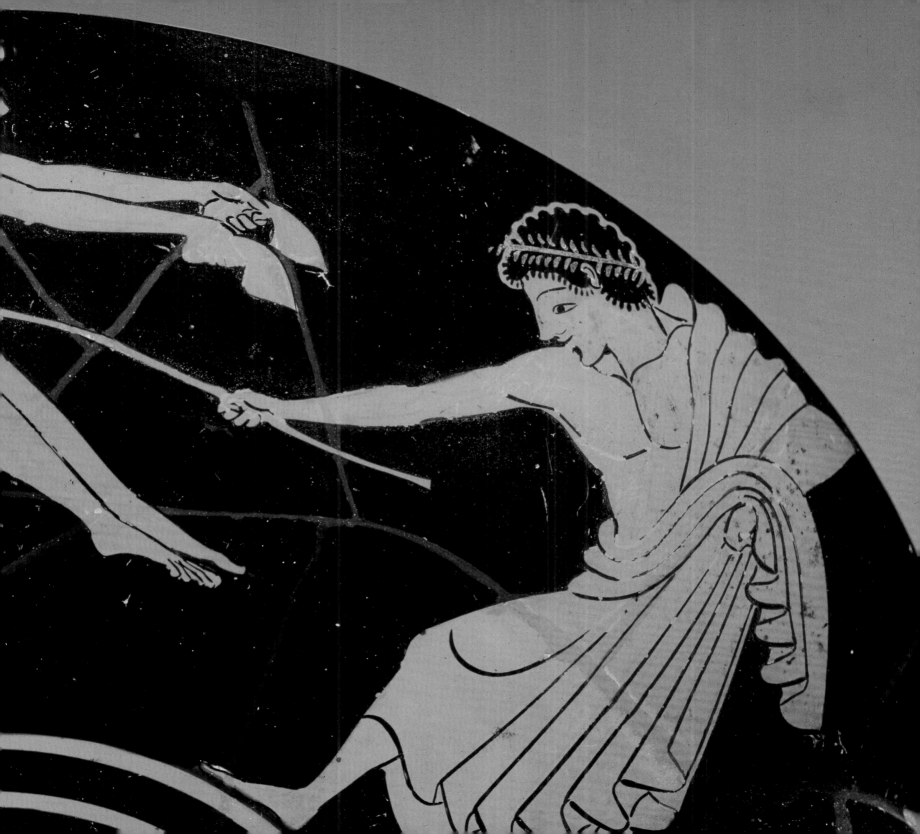

Photograph by Howard Schatz from *Athlete* (HarperCollins Publishers, 2002).

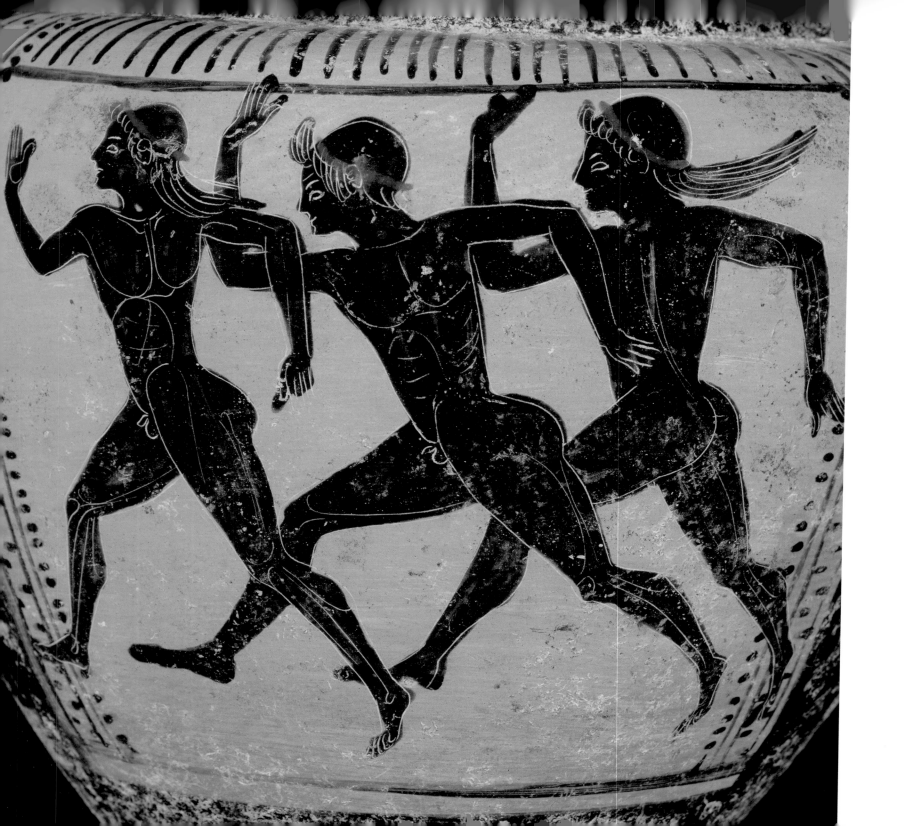

RUNNING

T he best candidate for the *dolichos* should have a powerful neck and shoulders like the candidate for the pentathlon, but he should have light, slender legs like the runners in the *stadion*. The latter stir their legs into the sprint by using their hands as if they were wings. The runners in the dolichos do this near the end of the race, but the rest of the time they move almost as if they were walking, holding up their hands in front of them, and because of this they need stronger shoulders.

—Philostratos *On Gymnastics* 32–33

Footraces were the oldest of the athletic competitions, and their winners were the most revered of ancient athletes. The high prestige of footraces for the ancient Greeks is attested by the fact that the Olympic Games were reported and recognized by the names of victors of the stadion, or short footrace, not by the year. This may have evolved from the fact that the stadion race was the only event in the first thirteen Olympiads. The length of the race was roughly equivalent to 180 meters (200 yards), or the Greek measure called a *stade*. Legend has it that Herakles fixed the distance of the race and thereby the length of the racetrack, or *dromos*, by placing one foot in front of the other six hundred times. As the Greeks did not have standardized measurements, the distances of the races and the lengths of the tracks varied slightly at the different sanctuaries and cities where the games were held. Moreover, we do not know of any timing devices or other means of tracking speed or distance.

Nonetheless, like us, the Greeks were fascinated with the idea of identifying the fastest men on earth. These individuals were the subject of adoration and legend throughout the long history of the games. Pindar immortalized local heroes such as Xenophon of Corinth, who won three times at Olympia for the stadion race and pentathlon.[1] As David Romano, a competitive runner and an authority on ancient sports, observes:

> The winner of the stadion race was well known in antiquity and by the Classical period was used as a kind of chronological bookmark to remember the year of the games. For instance, Koroibos of Elis was known as the winner of the first stadion race in 776 B.C. Today we look forward to learning who will be the world's fastest human and we remember the years in a similar way. For example, 1936 was the year when Jesse Owens won four gold medals at the Berlin Olympics in the 100 meter, 200 meter, long jump, and 4 x 100 meter relay. We remember that Carl Lewis duplicated the four victories at the Los Angeles Olympics in 1984.[2]

The ancient Greeks ran barefoot and in the nude, a vivid contrast to the sports outfits and technically advanced footgear of runners today. The reason for their nudity is debated. According to legend, the runner Orsippos who won the stadion at Olympia in 720 B.C. let his *perizoma*, or loincloth, slip off deliberately because he realized that an unclothed man could run faster, but this episode is generally discounted as a myth.[3] In modern times runners occasionally compete barefoot—for example, the Ethiopian Abebe Bikila who won the marathon in the 1960 Rome games—but they are, of course, exceptions. More familiar

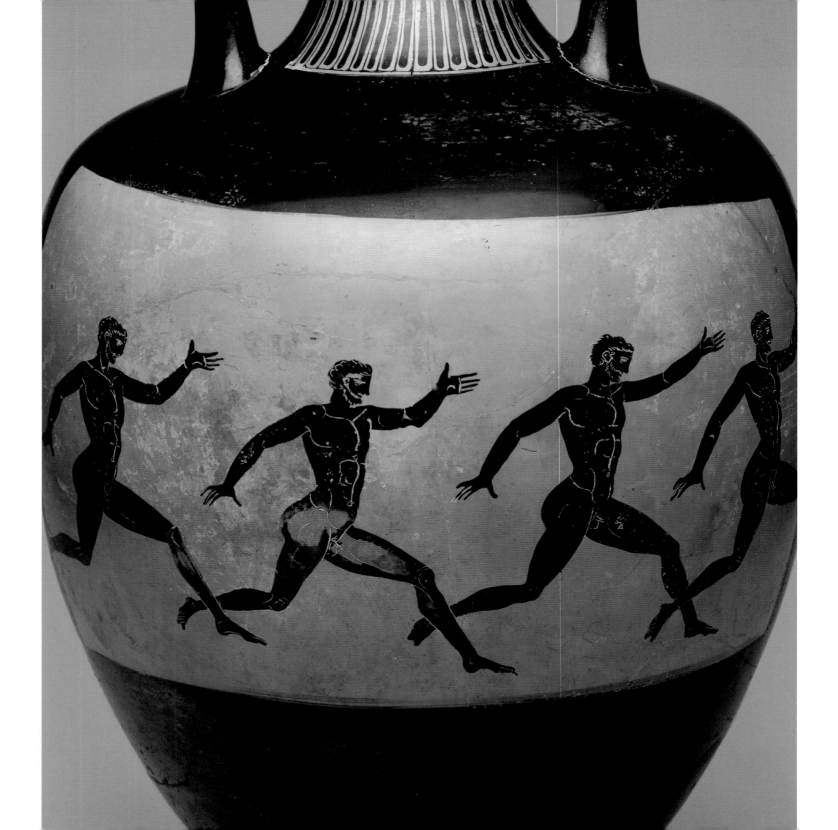

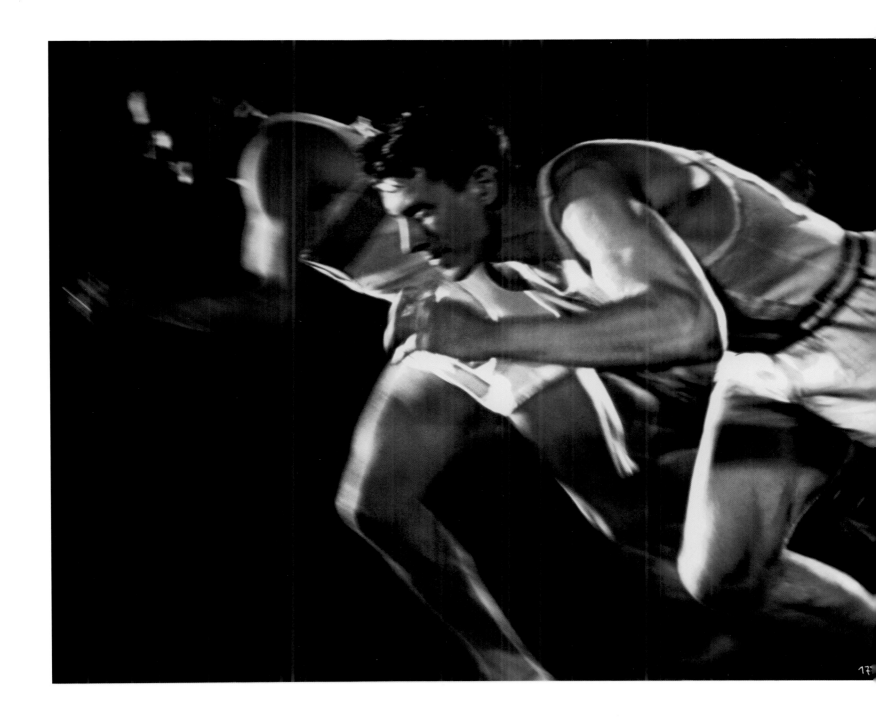

< These sprinters are shown swinging their arms freely (cat. no. 26).

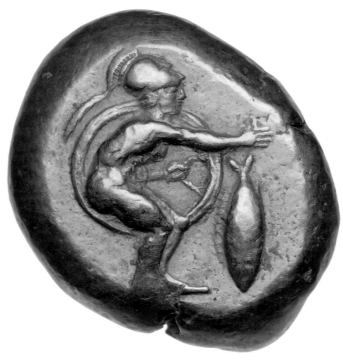

A participant in the armed race takes his starting position (cat. no. 31).

This fragment is from a helmet dedicated to Olympian Zeus (cat. no. 15).

to us are the brand-name apparel and flashy footwear of runners like U.S. track star Michael Johnson.

There were four major footraces in the ancient games. Although the marathon is firmly associated with the Greeks, it was actually not included in the crown games. The stadion race was the most venerable of the footraces, and it was also an event in the pentathlon competition. Stadion runners could also compete in the *diaulos* (literally, "double-flute") event—a double lap race (two stades) that was introduced in 724 B.C. The dolichos, or long-distance run, varied from seven to twenty-four stades, that is, from about 1.6 to 4.8 kilometers (about 1 to 3 miles). The fourth running event was the hoplitodromos, the race in armor, which was introduced in 520 B.C.

Hoplitodromos athletes ran a short race—one or two lengths of the stade—still in the nude but encumbered by weighty bronze

helmets, greaves, and shields. Our curiosity about the logistics of the footraces is certainly piqued when we try to imagine a runner weighted down by metal armor. A representation of this type of athlete can be seen on the obverse of a fifth-century electrum coin from Kyzikos in Asia Minor (cat. no. 31), on which the figure wears a crested Corinthian helmet and holds a large round shield. The runner bends forward in preparation for the starting signal, as does a nude runner shown on an Athenian cup (cat. no. 30). There are records of gifts of shields from wealthy and famous men to be used in these armed races; at Olympia twenty-five bronze shields were stored in the Temple of Zeus for the hoplitodromos.[4]

The more talented runners competed in several different races. One phenomenal runner, Leonidas of Rhodes, won the stadion, diaulos, and hoplitodromos in four successive Olympiads

(164–152 B.C.). By winning three consecutive footraces at Olympia, Leonidas earned the title *triastes,* or triple victor. Clearly, his body type combined several of the desired qualities for ancient runners. Astylos of Kroton won both the stadion and diaulos races in 488 and 484 B.C., and in 480 he won three of the running events, including the race in armor, which qualified him as triastes, too. However, his triumph was darkened because he ran for Syracuse and not his hometown of Kroton. One victor of the hoplitodromos, Phayllos, earned the catchy nickname "the odometer."

Our word "stadium" derives from the Greek "stadion," and in antiquity it was the name not only of the short footrace itself but also of the distance (180 meters or 200 yards) and place of the race. The ancient stadium was composed of a simple, flat running area, the dromos, which was either a rectilinear space or one with slightly bulging sides, bordered by spectator areas. The existing track at Olympia was built about 470 B.C. and was approximately 192 meters (210 yards) long and 31 meters (34 yards) wide. It is estimated that the earth embankment could accommodate some forty thousand spectators—mostly men. As noted by Romano, "tracks now are artificial, all-weather, and extremely fast. The track at Olympia was clay, a resilient surface to run on if maintained and moistened." Due to the heat of the late summertime when the games were held, the races were probably run in the early morning hours when the temperature was cool and the track surface was moist from the overnight dew.

Scholars still debate how the races were actually run.[5] Were there separate lanes for each runner? How did they negotiate the turns for the multiple lap races? Sometimes vases depicting runners show posts at one end of the painted scene. These posts were called *kampteres* or *terma* and were used to mark the starting and finishing points of the foot- and horse races. A mechanism called a *hysplex* is mentioned in a number of ancient texts and probably refers to the rope or part of a gate used to start the footraces. The takeoff was signaled by the blowing of a trumpet (cat. no. 75, p. 113). Modern runners start from a kneeling position. Greek runners, in contrast, started from a standing position.

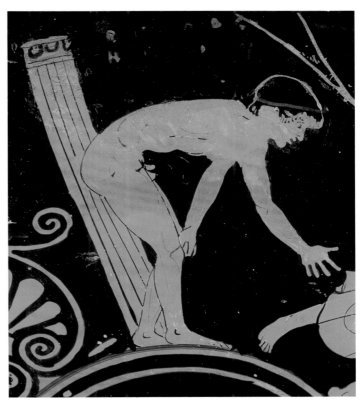

A runner bends over into his starting position (cat. no. 30).

In a rare representation a runner practices his start standing in the customary position beside a fluted post (cat. no. 30). If it were the actual race and not practice, his toes would be gripping the grooves in the sill. Stone sills have been found in the stadia of Olympia and Delphi. They were divided at regular intervals of 1.2 meters (4 feet) by square sockets to hold posts; there were twenty places for runners at Olympia. Parallel grooves were cut in the sill between the sockets to mark the place for the runners.

The discovery of a single limestone socket for a post at the stadium in Nemea sheds new light on the question of turns and lanes for ancient runners. Stephen Miller, the excavator of Nemea and an ancient sports specialist, proposed that the turn for the

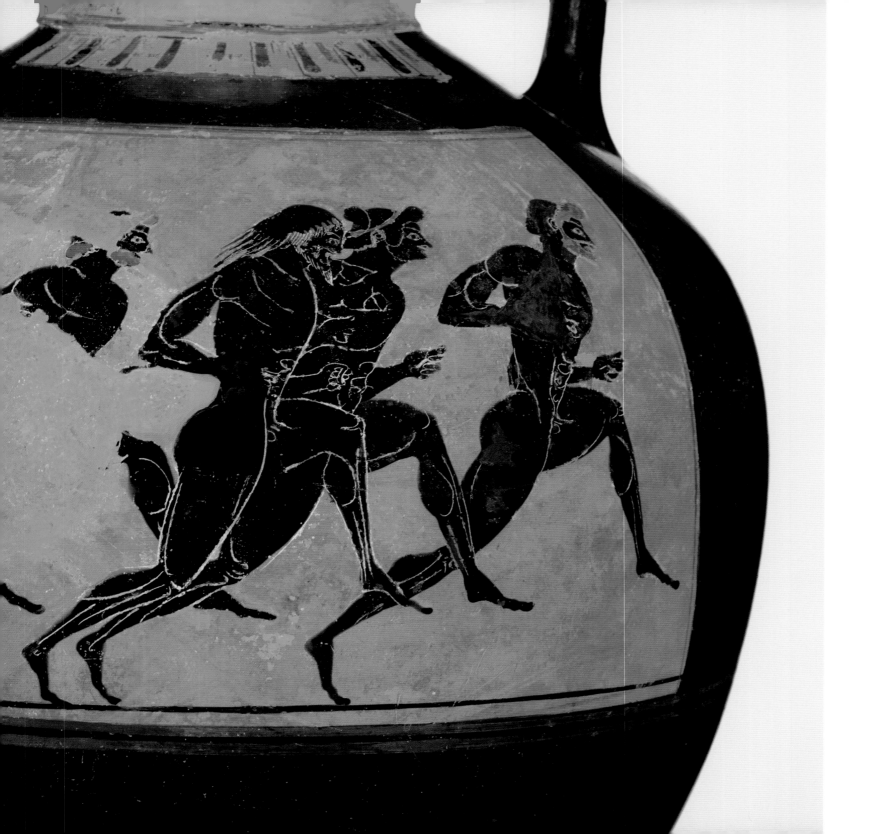

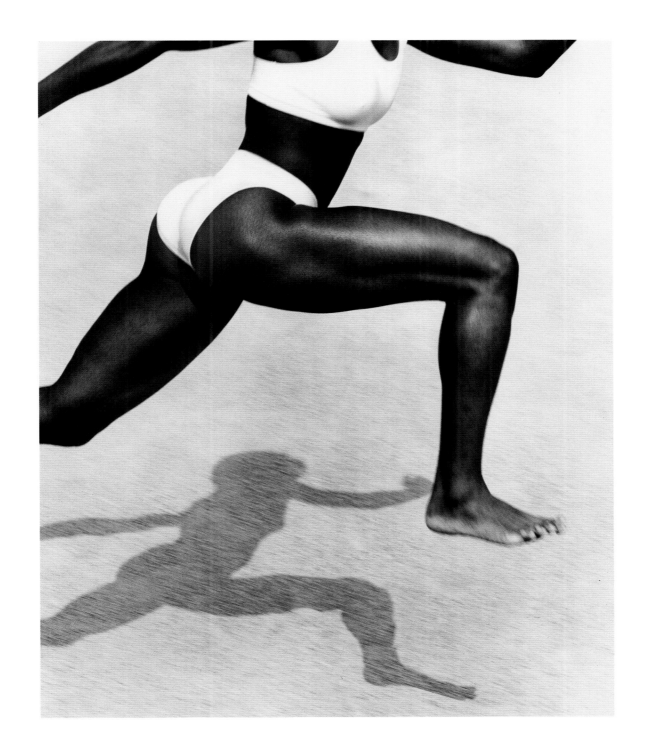

< These distance runners hold their arms at waist level (cat. no. 27).

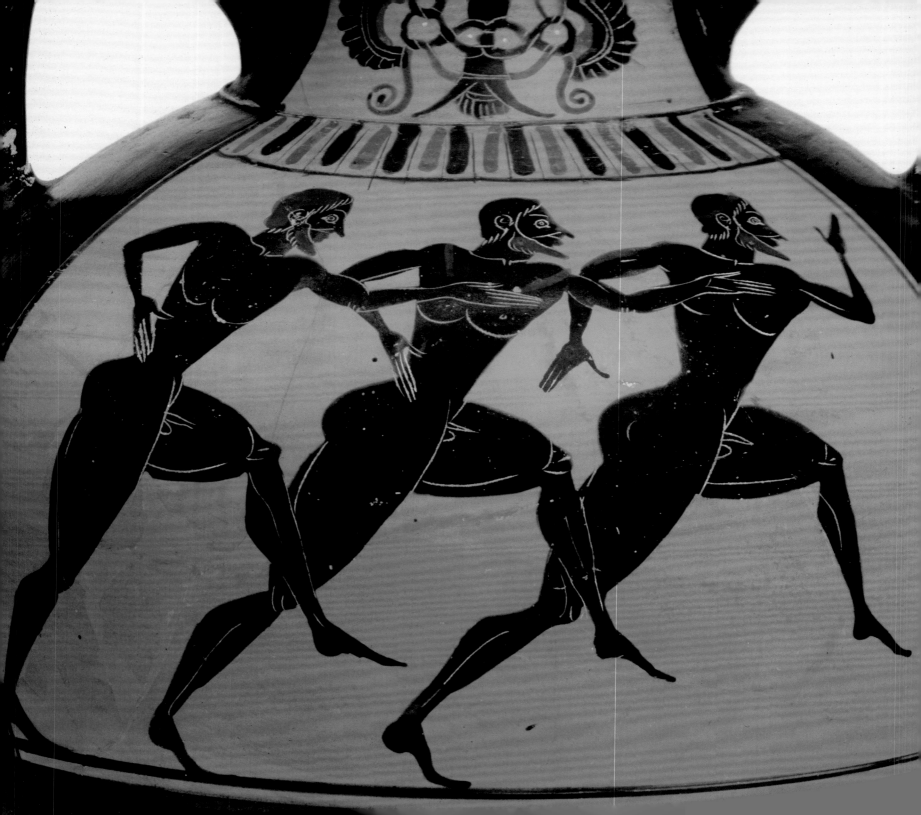

dolichos was around a single post at each end of the track in an elongated oval.[6] It is believed that runners in the diaulos and hoplitodromos each ran in two parallel lanes and turned around individual posts. In this way the armored runners could avoid dangerous collisions. The name diaulos, then, could more logically translate as "double channel," referring to the pair of lanes used for each runner, rather than "double flute." Miller further suggests that lanes were marked by a powdery substance such as gypsum or lime, referred to as *ga leuka*, or "white earth," in an inscription from Delphi from about 246 B.C. that describes work done on the stadium and hippodrome in preparation for the Pythian Games. The contestants in the middle-distance runs were guided toward their individual turning posts by the lane markers; likewise, the stadion runners could identify their own lane. Clearly, the different lengths of the races demanded various accommodations in the facilities.

In the introductory quote to this chapter, Philostratos describes the desirable body types and movements for the various running events. Depictions of runners on prize oil amphorae for the Panathenaic Games in Athens make it possible to distinguish between sprinters and distance runners. An example shows sprinters with their arms and legs flung out and hands wide open like the wings described by Philostratos as they dash to the finish line (cat. no. 26, p. 62). Confirmation of this identification as sprinters occurs on a fragment of a Panathenaic vase in the Athens National Museum that shows a runner in a similar position accompanied by the inscription, "I am a prize for a diaulos-runner." On another Panathenaic vase (cat. no. 27, p. 66) distance runners can be identified by the steady rhythm of their stride, each with their front leg off the ground, their arms held at the waist, and their fists closed. These depictions of runners raise interesting questions about the accuracy of representations, though, especially in terms of the technical aspects of these sports. Greek vases consistently show all types of runners moving with the same leg and arm forward, which contradicts the natural movement where the opposite arm swings forward. This was probably an artistic device to create a pleasing symmetry.

< Three mature runners sprint on a pseudo-Panathenaic prize vase (cat. no. 25).

> This vase shows three youthful runners sprinting (cat. no. 29).

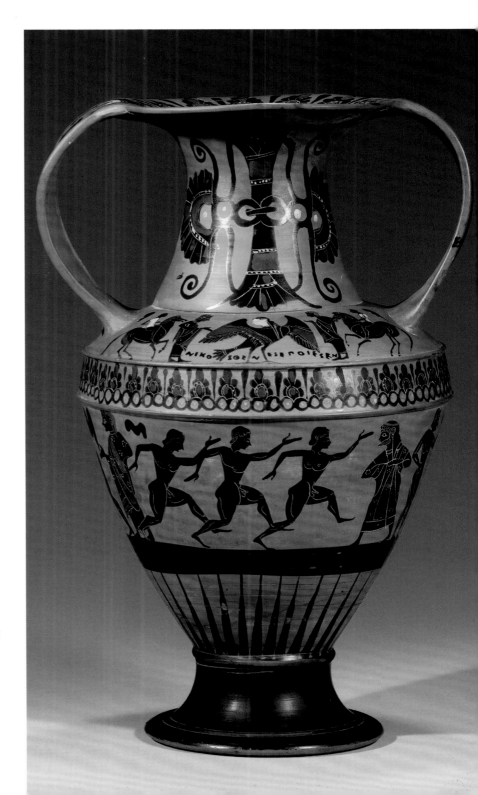

All of the runners appear powerfully built with articulated musculature. It is noteworthy that some are bearded and others are not; some have their hair swept up and tied back, whereas on others it hangs loose to their shoulders; and their bodies also vary slightly. In this way, the vase painters preserved the runners' individuality. The beardless youths also bear witness to the tradition of the stadion race for boys. Victors' lists survive that include prizes for the stadion in the boys' category; the award from a fourth-century list for the Panathenaic Games was fifty amphorae of olive oil, an estimated value of $11,880.

| TORCH RACES

There is an altar of Prometheus in the Academy [in Athens], and they run from this to the city holding burning torches. The contest is to run and keep the torch burning at the same time. The torch and the victory are extinguished together for the frontrunner, and the victory passes on to the second-place runner. But if his torch goes out, the third-place runner takes the victory; and if everybody's torches go out, nobody wins.

—Pausanias *Description of Greece* 1.30.2

The torch race is unrelated to the relay of runners who today carry the Olympic flame from Olympia to the venue of the games, although representations of these ancient contests must have inspired the creation of the modern event. Pausanias describes a relay race that was not an actual athletic competition but rather a ritual event especially connected to the celebration of the Panathenaic Games in Athens. Although other cities also held torch races, or *lampadedromia*, details of the Athenian ones are best documented. Like the boat races and the "beauty contests" (*euandria*), these events were civic enterprises. They were sponsored by the tribes of Athens and paid for by local citizens. As with the horse races in the Palio of Siena today, neighborhood groups contributed their resources and selected the men who would participate. The prize was a bull and one hundred drachmas (a value of about $2,300), and it went to the whole tribe.

The individual victor received a bronze water jar and thirty drachmas (a value of $660). Aristophanes relates an unorthodox episode when, at the Panathenaic torch race, the inhabitants of the Kerameikos beat up a slow runner, hitting him with open hands in the stomach, the ribs, the flanks, and the rear end, so that he farted, made his torch flare up, and got away.[7] From this anecdote we sense that there was a thin line between admiration and humiliation for these athletes and that their fans could easily turn on them.

Vase painters help us to visualize torch races. On a red-figured krater from Gela (cat. no. 22) two runners are depicted with different crowns that may well have identified their tribal affiliation. They run with torches aflame toward a priest who stands beside an altar and olive tree that must represent the sacred olive tree and Altar of Athena on the Acropolis. Some forty runners were assigned to each tribal team responsible for passing the lighted torch in a relay from the site of Plato's Academy, Athens's most prominent gymnasion, to the Altar of Athena—a distance of more than two miles. The torches were lit at the Altar of Prometheus—the giver of civilizing fire—which was part of a larger sanctuary area that included an important shrine to Eros situated at the entrance to the academy. The historian Thomas Scanlon views the race as a civic rite of passage, writing: "the Panathenaic torch race linked the gymnasium, where boys were trained in the ways of men, with the shrines and public areas where the active life of adults took place."[8]

> Two participants in a torch race run toward an altar (cat. no. 22).

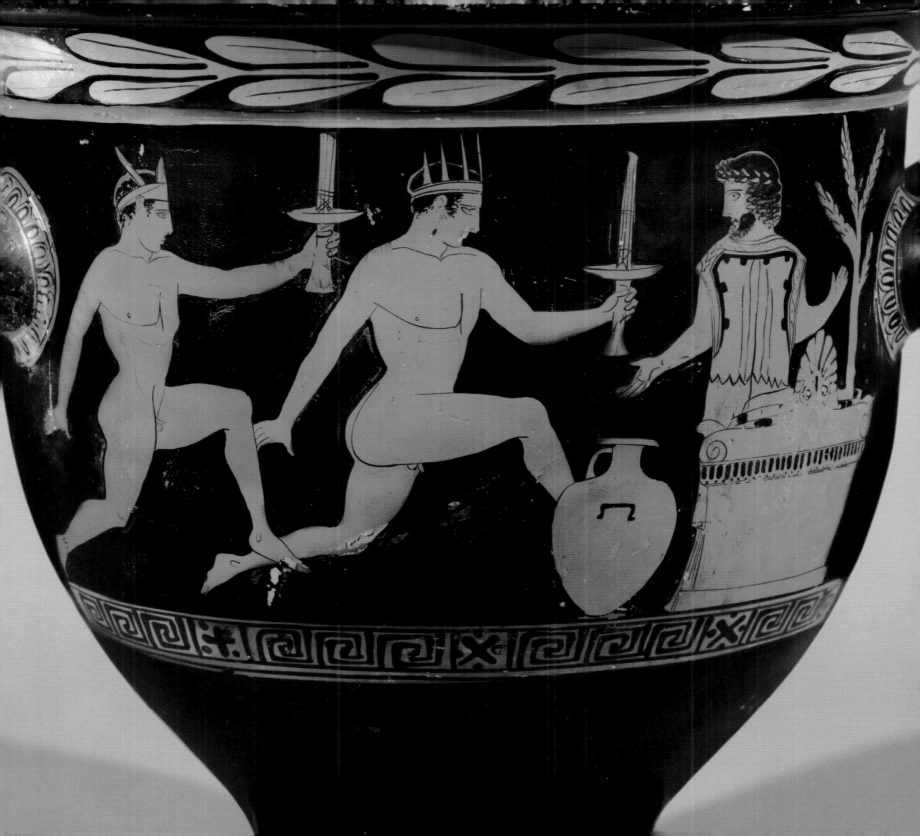

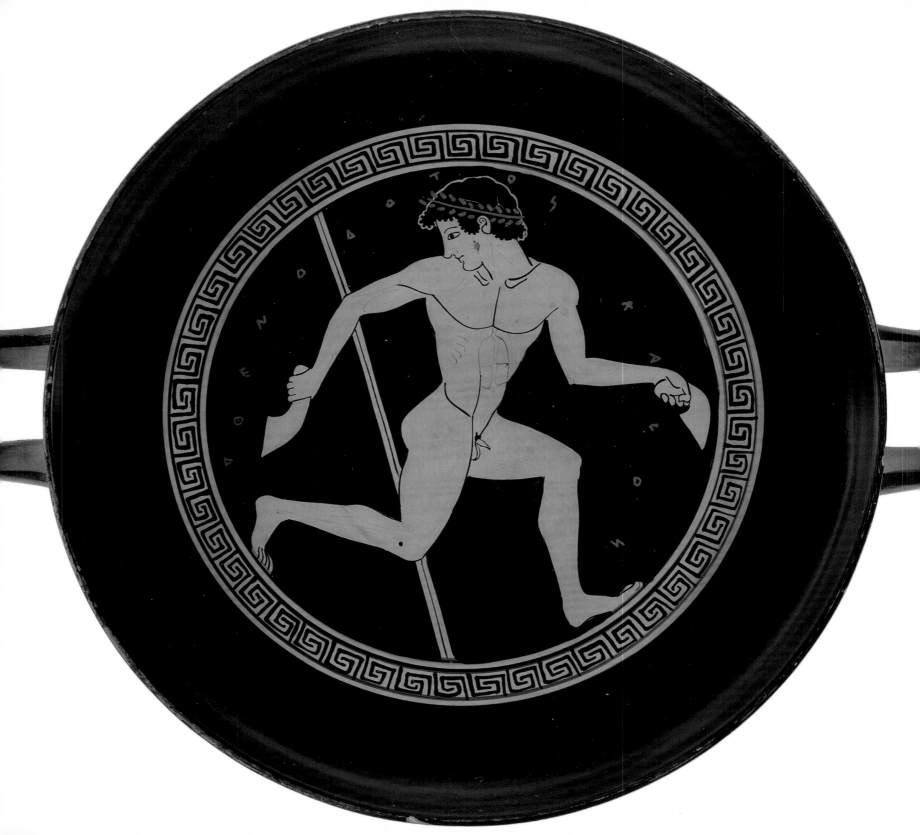

THE PENTATHLON

The pentathletes are the most beautiful; they are naturally adapted both for the exertion of the body and swiftness of foot.... One who can move his legs rapidly and in long strides makes a good runner. One who can grab and grapple makes a good wrestler. One who can thrust away his opponent by a blow of the fist makes a good boxer. One who excels in both boxing and wrestling makes a good pankratist. But he who excels in everything is fit for the pentathlon.

—Aristotle *Rhetoric* 1361b

As Aristotle remarks, those who competed in the pentathlon were highly regarded for their endurance, their strength, and the beauty of their bodies. The pentathlon comprised five events: long jump, javelin, discus, a short footrace, and wrestling.[1] Running and wrestling also existed as separate competitions for specialists in those activities; the field events, though, were held only as part of the pentathlon. It is believed that all five pentathlon events took place on the same day. Although the order of the events is unknown, most experts on ancient Greek sport agree that wrestling was last. The prevalent view is that the pentathletes would first compete in a triathlon of discus, long jump, and javelin. Any athlete who won three events was declared the victor even before the racing or wrestling contests. If an athlete was second in the first four events, he could still be the victor if he won the wrestling match. All of the pentathlon sports took place in the stadium. Plato reports that one fifth-century pentathlete, Ikkos of Taras, became a coach in the sport and wrote a manual on athletic training that, had it survived, would have answered many questions. Instead, much of our knowledge about the techniques of

these sports and the training of the athletes comes from a combination of literary and visual sources, as well as extant artifacts such as ancient discuses and weights.

| JUMPING

The rules regard jumping as the most difficult of the competitions, and they allow the jumper to be given advantages in rhythm by the use of the flute, and in weight by use of the *halter*. This is a sure guide for the hands, and leads to a clear and firm landing on the ground. The rules show the value of this point, for they do not allow the jump to be measured unless the footprints are perfect.

—Philostratos *On Gymnastics* 35

Of all the pentathlon events, jumping is least understood. We do know that the Greeks only performed the long jump; they did not practice the high jump or the pole vault. Ancient images of jumpers consistently show them holding a pair of weights, or halteres (cat. no. 36, p. 78). This equipment immediately sets the ancient sport apart from the modern jump. Depictions on vases also make clear that the technique was essentially a running jump. In order to start with as much force as possible, the jumper swung the weights forward, propelling himself into the air; on one vase (cat. no. 39, p. 76) we see the jumper in mid-air, with his arms and legs almost parallel to each other. He next swung them backward and then forward again, to push out as far as possible before landing. The ground in front of the takeoff was dug up and leveled to a certain distance to create a *skamma*, or sandpit. Pickaxes are often illustrated with pentathletes, because the

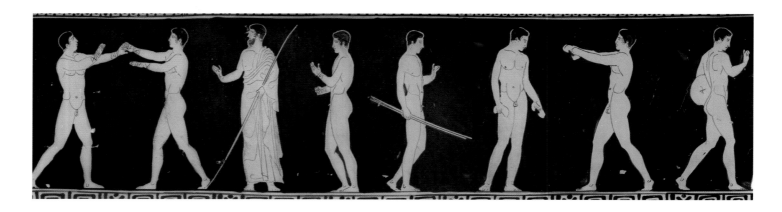

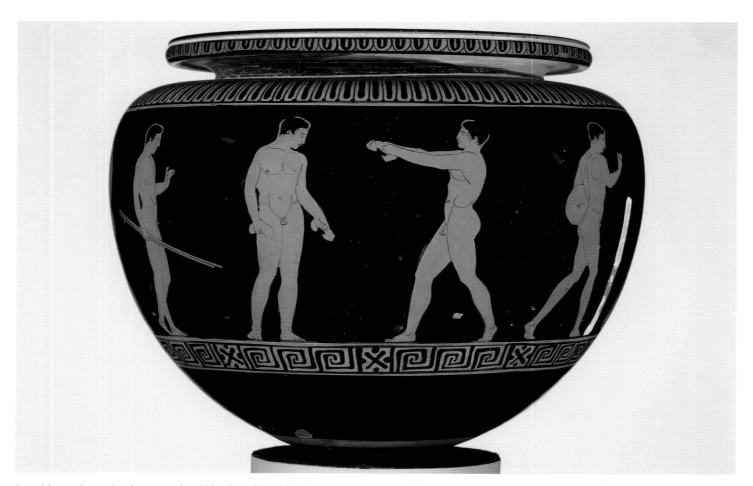

In a palaistra setting, two long jumpers practice with jumping weights while other youths rehearse the javelin throw, discus throw, and boxing (cat. no. 33, two views).

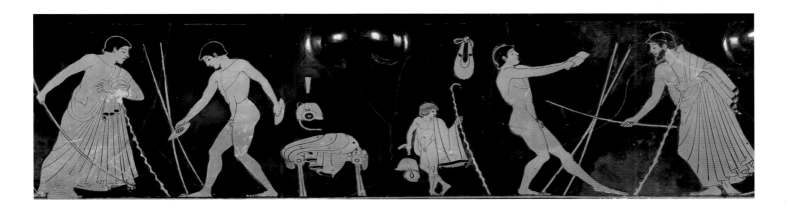

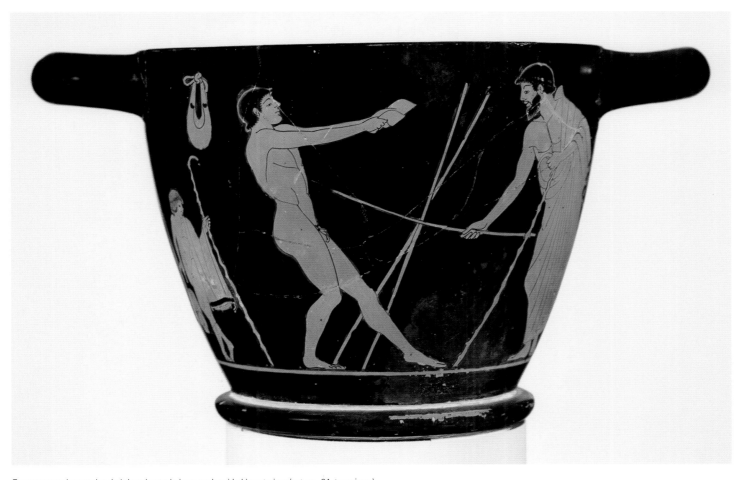

Two more youths practice their jumping technique, each guided by a trainer (cat. no. 34, two views).

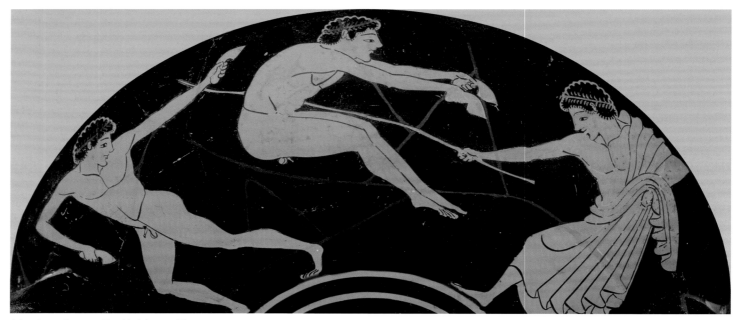

A long jumper is captured in mid-air (cat. no. 39).

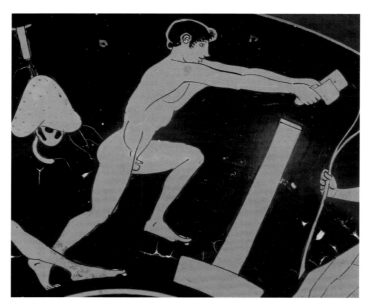

Another jumper holds his weights out, perhaps beginning his jump (cat. no. 37).

jumpers themselves loosened up the sand both in the practice yards and in the stadium (cat. no. 30, p. 84). In order for the jump to qualify, the jumper had to land firmly on both feet and make a clear imprint in the sand. The timing of the jump and the manipulation of the weights were demanding and required dedicated practice. The description by Philostratos, a Greek writer from the Roman period, makes clear that jumpers practiced and competed to the sounds of flute music.

Some vases depict sticks in the ground as devices to measure the lengths of the jumps. The distance that ancient jumpers actually achieved is a matter of speculation. Ancient reports of jumps over 15 meters (50 feet) seem incredible, especially when we consider a modern world record of almost 9 meters (29 feet) set by Bob Beamon at the Mexico City Olympics in 1968, which was exceeded only in 2001 by a mere 10 centimeters (4 inches). Modern jumpers use a triple-jump technique (hop, skip/step, and jump) because it was originally believed that was how the

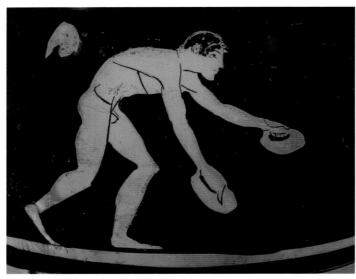

A jumper is preparing to start his jump (cat. no. 35).

This handheld jumping weight is made of lead (cat. no. 36).

ancient Greeks jumped. It is possible that ancient long jumpers took several standing jumps in a row within a given time period, so that the momentum of the weights accumulated and added to the distance. Modern athletes who have re-created the ancient jump with weights confirm their value as performance enhancers yielding a few extra inches. Researchers recently reported in the journal *Nature* that software-generated jumpers with halteres of various sizes revealed that weights could indeed lengthen the parabolic trajectory of the jump.[2] Judging by the number and variety of jumping poses depicted on Greek vases, the ancients also found the physics of this sport fascinating.

A variety of ancient jumping weights have been excavated, usually made of stone or lead (cat. no. 36), though sometimes of iron, and varying in size and weight from 1 to 4.5 kilograms (about 2.2 pounds to 9.9 pounds). It is possible, then, that athletes could select their own weights depending on their personal preferences and styles. Pausanias describes ancient weights as "made from an elongated circle or ellipse which is cut through . . . just as they do through the handle of a shield."[3] The weights shown on vases are usually curved or half-moon forms with cut-out hand grips, and some of the hemispherical blocks of stone that survive have depressions for the fingers. Depictions of athletes swinging weights as if for exercise lead us to conclude that they are the ancestors to our modern dumbbells. Philostratos makes this very clear in *On Gymnastics*: "long halteres provide exercise for the shoulders and the hands, the spherical halteres for the fingers as well. They should be used in all exercises, both the light and the heavy, except for the relaxing exercises."[4] In one sculpture a young boy holding cylindrical, or hour-glass-shaped, jumping weights stands beside a punching bag, indicating that the weights were part of a body conditioning routine; he was not necessarily training for the pentathlete jump (cat. no. 100, p. 130).[5]

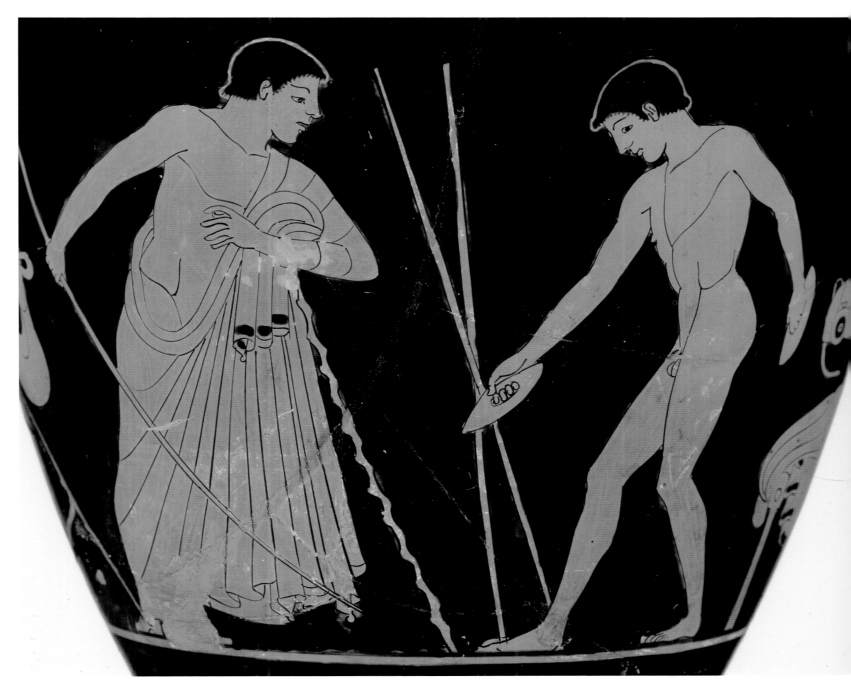

This jumper looks down in concentration, while his trainer observes (cat. no. 34).

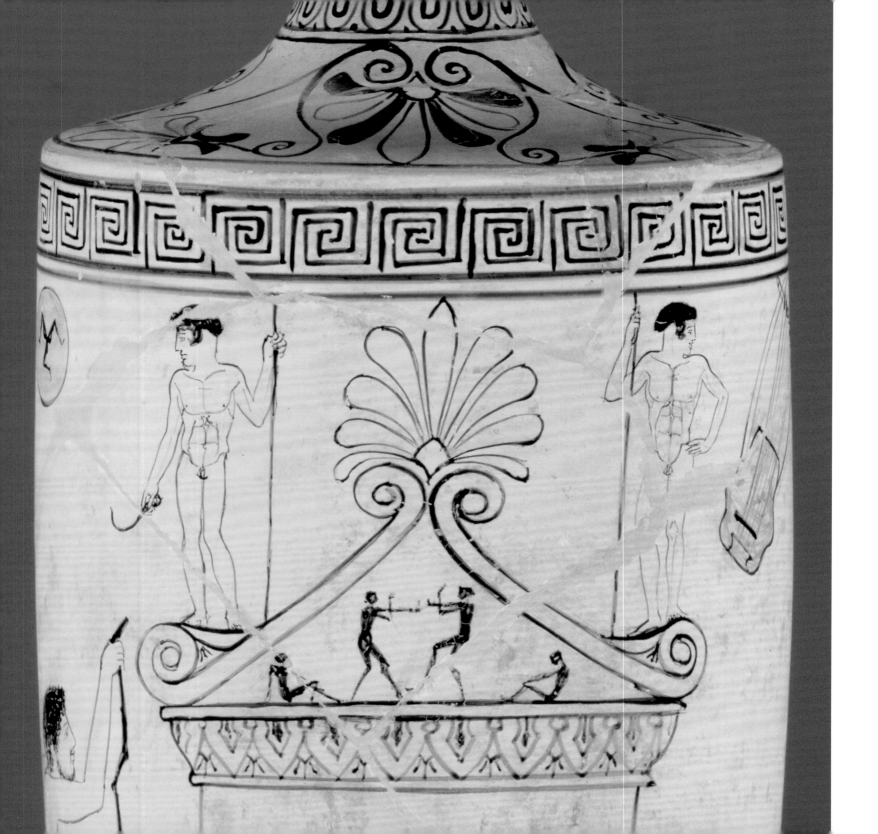

| JAVELIN THROWING

As for this bronze-pointed javelin which I am shaking in my hand, I hope I will not, as the expression goes, throw it out of bounds but rather hurl it a long distance, as to surpass my competitors.

—Pindar *Pythian Ode* 1.44–45

The throwing of spears or javelins (*akontia*) was a pentathlon event that certainly had its roots in preparing men for warfare. However, the objective of the athletic contest was to throw the greatest distance, not to injure one's opponent.[6] The woods used to make javelins for competition, such as elderwood, were lighter than the yew and other woods that the military utilized. As we read in Pindar, the competitive javelin had a metal point to allow it to stick in the ground and accurately mark the length of the throw. A votive deposit found at Nemea includes an iron javelin tip buried along with an iron discus and jumping weights, the equipment of the versatile pentathlete. No doubt during practice a blunt javelin was thrown. The wooden shaft seems to have been about the height of the thrower and the thickness of a finger. In contrast, the modern javelin is made of metal and measures about 2.6 meters (8½ feet) long, with a metal tip. As in ancient times, today distance is the goal; the modern world record is over 104 meters (340 feet), but it is likely the Greeks threw farther.

One difference between the Greek javelin event and the modern version was the use of a throwing aid in ancient times. Like the Greek jumpers who used weights to enhance their results, javelin throwers were aided by the use of a leather thong or throwing cord, known as an *ankyle*. The device was probably

< Two athletes holding javelins flank the grave monument painted on this oil jar (cat. no. 72).

∧ These pentathletes carry a javelin in each hand (cat. no. 38, two views).

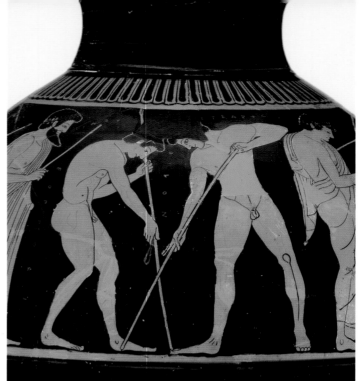

adapted from spears outfitted for the hunt and war. The thrower wrapped the cord around the center of the javelin, either by knotting it onto the shaft or merely twisting it around. He would then put his index and middle fingers through the cord; it seems the length of the fingers could be an advantage. As he ran at great speed, he would launch the javelin, at which point the thong would unravel and give a tighter spiral to the javelin's flight. This twisting motion apparently lengthened the arc of the throw and increased its thrust and distance.

The throw had to fall within lines drawn down the length of the stadium, where the contest was held. The participants used the same rectangular area, or *balbis*, that was used for the discus competition. If a toss went off at odd angles it was disqualified. Sometimes accidents occurred and bystanders were hurt: Antiphon, a fifth-century orator from Athens, cited the case of a youth accidentally struck by a javelin during practice in the

∧ Two more pentathletes practice with their javelins (cat. no. 41).

< A javelin thrower tests his javelins (cat. no. 46).

Photograph by Howard Schatz from *Athlete* (HarperCollins Publishers, 2002).

gymnasion in a law court exercise speech. Evidence of the presence of boundary lines and markers can be found on a drinking cup illustrated in this book (cat. no. 37, pp. 10–11). The exterior of the cup shows pentathletes practicing with their trainer, and the columns are identified as turning posts located at the ends of the course. The scene takes place in the practice yard of a gymnasion, as evidenced by the sponges, strigils, and aryballoi hanging from the walls. In the actual stadium the posts probably would have been set on stone sills that marked the start and finish of various events; however, it should be noted that some archaeologists have found evidence that disputes the equation of the turning post and the starting line. On the cup the javelin thrower shares the sill with a discus thrower and a jumper, suggesting that the three events used the same stone sill as their starting line.

| DISCUS THROWING

In the Treasury [of the Sikyonians at Olympia] are kept three *diskoi*, the number used for the competition of the pentathlon.

—Pausanias *Description of Greece* 6.19.4

Our understanding of the discus (*diskos*) event has been pieced together from archaeological evidence, depictions on vases, and monumental sculptures. For example, the famous discus thrower by Myron now in the Museo Nazionale Romano, in Rome, glorifies the physique of the discus thrower about to take his warm-up swing. The throwing of spherical objects probably had a natural start in the hurling of large, flat, rounded stones found by the seashore. Distance, not accuracy, was the goal in the discus contest. Ancient records preserve the name and distance of only one discus thrower, Phayllos (about 480 B.C.), whose throw was

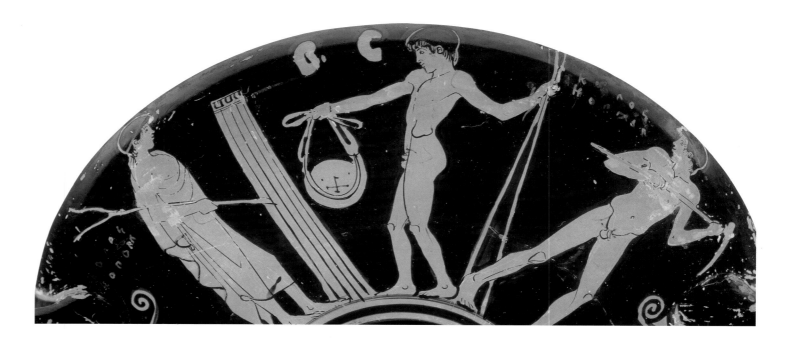

∧ The pentathlete in the center carries his discus in a bag (cat. no. 30).

> This athlete carries his discus into the palaistra, past jumping weights hanging on the wall and a pickax resting on the ground (cat. no. 42).

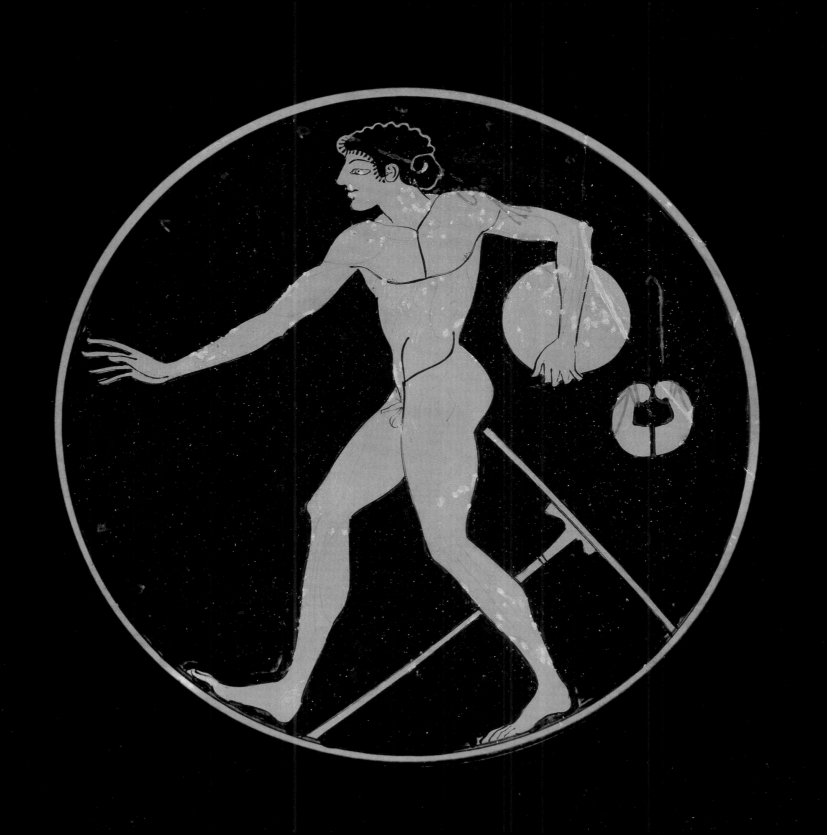

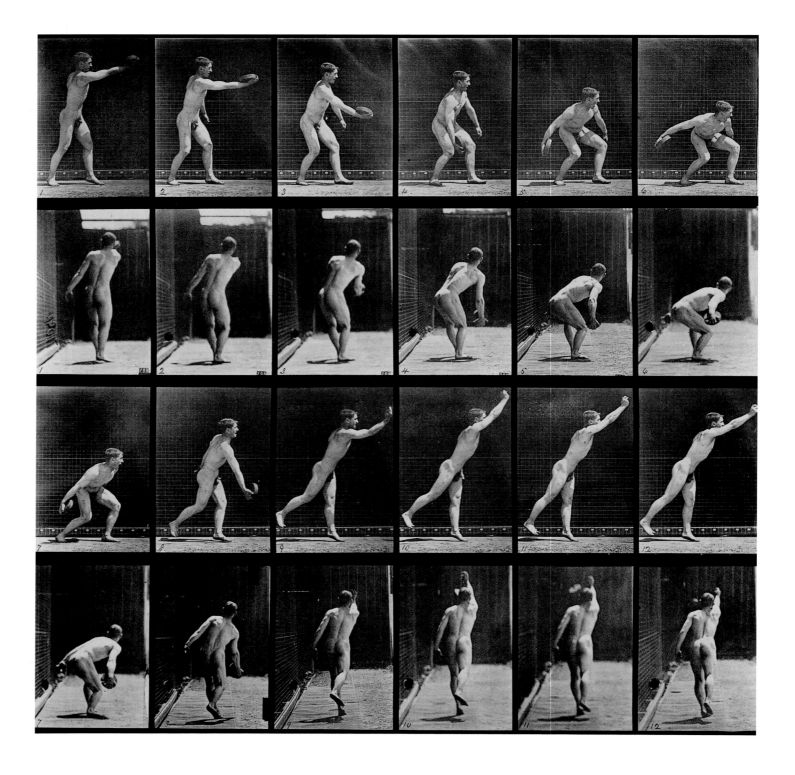

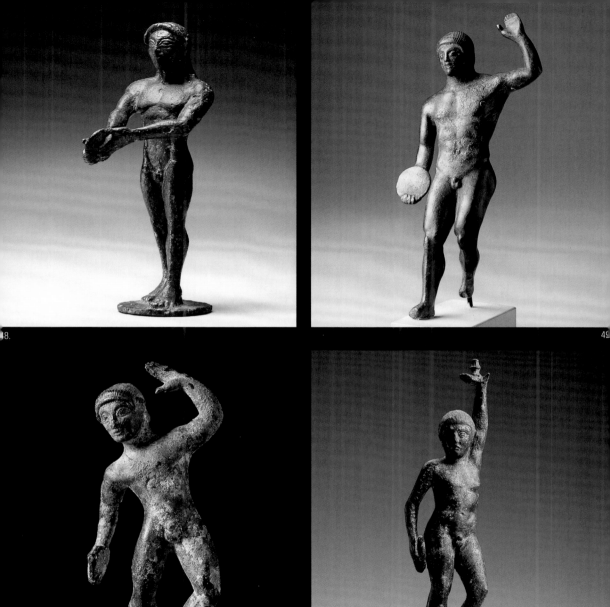
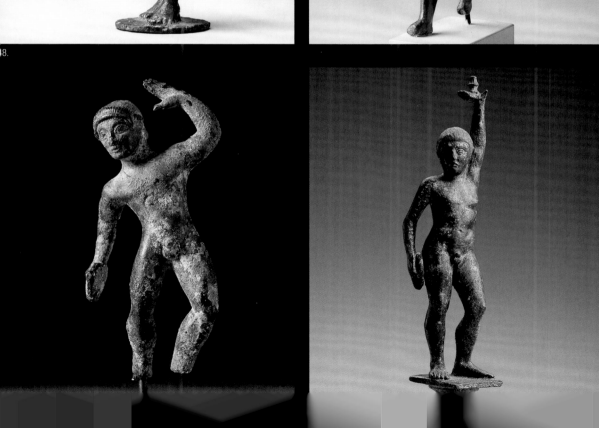

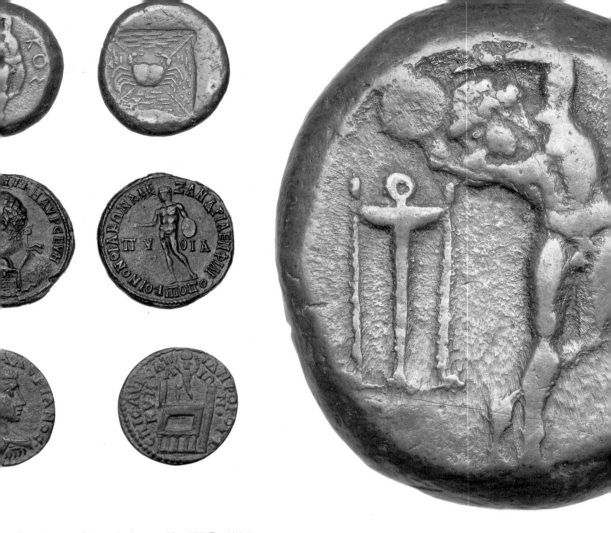

are featured on two of these coins (cat. nos. 52 and 53). The third shows an laistra building his muscles by lifting a large weight over his head (cat. no. 101).

30 meters (98½ feet). In comparison, the modern Olympic record is held by Lars Riedel of Germany for 69.4 meters (227½ feet). Although the ancient method for throwing the discus is unknown, experts assume that the Greek athletes did not spin around as much as modern athletes do, thus limiting the force and distance of their throws. Moreover, the modern discus is usually wooden with a metal rim and weighs about 2 kilograms (4.5 pounds), whereas discuses in antiquity were typically made of bronze—though sometimes marble, lead, or iron—and could weigh more than three times as much. Because the Greek sport was practiced to the accompaniment of music, the grace and rhythms of the turn and throw were probably considered, in addition to the distance, when judging a winner.

Pausanias informs us that three discuses were kept at Olympia to serve as the official equipment with standardized measurements. Eight bronze disks have been found at the site but, like all ancient discuses, they vary in size and weight. The diameters of the roughly twenty bronze discuses that survive from antiquity vary from about 17 to 35 centimeters (7 to 14 inches), with weights between 1.5 and 6.5 kilograms (3.3 to 14.3 pounds). The variations are confusing unless we assume that some were made as religious offerings or commemorative objects, others for the actual competitions. In fact, the inscriptions on two marble discuses support this possibility. The damaged inscription on one (cat. no. 43) was long believed to read, "From the games [*athlon*]," but a recent interpretation proposes an alternate reconstruction: "From the [funeral games at the] burial mounds [*eria*]."[7] This new reading is closer in meaning to the other marble discus to which it relates, now at the Metropolitan Museum of Art, and suggests that the marble discus was used as a commemorative object for the deceased, possibly an athlete, who was also honored with funeral games.[8]

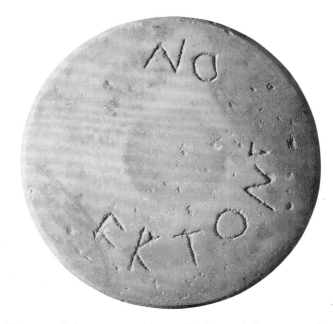

This heavy marble discus was not used in competition; it was probably a commemorative object or a prize at funeral games (cat. no. 43).

> A youthful discus thrower converses with an older javelin thrower (cat. no. 45)

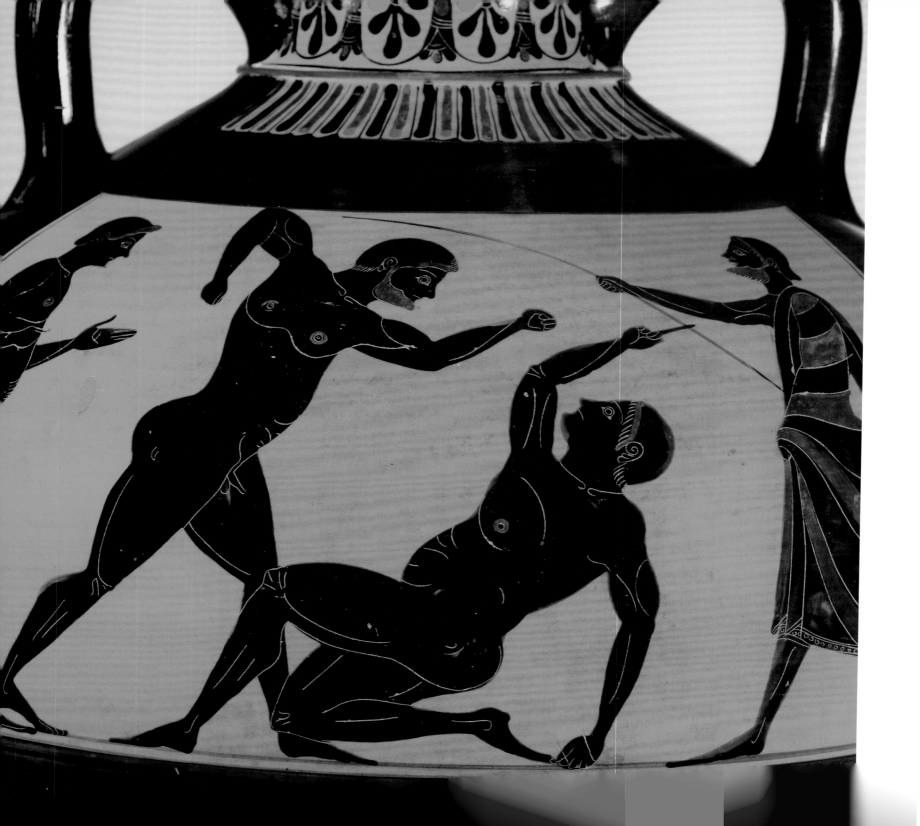

COMBAT EVENTS

One must wipe out his rival by doing everything.

—Pindar *Isthmian Ode* 4.48

The champions of the heavy events were the stuff of legends, and their immortal paradigm was Herakles. Whether the superhero was wrestling the Nemean lion with his bare hands (cat. no. 3, p. 53) or defeating the giant Antaios by lifting him off the earth, from which he gained his strength, Herakles was an inspiration to combat contestants. Hyperbole is the preferred tone of ancient accounts of combat athletes, no doubt encouraged by myth. The bar was set by the boast of Antaios, who claimed he could build a temple to his father, Poseidon, with the skulls of those he had killed in wrestling matches. In the victory songs of Greek athletes written by Pindar, Herakles is often invoked to praise the mortal athletes, especially in the *Isthmian Ode* 4, written for a fellow Theban.

The most famous of the Greek wrestlers, Milo (536–508 B.C.), is said to have led the troops of his hometown Kroton against the rival town Sybaris dressed as Herakles with club and lion skin, and donning his Olympic wreaths. A flesh-and-blood analogue for Herakles, Milo seems to have lived up to his hype. According to the records of Olympic victors, he won five times at Olympia, six times at Delphi, ten times at Isthmia, and nine times at Nemea. He achieved the title *periodonikes,* or "winner in all-around circuit," four times; in other words, he won at all four crown festivals four consecutive times. His fierce reputation intimidated some opponents who declined to fight; he would then win by a forfeit or *akoniti,* which meant literally "without dust," referring to the dust fighters applied to their bodies before a fight and also the dust from

a fall. He finally lost at the age of thirty-nine or forty against a younger man.

There were other great ones. Polydamas of Scotussa in Thessaly, the tallest man on record, was the champion of the pankration in 408 B.C. at Olympia. He, too, was an imitator of Herakles in that he was said to have killed a lion barehanded; he also held a bull in place and stopped a racing chariot. His victory statue at Olympia was said to cure the sick. Their gigantic strength, their powers of healing, and their outsized deeds indicate how the combat athletes evoked Greek heroes. Cities bestowed their highest honors and rewards on these athletes, emphasizing their special status. No doubt because combat events were so dangerous, even life threatening, spectators were particularly invested in their heroic success and humiliating defeat. Evidence of how deeply these events penetrated the Greek subconscious can be found in a book on dream interpretation, which states that to dream about the pankration was a bad omen and to dream about boxing foretold bodily harm.[1]

Combat athletes practiced in the palaistra, the name for which derives from the Greek word *palaio,* "to wrestle." The wrestling area consisted of a softened sandpit, or skamma, like that used for the long jump. Another area was covered with mud for ground wrestling, providing a softer surface to protect the men against impacts that could cause injuries. The athletes were responsible for the upkeep of the area, which consisted of spreading the sand and mud and using pickaxes to break up the ground. For this reason they are often shown on Greek vases with their pickaxes nearby. The quality of the sand seems to have been

< The combatant on the ground raises his finger in surrender to end this pankration match (cat. no. 64).

91

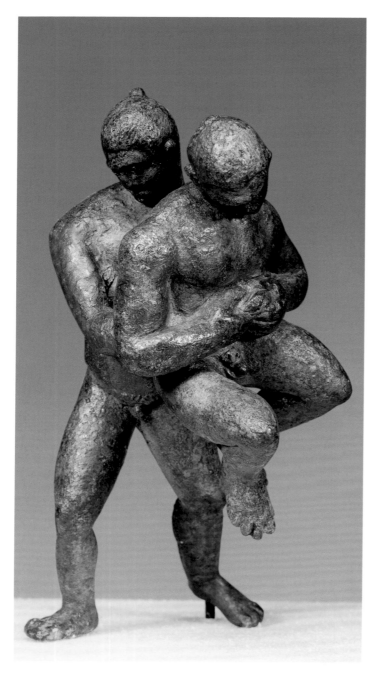

A wrestler lifts his opponent off the ground in a waistlock (cat. no. 57).

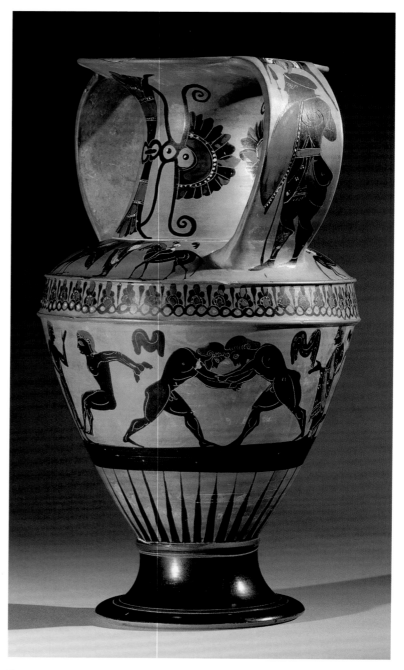

Two wrestlers practice in a palaistra (cat. no. 29).

of some importance, because the Roman emperor Nero ordered a ship from Alexandria loaded not with grain but with a special grade of sand used by wrestlers—this during a food shortage in Rome. In terms of personal care, the combat athletes rubbed themselves with olive oil and covered their bodies with dust to furnish a good grip. For wrestlers, oil also helped reduce skin abrasions and kept dirt from becoming packed into the pores of the skin. Greek and Roman combat athletes are often shown with a distinctive hairstyle, a long lock or braid of hair worn at the top or back of the head (cat. no. 57).

It is speculated that the combat events were held on the fourth day of the five-day games at Olympia. Excavators at Corinth believe they have found a ring for wrestling, boxing, and pankration events that includes a parabolic terrace at the southeast limit of the space, probably dating to the late third century B.C. They suggest that the spectators would have stood or sat on temporary bleachers erected over the terrace.[2] In the combat sports there were no seedings, and the luck of the draw for pairings was extremely important. If there were an uneven number of contestants, one contestant would draw a bye and arrive at a later round in fresher condition. Getting a weak opponent might have the same effect. Drawing lots for the pairings was so important that it became an artistic subject; Roman coins from Baris in Asia Minor show athletes drawing lots from an urn and staring at them intently (cat. no. 62, p. 98).

| WRESTLING

Once only Milo, the wrestler, came to the games, and the *athlothetes* summoned him to be crowned immediately. But he slipped and fell on his back as he came up, and the crowd shouted that he should not be crowned since he fell down all by himself. Milo stood up in their midst and shouted back: "That was not the third fall, I fell once. Let someone throw me the other times."

—*Greek Anthology* 11.316

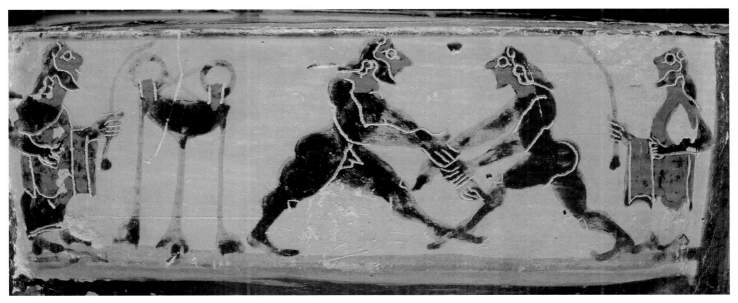

From the position of the combatants, this wrestling match appears to have just begun (cat. no. 54).

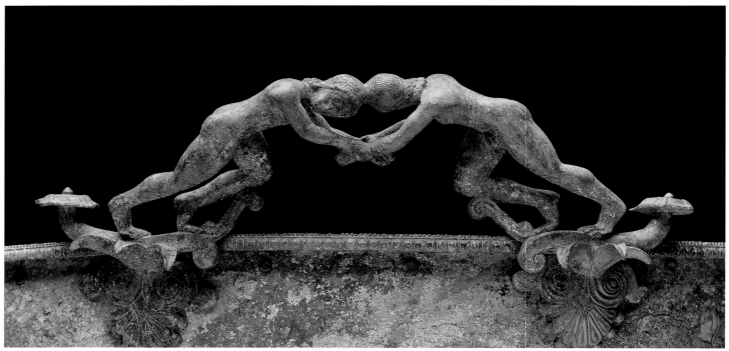

Two wrestlers grab each other's arms in an attempt to win a fall (cat. no. 55).

Probably most ancient wrestling was practiced in a standing position, and this was certainly the technique most often depicted. Upright wrestling was one of the five events of the pentathlon, as well as a separate competition in its own right. An early type of upright wrestling was a confrontation that involved holding an opponent by the belt to gain leverage for a throw, as seen in examples of Mesopotamian and Mycenaean art (cat. no. 1, p. 44). The same technique of standing upright to engage with an opponent and struggling to grab each other's arms appears to be the favored position for artistic representations of early Greek wrestlers (cat. no. 55). On both a sixth-century tripod vessel (cat. no. 54) and an amphora produced for the Etruscan market (cat. no. 29) the wrestlers grab each other's arms and go head

to head with outspread legs. The position is also found as a design on Greek coins, such as a fourth-century silver coin from Aspendos in Asia Minor (cat. no. 59, p. 98). The goal of upright wrestling was to throw one's opponent to the ground three times out of five bouts; thus the victor was called a *triakter*, or trebler. A fall was called if the shoulders or back touched the ground or if the opponent was trapped in a confining hold.

Greek vases are a rich source of the variety of holds and throws practiced by wrestlers: wrist hold and leg trip; headlock and hip throw; shoulder throw; wrist hold and underhook of shoulder. Philostratos calls one dramatic throw "the flying mare," to describe the flipping of the opponent overhead. Some opponents approached from behind, as seen on a Panathenaic vase

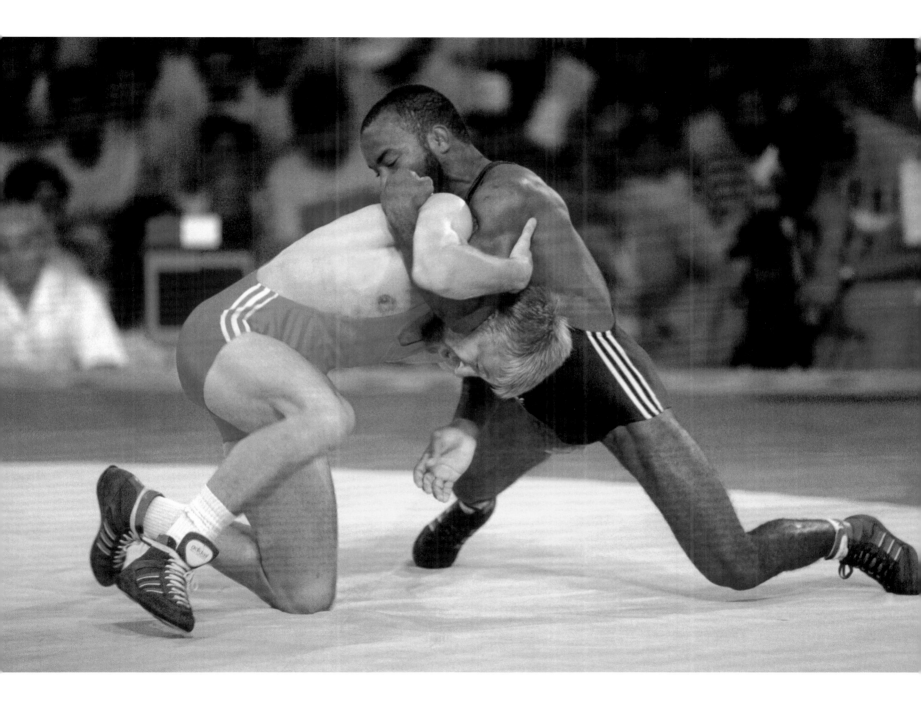

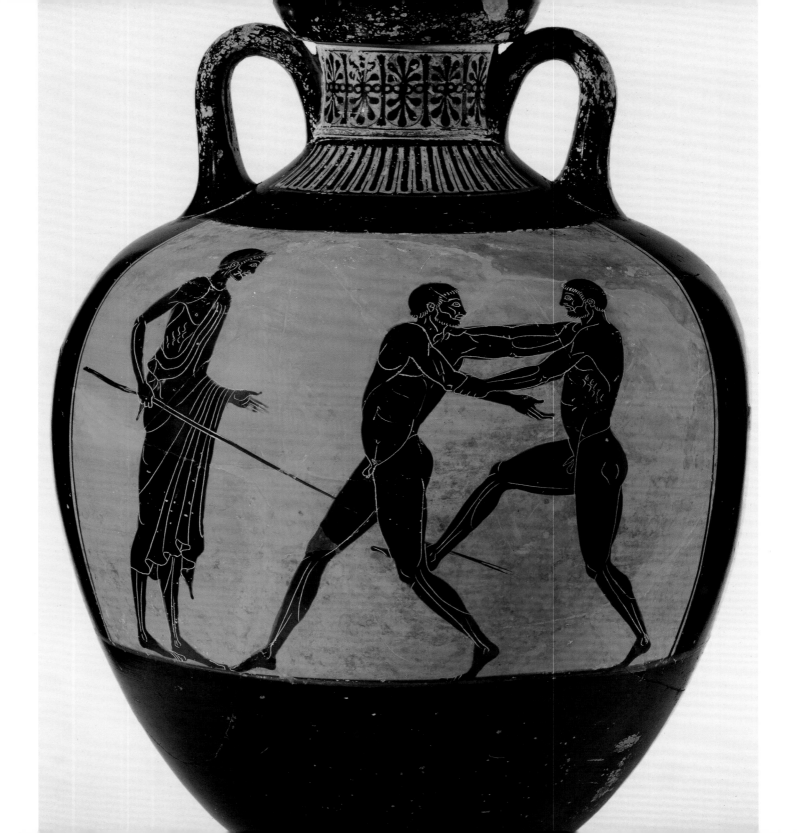

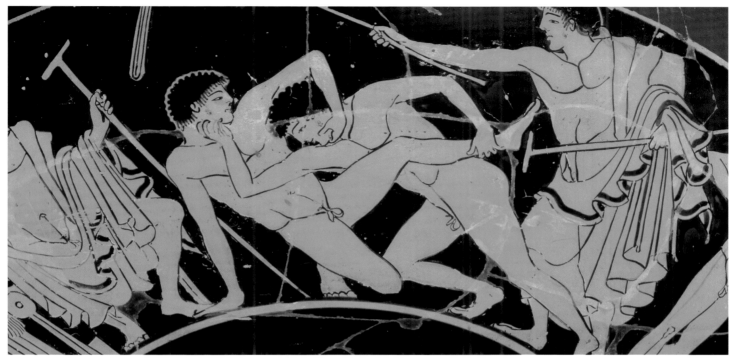

A judge has seen a foul and leans in to punish the offending wrestler (cat. no. 58).

where the wrestler on the right holds the other by the shoulder and upper arm while attempting to trip his leg (cat. no. 56). A dynamic demonstration of a wrestler using a waistlock from behind to lift his opponent off the ground is shown in a bronze statuette (cat. no. 57, p. 92). On a drinking cup (cat. no. 58) two young wrestlers have gone to their knees. One lifts his adversary's leg to force him onto his back. They are attended by two cloaked trainers, one of whom holds a stick to strike them for fouls. A younger athlete stands to the side carefully observing the moves. Sometimes painters illustrated training exercises in which it is clear that the wrestlers are walking through their moves, such as a reverse waistlock (cat. no. 41).

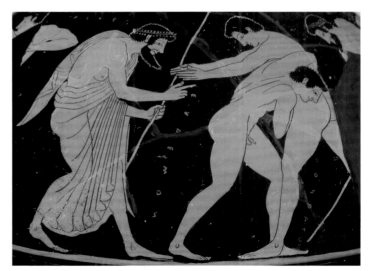

< The wrestler on the right attempts to trip his opponent (cat. no. 56).

A trainer coaches two wrestlers practicing a reverse waistlock (cat. no. 41).

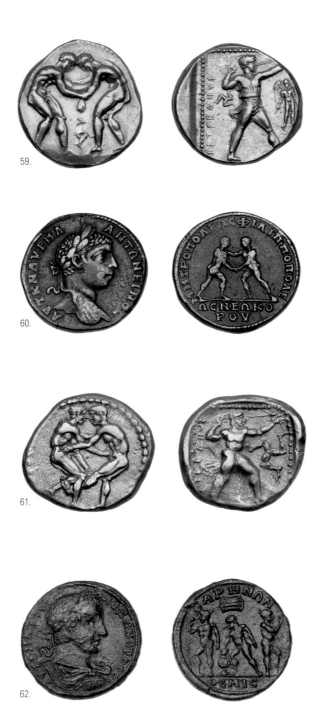

59.

60.

61.

62.

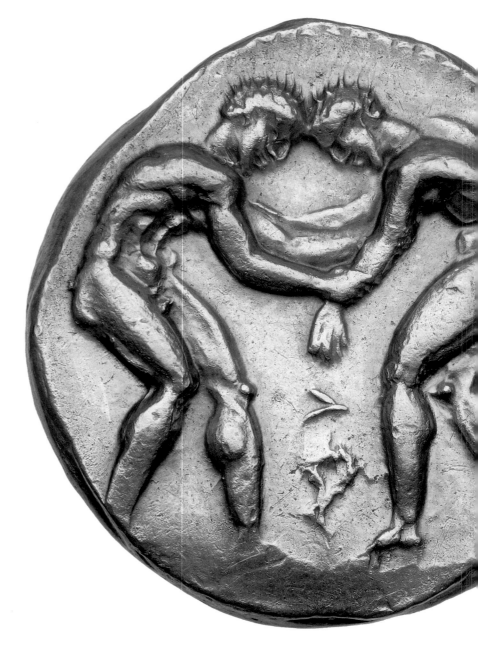

These coins illustrate wrestlers competing (cat. nos. 59–61) and athletes drawing lots (cat. no. 62).

| PANKRATION

You come to the Olympic festival itself and to the finest event in Olympia, for right here is the men's pankration. Arrichion who has died seeking victory is taking the crown for it.

— Philostratos *Imagines* 2.6

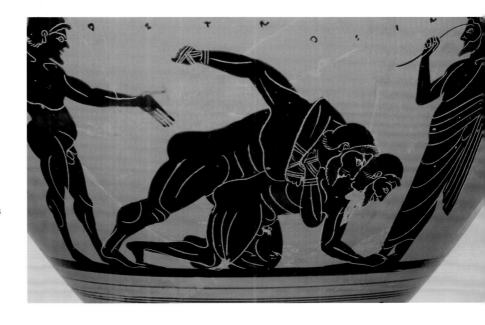

Theseus is credited with the invention of the pankration, a no-holds-barred combination of boxing and wrestling that also included kicking and ground wrestling. While Herakles served as an overall heroic model for athletes, Theseus was specifically linked with wrestling. He encountered a number of tough bandits whom he killed in violent ways on his journey from Troizen to Athens. One of these was the outlaw Kerkyon, whom he wrestled to death at Eleusis. Their fight is often depicted on Greek vases, where artists show them both nude and in a variety of wrestling holds that clearly reflect actual athletic practices.

Pankration was the most dangerous of the heavy events; matches ended when one opponent submitted or was incapacitated. All holds were allowed, and only eye gouging and biting were forbidden. Artists represented violent actions such as eye gouging on Greek vases, but usually a trainer is nearby to strike at the offender. Both upright and ground wrestling, as well as strikes with fists or open hands, were allowed in the pankration. Some contestants used a tactic called *akrocheirismos*, in which they tried to bend back their opponent's fingers. One athlete, Sostratos of Sikyon, managed to win twelve crowns in the pankration with this trick, earning himself the nickname Akrochersites ("fingerman"). Usually, however, the bouts were decided by punching, kicking, and struggling on the ground (cat. no. 63). Ground wrestling was typically practiced in the mud to cushion the wrestlers.

The pseudo-Panathenaic amphora illustrated at the beginning of this chapter probably represents a pankration event, because the winning fighter uses his fists and the defeated one is on the ground raising his finger in the gesture of submission (cat. no. 64, p. 90). The presence of the *paidotribes* or trainer—

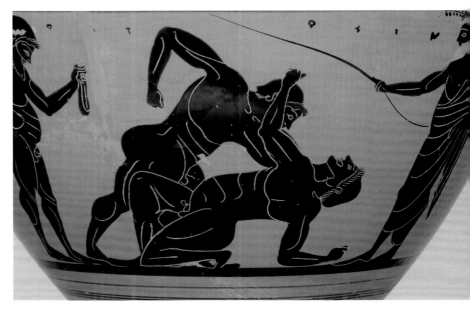

Two pairs of pankratists grapple like wrestlers but also deliver blows like boxers (cat. no. 63, two views).

A fighter grabs his opponent's leg and face, attempting to turn him (cat. no. 65).

bearded, cloaked, and ready with his rod to strike for fouls—is typical of these images. Often, though, it is difficult to be certain whether we are looking at a wrestling or pankration scene. The fragment of a drinking cup (cat. no. 65) on which one opponent is about to be turned on his back by the other, who is pulling one leg and tugging ferociously at his mouth area, could represent either; scratches or the bloody imprints of their hands are visible on the bodies of both fighters.

A sixth-century decree was found in excavations at Olympia that states that wrestlers were forbidden to break each other's fingers and that the judges were permitted to beat the offenders. Such measures may not have applied to the pankration, frequently won by Sostratos the Fingerman. Probably because of differing levels of brutality, Plato, himself a wrestler, wrote in the *Laws* that wrestling was worthy of his ideal state, but the pankration was not.[3]

| BOXING

When the two combatants [Amykos and Polydeukes] had strengthened their hands with oxhide straps and had wound the long *himantes* [boxing gloves] around their arms, they met in the middle of the gathering and breathed out mutual slaughter.

—Theokritos *Idylls* 22.27–135

What distinguishes boxing from wrestling events is that boxers wore leather thongs, called himantes, around their arms and hands, and most blows were delivered to the face and head. As there were no rounds in Greek boxing, competitors fought until a knockout or a submission determined the winner. Usually, as in the pankration, the trainers were standing by to strike for fouls. One of the most popular scenes on sixth- and fifth-century B.C. vases shows young athletes elegantly poised and carefully wrapping their hands with oiled oxhide straps—usually with loops at the ends—measuring about 2.7 to 3.7 meters (9 to 12 feet) in length (see, for example, cat. no. 66). Greek boxers covered their hands and wrists with these thongs in a variety of manners; some boxers wrapped to their fingertips, others left them free except for the thumb, still others just wrapped their wrists. These thongs were probably originally intended as a protection for the wrists and fingers from fractures. However, by the late fourth century B.C. a heavier glove was introduced with thick bands of a soft material, possibly sheepskin, in the arm area and extra-hard leather bands around the knuckles. Plato describes these gloves as *spherai*, or balls. They were also called "sharp thongs," and they could wield a more damaging blow. The Romans introduced metals into the sport and created the caestus, a boxing glove studded with metal that wrapped around the knuckles while the entire arm was protected by a padded sleeve (cat. no. 70, p. 105). As there were no weight categories, it was an advantage to be heavier; we see pudgy pugilists on several vases. However, it was considered a serious infringement of the games to kill a man, and it entailed immediate banishment from the games and victory for the deceased opponent.

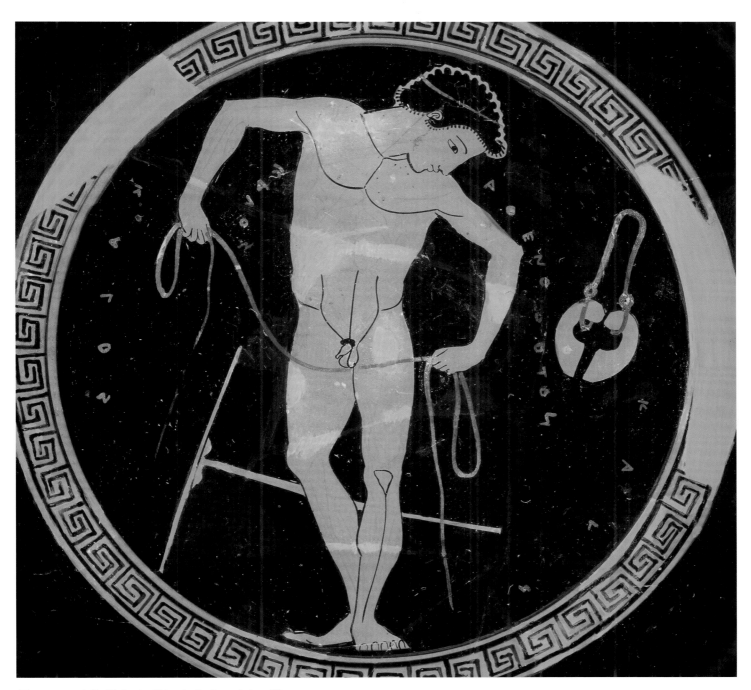

A boxer prepares to bind his hands with long leather thongs (cat. no. 66).

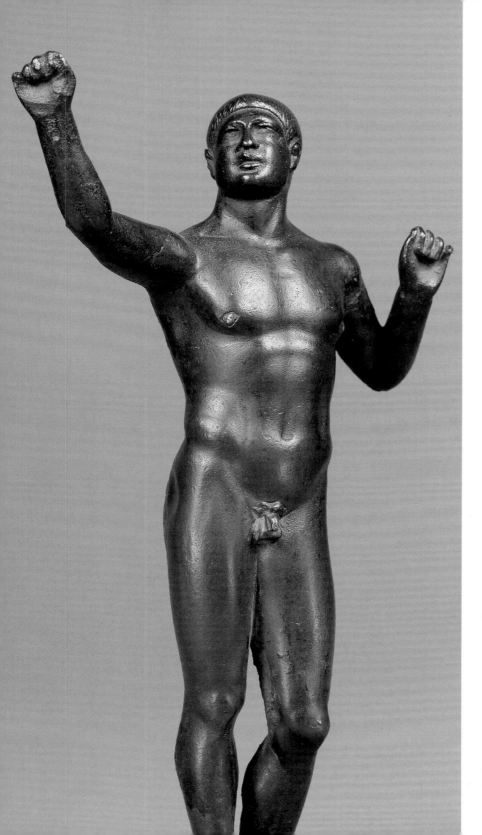

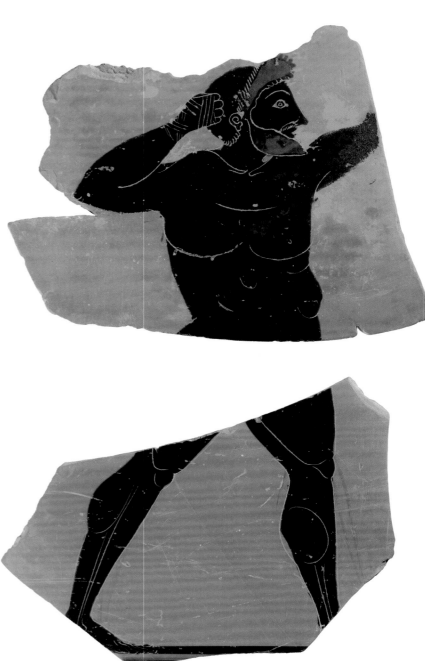

∧ A mature boxer stands ready to strike at his opponent's head and face (cat. no. 69).

< This athlete is stretching out the leather thongs (now missing) that he will later wrap around his hands (cat. no. 67).

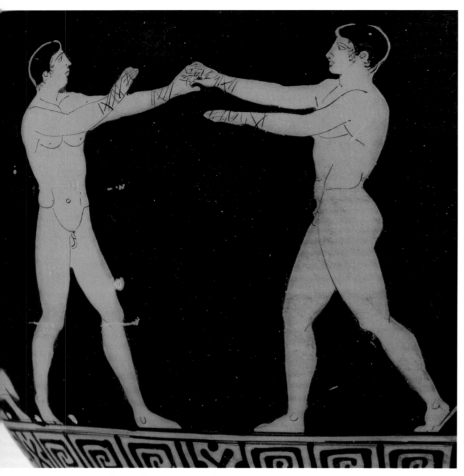

Two youths begin a practice boxing match (cat. no. 33).

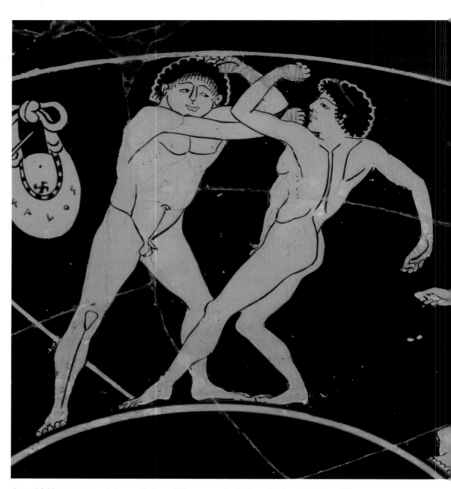

A youthful boxer appears to have unbalanced his opponent, who leans backward (cat. no. 58).

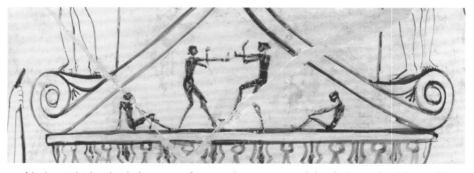

A boxing match takes place in the presence of two seated spectators on a painting of a decorated tomb (cat. no. 72).

The ancients were very aware of the hazards of boxing. Attention was paid to the injuries, as evidenced by the comments of Philostratos in *On Gymnastics*: "they prohibit pigskin himantes in the stadium because they believe them to cause painful and slow-healing wounds."[4] A marble statue shows a fighter with swollen ears tightening straps over his head and around his ears and chin (cat. no. 71). The straps may be ornamental, like the headbands worn by some competitors, but they could also be for protection. While the straps do not seem to cover the ears, they recall the head protectors that modern boxers wear when they practice sparring. The brutality of the sport is vividly portrayed by a bronze statue of a weary boxer of Hellenistic date, today on view at the Terme Museum in Rome. The face of the nude boxer is scarred, his nose is broken, and his ears are swollen. Vase painters likewise did not shy away from representing the bloody noses caused by facial blows in this event. Some fighters, though, were known for their ability to avoid facial deformity. Melancomas, a Greek boxer from southwest Asia Minor, remained undefeated and handsome. Apparently he wore out his opponents by his constant motion and thereby avoided getting hit—in the words of the great American boxer Muhammad Ali, he managed to "float like a butterfly, sting like a bee."

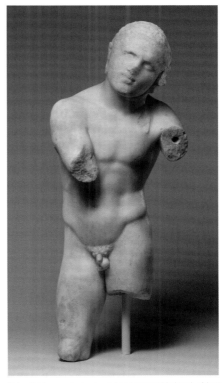

This athlete was fastening a band around his head, either as protection for his ears or as an emblem of distinction (cat. no. 71, two views).

Roman boxers used heavier gloves that delivered more harmful blows (cat. no. 70).

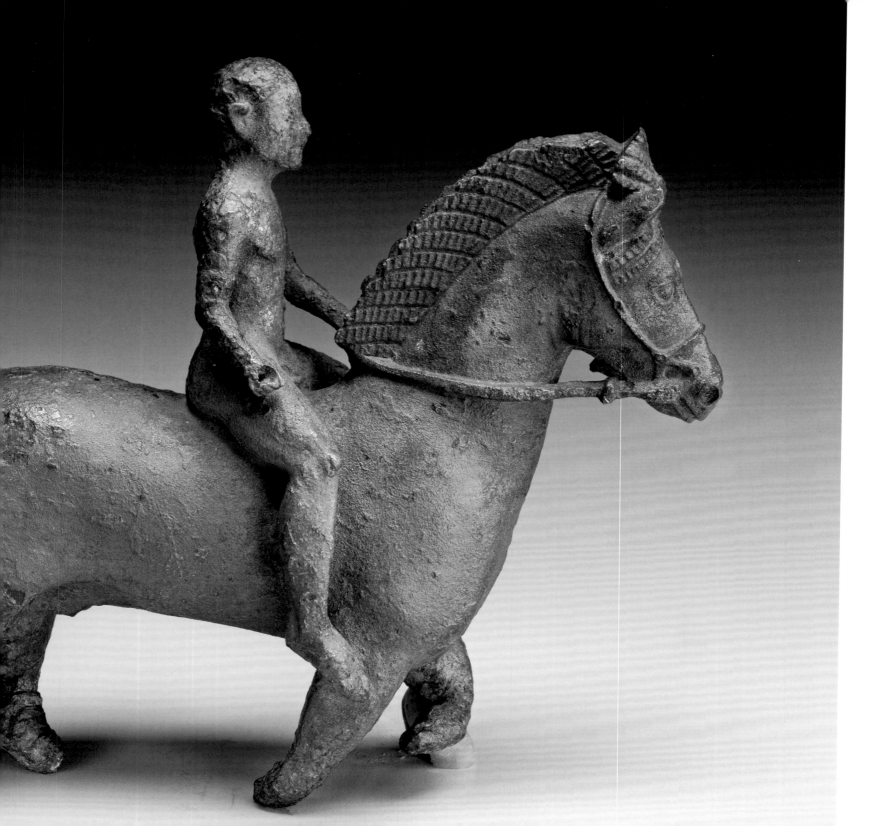

EQUESTRIAN EVENTS

The mare of the Corinthian Pheidolas was called Aura [Breeze]. At the beginning of her race, she threw her rider, but nonetheless ran on in good order and turned the post and, when she heard the trumpet, she ran faster, finished first at the Hellanodikai [Olympic judges] and recognizing her victory, stopped running. The Eleans awarded the victory to Pheidolas and allowed him to dedicate a statue of his mare [in 512 B.C.].

—Pausanias *Description of Greece* 6.13.9

| HORSE RACING

This play-by-play account appears in an inscription commemorating a sixth-century race. The tone recalls the excitement we experience today, whether viewing a race in person, watching the Kentucky Derby on television, or enjoying films and books like *Seabiscuit*. Ancient and contemporary audiences alike have relished anecdotes about horses and jockeys. The hazards of the races and the likelihood of spills add to the drama of these events. The action-filled spirit of the sport is well captured on Panathenaic prize vases for equestrian contests, on which jockeys use whips to speed their steeds along. The nude young men appear rather slight on their large galloping horses. These images seem to freeze action, as in the case of a jockey looking back to keep track of his competitors (cat. no. 74).

Some scholars look to Thessaly, a horse-breeding region, for the origins of competitive equestrian events; coins from Larissa in Thessaly bear images of acrobatic horse races and of bull wrestling by men on horseback. As is the case today, horses were bred and owned by the elite. Alkibiades, in defending his father, the famous Athenian statesman and orator of the same name, told a jury that horse breeding was the "work of the uppermost crust and not possible for a poor man."[1] Indeed, prizes went to the owners, not the riders who were paid servants. The exorbitant cost of horses is the theme of a satirical dialogue between a father and his racehorse-obsessed son in *The Clouds*, by Aristophanes: the father bemoans his debt for a horse valued at roughly $27,000. The memory of equestrian victories is relatively well preserved because these patricians could more easily afford celebratory monuments, whether glamorizing sculptures, hymns of praise commissioned from famous poets such as Pindar, or (in the case of rulers) coins commemorating victories. Equine subjects on Greek vases appealed to the well-heeled clients who owned the horses and chariots. Images of horses alone and of riding lessons were popular; sometimes the owner of the horse is named and depicted leading his winning steed.

Only one life-size statue survives to attest to the Greek fascination with horse racing: a bronze jockey and horse in full gallop found near Cape Artemision off the island of Euboea, now in the Athens National Museum. This extraordinary sculpture from the mid-second century exemplifies the highly naturalistic and keenly observed style of Hellenistic art; in fact, it has been argued that the hair and facial features of the jockey, as well as the black patina of his skin, were intended to show his Ethiopian origins.[2] From the eloquent sculpture we learn that the paid jockeys were young and rode bareback. The brand of a flying Victory with a wreath on the horse's right thigh suggests that the sculpture was

< This statuette probably commemorates a horse racing victory (cat. no. 77).

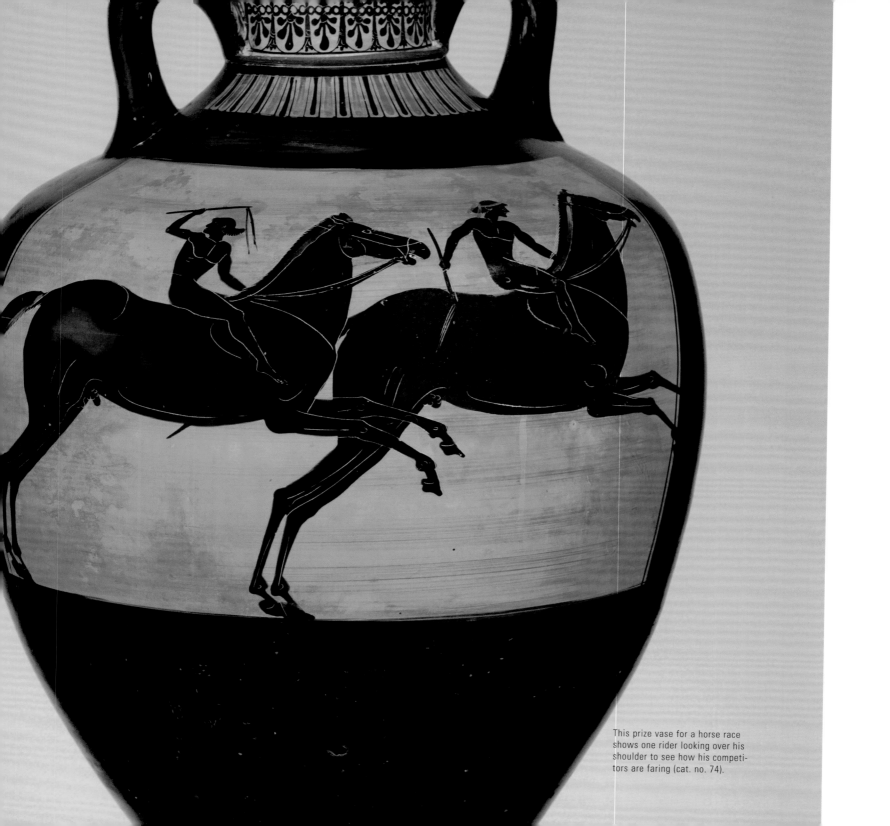

This prize vase for a horse race shows one rider looking over his shoulder to see how his competitors are faring (cat. no. 74).

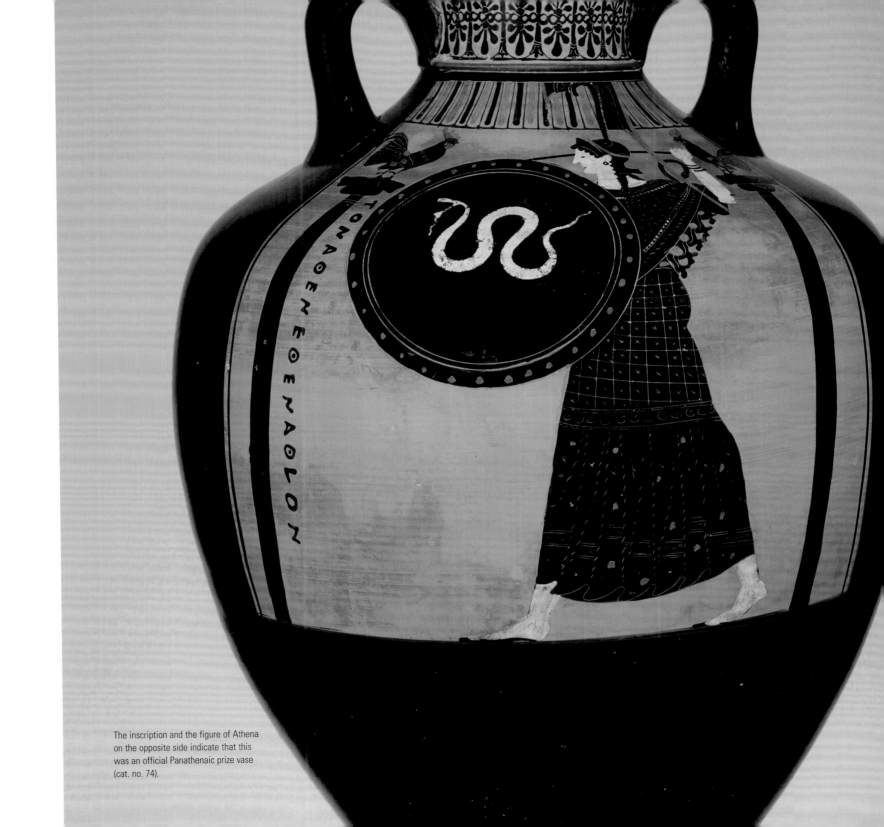

The inscription and the figure of Athena on the opposite side indicate that this was an official Panathenaic prize vase (cat. no. 74).

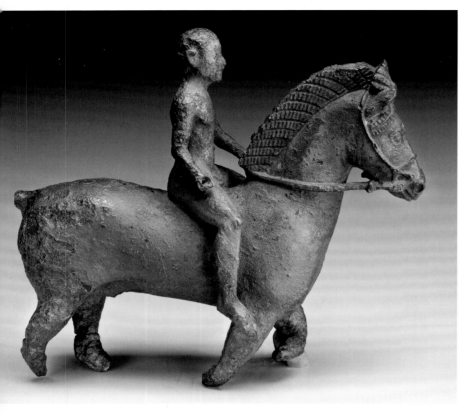

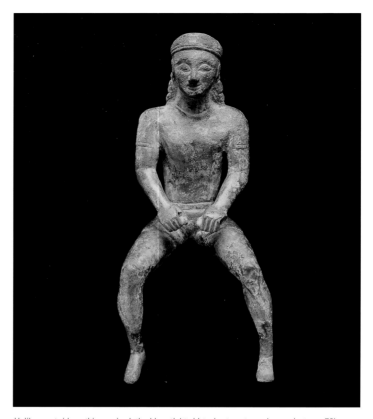

This rider originally held some object in his right hand, perhaps a palm branch to symbolize his victory (cat. no. 77).

Unlike most riders, this one is clothed in a tight shirt, short pants, and a cap (cat. no. 76).

probably commissioned by the owner of the horse and employer of the jockey. The legacy of the Artemision jockey type is attested in the issues of Roman Republican coins on which a nude jockey rides at full speed with a palm branch (cat. no. 80). Numerous small versions of bronze horses and riders, who for the most part are nude and beardless (cat. no. 77), survive and were most likely given as votives from victors.

Horse races were held on the second day of the Olympic program in the hippodrome (literally "horse track"). The nature of this structure remains unclear. In the early periods it was simply an open stretch of level ground with embankments for specta-

tors; at Olympia, the hippodrome was a long rectangle that lay to the south of the stadium. In Roman times these structures became more elaborate, with interior barriers and cones. This is documented visually in sculpture, coins, and medals. The crowds were undoubtedly protected from bolting horses and falling chariots by barriers. Pausanias mentions the position of the judges' seats somewhere in the western end of the northern bank at Olympia. The length of the Greek hippodrome is estimated at about half a kilometer (one-third of a mile), and all horse races in the Olympics were twelve laps. The width of the track could accommodate a lineup of forty chariots, at least according

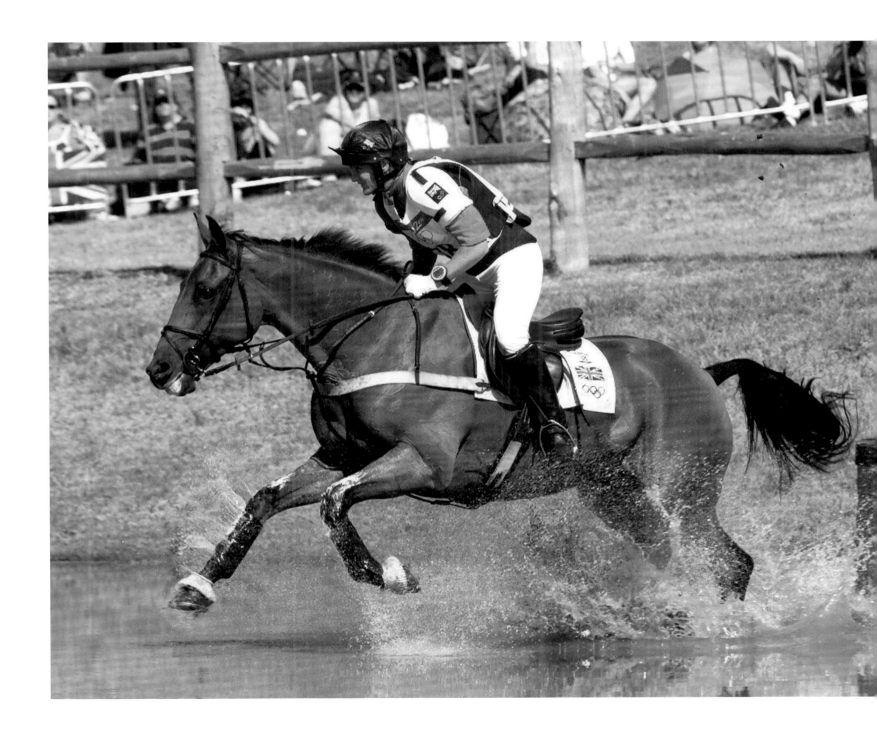

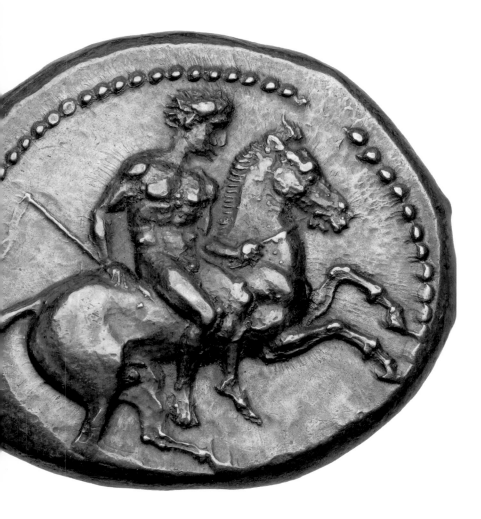

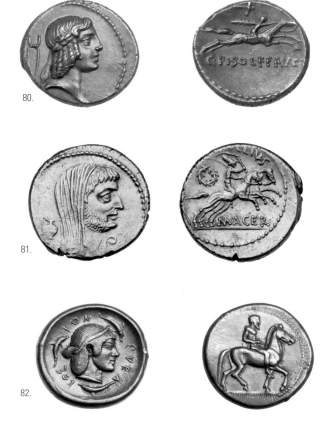

80.

81.

82.

79.

These coins (cat. nos. 79–82) illustrate the drama of horse racing, including a race in which the rider would dismount and run to the finish line alongside his horse (cat. no. 79) and others in which a rider would change horses on the fly (cat. nos. 81–82).

to an ode by Pindar to a victor from Cyrenaica at Delphi.[3] A bronze mug depicting chariot racers (cat. no. 86 and fig. 6) indicates that two pillars on the course marked the turns.

Like footraces, horse races required some type of starting mechanism. An inscription honoring the inventor Kleoitas uses the word *aphesis* for this apparatus, but its details have not been fully worked out or reconstructed. Probably some sort of rope barrier was placed in front of each contestant, and the contestants were arranged in staggered positions. In this way the spectators viewed the horses and chariots breaking out of their gates in stages. The takeoff was signaled by the blowing of a trumpet (cat. no. 75).

A charioteer drives his four-horse chariot (cat. no. 86).

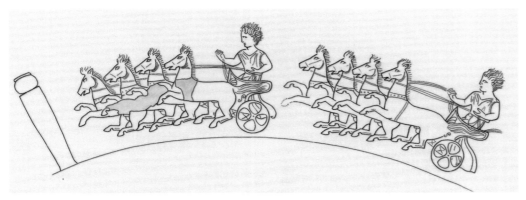

Fig. 6. This drawing based on cat. no. 86 illustrates two four-horse chariots approaching a finishing post with a prize dinos on top.

Made of bronze and bone, this is the only known example of a Greek trumpet (cat. no. 75).

113

| CHARIOT RACING

My ancestors and my brothers were kings of Sparta; I, Kyniska, won
the chariot race with my swift-footed horses and erected this statue.
I claim that of all Greeks I am the only woman to have won this crown.

— *Greek Anthology* 13.16

Actually, Kyniska won twice, in 396 and then again in 392 B.C.
Her wins prove that it was possible for a woman to be a victor—
but only by owning the chariot, as she was forbidden from racing
herself. This rare moment in the history of the Greek games also
makes very clear that the owners of the chariots were the victors.
Only the wealthiest families could afford to participate in the
equine events: chariot racing was the sport of kings. The most
famous of the chariot victors was Philip II of Macedon, father of
Alexander the Great, who seems to have had a victory in both a
chariot race and a horse race at Olympia in 356 B.C. Both events
are represented on the reverse of his coins minted in Pella: a gold
stater depicts a two-horse chariot race (cat. no. 92), and a silver
tetradrachm shows a jockey on a galloping horse holding a victo-
ry palm (cat. no. 78). The kings of Macedon considered Olympia
the capital of the Greek world, and victories there were a sure
path to fame and glory. The association of power, prestige, and
political clout with chariot racing is emphasized in Plutarch's
biography of Alkibiades. He entered seven teams (a record
number) in the chariot race at Olympia in 416 B.C., at his own
expense, to demonstrate Athenian power and to win the favor of
Athenian voters. Both Thucydides and Euripides confirm this
report. Sometimes communities pooled their resources to spon-
sor a chariot, as in the case of the people of Argos, who won two
chariot victories in 480 and 472 B.C.

Chariots drawn by four horses (called *tethrippon* in Greek)
were introduced to the Olympics in 680 B.C., and those drawn by
two horses (called *synoris* in Greek) were introduced in 408 B.C.
Mules were also used in the competitions but they went in and
out of fashion; a mule cart race was added to the Olympics in

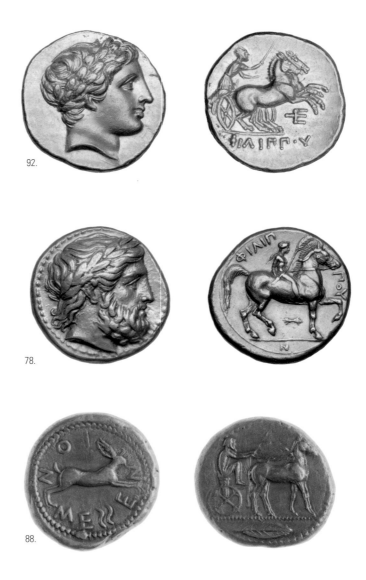

92.

78.

88.

Two of these coins publicize racing victories of Philip II of Macedon
(cat. nos. 92 and 78). On the lower coin, a seated charioteer drives a two-mule
chariot (cat. no. 88).

> Four chariots compete in a race (cat. no. 85).

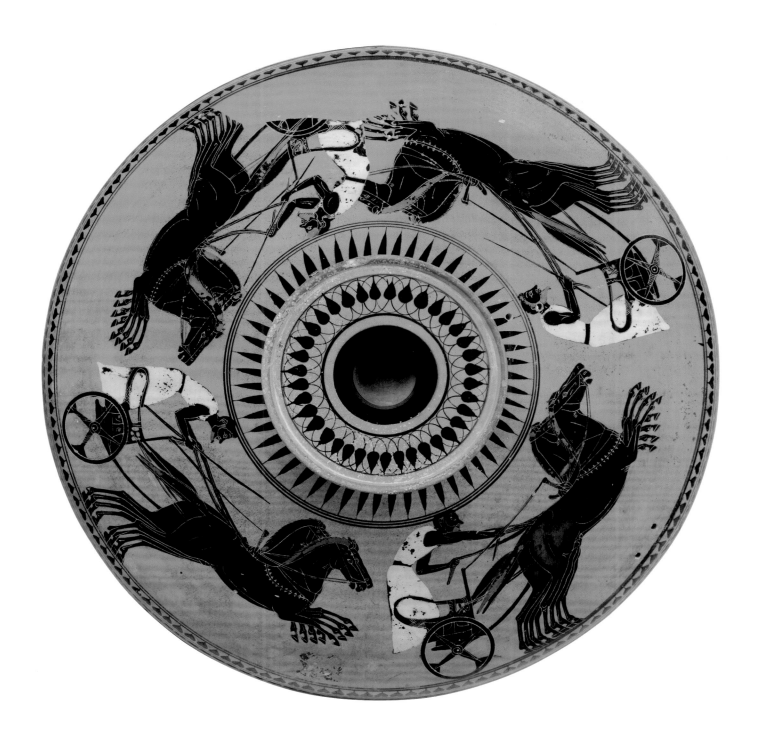

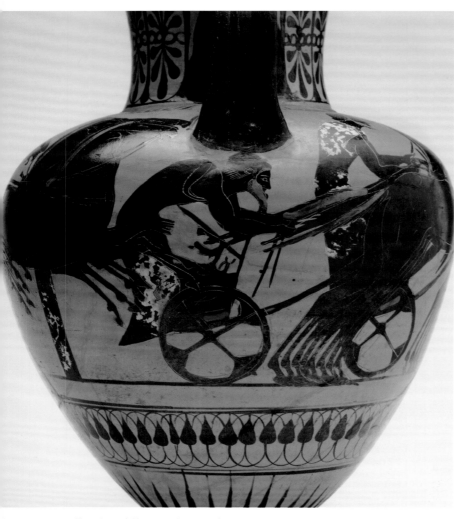

The painter of this vase made one charioteer stoop to pass under a handle (cat. no. 84).

500 B.C. but then dropped in 444 B.C. (cat. no. 88). The Athenians added their own variations to the equestrian events: the *apobates* was a ceremonial race involving armed nude men who ran alongside, entered, and dismounted from a moving chariot. The processions of chariots figured on the south and north friezes of the Parthenon represent this event by including a figure beside the charioteer who is nude but helmeted and carrying a round shield. Many of the depictions of charioteers show bearded men, and it would appear from the records of the winners and a rough account of their birth dates that older athletes could compete in equestrian events.[4] Homer provides the model of an elder horseman in Nestor, who passes on his strategies to charioteers for the funeral games of Patroklos.[5]

Charioteers are the only athletic contestants to wear a uniform, a long sleeveless tunic usually painted white on vase depictions (cat. nos. 84–85). They typically hold goads to control their horses. In the Roman period charioteers wore a harness of leather bands to protect their ribs (cat. no. 95). Depending on the artist, the long tunic is sometimes revealing and fitted to the form of the muscular athlete; for example, carved drapery hugs a young marble charioteer from Motya, Sicily, in a seductive manner (about 465 B.C.). A more detailed view of the costume of the profession is recorded on a sculpture known as the Delphi charioteer, who wears a tunic belted above the waist and fastened down by a band running over each shoulder and behind his neck to keep the garment from blowing about during the race. A vivid visual memorial to the dignity and control of the charioteer, this life-size bronze from Delphi belonged to a monumental sculptural group that included horses, a chariot, and a groom, which stood within the sanctuary area of Apollo at Delphi. It was dedicated by Polyzalos, tyrant of Gela in Sicily, after a victory at the Pythian Games (about 478 or 474 B.C.). Perhaps it is Polyzalos, the owner of the chariot, who is represented in the statue, probably in a victory procession as the owners did not typically race their own chariots.

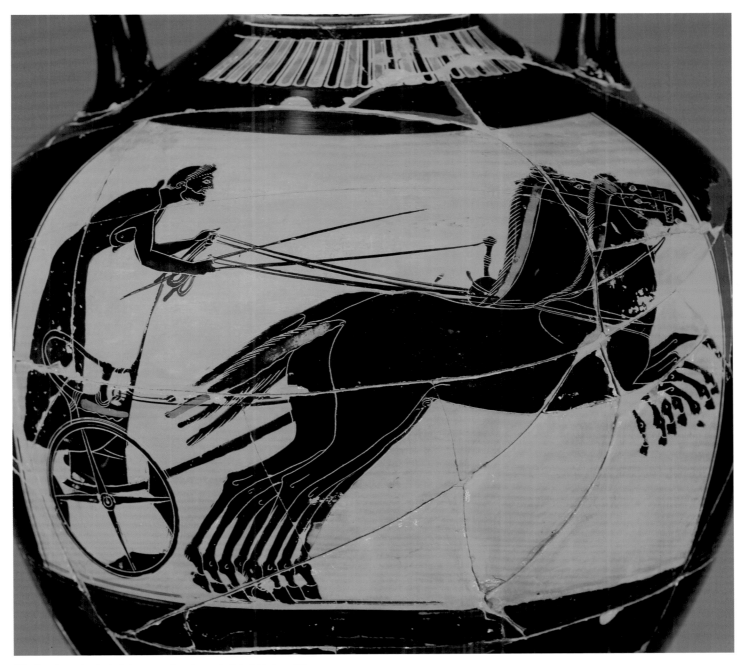

This view shows the simple, light construction of an ancient chariot (cat. no. 83).

117

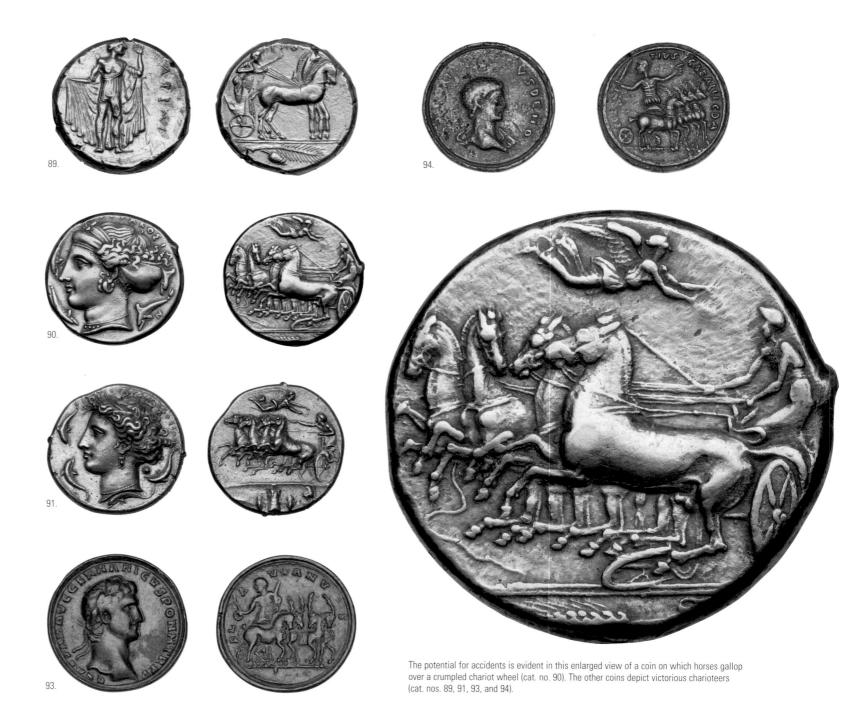

89.

90.

91.

93.

94.

The potential for accidents is evident in this enlarged view of a coin on which horses gallop over a crumpled chariot wheel (cat. no. 90). The other coins depict victorious charioteers (cat. nos. 89, 91, 93, and 94).

The hazards of chariot racing are featured in the founding myths of the Olympic Games in the legend of the treacherous victory of Pelops against King Oinomaos, whose chariot was sabotaged by the suitor of his daughter, Hippodameia. Scenes of chariots losing a wheel inspired the designs on ancient coins (cat. no. 90). Similarly, an insight into the dangers of the racecourse is graphically given by the messenger speech found in Sophocles's *Electra*, written about 415 B.C. Electra's brother, Orestes, contrives a plot wherein his old slave/tutor must relate his death to those in the palace. The tutor performs as instructed and reports that Orestes was the crown winner of the pentathlon at the Delphic Games. He goes on to say that the very next day Orestes competed in the chariot races (from which we can infer the order of events at these games). The drivers of the ten chariots running the course included men from Achaea, Cyrenaica, and Sparta. The tutor's speech gives a vivid account of these races. At the sound of the trumpet, the course was filled with the crash of rattling chariots and dust. "And Orestes, keeping his horses near the pillar at the end, each time grazed the post, and giving his right-hand trace-horse room he tried to block off his pursuer."[6] But soon the whole plain was filled with the wreckage of crashed chariots, and only Orestes and an Athenian driver were left racing neck and neck. The tutor closes the tragedy with the unfortunate Orestes hitting the edge of the turning post and breaking the axle of his wheel. He became entangled in the leather reins and fell to the ground. While the story ends on a tragic note, albeit a false one, it is precisely this sense of drama that captivated fans of chariot racing for hundreds of years.

This Roman charioteer wears a protective leather harness (cat. no. 95).

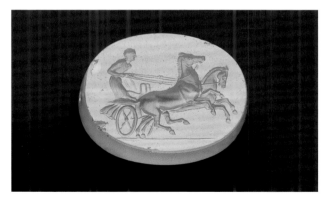

The charioteer on this gem maneuvers a two-horse chariot around a corner (cat. no. 87).

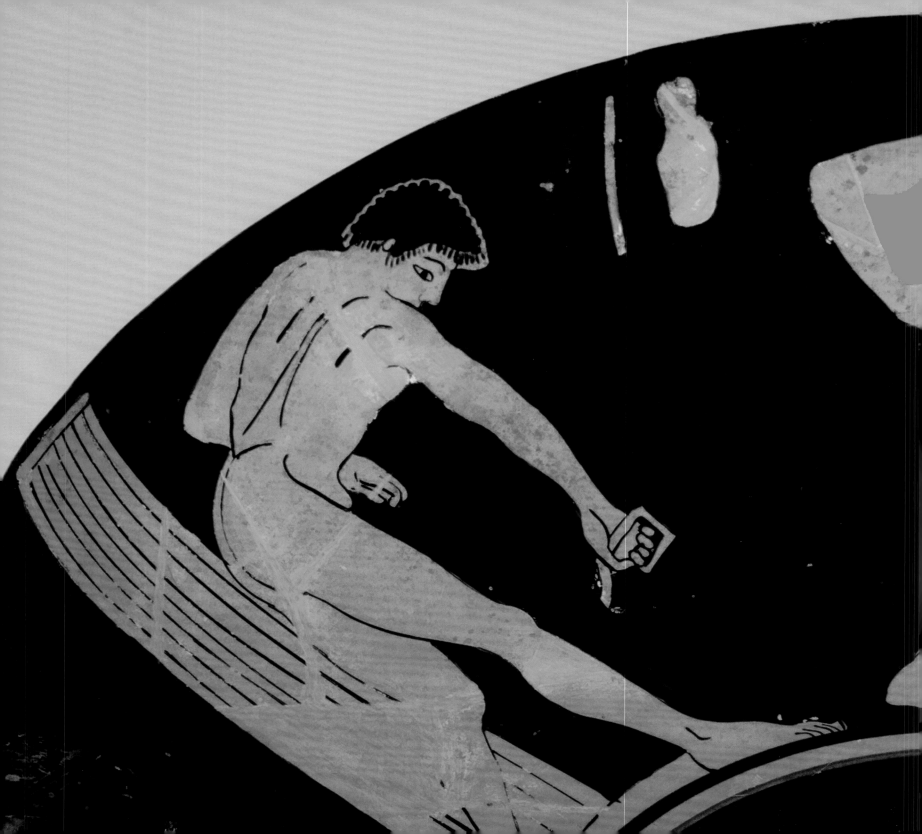

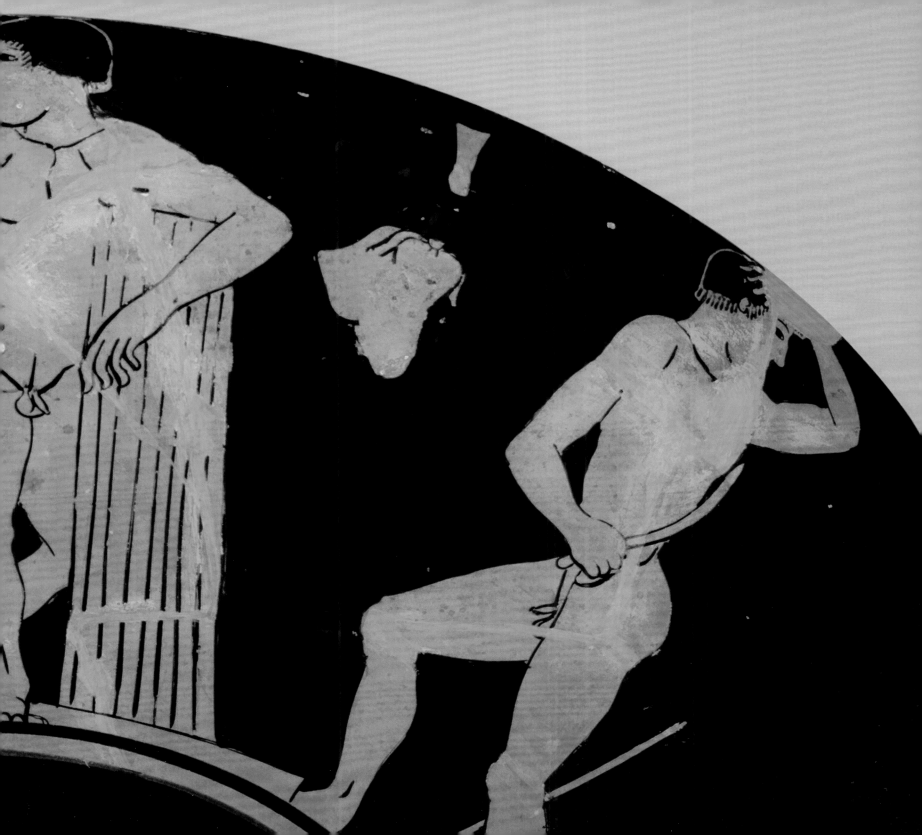

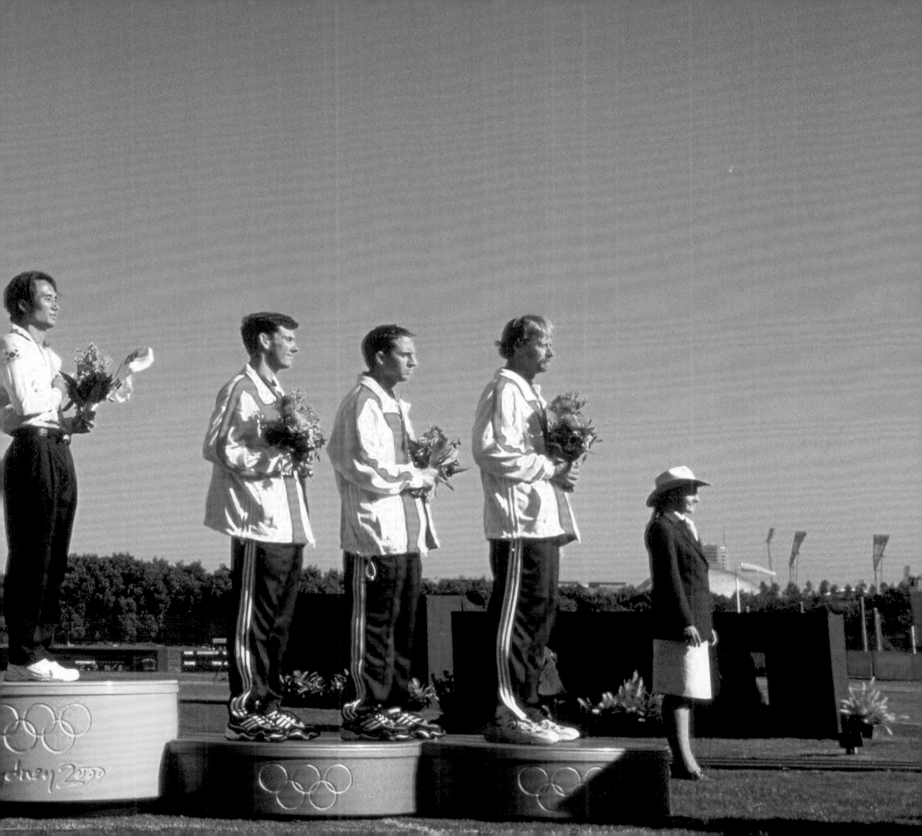

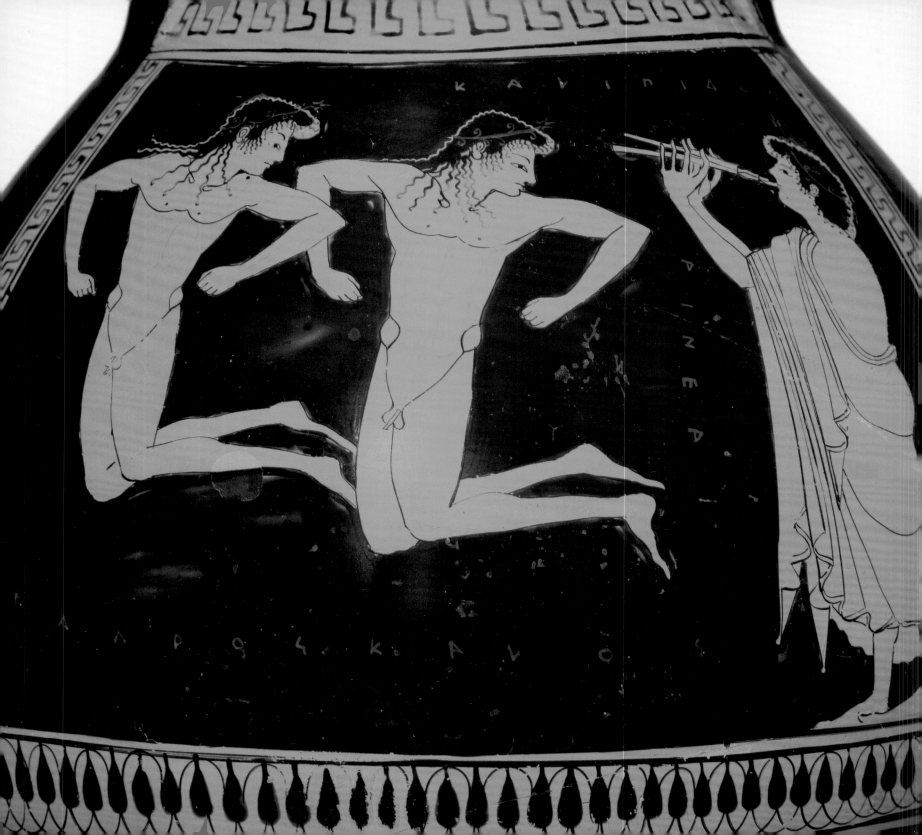

Dialogue between Hippothales and Sokrates:
We pass our time here, we and many other beautiful boys....
[Sokrates asks] What is this place? [Hippothales responds] It is a
palaistra, recently built, and we pass our time in discussions which
we would be glad to share with you.

—Plato *Lysis* 203a

This exchange between Sokrates and his young friend
Hippothales contains the essence of Greek athletics: the body,
the beautiful, and the mind. These elements came together in the
structure of the gymnasion. The athletic complex, usually com-
posed of the gymnasion and the palaistra, was a feature in all
Greek cities worthy of the title polis. It was as basic as the theater,
agora, and government offices for the proper functioning of a
Greek city. The name gymnasion derives from the Greek word
gymnos, or "naked," as this was where the young men performed
their exercises in the nude. The term palaistra derives from the
Greek word *palaio,* or "to wrestle," and indeed this was where
training in combat and jumping events took place. It seems,
though, that the Greeks used the terms palaistra and gymnasion
somewhat interchangeably. Participation in the activities at these
facilities was the key experience for young sons of the elite. Here,
their bodies and minds were engaged, for aside from being train-
ing grounds for athletic exercise and competition, gymnasia were
sites for lessons in philosophy and music. It was here that male
youths made their transition to manhood: boys as young as
twelve, called paides, could attend and continue as epheboi, or
beardless adolescents, and finally as young men into their mid-

twenties. This nexus of intellectual activities in an athletic facility
became the core of the Greek educational system, and that sys-
tem provided inspiration for European academic high schools,
which, out of respect for their model, are called "gymnasia."

Although the ancient texts often mention the great gymnasia
in Athens (the Lyceum, the Academy, and the Kynosarges), they
do not help archaeologists to locate these sites geographically.
They do, however, provide us with insights into how these
spaces were used and by whom. The texts refer to lecture halls,
or recesses with benches, called exedra, where orators and
philosophers met with pupils. Pseudo-portraits of the great
minds of the age probably adorned these spaces and inspired dis-
cussions based on their philosophical schools (cat. nos. 126–27).
The names of Sokrates and Plato, in particular, are closely associ-
ated with the palaistra. Music lessons were also part of the cur-
riculum of the Greek gymnasion, as illustrated on a small cup
(cat. no. 128) on which a young nude boy holding a strigil and
aryballos—designating his athlete status—is engaged in a lyre
lesson with a seated, bearded man. Athletes worked out to the
rhythms of the double-flute, or aulos. A storage jar elegantly illus-
trates this practice, depicting two youths jumping in what might
be an exercise routine; they look attentively toward the flute play-
er as if to underscore their dependence on his lead (cat. no. 129).
On another storage jar an athlete holds exercise weights and
moves to the rhythms of the flute player behind him (cat. no.
130). Plato informs us, again in his dialogue *Lysis,* that the boys
at the palaistra performed sacrifices and sacred rites before they
began to engage in their games of leisure. Like the contests them-

< Two young athletes jump to the rhythm provided by a flute player (cat. no. 129).

This marble head is probably a likeness of the philosopher Demokritos (cat. no. 127).

Sokrates probably held philosophical discussions in and around the palaistra and gymnasion (cat. no. 126).

selves, then, the daily routines at the exercise grounds were accompanied by pious acts in honor of the gods.

Many palaistrai were privately funded, and their facilities were open only to members. A Greek inscription found in a niche at the Hellenistic gymnasion at Melos cites Bacchios as an officer, or gymnasiarch, who dedicated the exedra and the statue to Hermes and Herakles. From this Roman-period inscription we can deduce that wealthy citizens underwrote the expenses of building and furnishing athletic facilities. Scholars agree that the gymnasion-palaistra complex at Olympia was used only by the competitors. When the athletes arrived from their various hometowns or other games, they were invited to train there for a maxi-

mum of five days. As the Olympic Games were held every four years, competitors did not have much time to prepare at the site; they must have practiced hard at the sports centers in other cities. This was not always easy, and it seems that at least in the early years, athletes needed considerable family funding to be properly instructed. Later, in the fourth century B.C., there is evidence of state funds to support individual training for athletes.

Several types of athletic trainers existed. Those who taught the specific athletic skills necessary for competition, such as the wrestling moves, were called *gymnotribai*. Wealthier athletes might hire a personal trainer; these men were considered the equals of the paidotribai, or those responsible for the intellectual

education of youths. Medically skilled trainers called *gymnastes* applied massage and diet therapies to cure ailments. Olympians had to swear that they had been in training for ten months, and for one month before the games they could use the gymnasion complex in nearby Elis, the host city of the Olympic festivals. The physical aspects of this old gymnasion are described by the second-century travel writer Pausanias.[1] He also informs us that the priestly judges, or Hellanodikai, went to Elis to learn the rules and their duties for the festival. These judges watched over the athletes as they trained, exercised their authority with whipping sticks, and carefully matched opponents, determining who was worthy of the competitions.

Athletic training could include various diets as well as exercise routines. For example, the athletes from Kroton in southern Italy relied heavily on meat as a source of strength, while others promoted the value of beans, although noting the unwanted side effects. Ancient manuals of health such as Galen's treatise *Is Health the Concern of Medicine or Athletics?* and exercise manuals such as Philostratos's *On Athletics* reflect the variety of training regimes and concerns. Philostratos, who sets out to introduce the science of athletics as a combination of medicine and physical education, includes sections dealing with treatments for athletes who have overeaten, drunk too much, had sexual intercourse, or are apprehensive. Typical of the sort of information he offers, he bemoans the introduction of Sicilian-style fancy foods (perhaps meats?) that took the "guts out of athletics" and made the contestants lazy.

The precincts of the gymnasia also provided a setting for liaisons between young men and their elders in which devotion to the body, athletic competition, and philosophy met on common ground. A sixth-century poem by Theognis of Megara proclaims: "Happy is the lover who after spending time in the gymnasion goes home to sleep all day long with a beautiful young man."[2] Scenes of young boys serving men at the drinking and feasting of *symposia* abound on Greek vases and remind us that this was a deeply rooted tradition in Greek society of the sixth and fifth centuries B.C. Images of physical affection between older

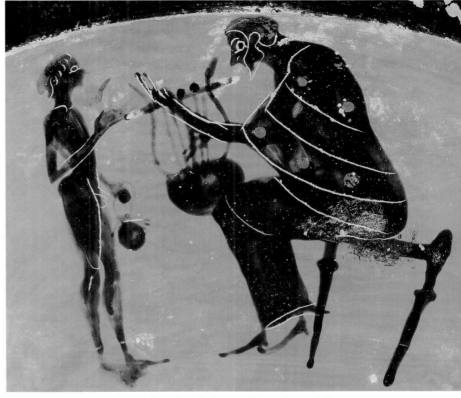

A young athlete, identified by his aryballos and strigil, takes a music lesson (cat. no. 128).

bearded men, often shown draped, and younger males are also fairly common and are understood to represent courtship scenes (fig. 7). They are emblematic of a complicated tradition of pederasty that was condoned by the state and by parents. In his *Symposion* Plato is explicit about the relationships that existed between men and boys, when Alkibiades challenges Sokrates to a wrestling match in the hope that he might thus seduce him. To interpret such scenes or texts within the constructs of modern sexuality is problematic and anachronistic. The difference in status between the lover and the beloved—for instance, a younger and an older man or a citizen and a noncitizen—seems to be at the core of the pederastic experience. In his account of his attraction to

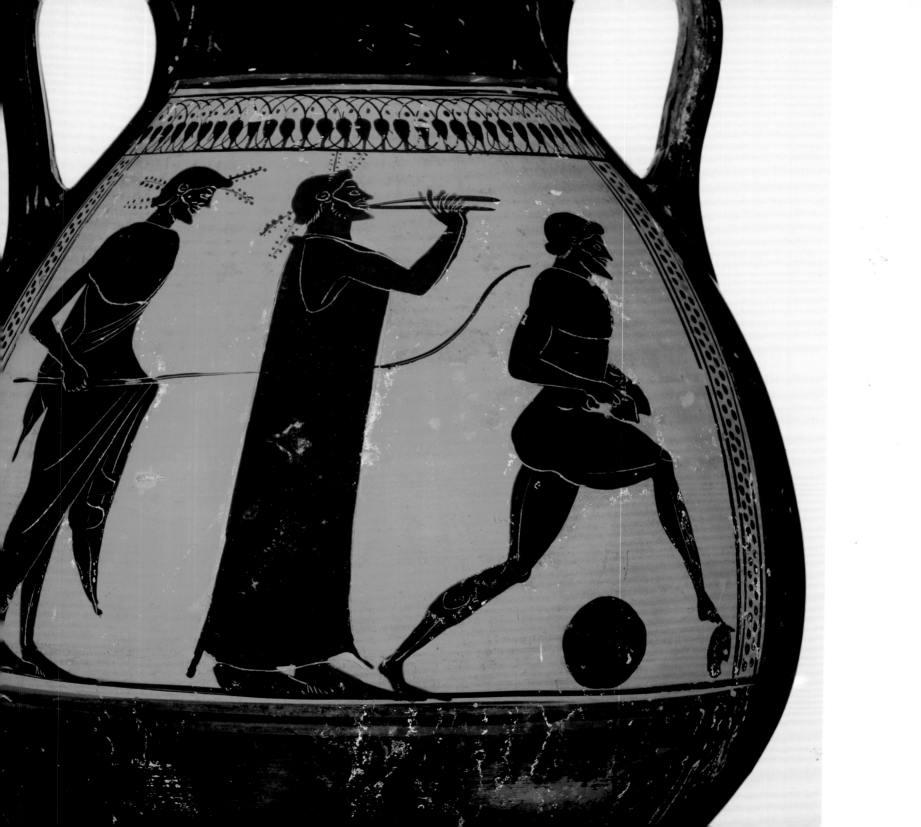

Sokrates, Alkibiades makes it clear that he is seeking an intellectual mentor. His desire for Sokrates must be framed within the ideal of self-improvement, accomplished through bonds with one of a socially higher position or of greater brilliance. In this context young Greek men engaged in physical and mental exercises under the supervision of their superiors. The ideal of love between men seems to have functioned as a means for the young men to make the transition into sexual maturity under the guidance of older men.[3]

Ancient texts, however, contain some ambiguity about this aspect of gymnasion culture. One of the laws of the sixth-century archon and lawgiver Solon forbade trainers from opening the palaistra before sunrise and required them to close it at sunset, for fear that their young charges would be vulnerable to unwanted attentions from older males—in other words, unsupervised pederastic activities. The existence of the law indicates a concern about pederasty, especially around the gymnasion, among the citizens of Athens. It seems, though, that relationships between older and younger men were accepted if they were under the watchful eyes of teachers and trainers in the gymnasion or during the supervised social environment of the symposion.

Many Greek texts refer to the benefits of chasteness for athletes. Self-control and moderation, nothing in excess, were valued in Greek society. The fact that men robed and disrobed within plain sight of one another is clear from Plato, who describes Sokrates standing within the *apodyterion* ("undressing room") and eyeing those who entered the palaistra.[4] Physical control over one's body was implied by this daily routine and by athletic exertions in the nude. Infibulation, which is the drawing up of the foreskin of the penis with a cord, is represented in a number of vase paintings and even in Etruscan tomb paintings. Although it is unlikely that this practice was common, it does indicate a level of sexual abstinence that is underscored in textual references to athletes and their trainers, who believed that sexual encounters deprived them of the vigor of body necessary for successful competition. Plato mentions that a famous pentathlete victor of the

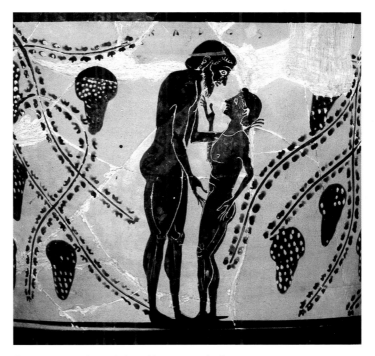

Fig. 7. A mature athlete and a boy athlete caress each other.

mid-fifth century B.C., Ikkos of Taras, was said never to have touched a woman or a boy while in training, despite his strong sexual drive.[5]

| LAYOUT AND STATUARY

To have a palaistra you must build a peristyle, either square or oblong, which will furnish a walk around it of two stades, a distance which the Greeks call a diaulos. Three sides of this peristyle should have a portico with a single row of columns, but the south side should be two rows deep, so when the wind blows in bad weather the rain will not drive in.

—Vitruvius *On Architecture* 5.11

< A trainer watches while an athlete exercises to flute music (cat. no. 130).

129

A young athlete with weights slung over his shoulder stands next to a punching bag (cat. no. 100).

tangular peristyle court with colonnades on all sides. The length of the colonnades corresponds to the measurement of a footrace, approximately 180 meters (200 yards). The Roman architect Vitruvius, writing about 28 B.C., mentions paths and walks, groves and plane trees, open-air tracks and covered running tracks. At Olympia the gymnasion contained a running track that was the same distance as the track in the stadium itself. Moreover, sills for the runners like those found in the stadium have been uncovered at each end of the colonnade. We can easily imagine athletes running from end to end and cooling off in the shade of the colonnades. The courtyard was large enough to fit other running tracks and areas where competitors could practice discus and javelin throwing. As in the stadium, the athletes maintained the leveled earth floor in the gymnasion and palaistra with pick-axes. Greek vase painters favored scenes of athletes practicing in the palaistra with their equipment (for instance, discus bags, javelins, and picks) hanging on the back wall, usually set between columns, and with trainers nearby to coach them (see, for example, cat. no. 30, p. 84).

At Olympia the palaistra was located next to the gymnasion. Thanks to the writings of Vitruvius we have a description of a typical palaistra, probably of Hellenistic date. (He specifically notes that the palaistra was not common in his own country, Italy.) Opening off the courtyard of the palaistra was a series of rooms that Vitruvius assigns to different functions. At Olympia nineteen rooms have been found—most with built-in benches—that must have been used for practice during bad weather. Vitruvius mentions rooms with specialized uses such as an exercise room with a punching bag. When viewing a statue such as the one seen here (cat. no. 100), we can well imagine a young boy standing in a relaxed pose beside a punching bag in such a workout space, holding weights over his shoulder. The sculpture is a replica of a popular image in antiquity that vividly evokes the words of Lucian: "When we arrived at the gymnasion, we removed our clothing . . . [then we] battered away at the sandbag; still another shadowboxed with lead weights in his hands."[6]

Scholars have been able to piece together written descriptions and physical evidence to approximate the layout of the athletic facilities. In the earliest phases, during the sixth century B.C., the gymnasia were probably large outdoor areas with running facilities that were set off from the city centers and protected by walls. The archaeological evidence from Olympia, Delphi, Delos, and, beyond the Greek mainland, Pergamon and Priene (in southwestern Asia Minor) indicates a general plan of a large square or rec-

> An athlete arrives still dressed at the gymnasion and stands with his javelin between a washbasin and a starting post (cat. no. 37).

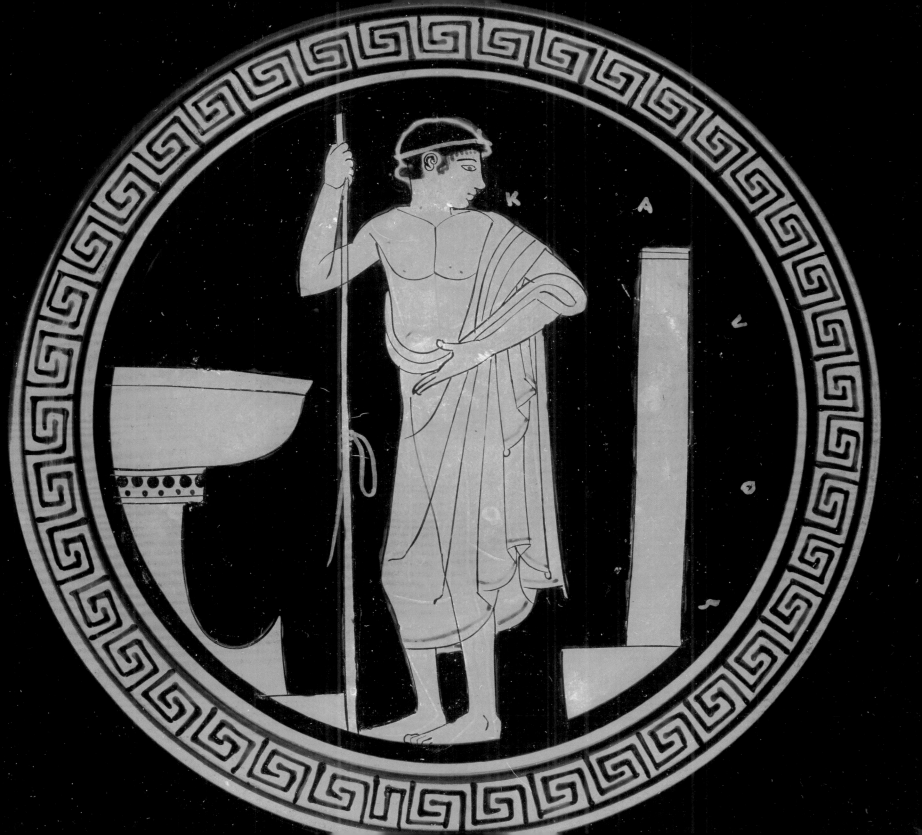

After oiling himself, an athlete sprinkles sand on his skin (cat. no. 114).

A metal oil scraper, or strigil, is the most common attribute of the ancient Greek athlete (cat. nos. 118–20).

Other types of rooms found in the Olympian palaistra were intended for grooming and preparations. Some were side rooms with basins and lavatories (cat. no. 37). The inventory of the athletic building on the island of Delos records three elevated tubs, ten tubs on the floor, and a stool as the contents of the *loutron*, or bathing area. Vitruvius itemizes oiling and powdering rooms for wrestlers. The oiling of the body was a key ritual in preparing for all nude exercise and competition. As Philostratos urges in his treatise *On Gymnastics* 18 (A.D. 230): "It is necessary that the athlete in the palaistra at Olympia be dusted and sunburned; in order that . . . [he] not ruin his condition. The *stlengis* reminds the athlete of oil and that he should apply it so liberally that it can be scraped off easily."[7] Precious olive oil was used as a skin conditioner; advocates made the analogy to the treatment of leather. Dust or sand was then poured over the body (cat. no. 114). Its presumed benefits were to inhibit sweating, thereby retaining strength, and to protect the body from the effects of wind on the open pores. After exercising, the athletes stripped off the oily, dirty, sweaty, and often bloody mess using a metal scraper—called a stlengis in Greek, but better known by its Latin name, strigil

(cat. nos. 118–20). The oils were kept in long alabastra or small round aryballoi, which have been found in glass, bronze, and ceramic versions (cat. nos. 105–13). Athletes typically carried these from a strap wrapped around their wrists (cat. no. 115, p. 138). That this was masculine apparatus is made clear in a ceramic version shaped as a phallus (cat. no. 108).

As distasteful and smelly as these hygenic operations might have been, they were a popular subject for vase painters of the fifth century (cat. nos. 117 and 131) and sculptors of the fourth century B.C., and these images were multiplied far into Roman times. Greek vases show a variety of disrobing scenes with grooming paraphernalia such as sponges, oil jars, and scrapers hanging on the back wall (cat. no. 103, p. 139). In one such scene a javelin thrower has just cleaned his arm and a dog waits below for a few drops to fall (cat. no. 121, p. 139). Similarly, some of the most famous sculptures of athletes show an idealized youth after competition about to scrape the dirt and oil off his body (cat. nos. 122, pp. 136 and 161, and 124, p. 163).

Inventories, inscriptions, and texts inform us about the types of sculptures that could be found in gymnasia: namely, statues of

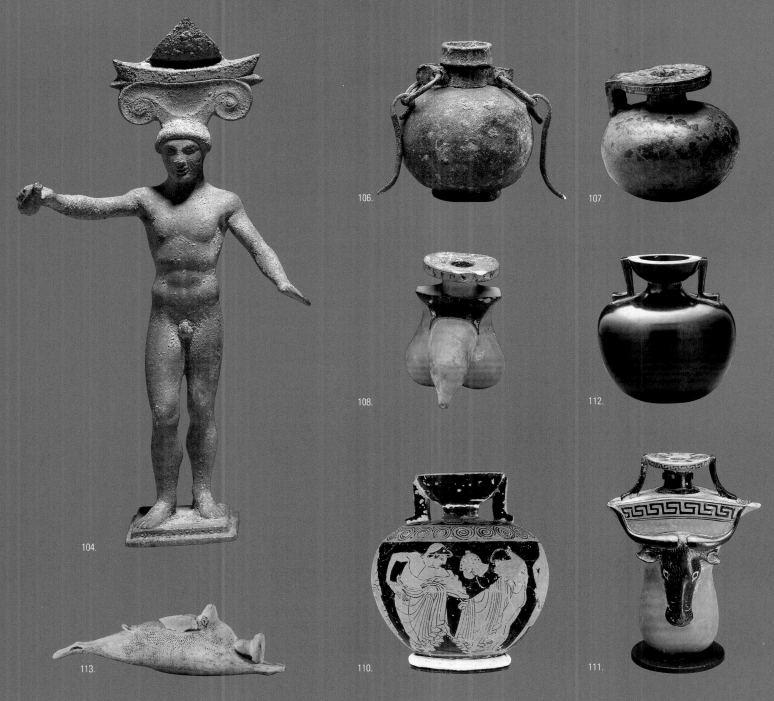

This athlete is about to pour oil from his oil flask onto his skin (cat. no. 104).

This alabastron—an elongated oil flask—is shaped like a hare (cat. no. 113).

Oil flasks were often spherical aryballoi, but they came in many different shapes, sizes, and materials (cat. nos. 106–8 and 110–12).

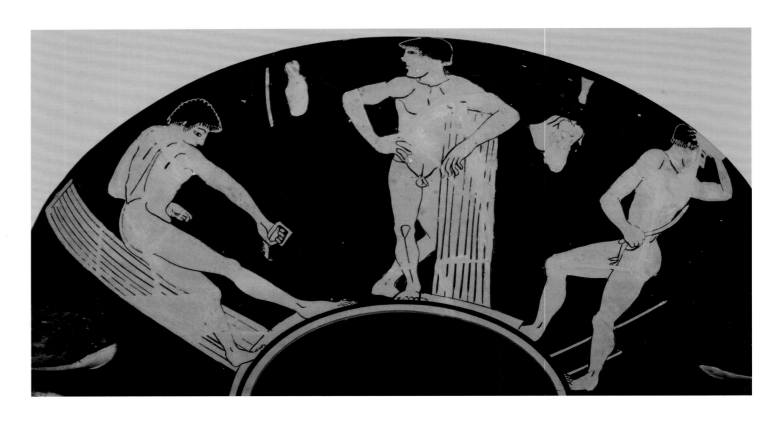

On this drinking cup, athletes relax and clean up after exercising (cat. no. 117, three views).

134

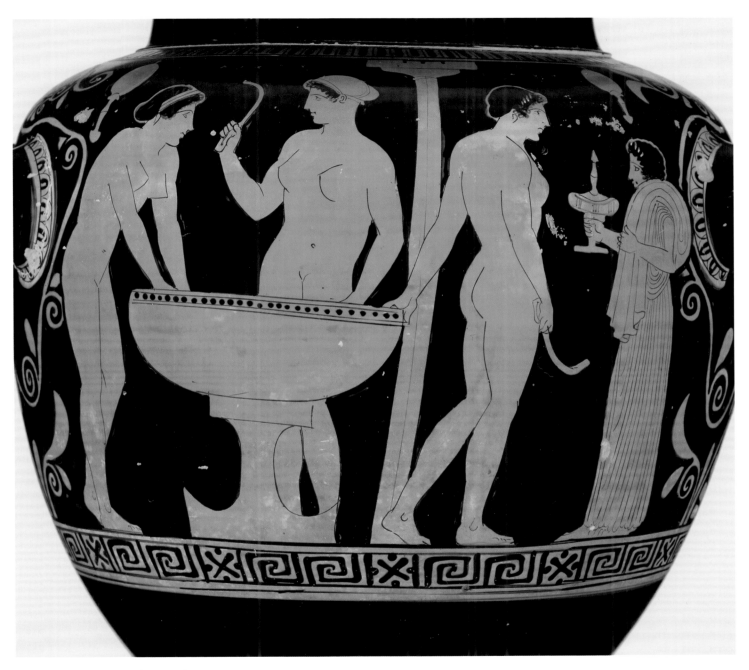

Three girls bathe after exercising (cat. no. 131).

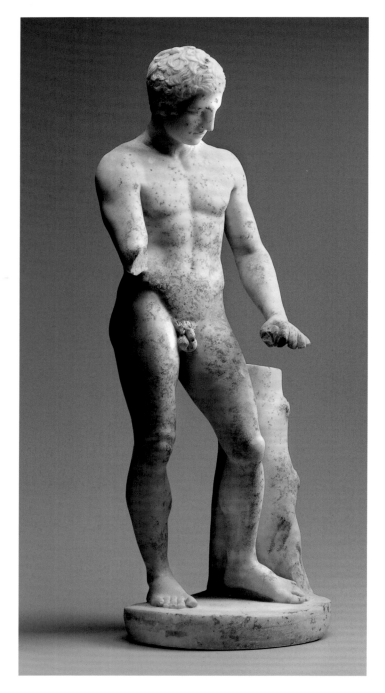

∧ This athlete holds a strigil in his left hand but is clothed, indicating that he has probably finished bathing (cat. no. 125).

< This athlete's pose suggests he was cleaning a strigil held in his right hand (cat. no. 122).

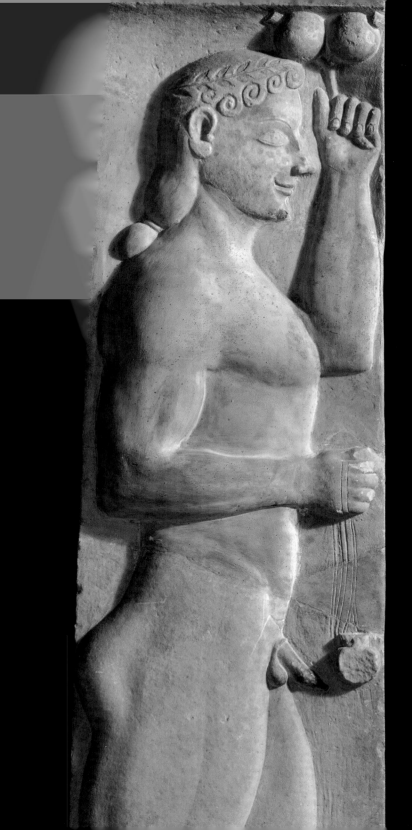

divinities, portraits of benefactors and teachers, and sculptures of athletes and athletic victors. These were in addition to dedications by victors, such as torches from torch racers and shields from hoplitodromos runners. The impressive array of bronze and marble sculptures that adorned the gymnasion-palaistra complexes of the Greek and Roman cities made them into a kind of civic art space. The themes of these sculptures and other artworks express the values of the gymnasion. For example, at Melos a statue of a boxer and the celebrated statue of Aphrodite of Melos were found near each other; statues of Aphrodite began to appear in gymnasia during the Hellenistic period, suggesting that young men were in her sphere of marital and familial love, as well as that of her son Eros (the god of desire, who was often associated with male relationships), during their education.

Of the divine presences in athletic complexes, the triad of Hermes, Herakles, and Eros were predominant. Herms—busts set up on pillars—of Hermes (cat. no. 98, p. 142) and Herakles were most common; the two gods could be either bearded or unbearded. A small temple to Herakles and Hermes stood in a gymnasium at Pergamon. While the significance of Herakles to athletics is made clear in the ancient sources, Hermes's association with athletes is less direct; very few myths or anecdotes are recorded to support it. He was the messenger of Zeus, a role that cast him as swift and energetic. His image frequently appears on herms protecting passageways in and out of buildings and roadways in and out of towns, indicating his association with commerce and transitions, both literal and metaphorical. In the context of Greek gymnasia he may well have been the guardian of the transition from boyhood to manhood. The absence of a torso, arms, and legs on the stone herms stand in stark contrast to the idealized action figures immortalized by Greek sculptors. However, unlike Herakles, it was not Hermes's fighting power that was valued but his cleverness. In addition, a very early legend about the Olympic Games names Hermes as the father of Pelops—the founder of the Olympic Games and center of a cult there. He is also believed to be the first to teach wrestling to mortals through his daughter, Palaistra.[8] Whether because of his

< A funerary marker shows the deceased as an athlete: he wears an olive wreath and carries an aryballos and pomegranates (cat. no. 115).

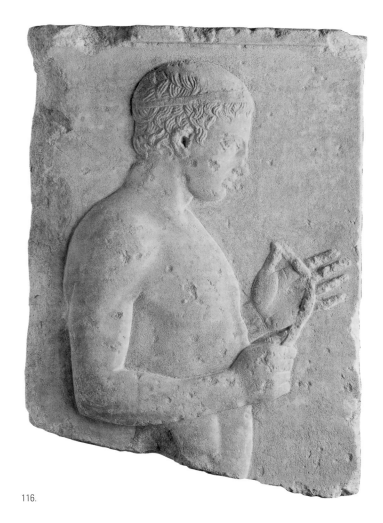

116.

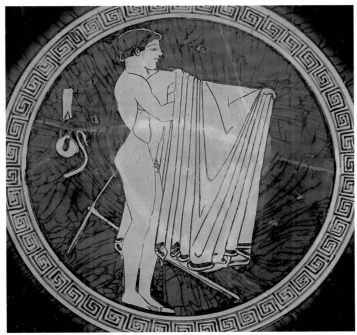

103.

121.

This funerary monument depicts an athlete wearing a ribbon and carrying a strigil (cat. no. 116).

After bathing, this athlete dresses; his toilet kit hangs on the wall behind him (cat. no. 103).

Another athlete offers the scrapings from his strigil to a dog (cat. no. 121).

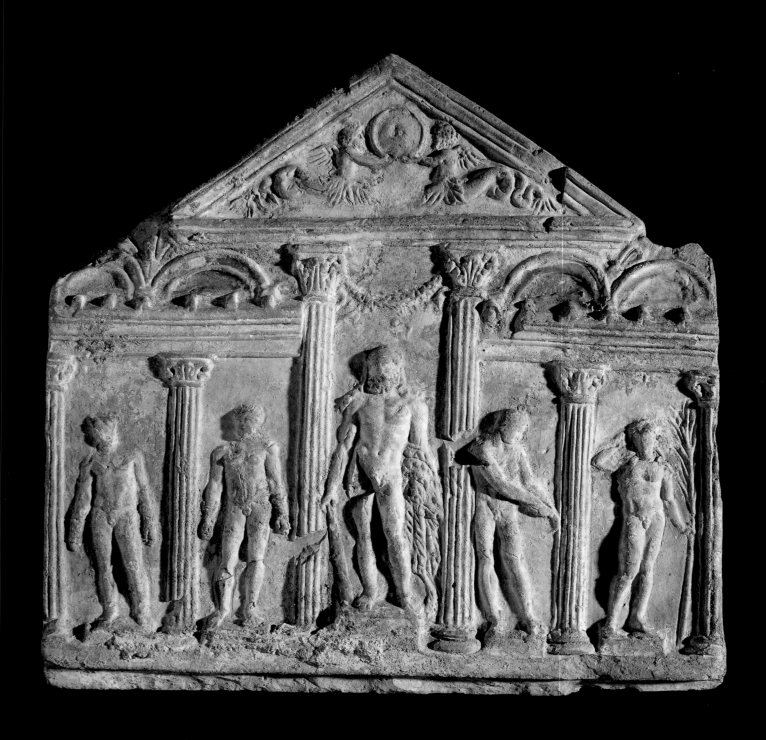

Boxers and other athletes flank a statue of Herakles in a palaistra setting (cat. no. 97).

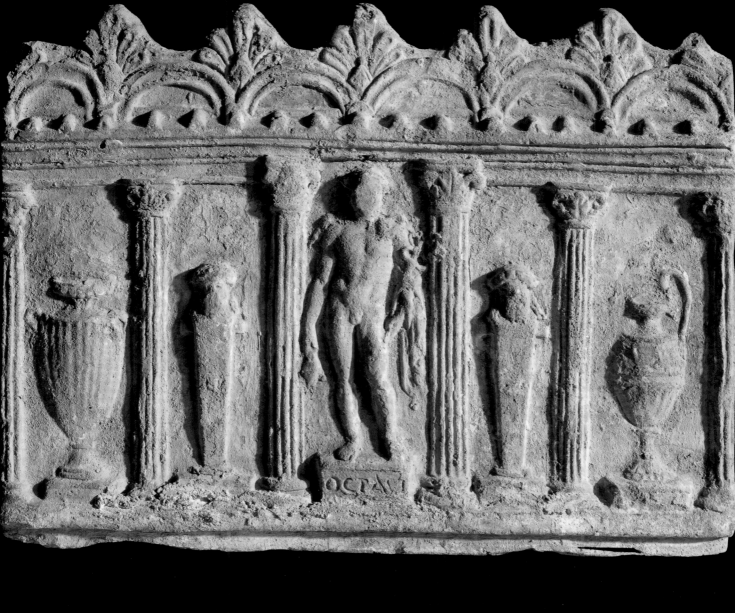

This palaistra scene shows a statue of Hermes surrounded by herms and prize vases (cat. no. 96).

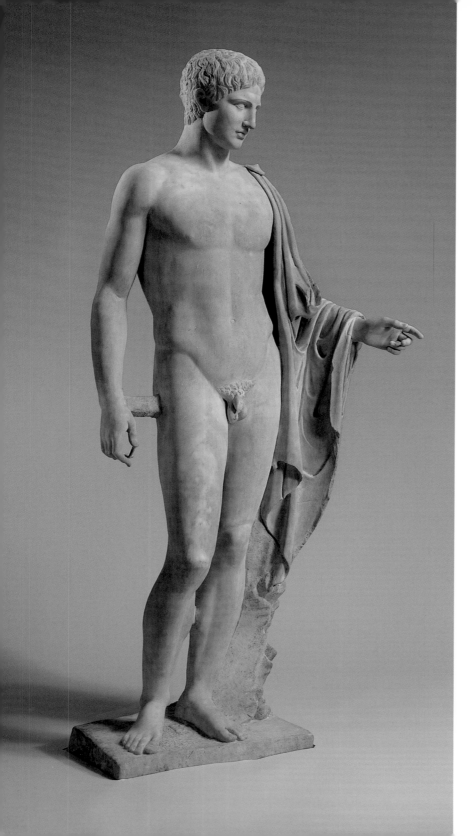

Busts of Hermes topping a shaft were often set up in gymnasia and palaistrai (cat. no. 98).

shrewdness, his skill in wrestling, or his role as a guardian spirit, Hermes was ever present in the gymnasion.

A visual clue to how statues of Hermes and other gods were displayed in the palaistra is offered by a Roman terracotta plaque of the early Imperial period, which is adorned with a statue of Hermes upon a pedestal in the middle of a colonnade flanked by bearded herms and prize vases (cat. no. 96). Another plaque from the same group features Herakles at its center standing in a gabled, templelike structure. To the sides, four statues of nude athletes stand on low pedestals amid colonnades: two are boxers with gloves, another holds a strigil, and another carries a palm branch to denote victory (cat. no. 97). This large group of plaques, called the Campana plaques, could have served as wall decorations for Roman palaistrai, reflecting continuity with the Greek cults.

< Hermes was admired for his cleverness and for his role as a teacher and guardian (cat. no. 99).

Eros was also very popular in the realm of the gymnasion (cat. no. 21).⁹ The cult of Eros was a key factor in the socialization of aristocratic Greek youths that occurred within the perimeter of the gymnasion-palaistra complex. Eros was the mythical and religious force operating in the physical engagements, friendly partnerships, mentoring relations, and genuine affections that were part of the daily experience of these young men. His title on some sculptures and inscriptions appears as "Eros Enagonios," or "he who presides over contests." Aside from overseeing the development of friendly relations among the athletes in training, he was also celebrated as a wrestler—an odd role for this youthful divinity of diminutive size. One sculpture type shows Eros with the topknot of a wrestler, referring to his role as expert combatant. He was also portrayed stealing the attributes of Herakles, his club and lion skin: the Delian inventory states that an approximately sixty-centimeter-high (two-foot) statue of Eros holding a lion skin and a club was set upon a column at the entrance of the gymnasion at Delos. While there is no literary source or myth that accounts for this artistic invention, the composition must have served as an allegory for the triumph of love and desire over the physical strength of Herakles—an inventive leap for the artists and one that reflected the belief in the power of Eros. No doubt, there was also an element of playfulness in the conception of the type, and it must have amused Greek viewers to see tiny, tender Eros beside the huge, muscular Herakles.

Eros was properly acknowledged as a deity through sacrifices and other rites. Sometimes, as in Athens, races might start and end at the altars of Eros. Moreover, victors were themselves imbued with the power of Eros, as they were much admired in their new heroic status. In the words of one ancient writer, when the cults of Eros, Hermes, and Herakles were "united, friendship and concord come about, out of which the fairest freedom is enhanced for those who pursue them."¹⁰ The ideals of the Greek state, its civic values, were taught to youths as they shaped their bodies for the contests in honor of their gods. Eros was present to insure that friendly, communal feelings were fostered along with physical prowess and strategy.

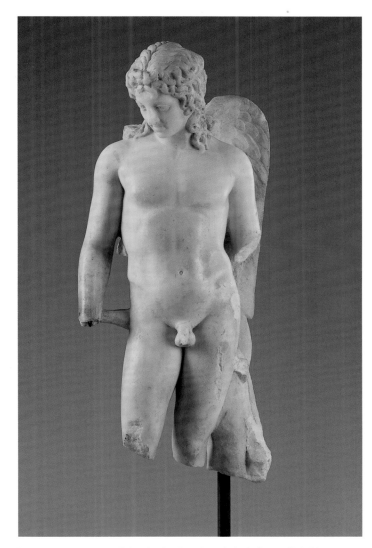

Eros, shown here as a beautiful youth, played a variety of roles in Greek athletic life (cat. no. 21).

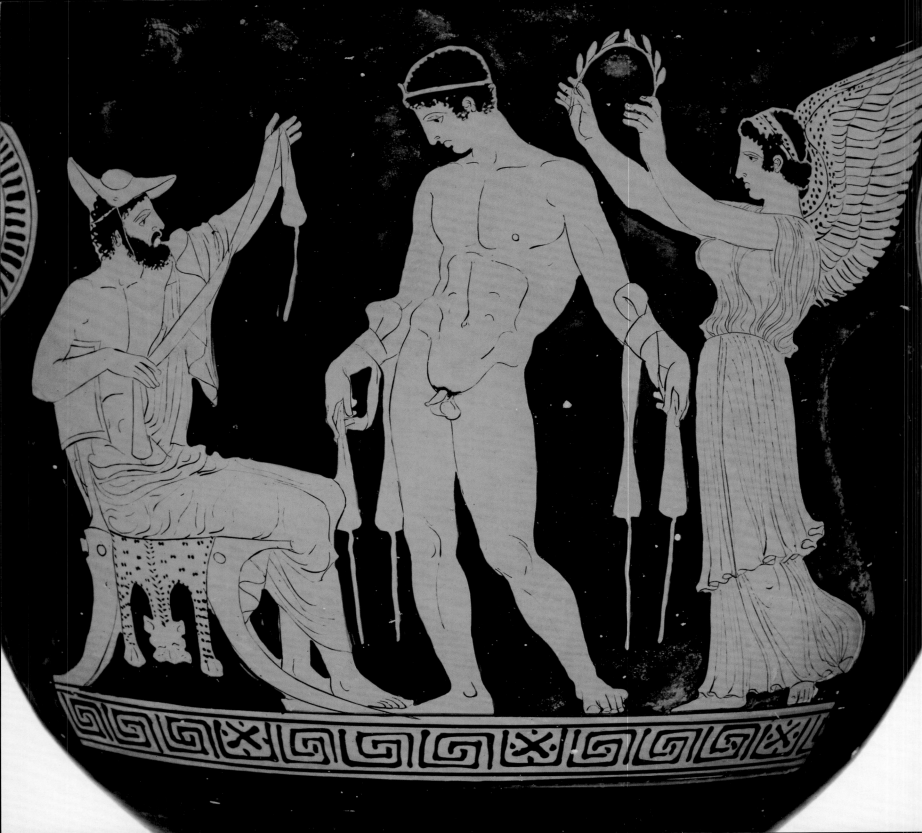

THE VICTORS

A nd in athletic contests, someone who has wreathed his hair with many garlands has achieved longed-for fame, when he has been victorious with his hands or with the swiftness of his feet.

— Pindar *Isthmian Ode* 5.9–12

| COMPETITORS AND PRIZES

The ancient Greeks are often thought of as a competitive people who expressed their cultural values through contests, or *agones*.[1] This characterization is supported by the fact that there were many contests, in addition to those for athletics, including ones for dramatists, poets, musicians, dancers, potters, and sculptors. In Athens male citizens even competed in a type of beauty contest called euandria that tested their physical fitness and stamina. The agonistic spirit permeated many aspects of life, and those with the skill and good fortune to become victors were a living embodiment of arete—excellence and virtue. Recognition by their fellow citizens at home and abroad brought glory and fame to victors and their hometowns. The extent to which athletic competitions and their awards were deeply embedded in Greek culture is evidenced by the fact that Athenians announced the birth of a boy by placing an olive wreath on their door—a wish for his future glory as a victor in the games.

A wreath was the official prize for victory at each of the Panhellenic competitions—a modest trophy by our standards. At Olympia the wreath was made from branches of the wild olives of Elis; at Isthmia the crown was fashioned from pine, at Nemea from wild celery, and at Delphi from the laurel berries sacred to Apollo. The Romans continued this tradition of the *stephanitai*, or "crown games," as attested by a second-century relief carved with the same wreaths for the appropriate festivals (cat. no. 145). Though the crowns made of organic materials obviously decayed in time, elite members of Greek society, whether or not they were victors, were at times buried with golden versions (cat. no. 147). A ribbon was also awarded for an athletic victory, and at the great festivals the ribbon would be a supplement to the wreath.

Although wreaths and ribbons were the formal prizes, victorious athletes were the recipients of many additional honors and awards in Greek society. The Greek word for athlete (*athletes*) derives from the word for contest (*athlos*) and the word for the prize of the contest (*athlon*); thus, the concept of rewarding victory is embedded in the subject of the athlete. In books 23 and 24 of the *Iliad*, when Achilles offers precious awards such as tripods, cauldrons, goblets, and even women weavers to the winners of the games in honor of his beloved companion Patroklos, he links material gains with the contests. Setting out the prizes for the fastest runner (a silver mixing bowl of rare artistic beauty, a large ox, and gold), he rallies the men with the words: "Rise up, you who would try for this prize." Indeed, in the Classical and Hellenistic periods cash and other valuable prizes (such as bronze hydriae, woolen cloaks, silver goblets, and olive oil) were awarded in local games established by cities all over the Greek-speaking world. Victors of the crown games, even in the earliest times, also received additional rewards from their hometowns. Olympian victors from Athens, for example, were given lifelong meals in the public dining room in the Prytaneum.

< A much-honored athlete, about to be crowned by Victory, receives a ribbon from a seated man (cat. no. 140).

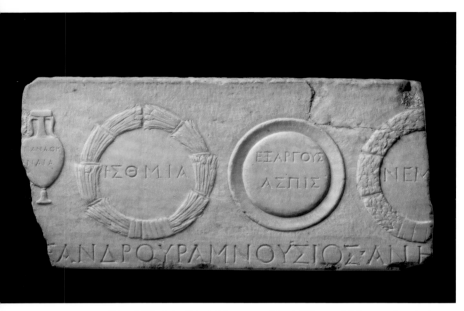

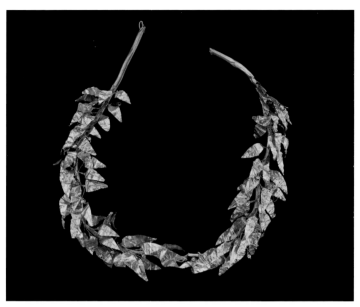

This relief illustrates the prizes from some of the most famous athletic games in ancient Greece (cat. no. 145).

This olive wreath made of gold was buried with a Macedonian aristocrat (cat. no. 147).

The awards ceremonies were simple. Although poets and musicians stood on two-stepped podia during their contests, as evidenced in many representations on Greek vases, athletes may not have mounted anything to receive their prizes. The victor merely walked up to the judge and accepted his wreath or ribbon. The award was sometimes placed on his head by another; in other cases the victor placed his wreath or tied his ribbon himself. Additional ribbons were often bestowed on athletes as tokens of esteem: representations of athletes wearing multiple ribbons reflect the custom of excited spectators bestowing extra ribbons or wreaths on their favorites. The ribbons were broad straps with cords or tassels at the ends that admirers tied around their champion's arms, legs, or forehead. Numerous vase paintings feature athletes receiving these wreaths and victors' ribbons from admirers; some stand in the nude with multiple ribbons tied around their arms and thighs (see, for example, cat. no. 149, p. 6). On one drinking cup a clothed judge awards red and white

ribbons to five athletes depicted around the cover; the presence of the flute player indicates a victory ceremony (cat. no. 150). The inclusion of several inscriptions of *kalos* ("handsome one") on this cup indicates the inextricable link between the Greek appreciation of beauty and athletic prowess. In other portrayals, athletes hold leafy branches that were thrown to them by spectators to honor their victory, in a custom called *phyllobolia*. Perhaps the bronze athlete with open hands illustrated in this chapter once held such honors (cat. no. 152, p. 153). Admirers even went so far as to present good-looking young athletes with pomegranates, fighting cocks, or hares—useful and symbolic gifts that alluded to the fertility, competitive spirit, and desirability of the victors (fig. 8).

The lists of Olympic victors preserved in the chronicles of later ancient writers on athletics, as well as the prize lists recorded in stone reliefs and the agonistic epigrams that survive, all underline the fact that Greek athletes were professionals. Many of them had long careers and were on the circuit gathering awards year-

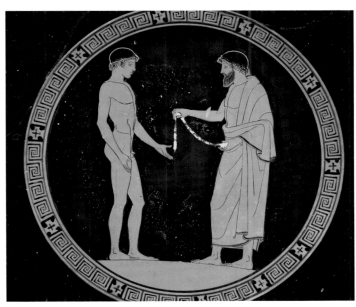

A young athlete receives a ribbon from an older man, probably an admirer (cat. no. 148).

round. Great victors won valuable prizes and went on to lead highly privileged lives. For instance, victors at the Panathenaic Games were awarded prize amphorae filled with premier olive oil from the sacred groves of Athena. The quantities varied according to the event and the age of the competitors. For example, fifty amphorae valued at about $45,000 were given to the winner of the stadion in the boy's class, while sixty valued at about $54,000 went to the winner in the youth's class. A boy in the pentathlon received thirty jars, or about $27,000 worth. Wrestlers received even more than runners. The largest sums by far were awarded to the winners of the chariot races: 140 amphorae of olive oil, valued at $122,000.[2]

These amounts were well in excess of most annual salaries and reflect the contributions of a large community toward the giving of prizes. The treasurers of the Acropolis were responsible for measuring out the correct amounts, and the commissioners of the games were in charge of the distribution. The oil was put into

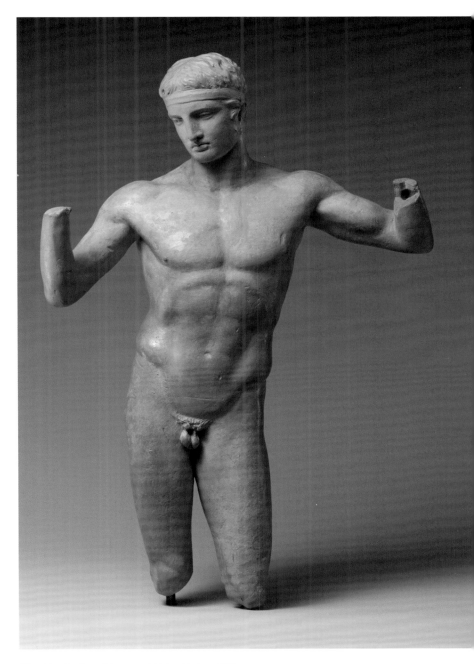

This athlete is tying a ribbon around his head (cat. no. 153).

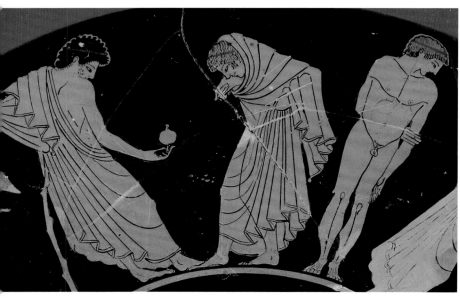

Fig. 8. An admirer (on the left) gives a pomegranate to a boy athlete.

containers whose shape, capacity, and design were standardized about 530 B.C. and repeated for more than four hundred years. The type is known as the Panathenaic amphora. These vases were produced in great numbers every four years to hold and transport about 35 to 40 liters (9¼ to 10½ gallons) per vessel.³ The front side was always painted with Athena striding in a militant pose between two columns, with an inscription parallel to the left frame of the panel bearing the official line "from the games at Athens" (as on cat. no. 73). In the later periods, toward mid-second century B.C., the name of the official who directed the games was also included. The reverse side always featured a scene of the event for which the athlete was awarded the prize (cat. no. 73). About three hundred of these Panathenaics survive, revealing details about the events—such as the use of equipment, the rules of the games, and the role of the judges—that might otherwise have been lost to us.

Victors were honored in other ways, too. One lasting memo-rial to winners was the epinician, or victory song, an art form devised to celebrate these extraordinary men. The leaders of athletes' home cities, as well as some wealthy winners themselves, hired poets such as the fifth-century contemporaries Pindar and Bacchylides for their skill in composing these songs. The poets worked for a variety of places, including Aegina, Macedon, Sparta, and Syracuse. While it is still debated whether the odes were sung solo or by a chorus, they were definitely performed in public and served as paid propaganda. They eloquently reported on the achievements of the victor, praised his ability, recognized his labors, and celebrated his divine favor. The songs followed a formula in which the victor emerged from a pool of equal competitors as a heroic figure favored by the gods. The mythical foundations of his hometown were always detailed. In other words, the glory of the victor was tied to his birthplace, and the achievements of one man became a symbol of pride for the whole community. Indeed, the language of athletic inscriptions follows a similar formula whereby the athlete is named as "first from his hometown X to do the event X."

With so much at stake, there were naturally those who cheated and brought dishonor upon themselves and their sponsors. In fact, the earliest Olympic law dealt with cheating. Heracleides Ponticus claimed that Sybarites tried to bribe Olympic athletes to compete for their city.⁴ The great runner Astylos of Kroton was persuaded to run as a Syracusan in the Olympics of 484 and 480 B.C., which so infuriated the citizens of Kroton that they tore down his statue.⁵ Olympic scandals, then, are not a modern phenomenon. One of the more unusual cases is the compelling story of a woman named Kallipateira, who trained her son as a pankratist and accompanied him to Olympia dressed as a male gymnastes. She revealed her sex when she leapt up in excitement, and because the games were forbidden to married women, she was supposed to be severely punished. As she was the daughter, sister, and mother of Olympic victors, she was ultimately excused. However, from that point forward trainers had to register in the nude.⁶

> A judge awards red and white ribbons to seven athletes, while a flute player accompanies the ceremony (cat. no. 150).

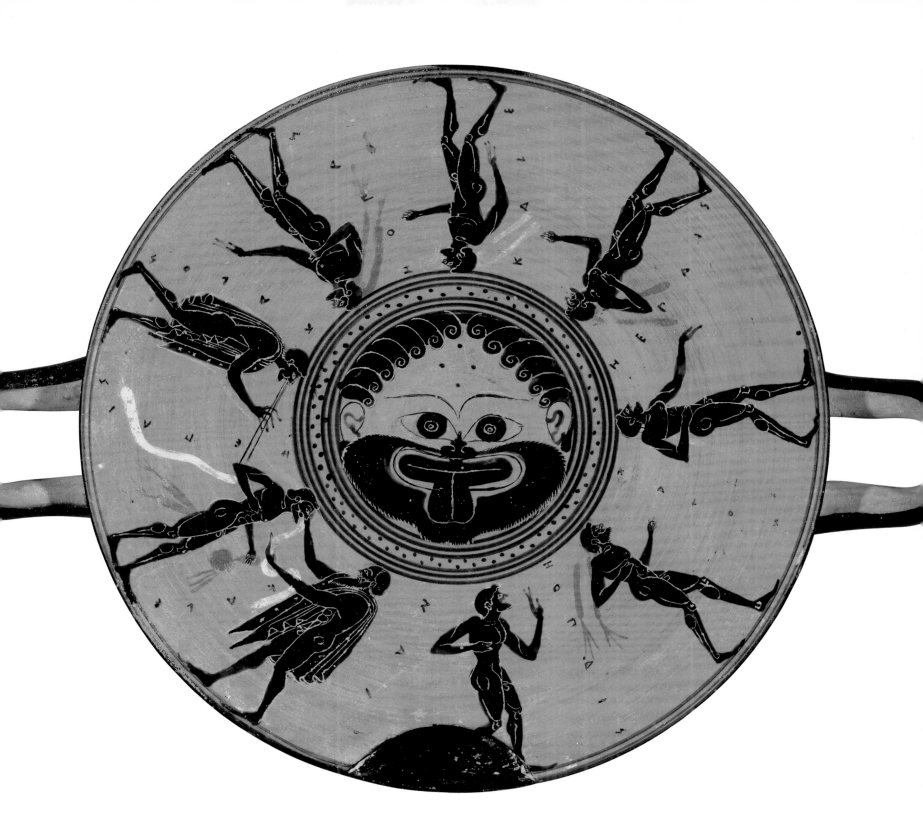

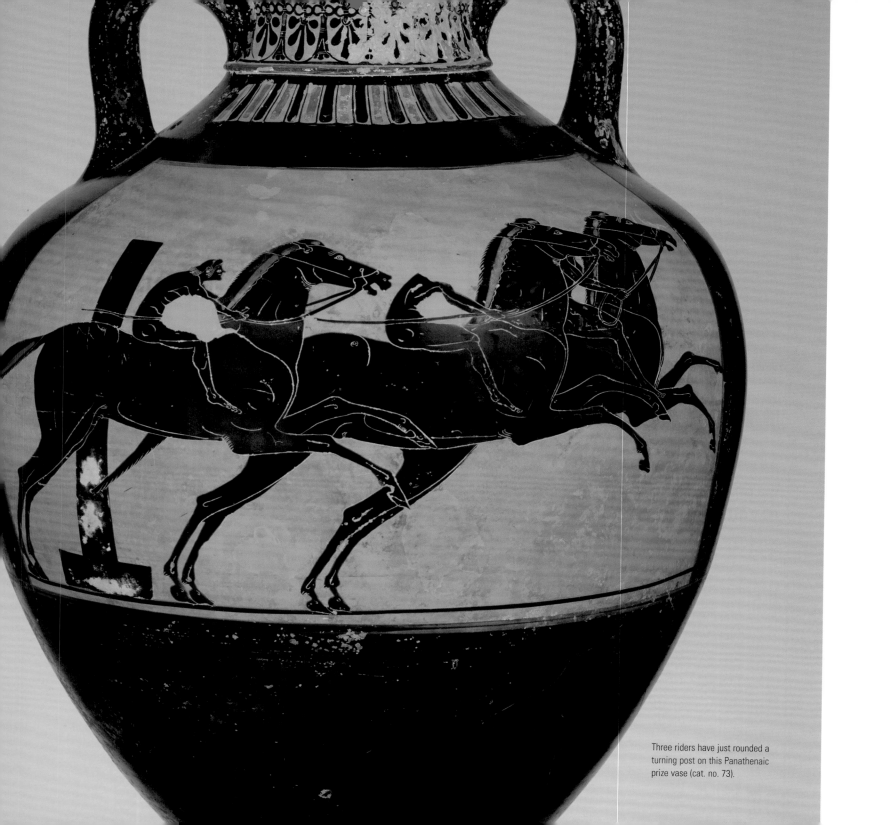

Three riders have just rounded a turning post on this Panathenaic prize vase (cat. no. 73).

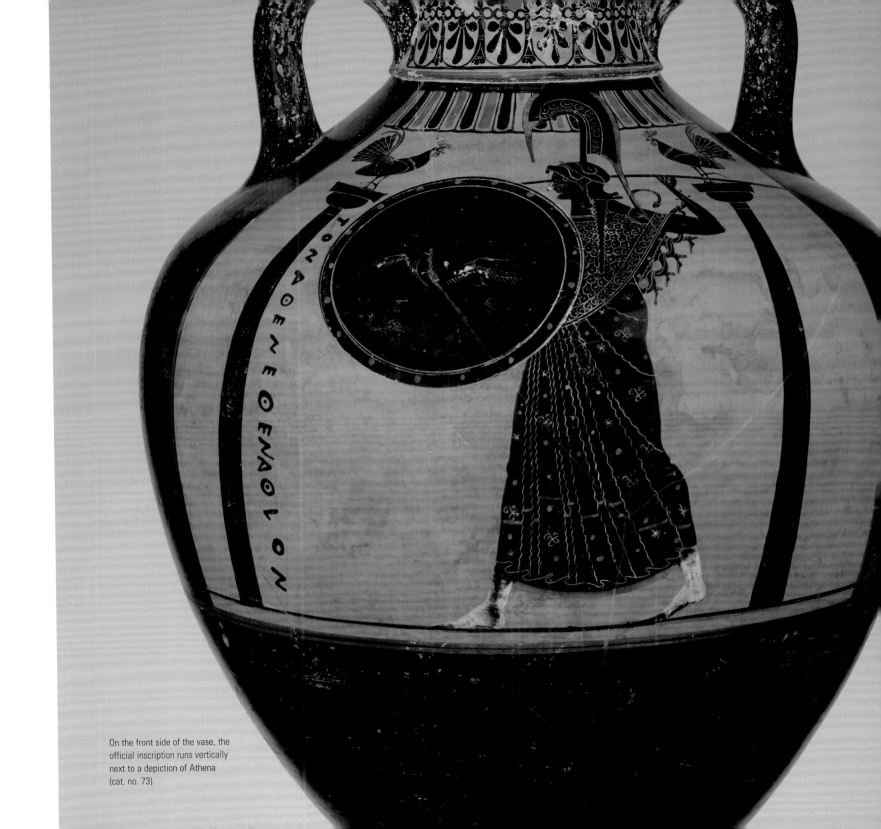

On the front side of the vase, the official inscription runs vertically next to a depiction of Athena (cat. no. 73).

Pausanias informs us that a row of bronze statues of Zeus, called *zanes*, lined the entrance to the stadium at Olympia. They were paid for by the fines charged to athletes who dishonored their oaths to Zeus through corrupt practices. The misdeeds were recorded in inscriptions, many of which Pausanias reports in his travelogue of Olympia. One pentathlete, Kallippos of Athens, tried to fix a match by bribing his opponents. Curiously, his fine became the burden of his home city, but the Athenians refused to pay and decided to boycott the Olympic Games. The modern games, of course, are filled with boycotts, usually as expressions of nationalism and political dissent. During the Cold War, for example, the United States and several of its allies boycotted the 1980 Olympics in Moscow to protest the Soviet Union's invasion of Afghanistan, and in 1984 the Soviet Bloc boycotted the Los Angeles games in return.

In the case of Kallippos and the Athenians, the incident was finally brought to the Oracle at Delphi, where it was made clear that unless the Athenians paid the Eleans (who were in charge of the Olympics), no oracles would be given to their city. The Athenians then paid the fine, which resulted in the erection of six bronze statues of Zeus.[7] All athletes had to pass the zanes en route to their contests, and the presence of these expensive symbols of dishonor must have been a real deterrent.

| MONUMENTS AND COINS

Each age has its own beauty. In youth, it lies in the possession of a body capable of enduring all kinds of contests whether of the race-course or of bodily strength, while the young man is himself a pleasant delight to behold.

—Aristotle *Rhetoric* 1361b

Glorification of athletes was a major realm of Greek artistic activity, and artists celebrated the strivers as well as the winners. The tradition began in the first half of the sixth century B.C., when a great many of the important games were founded. In this major phase of athletic enthusiasm, the rich but not necessarily famous wanted to present themselves as athletes on their grave markers. From about 560 to 550 B.C. virtually all figure-decorated marble grave reliefs from central Greece (Attica and Boiotia) showed the dead man nude and with some trappings of sport.[8] Thereafter the fashion weakened somewhat. In gravestones from 550 to 500 B.C. only younger men were shown as nude athletes, while older men were represented as soldiers in armor. At first the deceased athletes carried equipment for specific events (discus, javelin, or knuckle wrappings); after 550 B.C. they carried apparatus for clean up (aryballoi or strigils) or the badges of victory and affection (wreaths, ribbons, or gifts) (cat. no. 115, p. 138).

The primary place for the celebration of true victors was at Olympia, where a forest of life-size statues survived through Roman times, although other festival sites and city centers had statues of winners as well. Most were in bronze and went into the melting pot for their metal content in later times. Only a few that were buried for safekeeping, preserved in old collections, or lost in calamities such as shipwrecks have survived into modern times. A majestic head of a young athlete (cat. no. 123, p. 160) and a statue of a boy victor wearing a headband and originally holding wreaths or branches of a plant sacred to a god (cat. no. 152) are among these life-size bronze rarities. Small bronze and terracotta statuettes of athletes, which survive in much greater numbers, usually celebrated victories at athletic festivals as well. Throughout the Greek world athletic statuettes were dedicated at shrines in gratitude for divine favor.[9] An early bronze statuette of a jumper reportedly found at Olympia itself is emblematic of this custom (cat. no. 13). In the Greek cities of southern Italy bronze figures of athletes were also used as handles of basins or ladles for sacred purifications (cat. no. 104, p. 133). Victors were painted on vases, particularly amphorae, which may have been intended as athletic prizes, whether official Panathenaics or not.

In today's sports museums and halls of fame, champion athletes are shown with the greatest realism possible to render both

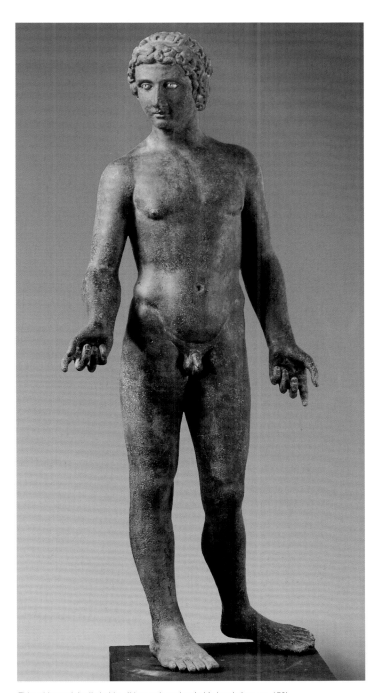

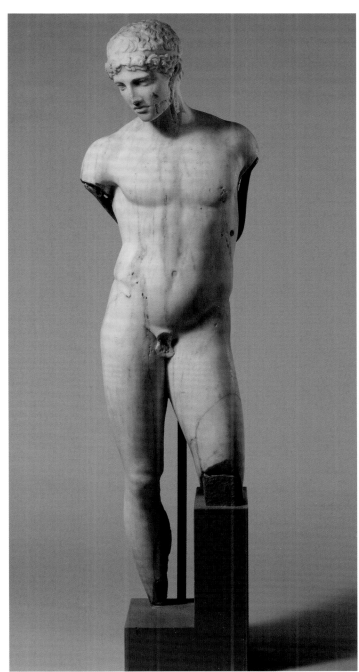

This athlete originally held a ribbon or branches in his hands (cat. no. 152).

This young athlete, perhaps a javelin thrower, has a victor's ribbon around his head (cat. no. 154).

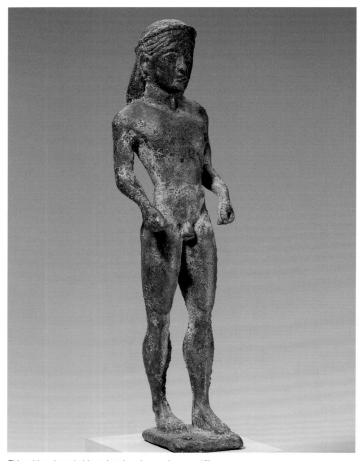

This athlete is probably a victorious jumper (cat. no. 13).

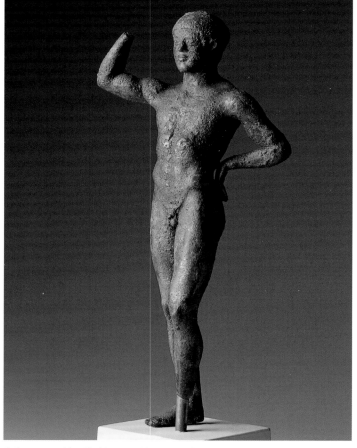

A victor crowns himself with a wreath (cat. no. 157).

the subject's power and his or her unique individuality. Ancient artists, however, aimed at making a statement about the ideal beauty of the winner, to the point that in later times the name of the athlete could be forgotten while the beauty of the statue was still remembered—and copied. These ancient images of winners are permeated with a special ethos. The joy of victory or the ferocity of combat is played down. Statues of Greek athletic victors are normally impassive in a way that we would

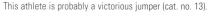

call stoic, were it not that many such sculptures substantially antedate Stoicism (a philosophical school originating in the fourth century B.C.). They show no jubilation, although a hand might be raised in a universal gesture of victory. There are no grimaces of effort. Facial distortion was only for semihuman beings, such as satyrs, tritons, or giants.

Typically, the athlete appears majestically calm after victory. The sculptor might show the winner standing quietly

∧ Having won his race, a runner relaxes, leaning against a turning or finishing post (cat. no. 156).

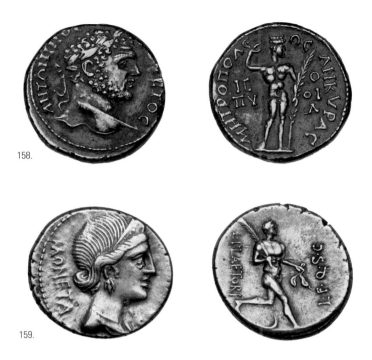

158.

159.

Wearing a crown and holding a palm branch, the athlete on the upper coin may be a victor or a personification of the games themselves (cat. no. 158).

The runner on the lower coin is taking a victory lap (cat. no. 159).

> Fig. 9. This runner is captured in full stride in his victory lap.

in a balanced pose, usually incorporating a minimum of movement. Archaic athletes are virtually "at attention," with only one foot advanced (cat. no. 13). Only minor details—especially the presence or the possible presence of athletic equipment—differentiate them from the generic figures of nude youths called kouroi, which might have been intended to be the god Apollo, beautiful young men, or young athletes. For instance, two hands shifted forward together to hold a pair of jumping weights can be a clue that the figure is an athlete (cat. no. 13).

In the fifth century B.C. and thereafter poses became looser and incorporated restrained action. The javelin of the pentathlon was a favorite prop to activate the body, but these peripherals are now invariably missing from large-scale figures (cat. no. 154). On the one hand, statues of athletes tying on ribbons of honor (cat. no. 153, p. 147) or crowning themselves with wreaths of victory (cat. no. 157) articulate the body and at the same time create a mood of self-absorption. Athletes shown holding out their wreaths of victory, on the other hand, address the specta-

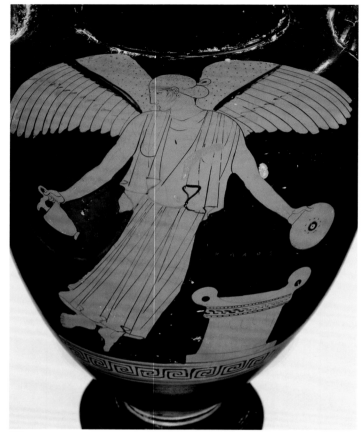

138.

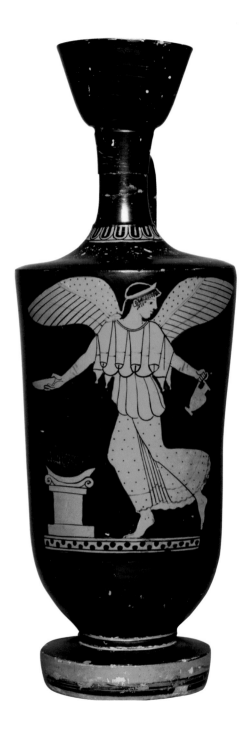

137.

In both of these scenes, Victory prepares to pour a libation at an altar (cat. nos. 137 and 138).

156

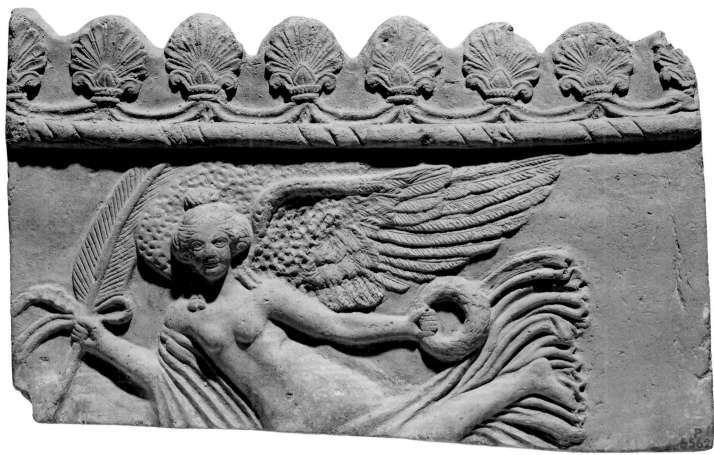

Victory flies in to crown an athlete (cat. no. 139).

tors directly (cat. no. 152). A sculpture created in the late fifth century B.C. and known from Roman marble replicas and from gems shows a runner leaning on a turning or finishing post (cat. no. 156). This composition adds a new element to representing victory: the winner is fatigued after competition. Feats of strength—particularly lifting stones—were also celebrated. A statue in a gymnasion at Kyme (on the western coast of Asia Minor) seems to have commemorated a weightlifter (cat. no. 102, p. 16).

Modern photography captures the athlete at the moment of intense, critical action. In antiquity efforts to freeze rapid motion are adventurous rarities. The discus thrower by Myron is the most famous example. Some small-scale works show the athlete beginning his movement, and others catch him bending at the bottom of his back swing, as in Myron's work (cat. no. 46, p. 34). Late Hellenistic artists attempted to freeze runners in full stride; a life-size bronze statue recovered from the sea off the western coast of Asia Minor shows the runner poised on one foot but

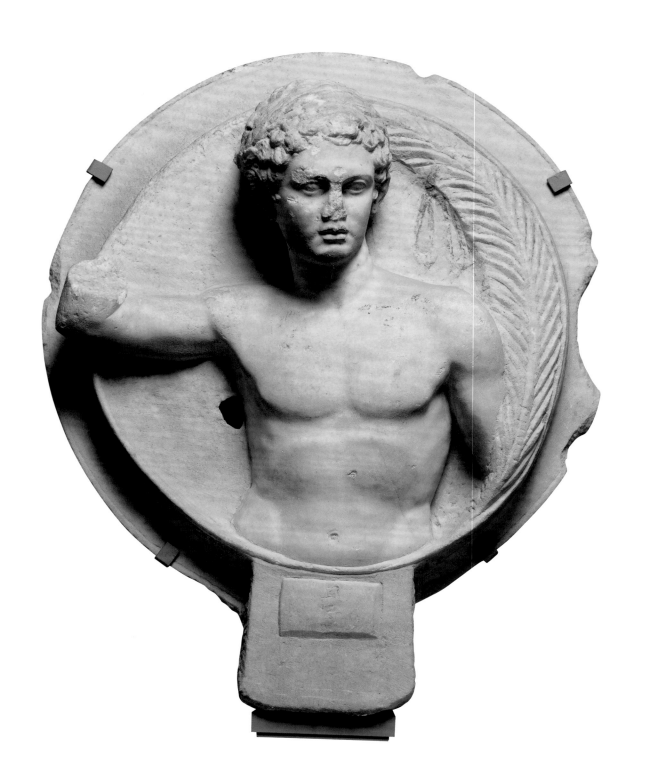

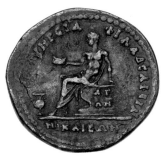

Agon, the personification of competition, holds out a prize crown (cat. no. 160).

with head upturned (fig. 9).[10] The image becomes more intelligible on a Roman coin from 74 B.C. (cat. no. 159), on which the runner is carrying the winner's palm branch and ribbon. He is evidently running a victory lap around the stadium and basking in glory and divine favor, rather than concentrating on winning.

The Greek language of victory is most explicitly embodied in the figures of Nike, or Victory, and Agon. Victory is invariably depicted as a draped, winged female. She is often shown flying in with ribbons, wreaths, or palm branches for the victors or with libations for the altar, exemplifying the piety and thanksgiving associated with the games (cat. nos. 137–39). She is also popular as a coin design, especially on fifth-century tetradrachms of Elis (cat. nos. 142–43, p. 38). Less frequently depicted is Agon, who personifies either the spirit of competition or the place of the contest. He is shown as a victorious athlete, in some cases crowning himself. On a rare coin he sits on a judge's throne inscribed with his name and holds out a crown of victory (cat. no. 160). The unusual Hadrianic monument of a nude male crowning himself and holding a large palm branch, carved as a marble roundel, may represent Agon (cat. no. 161).

The significance of athletic victories to each region is evidenced in the numerous coins depicting agonistic subjects that were issued throughout the Greek and Roman periods. For instance, Aspendos in Asia Minor and Philippopolis in Thrace issued coins illustrated with wrestlers (cat. no. 59–61, p. 98),

and fifth-century silver tetradrachms from Kos depict a discus thrower (cat. no. 52, p. 88). Horse-racing victors were also celebrated by their local towns with the issuing of new coin designs, and these demonstrate the importance of chariot racing to the Greek-speaking world. A chariot crowned by Victory was taken up as a symbol of the ruling aristocracy on the coinage of Syracuse in the late sixth century B.C. and was used for two centuries thereafter (cat. nos. 90–91, p. 118). Several other Sicilian cities took up the design as well. A close bond with the Olympic Games is demonstrated by a coin of Himera, where the victorious charioteer, dressed in his characteristic long tunic, is Pelops, the winner of the mythical first chariot race at Olympia (cat. no. 89, p. 118). There is an interesting artistic development in these equestrian numismatic designs during the course of the fifth century B.C. At first the chariot team is seen walking and then racing, both in profile views. By the end of the century masterful die-cutters used oblique views to show the horses tossing their heads as the team rounds the turning post at the critical moment of the race (cat. no. 90).

| SWEAT, NOBILITY, AND ALLEGORY

I don't like excessive hair and ringlets, / Which are trained in the deeds of artifice, not nature. / But I do take delight in the dusty filth of a boy in the palaistra. / And the anointed skin of the flesh of his limbs.

— Strato *Greek Anthology* 12.192

Some Greek images of athletes have multiple potential meanings: they may depict either a specific athlete, a specific athletic victor, or a typical athlete, or they may personify an abstract idea. The composition of an athlete placing a wreath on his head and holding a palm branch is the most evident case of images bearing multiple potential meanings, as in the marble roundel mentioned previously (cat. no. 161). Such images are usually interpreted as specific victors but, as noted above, they may equally well represent the god Agon. A Roman coin from Nicaea in Asia Minor labels an athlete crowning himself as "Sacred Agon."[11] On a coin from

< This athlete crowning himself may represent Agon (cat. no. 161).

159

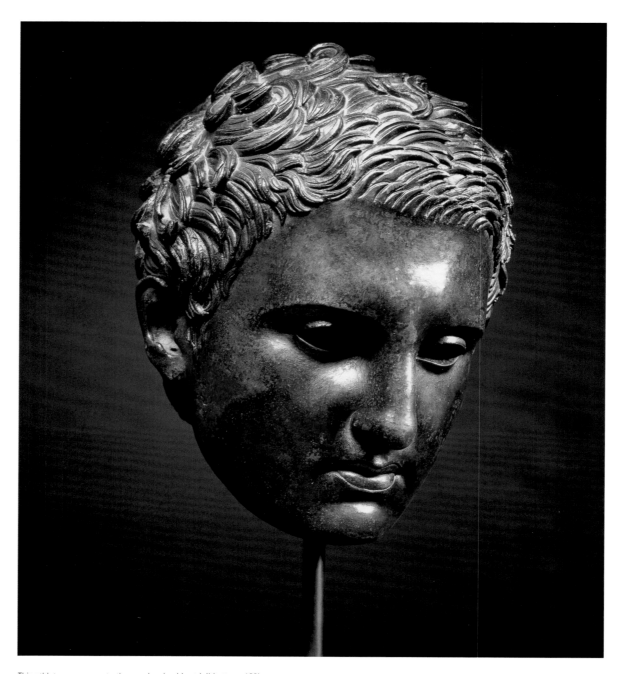

This athlete was concentrating on cleaning his strigil (cat. no. 123).

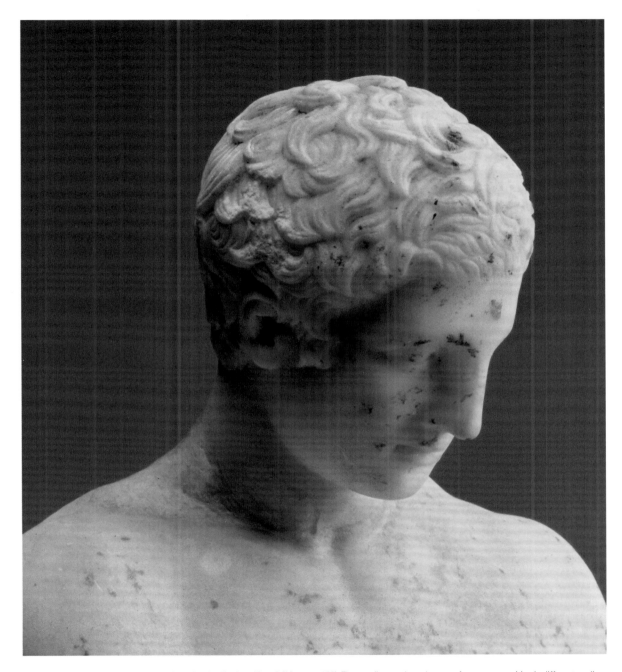

This athlete's gaze is similarly intense as he strips the dirt from his strigil (cat. no. 122). The two figures show the same famous composition in different media.

Ankyra (Ankara) the label "Isopythian Games" accompanies an athlete who wears a crown and holds a palm (cat. no. 158, p. 155). This figure may be a typical winner or he may be the embodiment of the games. Given such inscribed coins, it is almost impossible to determine whether unlabeled athletes crowning themselves are personifications or specific winners.

Statues, too, can have various interpretations. Greeks often placed sculptures of nude youths carrying lances in their gymnasia. According to the Roman writer Pliny the Elder, they called such images "Achillean" (after Achilles, the greatest of the Greek warriors in the Trojan War). These statues were looked at as models for, or symbols of, the young athletes and warriors-to-be (epheboi) in the gymnasia.[12] Pliny specifically mentions the famous spear bearer by Polykleitos as such an "Achillean" statue. Copies of the spear bearer are abundant and often of wonderful quality. One of the few whose original setting is known was actually excavated in an exercise ground at Pompeii. The lance symbolized the end of athletic training of youths at Athens: after two years as epheboi, the young men received a lance and entered military service as frontier guards.[13] Statues of victorious pentathletes with headbands of victors (cat. no. 154, p. 153) could be interpreted as Achillean figures, if the javelin symbolic of their athletic victories were in fact understood as a military spear.

The most slippery cases of all are the figures of athletes in the process of oiling and dusting themselves before or cleaning themselves after exercise. Some of the most majestic of Greek athletic statues show oiling and cleanup. In one of the most popular compositions, probably created by Lysippos, the court sculptor of Alexander the Great, an athlete cleans his strigil after scraping his body. The work is known from at least four over-life-size versions in bronze and marble (cat. no. 123) and from several smaller-scale versions in marble and ceramic (cat. nos. 97, p. 140, and 122, pp. 136 and 161). One example was excavated in the exercise yard of the Harbor Baths in Ephesos, where, even without a spear, it may have served as an Achillean statue, presiding over the athletes in the palaistra. In the large bronze versions of

the strigil-cleaner, the sculptors succeed in rendering oily clumps of hair, which create a spiked effect (cat. no. 123). Another majestic figure (cat. no. 124) is probably finishing the process of cleaning himself by scraping under his right arm (judging by the shift of axis to the right). His complex but subtle pose likely was inspired by another athletic statue by Lysippos.

These statues do not seem to have been intended as specific athletes. They are too large to be statues of victors—at Olympia, and probably most other sites, victors could erect statues of themselves that were no larger than life-size.[14] Over-life-size statues were meant, in Greek times at least, as emblems of the athletic training of prosperous, free young men. According to Sokrates, the oily smell of the athletic field was preferable to the expensive perfumes of slaves and freedmen. It required noble training and much time to achieve, but it was the aroma of freedom.[15] By Sokrates's time the oily, sweaty smell had evidently become a focus of attention in itself and a badge of nobility. Statues showing fit young citizens oiling and cleaning themselves would be eminently suitable to exemplify high-status athletic training and preside over Greek gymnasia. In Roman times artists sometimes evoked the idea of victory by placing palm branches and prize vases on the ground next to such images or by using trunks of palm trees as supports (cat. no. 124).[16] The essential message conveyed by images of oilers and scrapers, however, was the beauty and nobility of athletically trained Greek youth.

> This athlete was probably scraping the underside of his right arm (cat. no. 124).

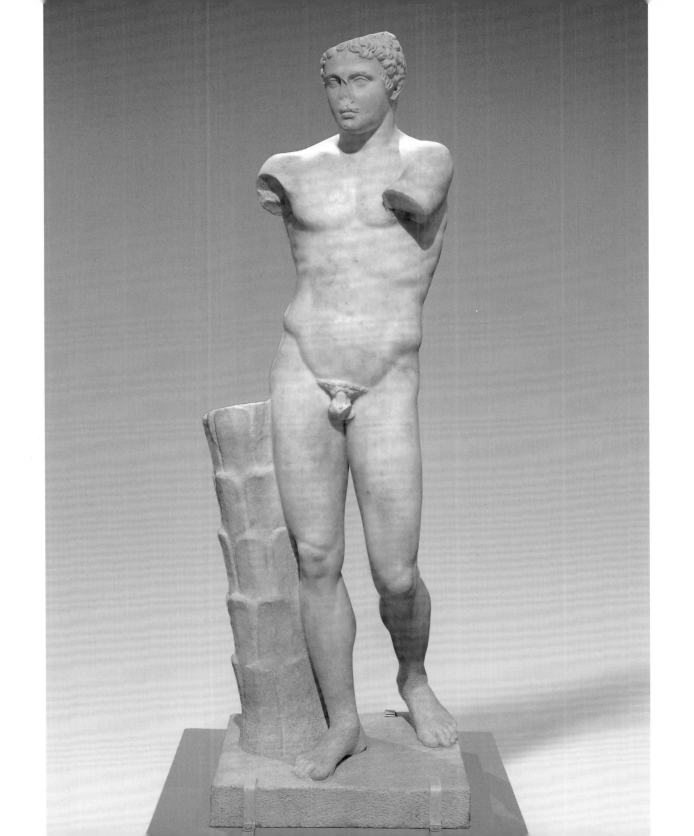

NOTES

EPIGRAPHS

The epigraphs used throughout the text are excerpted from translations in the following sources:

P. ix: *The Odes of Pindar*, trans. John Sandys, Loeb Classical Library (Cambridge, Mass.: Harvard University Press, 1946), 123.

P. 15: *Herodotus*, trans. A. D. Godley (New York: G. P. Putnam's Sons, 1921–24), 27.

P. 43: Stephen Gaylord Miller, *Arete: Greek Sports from Ancient Sources*, 2nd ed. (Berkeley: University of California Press, 1991), 53.

P. 48: *Pausanias: Description of Greece*, trans. W. H. S. Jones, Loeb Classical Library (New York: G. P. Putnam's Sons, 1926), 2:451.

P. 50: Miller, *Arete*, 65–66.

P. 53: *The Odes of Pindar*, trans. John Sandys, 114–15.

P. 61: Miller, *Arete*, 21–22.

P. 70: Ibid., 83.

P. 73: Ibid., 39.

P. 73: Ibid.

P. 81: Waldo E. Sweet, *Sport and Recreation in Ancient Greece: A Sourcebook with Translations* (New York: Oxford University Press, 1987), 54.

P. 84: Miller, *Arete*, 47.

P. 91: *The Odes of Pindar*, trans. John Sandys, 464–65.

P. 93: Miller, *Arete*, 27.

P. 99: *Philostratus the Elder and the Younger. Imagines*, trans. Arthur Fairbanks, Loeb Classical Library (Cambridge, Mass.: Harvard University Press, 1979), 149.

P. 100: Miller, *Arete*, 33.

P. 107: Ibid., 57.

P. 114: Sweet, *Sport and Recreation in Ancient Greece*, 91.

P. 125: Miller, *Arete*, 124.

P. 129: Sweet, *Sport and Recreation in Ancient Greece*, 112.

P. 145: "*Isthmian Odes*, by Pindar, translated by T. K. Hubbard," *The Perseus Digital Library*, © 1994–2000, http://www.perseus.tufts.edu/cache/perscoll _Greco-Roman.html (accessed October 22, 2003).

P. 152: Miller, *Arete*, 39.

P. 159: Thomas Francis Scanlon, *Eros and Greek Athletics* (New York: Oxford University Press, 2002), 219.

OLYMPICS THEN AND NOW

1. For the historical aspect, see Judith Swaddling, *The Ancient Olympic Games*, 2nd ed. (Austin: University of Texas Press, 2000), 101–3. For the ethical and pacific aspects of the Olympic movement, see International Olympic Committee, "Fundamental Principals," *Olympic Charter*, © August 2003, http://multimedia.olympic.org/pdf/en_report_122.pdf (accessed September 12, 2003), 9–10.

2. Herodotus *Histories* 8.26.3, as translated by A. D. Godley in *Herodotus*, 27. For more on the barbarians' reaction, see Lucian *Anacharsis or Athletics* 9.

3. Jean-Paul Thuillier, *Les jeux athlétiques dans la civilization étrusque* (Rome: Ecole Française de Rome, 1985), 201.

4. David M. Lewis, ed., *Inscriptiones graecae*, 3rd ed., vol. 1, *Attica* (Berlin and New York: De Gruyter, 1981), 131; see Stephen G. Miller, ed., *Nemea: A Guide to the Site and Museum* (Berkeley: University of California Press, 1990), 3, and Jenifer Neils, *Goddess and Polis: The Panathenaic Festival in Ancient Athens*, exh. cat. (Hanover, N.H.: Hood Museum of Art, Dartmouth College; Princeton, N.J.: Princeton University Press, 1992), 14.

5. On Panathenaic prizes, see Neils, *Goddess and Polis*, 16, fig. 1. For other commodities see Pindar *Nemean Ode* 10, ant. 3. On fig. 1, see note 12.

6. See I. R. Arnold, "Agonistic Festivals in Italy and Sicily," *American Journal of Archaeology*, v. 64 (1960): 245–51, and Malcolm Bell III, "The Motya Charioteer and Pindar's *Isthmian 2*," *Memoirs of the American Academy in Rome*, v. 40 (1995): 4.

7. See Henry R. Immerwahr, "An Inscribed Terracotta Ball in Boston," *Greek, Roman, and Byzantine Studies*, v. 8 (1967): 255–67, and Lynn E. Roller, "Funeral Games for Historical Persons," *Stadion*, v. 7 (1981): 1–18.

8. He paid one talent to Olympia and another to an opponent; Pausanias *Description of Greece* 6.6.6. See Michael B. Poliakoff, *Combat Sports in the Ancient World: Competition, Violence, and Culture* (New Haven, Conn.: Yale University Press, 1987), 121–22.

9. Thuillier, *Les jeux athlétiques*, 269–327.

10. Henri Irénée Marrou, *A History of Education in Antiquity*, trans. George Lamb (New York: Sheed and Ward, 1956), 116.

11. See Scanlon, *Eros and Greek Athletics*, 25–39.

12. The dotted inscription on the rim was read by Annewies van den Hoek as:

ΑΘΛΟΝΕΓΜΥΛΑΣΩΝΖΗΝΟΠΟΣΕΙΔΕΩΝΟΣ
ἆθλον ἐγ Μυλάσων Ζηνοποσειδεῶνος

"Prize from Mylasa of [the games of] Zenoposeidon."

13. Donald Kyle, "Panathenaic Games: Sacred and Civic Athletics," in Neils, *Goddess and Polis*, 96; Dietrich O. A. Klose and Gerd Stumpf, *Sport, Spiele, Sieg: Münzen und Gemmen der Antike*, exh. cat. (Munich: Staatlichen Münzsammlung München, 1996), 49.

14. Homer *Odyssey* 8.193–98, 18.69–71, 18.133–34; Homer *Iliad* 23.383–400, 23.770–76, 23.872–73; see Neils, *Goddess and Polis*, 121–22, and Scanlon, *Eros and Greek Athletics*, 26.

15. Alfred Mallwitz, *Olympia und seine Bauten* (Munich: Prestel-Verlag, 1972), 71.

16. Hans-Volkmar Herrmann, *Olympia: Heiligtum und Wettkampfstätte* (Munich: Hirmer Verlag, 1972), 72–73; Susan Langdon, *From Pasture to Polis*, exh. cat. (Columbia: University of Missouri Press, 1993), 127, cat. no. 97.

17. On demonic damage, see Pausanias *Description of Greece* 6.20.15; Edward Norman Gardiner, *Greek Athletic Sports and Festivals* (London: Macmillan, 1910), 463–65. On tricky races, see Pausanias *Description of Greece* 5.9.2; Gardiner, *Greek Athletic Sports and Festivals*, 461.

18. Kyle, "Panathenaic Games," 95–96; William Armstrong Percy III, *Pederasty and Pedagogy in Archaic Greece* (Urbana: University of Illinois Press, 1996), 126, 181; Scanlon, *Eros and Greek Athletics*, 205.

19. Percy Gardner, "Boat Races among the Greeks," *Journal of Hellenic Studies,* v. 2 (1881): 90–97, 315–17; Marrou, *A History of Education*, 118; Neils, *Goddess and Polis*, 15; Kyle, "Panathenaic Games," 97. The nautical aspect of the Actian Games need not date from the time of Augustus.

20. D. Peppa-Delmousou and V. Machaira, in *Mind and Body: Athletic Contests in Ancient Greece*, exh. cat. (Athens: National Archaeological Museum, 1989), cat. nos. 87, 206. Previously it has been thought that these crews were participants in staged naval battles (*naumachiai*), but since they lack weapons, the simpler interpretation as racers is preferable.

21. Immerwahr, "Inscribed Terracotta Ball," 255–67; J. M. Hemelrijk, "*Le jeu*," in Doris Vanhove, *Le sport dans la grèce antique. Du jeu à la compétition*, exh. cat. (Brussels: Palais des Beaux-Arts, 1992), 25–27, figs. 10–11, cat. nos. 20–28.

22. See Michael Padgett et al., *Vase-Painting in Italy: Red-Figure and Related Works in the Museum of Fine Arts, Boston* (Boston: Museum of Fine Arts, 1993), cat. nos. 42 (harpist) and 46 (identified there as balls of wool).

23. Scanlon, *Eros and Greek Athletics*, 83.

24. Gardiner, *Greek Athletic Sports and Festivals*, 316.

25. Pausanias *Description of Greece* 5.21.13–14.

26. Mallwitz, *Olympia und seine Bauten*, 60, 68–69.

27. On the statues financed from fines, see Pausanias *Description of Greece* 5.21.2–16. On fines for judges, see Pausanias *Description of Greece* 6.3.7.

28. Donald Jackson, "Philostratus and the Pentathlon," *Journal of Hellenic Studies*, v. 111 (1991): 178–81.

29. Plato *Lovers* 135E–136A.

30. Neils, *Goddess and Polis*, 15–16, fig. 1.

31. Poliakoff, *Combat Sports in the Ancient World*, 89–93.

32. Lucian *Anacharsis or Athletics* 38.

33. Poliakoff, *Combat Sports in the Ancient World*, 85, fig. 89; Vanhove, *Le sport dans la grèce antique*, cat. nos. 212, 222.

34. *Papyrus Oxyrhynchus* 466; cited in Marrou, *A History of Education*, 124.

35. Lucian *Anacharsis or Athletics* 1.

36. Plutarch *Alcibiades* 2; Plutarch *Spartan Sayings* 234 D, 44; Gardiner, *Greek Athletic Sports and Festivals*, 445; Poliakoff, *Combat Sports in the Ancient World,* 102.

37. Gardiner, *Greek Athletic Sports and Festivals*, fig. 151; Poliakoff, *Combat Sports in the Ancient World*, figs. 83–84; Peter Siewert, "The Olympic Rules," in W. Coulson and H. Kyrieleis, eds., *Proceedings of an International Symposium on the Olympic Games* (Athens: Deutches Archäologisches Institut, 1992), 115.

38. On the issue of nudity, see Larissa Bonfante, "Nudity as a Costume in Classical Art," *American Journal of Archaeology*, v. 93 (1989): 543–70; Myles McDonnell, "The Introduction of Athletic Nudity: Thucydides, Plato, and the Vases," *Journal of Hellenic Studies*, v. 111 (1991): 182–93; Andrew Stewart, *Art, Desire, and the Body in Ancient Greece* (Cambridge: Cambridge University Press 1997), 24–42; and Scanlon, *Eros and Greek Athletics*, 205–19.

39. Homer *Iliad* 22.71–81. The same idea is expressed by Tyrtaios; see Bonfante, "Nudity as a Costume in Classical Art," 547–48.

40. Herrmann, *Olympia: Heiligtum und Wettkampfstätte*, pls. 10, 11c–e, 13, 17, 18; Stewart, *Art, Desire, and the Body*, 34–40.

41. Plato *Republic* 5.452c; Thucydides *The Peloponnesian War* 1.6.5.

42. Thuillier, *Les jeux athlétiques*, 388–89.

43. Plato *Charmides* 1154d; Stewart, *Art, Desire, and the Body*, 63–65; Scanlon, *Eros and Greek Athletics*, 204.

44. See Kate Zernike, "Old Enough To Make a Lanyard, and To Do It Nude," *New York Times*, June 18, 2003, A18.

45. Stewart, *Art, Desire, and the Body*, 108–18; Scanlon, *Eros and Greek Athletics*, 220–22.

46. For a recent treatment of homoeroticism, pederasty, and athletics, see Scanlon, *Eros and Greek Athletics*, 64–97, 199–273.

47. Pat Griffin, *Strong Women, Deep Closets: Lesbians and Homophobia in Sports* (Champaign, Ill.: Human Kinetics, 1998) and Billy Bean, *Going the Other Way: Lessons from a Life In and Out of Major-League Baseball* (New York: Marlowe, 2004), cited in Johnny Diaz, "Playing It Out," *Boston Globe*, June 23, 2003, D13.

48. Stewart, *Art, Desire, and the Body*, 8–12.

49. Ellen D. Reeder, ed., *Pandora: Women in Classical Greece,* exh. cat. (Baltimore: Walters Art Gallery, 1995), 20–26.

50. Anne C. Reese and Irini Vallera-Rickerson, *Athletries: The Untold History of Ancient Greek Women Athletes* (Costa Mesa, Calif.: Nightowl Publications, 2002), 139–64.

51. On Olympia and Nemea, see Pausanias *Description of Greece* 5.16.2; Scanlon, *Eros and Greek Athletics*, 110; and Reese and Vallera-Rickerson, *Athletries*, 83, 147. For other festivals (Epidauros, Isthmia, Sikyon, and Sparta in the Peloponnesos; Brauron, Delphi, and

Munichion in central Greece; and perhaps elsewhere), see Wilhelm Dittenberger, *Sylloge Inscriptionum Graecarum* (Leipzig: S. Hirzel, 1917), 2: inscrip. 802; Reese and Vellera-Rickerson, *Athletries*, 76, 143, 147, 155, 158; and Scanlon, *Eros and Greek Athletics*, 102–5, 371 n. 25. On Brauron and its vases, see Reeder, *Pandora*, 321–26, cat. nos. 98–99, and Stewart, *Art, Desire, and the Body*, 122–24, fig. 74.

52. On costumes with one shoulder strap, see Nancy Serwint, "The Female Athletic Costume at the Heraia and Prenuptial Initiation Rites," *American Journal of Archaeology*, v. 97 (1993): 403–22; Stewart, *Art, Desire, and the Body*, 33; and Scanlon, *Eros and Greek Athletics*, 98–102, 108, figs. 4-1, 4-2. On other running outfits, see Scanlon, *Eros and Greek Athletics*, 102–6, figs. 4-3, 4-4, 4-5.

53. A hydria in the Vatican: see Nicolaos Yalouris, *The Eternal Olympics: The Art and History of Sport* (New Rochelle, N.Y.: Caratzas Brothers, 1979), fig. 23.

54. Stewart, *Art, Desire, and the Body*, 108–18; Scanlon, *Eros and Greek Athletics*, 121–27.

55. Stewart, *Art, Desire, and the Body*, 108–12, fig. 66; 231–34; Scanlon, *Eros and Greek Athletics*, 130–37, figs. 5-3, 5-4.

56. John Boardman with advice from G. Arrigoni, "Atalante," *Lexicon iconographicum mythologiae classicae*, v. 2 (Zurich and Munich: Artemis Verlag, 1984): 945–50, cat. nos. 62–90, pls. 695–99; Reeder, *Pandora*, 363–71, cat. nos. 117–19.

57. Propertius *Poems* 3.14.1–4, as translated in Scanlon, *Eros and Greek Athletics*, 121.

58. Verena Paul-Zinzerling, *Der Jena-Maler und sein Kreis* (Mainz: Philipp von Zabern, 1994), 112–18, pls. 54–64; Stewart, *Art, Desire, and the Body*, 121–23, 252, fig. 73.

59. On the ball is painted:

ΜΥΡΡΙΝΕΣΕΙΜΙ Μυρρίνες εἰμί
ΝΑΙΧΙ ναίχι

"I belong to Myrrhine."
"Yeah."

An inscription is incised in a circle on top of the ball:

ΗΟΠΑΙΣΚΑΛΟΣ
ΗΟΣΕΟΙΚΕΝΑΠΟΤΟΝΕΡΙΟΝΕΝΑΙ
ὁ παῖς καλός ὃς ἔοικεν ἀπὸ τὸν ἐρίον ἔναι

"That boy is beautiful, that is how he looks as he comes from the [games at the] funeral mounds [*eria*]."

On the bottom of the ball is incised:

ΜΥΡΡΙΝΕΣΕΙΜΙ Μυρρίνες εἰμι

"I belong to Myrrhine."

These translations were provided by Annewies van den Hoek and Gregory Nagy.

60. Scanlon, *Eros and Greek Athletics*, 245–49.

61. Neils, *Goddess and Polis*, 18–20; John Travlos, *Pictorial Dictionary of Ancient Athens* (London: Thames and Hudson, 1971), 291, 498–503, fig. 379 n. 198.

62. Mallwitz, *Olympia und seine Bauten*, 64–65.

63. Ibid., 20–24.

64. Pausanias *Description of Greece* 5.17.5–5.19.10.

65. Mallwitz, *Olympia und seine Bauten*, 84–89.

66. Charles Seltman, *The Temple Coins of Olympia* (Berlin: Mayer and Müller, 1921); Klose and Stumpf, *Sport, Spiele, Sieg*, 27–37, cat. nos. 1–33.

67. Herrmann, *Olympia*, 69–70, n. 254; Scanlon, *Eros and Greek Athletics*, 113.

68. Arnold, "Agonistic Festivals in Italy and Sicily," 245–51; Poliakoff, *Combat Sports in the Ancient World*, 102–3.

69. Georg Wissowa, "Capitolia," in Georg Wissowa, ed., *Paulys Real-encyclopädie der classischen Altertumswissenschaft* (Stuttgart: Metzlersche Verlagsbuchhandlung, 1899), 3:1527–29; Samuel Ball Platner and Thomas Ashby, *A Topographical Dictionary of Ancient Rome* (London: Oxford University Press, 1929), 495; Edward Norman Gardiner, *Athletics of the Ancient World* (Oxford: Clarendon Press, 1930), 118–19; Arnold, "Agonistic Festivals in Italy and Sicily," 245; Ernst Nash, *Pictorial Dictionary of Ancient Rome* (New York and Washington, D.C.: Praeger, 1962), 2:387–90.

70. On the end of Olympia, see Mallwitz, *Olympia und seine Bauten*, 110–17, and Swaddling, *The Ancient Olympic Games*, 99–101.

71. Arnold, "Agonistic Festivals in Italy and Sicily," 249; Marrou, *A History of Education*, 131–32.

72. Swaddling, *The Ancient Olympic Games*, 104–6.

THE ORIGINS OF THE GAMES

1. Pausanias *Description of Greece* 5.13.4–6. Pelops's shoulder blade was probably a fossil of a large extinct mammal: see Adrienne Mayor, *The First Fossil Hunters: Paleontology in Greek and Roman Times* (Princeton: Princeton University Press, 2000), 104–10.

2. The above analysis is guided by Helmut Kyrieleis, "Zeus and Pelops in the East Pediment of the Temple of Zeus at Olympia," in *The Interpretation of Architectural Sculpture in Greece and Rome*, ed. Diana Buitron-Oliver, 13–27 (Washington D.C.: National Gallery of Art, 1997).

3. For other examples of bronze libation pourers, see Renate Thomas, *Athletenstatuetten der Spatarchaik und des Strengen Stils* (Rome: Giorgio Bretschneider, 1981), 102, pls. 55–77.

4. Walter W. Hyde, *Olympic Victor Monuments and Greek Athletic Art* (Washington, D.C.: Carnegie Institute of Washington, 1921), 21–24.

5. Thucydides *History of the Peloponnesian War* 5.49–50.

6. Pindar *Olympian Odes* 6.65–70 and 10.24–59.

7. For a fuller discussion of the Herakles iconography at Olympia, see Beth Cohen, "From Bowman to Clubman: Herakles and Olympia," *Art Bulletin*, v. 76 (1994): 696–714.

8. Pindar *Olympian Ode* 10.55–59, as translated by John Sandys in *The Odes of Pindar*, 115.

RUNNING

1. Pindar *Olympian Ode* 13.

2. We would like to thank David Romano, at the University of Pennsylvania Museum of Archaeology and Anthropology, for sharing his unpublished essay on ancient runners, from which this quote and the one that follows are excerpted.

3. Pausanias *Description of Greece* 1.44.1.

4. Ibid., 5.12.8.

5. See Hugh M. Lee, "Stadia and Starting Gates," *Archaeology*, v. 49 (1996): 35.

6. Stephen Miller, "Turns and Lanes in the Ancient Stadium," *American Journal of Archaeology*, v. 84 (1980): 159–66.

7. Aristophanes *Frogs* 1089–98.

8. Scanlon, *Eros and Greek Athletics*, 273.

THE PENTATHLON

1. See Jackson, "Philostratus and the Pentathlon," 178–81.

2. Alberto E. Minetti and Luca P. Ardigo, "Halteres Used in Ancient Olympic Long Jump," *Nature,* v. 420 (November 14, 2002): 141–42.

3. Pausanias *Description of Greece* 5.26.3, as translated in Miller, *Arete,* 43.

4. Philostratos *On Gymnastics* 35, as translated in Miller, *Arete,* 39.

5. See Ariel Herrmann, "The Boy with the Jumping Weights," *The Bulletin of the Cleveland Museum of Art* (September 1993): 299–323.

6. See Hugh M. Lee, "The Terma and the Javelin in Pindar, Nemean vii 70–3, and Greek Athletics," *Journal of Hellenic Studies,* v. 96 (1976): 70–79.

7. ΕΚΤΟΝΕ[ΡΙ]ΟΝ ἐκ τôν ἐ[ρί]ον.

8. Lewis, *Inscriptiones graecae,* vol. 1, *Attica,* no. 1395 (see p. 164, n. 4). Thanks go to Annewies van den Hoek for providing this reference and translation. The inscription on the New York marble discus reads:

ΤΕΛΕΣΑΡΧΟΕΚΤΟΕΡΙ[Ο]
Τελεσάρχο ἐκ τô ἐρί[ο]

"Belonging to Telesarchos from the [funeral games at the] burial mound [*erion*]."

Both the New York and Boston discuses were part of the collection of E. P. Warren and were sold in 1929.

COMBAT EVENTS

1. Artemidoros *Book on Dreams* 1.62.

2. Charles K. Williams and Pamela Russell, "Corinth: Excavations of 1980," *Hesperia,* v. 50 (1981): esp. 15–21.

3. Plato *Laws* 796 A.

4. Philostratos *On Gymnastics* 9–10, as translated in Miller, *Arete,* 31.

EQUESTRIAN EVENTS

1. Isokrates *The Team of Horses* 32–35, as translated in Miller, *Arete,* 53.

2. See Seán Hemingway, *The Horse and Jockey from Artemision: A Bronze Equestrian Monument of the Hellenistic Period* (Berkeley: University of California Press, 2004).

3. Pindar *Pythian Ode* 5.49–54.

4. See Mark Golden, *Sport and Society in Ancient Greece* (Cambridge: Cambridge University Press, 1998), 121, table E5.

5. Homer *Iliad* 23.629–37.

6. Sophocles *Electra* 720–48, as translated by Hugh Lloyd-Jones in *Sophocles: Ajax, Electra, Oedipus Tyrannus,* Loeb Classical Library (Cambridge, Mass.: Harvard University Press, 1994), 230–33.

THE TRAINING GROUNDS

1. Pausanias *Description of Greece* 6.23–24.

2. As translated in Scanlon, *Eros and Greek Athletics,* 211.

3. Judith Barringer, *The Hunt in Ancient Greece* (Baltimore: Johns Hopkins University Press, 2001), 59, 88.

4. Plato's account of the physical layout of the palaistra and the activities therein is given in his *Lysis* 203a–11a.

5. Plato *Laws* 8.839E–40A; see Sweet, *Sport and Recreation in Ancient Greece,* 115.

6. Lucian *Lexiphanes* 5, as translated in Sweet, *Sport and Recreation in Ancient Greece,* 114.

7. As translated in Miller, *Arete,* 19.

8. The source for the Palaistra legend is Philostratos *Imagines* 2.32; see the translation by Arthur Fairbanks in *Philostratus the Elder and the Younger. Imagines,* Loeb Classical Library (Cambridge, Mass.: Harvard University Press, 1979), 262–65, esp. n. 1.

9. The role of Eros in Greek athletics has been the focus of recent scholarship. See in particular Scanlon, *Eros and Greek Athletics,* esp. 251–73.

10. Athenaeus *The Sophists at Dinner* 16.561d, as translated in Scanlon, *Eros and Greek Athletics,* 267.

THE VICTORS

1. For a critical discussion of the Greeks and their competitions, see Golden, *Sport and Society in Ancient Greece,* 28–33.

2. The values are estimated based on the modern price of a liter of the highest grade olive oil; see Golden, *Sport and Society in Ancient Greece,* 142. The quantities of prize vessels awarded to each athlete are based on an Athenian inscription dated to the first half of the fourth century B.C.

3. Neils, *Goddess and Polis,* 39–40.

4. Athenaeus *The Sophists at Dinner* 12.521F; see Miller, *Arete,* 188–89.

5. Pausanias *Description of Greece* 6.13.1; see Miller, *Arete,* 183.

6. Pausanias *Description of Greece* 5.6.7–8.

7. Ibid. 5.21.5; see Miller, *Arete,* 188.

8. Emiko Tanaka, "Athleten auf Grabstelen," in *Temenos: Festgabe für Florens Felten und Stefan Hiller,* ed. Beatrix Asamer et al. (Vienna: Phoibos Verlag, 2002), 131–39.

9. Thomas, *Athletenstatuetten der Spätarchaik,* 17, 20.

10. Ekrem Akurgal, *Griechische und Römische Kunst in der Türkei* (Munich: Hirmer Verlag, 1987), 142, pls. 227–29; R. R. R. Smith, *Hellenistic Sculpture: A Handbook* (New York: Thames and Hudson, 1991), 55, fig. 61; Marta Weber, "Zum griechischen Athletenbilde: Zum Typus und zur Gattung des Originals der Apoxyomenosstatue im Vatican," *Römische Mitteilungen,* v. 103 (1996): 31–49; Brunilde Sismondo Ridgway, *Hellenistic Sculpture,* vol. 2, *The Styles of ca. 200–100 B.C.* (Madison: University of Wisconsin Press, 2000), 331, pl. 76.

11. ΙΕΡΟΣ ΑΓΩΝ. See Fulvio Canciani, "Agon," *Lexicon iconographicum mythologiae classicae,* v. 1 (1991): 304, no. 17, pl. 225; and Klose and Stumpf, *Sport, Spiele, Sieg,* 93, cat. no. 173.

12. "Statues of nude youths, like the *ephebes* frequenting the gymnasiums, who carry a spear and were referred to as Achillean": Pliny *Natural History* 34.10, as translated by H. Rackham, Loeb Classical Library (Cambridge, Mass.: Harvard University Press, 1968), 9:141. See Jeffrey M. Hurwit, "Doryphoros: Looking Backward," in *Polykleitos, the Doryphoros, and Tradition,* ed. Warren G. Moon (Madison: University of Wisconsin Press, 1995), 17 n. 59; and John Boardman, *Greek Sculpture: The Classical Period* (London: Thames and Hudson, 1985), 205, fig. 184.

13. Weber, "Zum griechischen Athletenbilde," 46.

14. Lucian *Essays in Portraiture Defended* 11; see Weber, "Zum griechischen Athletenbilde," 24.

15. Xenophon *The Banquet* 2.3–4, cited in Weber, "Zum griechischen Athletenbilde," 40.

16. Klose and Stump, *Sport, Spiele, Sieg,* 139–40, cat. nos. 278–79 (oiling), 284 (cleaning).

ANNOTATED CHECKLIST AND FIGURE LIST

ORIGINS, MYTHS, AND GODS

1.
Wine-mixing bowl (krater) depicting belt wrestling (p. 44, detail)
Greek, probably made in Cyprus, probably found on Rhodes
Late Bronze Age, about 1350–1250 B.C.
Ceramic
H. 43.6 cm (17 ³⁄₁₆ in.)
Museum of Fine Arts, Boston. Henry Lillie Pierce Fund 01.8044

Provenance: By the 1870s: Cesnola Collection in Cyprus; by 1901: with E. P. Warren (bought in London; said to come from Rhodes); purchased by MFA from E. P. Warren, December 1901.

On this vase two pairs of men are belt wrestling, while a procession of chariots passes by. The scene may illustrate a funeral with athletic contests in honor of the deceased. Funeral games were common in ancient Greece and were precedents to organized Panhellenic games.

2.
Statue of Herakles (p. 54)
Roman, found in Rome; based on a Greek original of the mid-5th century B.C., perhaps by Myron
Roman Imperial period, probably about
A.D. 117–38

Marble
H. 57 cm (22 ⁷⁄₁₆ in.)
Museum of Fine Arts, Boston. Francis Bartlett Donation of 1912 14.733

Provenance: By 1903: with E. P. Warren (said to have been found in Rome, between the Aventine and the Tiber); purchased by MFA from E. P. Warren, August 6, 1914.

Herakles holds his club and the skin of the Nemean lion, visual reminders of his first labor, in which he wrestled a lion to death. The mortal son of Zeus, Herakles is considered the founder of the Olympic Games and a heroic model for all athletes.

3.
Drinking cup (kylix) depicting Herakles wrestling the Nemean lion (p. 53)
Greek, made in Athens, probably found in Caere (modern Cerveteri), Etruria
Archaic period, about 530–510 B.C.
Ceramic, black-figure technique; painted by a member of the Segment Class
H. 7.7 cm (3 ¹⁄₁₆ in.)
Museum of Fine Arts, Boston. Gift of Robert E. Hecht, Jr. and George Allen 60.1172

Provenance: By 1960: with Robert E. Hecht, Jr., and George Allen (said to come from Cerveteri); gift of Robert E. Hecht, Jr., and George Allen to MFA, October 13, 1960.

Leaving his bow and quiver of arrows hanging in the tree behind him, Herakles used his bare hands to choke the lion to death. In depictions of his labors he often is shown as a nude athlete, reflecting that his heroic feats were an inspiration to the actual competitors.

4.
Vase for bath water (loutrophoros) depicting Pelops and Hippodameia in a chariot (p. 42, detail)
Greek, made in Apulia
Early Hellenistic period, about 320–310 B.C.
Ceramic, red-figure technique; painted by the White Sakkos Painter
H. 80 cm (31 ½ in.)
Museum of Fine Arts, Boston. Mary S. and Edward J. Holmes Fund 1988.431

Provenance: By 1984: with Sotheby's, London (auction, December 10, 1984, lot 366); by 1985: with Royal-Athena Galleries, New York; purchased by MFA from Royal-Athena Galleries, October 26, 1988.

This vase illustrates one of the founding legends of the Olympic Games. Pelops, a prince from Asia Minor, won the hand of Hippodameia by beating her father, Oinomaos, king of Pisa (near Olympia), in a chariot race. Had Pelops lost, Oinomaos would have killed him. Here Pelops and Hippodameia ride together in the hero's chariot. The scene may represent either the race itself or the couple riding off into the future. Through this mythical episode, Pelops was considered the founder of the Olympic chariot race.

5.
Funerary urn carved with Pelops and Hippodameia after winning the race against Oinomaos (p. 49)
Etruscan, made in or near Velathri, Etruria
Hellenistic period, about 150–100 B.C.
Alabaster
H. 52.7 cm (20 ¾ in.), l. 70 cm (27 ⁹⁄₁₆ in.), w. 28.5 cm (11 ¼ in.)
Princeton University Art Museum. Gift of David G. Carter, Class of 1945, in memory of Charles Rufus Morey y1986-68
Photograph by Bruce M. White. © 2003 Trustees of Princeton University

King Oinomaos's charioteer, Myrtilos, betrayed his master by sabotaging his chariot in the race at Olympia for the hand of the king's daughter, Hippodameia. Here Myrtilos, who secretly loved Hippodameia, helps her down from the chariot, while she looks longingly back at Pelops. Oinomaos lies trampled below the chariot, as a sea monster and two death-demons look on. Pelops later killed Myrtilos, making the Olympic founding legend a double tragedy.

6.
Head of Zeus (p. 52)
Greek, said to have been found at Mylasa, Asia Minor
Late Classical period, about 350–340 B.C.
Marble, from Mount Pentelikon near Athens
H. 48 cm (18 ⅞ in.)
Museum of Fine Arts, Boston. Henry Lillie Pierce Fund 04.12

Provenance: By 1904: with E. P. Warren (said to be from Mylasa in Asia Minor); purchased by MFA from E. P. Warren, January 19, 1904.

This head, carved by an Athenian sculptor working in southwest Asia Minor, was inspired by Pheidias's colossal statue of Zeus, which stood in the Temple of Zeus at Olympia. Completed about 430 B.C., the Olympian Zeus was a key cult statue to which athletes made vows and sacrifices. Well over life-size and made of valuable materials, including ivory, gold, silver, and bronze, it was considered one of the seven wonders of the ancient world.

7.
Pair of figures, probably Zeus and Hera (p. 50)
Greek, possibly from Olympia
Geometric period, 8th century B.C.
Bronze
H. 8 cm (3 ⅛ in.)

Museum of Fine Arts, Boston. Gift of Leslie Hastings, Esq. 63.2755

Provenance: Date unknown in the nineteenth century: acquired by Mr. Hastings's grandfather, possibly from Olympia; by 1958: Leslie Hastings, Esq., Collection; 1958: loaned by Leslie Hastings to MFA; gift of Leslie Hastings to MFA, December 31, 1963.

This statuette represents Zeus, the key deity for whom the Olympic Games were celebrated, and his wife, Hera. Zeus wears a pointed, curving helmet and a large belt, and Hera wears a rounded cap. This particular image is close in date to the traditional founding of the Olympic Games in 776 B.C. It may have been a votive object, an offering of thanks dedicated to Zeus and Hera.

8.
Coin depicting seated Olympian Zeus (on reverse) (p. 38)
Obverse: Head of Antiochus as Zeus (p. 38)
Greek, minted at Antioch, Syria
Hellenistic period, 166 B.C.
Silver tetradrachm
Diam. 32 mm (1 ¼ in.), weight 16.70 gm
Museum of Fine Arts, Boston. Anonymous gift in memory of Zoë Wilbour (1864–1885) 35.133

Provenance: By 1925: with Naville & Cie., Geneva, Switzerland (Naville sale 10, Hôtel Schweizerhof, Lucerne, June 15–18, 1925, lot 1048); by 1935: anonymous private collection; anonymous gift to MFA in memory of Zoë Wilbour, April 4, 1935.

This coin closely replicates Pheidias's statue of Zeus. Although the original statue was quite famous, it did not survive and is known only from copies, many of them on coins such as this one. Here we see Zeus seated on an elaborate throne, wearing a wreath on his head and holding Victory in his right hand and a scepter in his left.

9.
Coin depicting the head of Zeus (on obverse) (p. 38)
Reverse: Eagle (p. 38)
Greek, minted at Olympia
Classical period, about 365–323 B.C.
Silver stater
Diam. 24 mm (¹⁵⁄₁₆ in.), weight 12.03 gm
Museum of Fine Arts, Boston. Henry Lillie Pierce Fund 04.892

Provenance: Said to be Catalogue Hoffmann, Photiades Pacha, 1890, lot 1039, Catalogue Sotheby, Montagu, 1896, lot 411, and Canon Greenwell Collection; by 1904: with E. P. Warren; purchased by MFA from E. P. Warren, September 1904.

The coins minted at Olympia helped the state of Elis cope with—and profit from—the huge numbers of athletes and spectators who flooded the area every four years. The coins probably served as mementos as well as a medium of exchange among visitors at Olympia. This Zeus is inspired by the colossal sculpture created by Pheidias.

10.
Coin depicting the head of Hera (on obverse) (p. 38)
Reverse: Upright thunderbolt (p. 38)
Greek, minted at Olympia
Classical period, about 420–385 B.C.
Silver stater
Diam. 22 mm (⅞ in.), weight 12.11 gm
Museum of Fine Arts, Boston. Henry Lillie Pierce Fund 04.889

Provenance: By date unknown: Canon Greenwell Collection; July 1902: acquired from the Canon Greenwell Collection by E. P. Warren; purchased by MFA from E. P. Warren, September 1904.

Relatively little is known about the athletic games for girls that were held at Olympia in honor of Hera. Hippodameia is said to have founded them. Unmarried girls competed in a footrace five-sixths the length of the stadium. The temple, altars, and images of Hera at Olympia serve to remind us of these parallel games for girls and suggest that Zeus and Hera were more equal partners in the early sanctuary.

11.
Statuette of Artemis (p. 40)
Greek, made in Laconia, the region surrounding Sparta, said to have been found at Mazi
Archaic period, about 530–520 B.C.
Bronze
H. 19.2 cm (7 9/16 in.)
Inscription: "Chimaridas [dedicated this] to [Artemis] Daidaleia" (on skirt)
Museum of Fine Arts, Boston. Henry Lillie Pierce Fund 98.658

Provenance: By 1897: Count Michel Tyszkiewicz Collection; 1898: auction of the M. Tyszkiewicz Collection, Paris, June 8–10, lot 139 (said to have been found at Mazi, near Olympia, in 1897); by 1898: with E. P. Warren; purchased by MFA from E. P. Warren, 1898.

Many altars at Olympia were dedicated to Artemis, goddess of wild nature and of health, a prime concern of every athlete.

12.
Statuette of an athlete pouring a libation (p. 51)
Roman, said to have been found in Phoenicia (modern Lebanon)
Roman Imperial period, first half of the 1st century A.D.
Bronze
H. 22 cm (8 11/16 in.)
Inscription: "Poublis [and] Achaiikos, having vowed, dedicated [this]" (on right thigh)
Collection of Shelby White and Leon Levy
Photograph by Sheldan Comfort Collins. © 1990 The Metropolitan Museum of Art

This figure originally held a libation bowl in his right hand and may have held a palm of victory or a pitcher in his left. An athlete might pour a libation as he swore his vows—primarily to follow the rules—at the beginning of the games. He might also pour a libation to a particular god in hopes of gaining his or her favor. Most athletic competitions were essentially religious events, and victors were often said to have divine blessings.

13.
Statuette of a young athlete (p. 154)
Greek, probably found at Olympia
Archaic period, about 540–520 B.C.
Bronze
H. 16.6 cm (6 9/16 in.)
Museum of Fine Arts, Boston. Francis Bartlett Donation of 1900 03.996

Provenance: By 1903: with E. P. Warren (said to be from Olympia); purchased by MFA from E. P. Warren, March 1903.

The fillet or wreath around this youth's head may indicate that he is a victor. The position of his arms and the holes in his hands suggest that he was originally holding jumping weights. This may have been an offering of thanks to Zeus presented by a victorious pentathlete.

14.
Libation bowl (p. 51)
Greek, said to have been found at Olympia
Orientalizing period, 7th century B.C.
Gold
Diam. 15 cm (5 7/8 in.)
Inscription: "The sons of Kypselos dedicated [this bowl] from Heraclea" (on exterior just under rim)
Museum of Fine Arts, Boston. Francis Bartlett Donation 21.1843

Provenance: By 1921: with Mr. D. K. Tseklenis and Mr. Stratos, Boston (said to come from Olympia, discovered five years ago east of the Altis between the stadium and the river Alpheios, in the bank of a small torrent formed by winter rains); purchased by MFA, September 1, 1921.

This dedication was made by the ruling family of Corinth, perhaps in thanks for success in a battle at Heraclea. It is uncertain what city of that name is meant. Only the wealthiest of Greeks could afford such a valuable dedication.

15.
Fragment of a helmet (p. 64)
Greek, said to have been found at Olympia
Archaic period, about 680–620 B.C.
Bronze
Diam. 25 cm (9 13/16 in.)
Inscription: "Of Olympian Zeus" (on side)
Museum of Fine Arts, Boston. Museum purchase by contribution 01.7479

Provenance: By 1901: with E. P. Warren (bought from Mr. Rhousopoulos; said to come from Olympia); purchased by MFA from E. P. Warren, December 1901.

Unlike many votives, this helmet was used before being dedicated. The small holes, mainly along the edge of the helmet, were for sewing in a leather lining. The letters of the inscription suggest that a Spartan dedicated the helmet. It would have been an offering of thanks for victory in battle.

16.
Statuette of a horse (p. 22)
Greek, probably found near the city of Elis
Geometric period, about 750 B.C.
Bronze
H. 8 cm (3 1/8 in.)
Museum of Fine Arts, Boston. William E. Nickerson Fund No. 2, 1965 65.1316

Provenance: By 1965: with a dealer in Athens (said to come from near Elis); purchased by MFA, November 10, 1965.

Horses were probably the most common votive dedication at Greek sanctuaries in the early Archaic period. Because of the expense required to raise and maintain the animal, the horse became an image associated with the wealthy elite of Greek society.

17.
Miniature chariot wheel (p. 50)
Greek, said to have been found near Delphi
Archaic period, about 525–500 B.C.
Bronze
Diam. 16 cm (6 5/16 in.)
Inscription: "Phalas son of Pediarcheion dedicated [this] to Apollo" (on rim)

Museum of Fine Arts, Boston. William Amory
Gardner Fund 35.61

Provenance: By 1935: with T. Zoumpoulakis,
Athens (said to be from near Delphi [Galaxidi, or
ancient Chaleion]); purchased by MFA from T.
Zoumpoulakis, March 7, 1935.

Although small in size, this votive chariot wheel is
realistic; it even has a hole for an axle. It must have
been a gift from a member of a chariot team. Its size
and material suggest that it may have come from a
charioteer and not a wealthy horse owner.

18.
Statue of Athena the Virgin (Athena Parthenos)
(p. 47)
Roman; reduced copy of the cult image made by
Pheidias for the Parthenon at Athens, about
438 B.C.
Roman Imperial period, about A.D. 138–238
Marble, from Mount Pentelikon near Athens
H. 154 cm (60 ⅝ in.)
Museum of Fine Arts, Boston. Classical Department
Exchange Fund 1980.196

Provenance: By 1980: with Antiken/H. Herzer and
Co., Munich; purchased by MFA from Heinz
Herzer, April 16, 1980.

The citizens of Athens held the major Panathenaic
Games every four years in honor of their patron, the
goddess Athena. In addition to the athletic events
held at other games, the Panathenaic Games includ-
ed torch races, boat races, musical contests, and
even a male beauty pageant. This statue is a copy of
the one that stood in the Parthenon.

19.
Oil flask (lekythos) depicting a sacrificial procession
(p. 46, detail)
Greek, made in Athens, probably found at Gela,
Sicily
Archaic period, about 520–510 B.C.
Ceramic, red-figure technique; painted by the Gales
Painter; signed by the potter Gales
H. 31 cm (12 ³/₁₆ in.)
Inscription: "Gales made it" (on lip)
Museum of Fine Arts, Boston. Frances Bartlett Fund
13.195

Provenance: By 1912: with E. P. Warren (said to be
from Gela); purchased by MFA from E. P. Warren,
January 2, 1913.

Most ancient athletic games were part of religious
festivals held to honor specific deities. Here a girl
leads a procession to the place of sacrifice, holding a
ritual basket on her head. Called a *kanephoros,* she
is followed by two adorned cows attended by two
wreathed youths. Kanephoroi took part in the pro-
cession at the Panathenaic festival, which ended
with the sacrifice of one hundred cattle whose meat
was then roasted and shared by all Athenian citi-
zens. Meat was a luxury for most Greeks so sacri-
fices like these provided rare occasions when many
Greeks would eat meat.

20.
Statuette of a bull (not illustrated)
Roman
Roman Imperial period, about 2nd century A.D.
Silver
H. 4.9 cm (1 ¹⁵/₁₆ in.)
Museum of Fine Arts, Boston. Theodora Wilbour
Fund in memory of Charlotte Beebe Wilbour
1973.215

Provenance: By 1973: with Mathias Komor (said to
come from an old English collection); purchased by
MFA from Mathias Komor, May 9, 1973.

A bull was a splendid offering, whose sacrifice both
pleased the gods and gave the citizens a rare meal of
roasted meat. The sacrifice of bulls and other large
animals was always part of the ritual of athletic games.

21.
Statue of Eros (p. 143)
Roman, said to be from coastal Syria; perhaps
based on a Greek original of the 4th century B.C. by
Praxiteles
Roman Imperial period, about A.D. 190
Marble, probably from the Greek island of Paros
H. 63 cm (24 ¹³/₁₆ in.)
Museum of Fine Arts, Boston. Classical Department
Exchange Fund 1979.477

Provenance: By 1979: with Münzen und Medaillen
AG, Switzerland (shown at Schweizerische Kunst-
und Antiquitätenmesse 1979, Basel, March 24
through April 3); purchased by MFA from Münzen
und Medaillen AG, October 17, 1979.

Eros, shown here as a beautiful youth, played a vari-
ety of roles in Greek athletic life. The god of love
was associated with wrestling, with competition,
with education and socialization, and with the
friendships and love affairs that often were formed
in the gymnasion.

22.
Wine-mixing bowl (krater) depicting a torch race
(p. 71, detail)
Greek, made in Athens, found in Gela, Sicily
Classical period, about 430–420 B.C.
Ceramic, red-figure technique; painted in the man-
ner of the Peleus Painter
H. 36.1 cm (14 ³/₁₆ in.)
Courtesy of the Arthur M. Sackler Museum,
Harvard University Art Museums, Bequest of
David M. Robinson 1960.344
Photograph by Michael A. Nedzweski. © 2003
President and Fellows of Harvard College

This scene depicts the torch race held at Athens as
part of the Panathenaic festival. The vase in front of
the runner is a prize for the winning team. Each
Athenian tribe fielded forty runners, each of whom
would carry a torch about fifty-five meters (sixty
yards).

23.
Coin depicting a race torch and prize tripod
(on reverse) (p. 48)
Obverse: Head of Apollo (p. 48)
Greek, minted at Amphipolis, Macedonia
Classical period, about 410–390 B.C.
Silver tetradrachm
Diam. 25 mm (1 in.), weight 14.32 gm
Museum of Fine Arts, Boston. Catharine Page
Perkins Fund 00.160

Provenance: Said to be from the Saloniki Hoard of
1859 and Catalogue Hoffmann, de la Salle auction,
April 4, 1877, pl. ii, 321; by 1882: Ferdinand
Bompois Collection (auction of the F. Bompois
Collection, January 16ff., 1882, Paris, lot 713); by
1900: with E. P. Warren; purchased by MFA from
E. P. Warren, 1900.

The simple juxtaposition of a torch and a prize tri-
pod work well to convey the idea of a torch race in
the very limited space available on a coin.

24.

Coin depicting a victorious ship (on reverse)
(p. 27)
Obverse: Head of Emperor Septimius Severus
(p. 27)
Roman provincial, minted on Corcyra
Roman Imperial period, about A.D. 193–211
Bronze
Diam. 27.5 mm (1 ⅟₁₆ in.), weight 12.20 gm
Museum of Fine Arts, Boston. Gift of Mr. and Mrs.
Cornelius C. Vermeule III 1998.539

Provenance: By date unknown: Mr. and Mrs.
Cornelius C. Vermeule III Collection; gift of Mr.
and Mrs. Cornelius C. Vermeule III to MFA,
December 16, 1998.

The figure of Victory can be seen standing on the
prow of this ship, an indication that the ship was
victorious in a boat race (naval battles were a thing
of the past in the middle Roman Imperial period).
While boat races were not a part of the Olympic
Games, they were a part of other games, including
the Panathenaic Games in Athens. This coin was
probably minted at Corcyra to celebrate a victory at
games held in nearby Actium, on the west coast of
Greece well to the north of Olympia.

RUNNING

PANATHENAIC AMPHORAE (CAT. NOS. 25–27)

Victors in the Panathenaic Games in Athens were
rewarded with several large vases, each holding a
substantial amount (between 35 and 40 liters [9 ¼
and 10 ½ gallons]) of valuable olive oil. Each official
prize vase carries the same decoration: the front
side depicts the city's patron goddess, Athena,
striding between two columns usually topped by
cocks. The official inscription, "From the games at
Athens," runs vertically next to the left column. On
the other side is a representation of an athletic
event. Panathenaic vases were always painted in
black-figure technique, even long after that style of
vase painting had fallen out of fashion. Athenian
workshops also produced many other black-figure
vases of the Panathenaic shape, decorated with
scenes of athletic competition, but they were not
prizes, since they lack the official inscription.

25.

Pseudo-Panathenaic vase (amphora) depicting
sprinters (p. 68, detail)
Greek, made in Athens
Archaic period, about 540 B.C.
Ceramic, black-figure technique; painted by a
Painter of Louvre F6
H. 30.5 cm (12 in.)
Collection of Shelby White and Leon Levy
Photograph by Sheldan Comfort Collins. © 1990
The Metropolitan Museum of Art

Because both sides of this vase depict sprinters, it
was not an official Panathenaic prize.

26.

Panathenaic prize vase (amphora) depicting sprint-
ers (side B) (p. 62, detail)*
Side A: Panathenaic Athena
Greek, made in Athens, found near Euesperides,
Cyrenaica (modern Benghazi, Libya)
Classical period, 392 or 391 B.C.
Ceramic, black-figure technique; painted by a
member of the Asteios Group
H. 70.5 cm (27 ¾ in.)
Inscription: "From the games at Athens" (on side A)
Detroit Institute of Arts. Founders Society
Purchase, General Membership Fund 50.193 a,b
Photograph © 1978 The Detroit Institute of Arts

Here the sprinters are shown swinging their arms
freely. The columns on side A are topped by figures
of Ploutos (Wealth) holding a cornucopia instead of
the customary cocks, emphasizing the value of the
prize rather than the fighting spirit required to win it.

27.

Panathenaic prize vase (amphora) depicting dis-
tance runners (side B) (p. 66, detail)
Side A: Panathenaic Athena
Greek, from Athens, found in Vulci, Etruria
Archaic period, about 530–520 B.C.
Ceramic, black-figure technique; painted by the
Euphiletos Painter
H. 60.7 cm (23 ⅞ in.)
Inscription: "From the games at Athens" (on
side A)
Museum of Fine Arts, Boston. Henry Lillie Pierce
Fund 99.520

Provenance: In 1889: excavated at Vulci, tomb
LXXIX, chamber B; 1889: Prince Torlonia
Collection; by 1899: purchased by E. P. Warren
from Prince Torlonia; purchased by MFA from E.
P. Warren, 1899.

Distance runners are shown here with arms flexed.

28.

Wine mixing-bowl (krater) depicting sprinters
(pp. i and 60, details)
Etruscan, made at Caere (modern Cerveteri), Etruria
Classical period, about 480 B.C.
Ceramic, black-figure technique; painted by a
member of the Lotus Bud Group
H. 26.1 cm (10 ¼ in.)
Museum of Fine Arts, Boston. Purchased by
Contribution and Bequest of Charles H. Parker, by
exchange 1998.49

Provenance: Before 1975: Pierre Sciclounoff
Collection, Geneva, Switzerland (said to have been
previously owned by a French collector); 1975:
acquired from Pierre Sciclounoff by Dr. André
Lagneau, Switzerland; 1975: Dr. André Lagneau
Collection; by 1997: with Phoenix Gallery,
Switzerland; April 1997: with Sekhmet Ancient Art
Limited, Gibraltar; 1997: conveyed by Sekhmet
Ancient Art Limited to Phoenix Ancient Art; pur-
chased by MFA from Phoenix Ancient Art, April
22, 1998.

Although the runners are shown in anatomically
incorrect poses, with the arm and leg of the same
side advancing, the artist captures quite well their
mad dash for the finish line: arms and legs pump-
ing, hair flying, jostling side by side. Whereas most
Greek artists depicted runners advancing to the
right, these Etruscan youths run to the left.

29.

Vase (Nikosthenic amphora) depicting athletes
training (pp. 69 and 92)
Greek, made in Athens
Archaic period, about 530 B.C.
Ceramic, black-figure technique; painted by Painter
N; signed by the potter Nikosthenes
H. 31.1 cm (12 ¼ in.)
Inscription: "Nikosthenes made it" (on shoulder)
Collection of Shelby White and Leon Levy
Photograph by Jerry Fetzer, Sotheby's, 2002

Though made to be exported to Etruria, this vase shows the same activities one would see in a Greek palaistra or gymnasion. A pair of boxers and a pair of wrestlers compete; each pair is comprised of an older and a younger athlete. Three youths are shown sprinting, and a jumper practices. Trainers and other athletes observe.

30.
Drinking cup (kylix) depicting palaistra scenes
(pp. 65 and 84, details)
Greek, made in Athens, found in southern Italy
Classical period, about 460 B.C.
Ceramic, red-figure technique; painted by the
Penthesilea Painter
H. 9.8 cm (3 ⅞ in.)
Inscriptions: "The boy is handsome" (once on interior and four times on exterior; all are misspelled)
Museum of Fine Arts, Boston. Helen and Alice
Colburn Fund 28.48

Provenance: Known in the 1750s and published by Mazochius in *In Regii Herculanensis Musaei aeneas tabulas Heracleenses commentarii*, 1754–1758; published by Inghirami in 1824 in *Monumenti etruschi* 5, pl. 69–70 (as being in the Museo degli studi, Naples); by 1928: with Seltman Collection; purchased by MFA from Mr. Seltman, March 1, 1928.

Two decorated starting posts and athletic equipment—such as a discus in its bag—hanging on the wall suggest the palaistra setting, in which we see athletes, probably pentathletes, practicing. A runner bends over into his starting position. The two draped figures carrying forked sticks are trainers. The figure at far right with a pickax is an athlete on his way to dig up and soften the ground for the long jumpers.

31.
Coin depicting an armed runner (on obverse)
(p. 64)
Reverse: Decorative square pattern
Greek, minted at Kyzikos, Asia Minor
Classical period, about 450–400 B.C.
Electrum stater
Diam. 20 mm. (¹³⁄₁₆ in.), weight 16.11 gm
Museum of Fine Arts, Boston. Catharine Page
Perkins Fund 01.5532

Provenance: By 1901: with E. P. Warren; purchased by MFA from E. P. Warren, 1901.

Participants in the armed race (hoplitodromos) ran a short distance but with heavy armor: a helmet, greaves, and shield. Otherwise they were nude. The runner here is in the starting position; his knees bent, he leans forward slightly, stretching out his right arm and holding his shield with his left. His helmet is pushed back on his head, revealing his face. The tuna is the emblem of Kyzikos.

32.
Panathenaic prize vase (amphora) depicting an
armed runner (side B) (p. 14, detail)
Side A: Panathenaic Athena
Greek, made in Athens
Late Archaic period, about 490 B.C.
Ceramic, black-figure technique; painted by the
Kleophrades Painter
H. 65.8 cm (25 ⅞ in.)
Inscription: "From the games at Athens" (side A)
Collection of Nicholas S. Zoullas
Photograph by Bruce M. White. © 2003 Trustees
of Princeton University

This scene probably shows a runner making preparations for the race in armor. Under the watchful eye of an official, the runner compares two shields. A nearby attendant holds a third shield.

PENTATHALON: JUMPING

33.
Bowl (dinos) depicting athletes training (pp. iv–v,
74, and 104, details)
Greek, made in Athens, probably found in Greece
Classical period, about 430–420 B.C.
Ceramic, red-figure technique; painted in the manner of the Dinos Painter
H. 22.1 cm (8 ¹¹⁄₁₆ in.)
Museum of Fine Arts, Boston. Catharine Page
Perkins Fund 96.720

Provenance: By 1896: with E. P. Warren (said to be traceable to Athens); purchased by MFA from E. P. Warren, 1896.

In a palaistra setting, nude youths practice the javelin, boxing, long jump, and the discus throw. Two trainers wearing mantles observe them, and a flute player in a tunic provides a rhythm for a javelin thrower.

34.
Deep cup (skyphos) depicting two jumpers
(pp. 75 and 79, detail)
Greek, made in Athens, probably found in Greece
Early Classical period, about 480 B.C.
Ceramic, red-figure technique; painted by the
Brygos Painter
H. 14.4 cm (5 ¹¹⁄₁₆ in.)
Museum of Fine Arts, Boston. James Fund and by
Special Contribution 10.176

Provenance: By 1901: with E. P. Warren (bought from a Greek in the spring of 1901); purchased by MFA from E. P. Warren, June 2, 1910.

Two jumpers, each holding a different shape of jumping weight, practice under the eyes of trainers. Two discus bags and a toilet kit—sponge, aryballos, and strigil—hang on the wall; a young blond attendant carries another toilet kit. Javelins and a pickax lean against the wall.

35.
Pitcher (oinochoe) depicting a jumper (p. 78, detail)
Greek, made in Athens
Classical period, about 460 B.C.
Ceramic, red-figure technique; painted by a member of the Group of Philadelphia 227
H. 10.5 cm (4 ⅛ in.)
The Metropolitan Museum of Art. Rogers Fund,
1941 41.162.154
Photograph © 2003 The Metropolitan Museum
of Art

This jumper leans forward as he swings his weights to build momentum before launching himself. His eyes are focused intently ahead.

36.
Jumping weight (halter) (p. 78)
Greek, probably made and found at Athens
Archaic or Classical period, 6th–4th century B.C.
Lead
L. 13.8 cm (5 ⁷⁄₁₆ in.), weight 815.4 gm (28 ¾ oz.)
Museum of Fine Arts, Boston. Henry Lillie Pierce
Fund 99.501

Provenance: By 1898: with E. P. Warren (acquired in 1898 from Mr. Rhousopoulos, who said it was found in Athens); purchased by MFA from E. P. Warren, 1899.

This is an example of the handheld weights that Greek long jumpers carried to increase the distance of their jumps. Its small size may indicate that it was used by boys.

37.
Drinking cup (kylix) depicting pentathletes
(pp. 10–11, 76, and 131, details)
Greek, made in Athens, found near Capua, Campania
Classical period, about 470–460 B.C.
Ceramic, red-figure technique; painted by the Telephos Painter
H. 10.6 cm (4 ³⁄₁₆ in.)
Inscription: "Handsome!" (on interior)
Museum of Fine Arts, Boston. Henry Lillie Pierce Fund 01.8033

Provenance: By date unknown: Alfred Bourguignon Collection (said to be from S. Maria di Capua); by 1901: purchased by E. P. Warren from Alfred Bourguignon; purchased by MFA from E. P. Warren, December 1901.

On the interior of this cup, an athlete arrives still dressed at the gymnasion and stands with his javelin between a washbasin and a starting post. On the exterior, pentathletes practice the discus throw, javelin throw, and long jump near starting posts, while a trainer watches. Two toilet kits hang from pegs on the wall and a pickax rests on the ground.

38.
Drinking cup (kylix) depicting pentathletes
(pp. 72 and 81, details)
Greek, made in Athens, probably found at Capua, Campania
Late Archaic period, about 510–500 B.C.
Ceramic, red-figure technique; painted by a member of the Proto-Panaitian Group
H. 7.6 cm (3 in.)
Inscriptions: "Athenodotos is handsome" (on interior); "the boy is handsome" (on exterior)
Museum of Fine Arts, Boston. Henry Lillie Pierce Fund 98.876

Provenance: Date unknown: said to have been in Hartwig's possession; date unknown: with Francesco Martinetti, who said it was found in a

tomb in the Via Campagna (or Campania) at Santa Maria di Capua Vetere (ancient Capua); by 1898: with E. P. Warren (acquired just after Francesco Martinetti's death); purchased by MFA from E. P. Warren, 1898.

The scene in the center of this cup celebrates pentathletes, the well-rounded athletes who competed in five diverse events all on the same day. This athlete is training by running while swinging weights. The exterior scenes show youths practicing the javelin throw and long jump.

39.
Drinking cup (kylix) depicting pentathletes
(pp. 18, 56–57, and 76, details)
Greek, made in Athens, found near Velzna (modern Orvieto), Etruria
Late Archaic period, about 500–490 B.C.
Ceramic, red-figure technique; painted by Onesimos
H. 9 cm (3 ⁹⁄₁₆ in.)
Inscription: "Panaitios is handsome" (on interior)
Museum of Fine Arts, Boston. Henry Lillie Pierce Fund 01.8020

Provenance: By date unknown: Alfred Bourguignon Collection (said to be from Orvieto); by 1901: purchased by E. P. Warren from Alfred Bourguignon; purchased by MFA from E. P. Warren, December 1901.

On the interior a pentathlete swings his discus and balances himself with his left arm. On one exterior side another athlete swings the discus and is corrected by a trainer. On the other side a jumper is in mid-air. Other pentathletes exercise with hand weights.

PENTATHLON: JAVELIN

40.
Drinking-cup (kylix) depicting a pentathlete
(p. 24, detail)
Greek, made in Athens, said to have been found in Italy
Late Archaic period, about 510–500 B.C.
Ceramic, red-figure technique; painted by the Poseidon Painter
H. 12.5 cm (5 in.)

Inscriptions: meaningless inscriptions (on interior and exterior)
Museum of Fine Arts, Boston. Catharine Page Perkins Fund 95.35

Provenance: By 1895: with E. P. Warren (said to come from Italy); purchased by MFA from E. P. Warren, 1895.

This pentathlete runs carrying a jumping weight and two javelins with throwing cords. He may be rushing to the field of competition.

41.
Wine cooler (psykter) depicting pentathletes
(pp. 82 and 97, details)
Greek, made in Athens
Archaic period, about 520–515 B.C.
Ceramic, red-figure technique; painted by Phintias
H. 34.4 cm (13 ⁹⁄₁₆ in.)
Inscriptions: "Simon," "Ptoiodoros," "Hegias," "Epilykos," "Eudemos," "Sos(t)ratos," "Xenophon," "Phayllos," "Philon," "Etearchos," "So(s)tratos," and "E(u)krates" (next to figures)
Museum of Fine Arts, Boston. Henry Lillie Pierce Fund 01.8019

Provenance: By date unknown: Alfred Bourguignon Collection; by 1901: purchased by E. P. Warren from Alfred Bourguignon; purchased by MFA from E. P. Warren, December 1901.

Three pairs of athletes practice with javelins. The red loops on the javelins are leather throwing thongs, which were used to increase the distance of the throw. The draped figures are trainers, who watched for errors or fouls, which they corrected with their sticks. Two wrestlers are clearly practicing and not competing. The trainer at the left, who points with his right index finger, is speaking to them. The fact that all of the figures are labeled suggests that the scene depicts known athletes; the name Phayllos may refer to a famous Greek athlete from southern Italy who was a multiple victor in wrestling and the pentathlon.

PENTATHALON: DISCUS

42.
Drinking cup (kylix) depicting an athlete
(p. 85, detail)
Greek, made in Athens, found at Tarquinii, Etruria
Late Archaic period, about 500 B.C.
Ceramic, red-figure technique; painted by Douris
H. 9.5 cm (3 ¾ in.)
Inscriptions: "Douris made it" (on inside);
"Chairestratos is handsome" (twice, on exterior)
Museum of Fine Arts, Boston. Henry Lillie Pierce
Fund 00.338

Provenance: By 1878: Count Bruschi Collection,
Tarquinia; by 1900: with E. P. Warren; purchased
by MFA from E. P. Warren, February 1900.

A youth walks into the palaistra, holding his discus
in his left hand. Red fillets hang from his hair and
decorate the two jumping weights that hang in the
background. The composition is well suited to the
round space, which supports the feet of the striding
athlete and props up the pickax.

43.
Discus (p. 89)
Greek
Late Archaic period, about 500 B.C.
Marble
Diam. 28.5 cm (11 ¼ in.), weight (as preserved)
6.63 kg (14 lbs., 10 oz.)
Inscription: "From the [funeral games at the] burial
mounds [*eria*]"
Museum of Fine Arts, Boston. Gifts in memory of
Albert Gallatin 1987.621

Provenance: Before 1928: Edward Perry Warren
Collection; by 1929: with Sotheby's; sold at
Sotheby's auction, May 1929, lot 89; by 1929:
Albert Gallatin Collection; loaned by Albert
Gallatin to the Metropolitan Museum of Art from
March 14, 1930, to May 26, 1947 (letter of August
19, 1969, from Henry R. Immerwahr); 1947:
Albert F. Gallatin Collection (loaned to MFA
September 18, 1948); 1973: Catherine Gallatin
Collection; partial purchase by MFA from
Catherine Gallatin and partial gift of Catherine
Gallatin to MFA, December 16, 1987.

This discus is one of only three published stone
discuses. At the center is a faded black circle on
which a red horseman with a lance was originally
painted. The inscription confirms what is suggested
by the weight and material of the discus—that it
was not actively used but was a commemorative
object or a prize given at funeral games.

44.
Plate depicting athletes (p. 30, detail)
Greek, made in Athens, found near Clusium (mod-
ern Chiusi), Etruria
Archaic period, about 525–520 B.C.
Ceramic, red-figure technique; painted by Paseas
Diam. 19 cm (7 ½ in.)
Inscriptions: "Xenophon" and "Dorotheos" (on
interior, next to figures)
Museum of Fine Arts, Boston. Francis Bartlett
Donation of 1900 03.785

Provenance: Dates unknown: said to have been
found in a tomb near Chiusi and to have been in
the Blaydes, Ancona, and Hartwig Collections; by
1903: with E. P. Warren (bought in Rome from
Hartwig); purchased by MFA from E. P. Warren,
March 1903.

Two athletes casually converse as they stand on the
athletic field. The one on the right, Dorotheos,
seems to be asking for or reaching for the discus
held by Xenophon. This scene may represent a les-
son in discus throwing or two friends joking.

45.
Fragments of a vase for carrying bath water
(loutrophoros) depicting a youth, a discus thrower,
and two older men (p. 89, detail)
Greek, made in Athens
Archaic period, about 520–500 B.C.
Ceramic, black-figure technique
H. 15 cm (5 ⅞ in.)
Museum of Fine Arts, Boston. James Fund and by
Special Contribution 10.222

Provenance: By 1899: with E. P. Warren (acquired
from a Greek dealer in Athens, 1899); purchased
by MFA from E. P. Warren, June 2, 1910.

Two young athletes face two older, bearded men.
One of the older men must be an athlete, for he is
nude and tests the point of a javelin. The older man
wearing a mantle is a trainer.

46.
Ball depicting palaistra scenes
(pp. 34 and 82, details)
Greek, made in Athens
Late Archaic period, about 500 B.C.
Terracotta, black-figure technique
H. 4.3 cm (1 ¹¹⁄₁₆ in.), diam. 4.6 cm (1 ¹³⁄₁₆ in.)
Inscriptions: "I belong to Myrrhine." "Yeah." (in
paint on frieze and incised on bottom); "That boy
is beautiful, that is how he looks as he comes from
the [games at the] funeral mounds [*eria*]" (incised
on top)
Museum of Fine Arts, Boston. Helen and Alice
Colburn Fund 63.119

Provenance: By 1929: with Ernest Brummer, New
York (purchased by him in 1929 from
Zoumboulakis in Athens); purchased by MFA from
Ernest Brummer, February 13, 1963.

This ball belonging to a girl named Myrrhine was
pierced, perhaps in order to be suspended by a
string. Such a toy would certainly be appropriate
for a girl who was interested in athletics and was
perhaps an athlete herself. The scenes on the ball
depict javelin and discus throwers and a man court-
ing a boy.

47.
Fragment of a flask (askos) depicting a burial
mound (p. 45)
Greek, made in Athens, said to have been found in
Caere (modern Cerveteri), Etruria
Late Archaic period, about 500–490 B.C.
Ceramic, red-figure technique; painted by the
Tyskiewicz Painter
H. 9 cm (3 ⁹⁄₁₆ in.)
Museum of Fine Arts, Boston. Gift of Edward Perry
Warren 13.169

Provenance: By 1912: with E. P. Warren (said to
come from Cerveteri); gift of E. P. Warren to MFA,
January 2, 1913.

This piece of a flask shows a burial mound with the
deceased, perhaps a hero, rising from it. The
mound is decorated with javelins, jumping weights,
a discus, and red and white ribbons. This athletic
equipment may have been mementos dedicated to
the hero after funeral games in his honor.

DISCUS THROWER STATUETTES (CAT. NOS. 48–51)

Victorious athletes dedicated bronze statuettes of discus throwers at sanctuaries like Olympia. The most famous Greek statue of a discus thrower was the fifth-century bronze by Myron, which we know only from marble Roman copies. It showed a discus thrower in the middle of his backswing. Polykleitos, another mid-fifth-century sculptor, also created a statue of a discus thrower holding a discus.

48.

Statuette of an athlete holding a discus (p. 87)
Etruscan
Archaic period, late 6th or early 5th century B.C.
Bronze
H. 17.8 cm (7 in.)
Private New England collection

This athlete holds out his discus in front of him with two hands before starting the backswing of his throw.

49.

Statuette of a discus thrower (p. 87)
Greek, said to have been found in Greece
Early Classical period, about 480 B.C.
Bronze
H. 14.9 cm (5 ⅞ in.)
Museum of Fine Arts, Boston. Museum purchase by contribution 01.7480

Provenance: By 1901: with E. P. Warren (bought from an Athenian dealer in Paris; said to come from Greece); purchased by MFA from E. P. Warren, December 1901.

This athlete is captured in motion, leaning backward and raising his left arm for balance. He may be in his backswing, but the discus is held perpendicular to the line of movement, a position that is not yet fully understood.

50.

Statuette of a discus thrower (p. 87)
Etruscan
Early Classical period, about 480 B.C.
Bronze
H. 6.7 cm (2 ⅝ in.)
Museum of Fine Arts, Boston. Museum purchase by contribution 01.7492

Provenance: By 1901: with E. P. Warren (bought in Rome); purchased by MFA from E. P. Warren, December 1901.

This athlete drives ahead on his right leg; his left leg and arm fly forward as the discus passes his thigh.

51.

Support for a stand in the shape of a discus thrower (p. 87)
Etruscan, said to have been found in Etruria
Classical period, about 450 B.C.
Bronze
H. 18 cm (7 ⅟₁₆ in.)
Museum of Fine Arts, Boston. Catharine Page Perkins Fund 95.69

Provenance: By 1892: with E. P. Warren (said to have been found in Etruria); purchased by MFA from E. P. Warren, February 1895.

This was used as a stand for a party game, *kottabos*, which involved throwing dregs of wine to knock a disc off the stand. The now-missing disc from the kottabos stand would have acted as a visual pun on the discus held by the athlete.

52.

Coin depicting an athlete throwing a discus (on obverse) (p. 88)
Reverse: Crab set in decorative square (p. 88)
Greek, minted on Kos
Classical period, about 450–420 B.C.
Silver tetradrachm
Diam. 29 mm (1 ⅛ in.), weight 16.46 gm
Museum of Fine Arts, Boston. Henry Lillie Pierce Fund 04.1082

Provenance: By 1882: Ferdinand Bompois Collection (auction of the F. Bompois Collection, January 16ff., 1882, Paris, lot 1575); by date unknown: Canon Greenwell Collection; July 1902: acquired from the Canon Greenwell Collection by E. P. Warren; purchased by MFA from E. P. Warren, September 1904.

Although the pose of the discus thrower is not accurate, the arc of his body nicely complements the circular field of the coin. A prize tripod is set in the background.

53.

Coin depicting an athlete carrying a discus (on reverse) (p. 88)
Obverse: Head of Emperor Caracalla (p. 88)
Roman provincial, minted at Philoppopolis, Thrace
Roman Imperial period, about A.D. 211–17
Bronze
Diam. 41.5 mm (1 ⅝ in.), weight 38.44 gm
Museum of Fine Arts, Boston. Theodora Wilbour Fund in Memory of Zoë Wilbour 1984.218

Provenance: By 1925: H. C. Levis Collection; 1925 with Naville & Cie., Switzerland (auction 11 [sale of the Levis Collection], Lucerne, June 18–20, lot 748); by 1942: John W. Garrett Collection; 1942: bequeathed by John W. Garrett to the Johns Hopkins University; 1984: with Numismatic Fine Arts, Inc., and Bank Leu AG, Switzerland (auction of the Garrett Collection, part 1, Beverly Wilshire Hotel, Beverly Hills, California, May 17, lot 843); purchased at the Garrett auction on behalf of MFA by Selim Dere; purchased by MFA from Selim Dere, June 13, 1984.

The city of Philippopolis proudly hosted its own "Pythian" athletic games, modeled after those at Delphi. Like other cities Philippopolis used its coinage, featuring athletic events, to promote its games (see also cat. nos. 60 and 144).

PENTATHALON: WRESTLING

54.

Three-legged vessel depicting a pair of wrestlers (p. 93, detail)
Greek, made in Boiotia
Archaic period, 6th century B.C.
Ceramic, black-figure technique
H. 14.1 cm (5 ⁹⁄₁₆ in.)
Museum of Fine Arts, Boston. Henry Lillie Pierce Fund 01.8110

Provenance: By 1901: with E. P. Warren (said to have been bought in Paris); purchased by MFA from E. P. Warren, December 1901.

A wrestling match pits a bearded and an unbearded fighter against each other. Judges stand by to punish fouls with their raised staffs. The ring-handled tripod is a prize for the contest. Bearded boxers battle on another panel of this unguent vase, which itself takes the form of a prize tripod.

55.
Large basin with wrestlers on its rim
(p. 94, detail)
Greek, probably made and found in east central
Italy
Late Archaic period, early 5th century B.C.
Bronze
H. 28 cm (11 in.)
Museum of Fine Arts, Boston. Francis Bartlett
Donation of 1900 03.999

Provenance: By 1903: with E. P. Warren (said to
have been found in the Picene district and to have
been brought from Rome to Lewes, where it was
purchased); purchased by MFA from E. P. Warren,
March 1903.

Basins like this one were common in the palaistra
and gymnasion. Basins could either be set on a base
(see cat. nos. 37, 131, and 132) or rest directly on
the ground and be used as a footbath.

56.
Panathenaic prize vase (amphora) depicting
wrestlers (side B) (p. 96, detail)
Side A: Panathenaic Athena
Greek, made in Athens
Early Classical period, about 480–470 B.C.
Ceramic, red-figure technique; painted by the
Berlin Painter
H. 62.2 cm (24 ½ in.)
Inscription: "From the games at Athens" (on side A)
Hood Museum of Art, Dartmouth College,
Hanover, New Hampshire. Gift of Mr. and Mrs.
Ray Winfield Smith, Class of 1918 C.959.53

The wrestler on the right has gained the upper
hand here. While holding both of his opponent's
arms, he attempts to trip him. Tripping was allowed
in wrestling; the judge standing at the left makes no
objection. Wrestling began from a standing posi-
tion, and a match was won when one man threw his
opponent to the ground three times.

57.
Statuette of two wrestlers (p. 92)
Greek
Hellenistic period, about 150–100 B.C.
Bronze
H. 15.2 cm (6 in.)
The Walters Art Museum, Baltimore 54.742

Using a waistlock, one wrestler succeeds in lifting
his opponent off the ground. The other athlete
fights back, hoping to break the hold before he is
thrown to the ground. Both men wear the distinc-
tive hairstyle associated with combat sport partici-
pants, a knot of hair at the crown of the head.

58.
Drinking cup (kylix) depicting athletic combats
(pp. 97 and 104, details)
Greek, made in Athens
Late Archaic period, about 490–480 B.C.
Ceramic, red-figure technique; painted by
Onesimos
H. 10.7 cm (4 ³⁄₁₆ in.)
Inscriptions: "Panaitios is handsome," "Lykos is
handsome," "handsome" (on exterior); "the boy is
handsome" (on interior)
Museum of Fine Arts, Boston. Arthur Tracy Cabot
Fund 1972.44

Provenance: By 1963: Swiss private collection; by
1972: with Dr. Leo Mildenberg, Bank Leu & Co.,
AG, Switzerland (as ex Moretti Collection); pur-
chased by MFA from Dr. Leo Mildenberg, February
9, 1972.

This drinking cup illustrates two types of combat
sport. On one side a trainer watches as two youths
box; nearby another youth binds his hands in
preparation for boxing. On the other side two fight-
ers struggle on the ground. The judge on the right
leans in, ready to strike one of the participants with
his staff. The athlete who has committed a foul will
be punished with a beating rather than being dis-
qualified. A prize cauldron sits atop a column at the
far left. The interior of the cup depicts a draped
athlete holding a hare, a token of affection from a
fan.

59.
Coin depicting two wrestlers (on obverse) (p. 98)
Reverse: Youth with a sling, and a small figure of
Eros (p. 98)
Greek, minted at Aspendos, Asia Minor
Classical period, about 394–380 B.C.
Silver stater
Diam. 23 mm (⅞ in.), weight 10.95 gm
Museum of Fine Arts, Boston. Henry Lillie Pierce
Fund 04.1126

Provenance: By date unknown: Canon Greenwell
Collection; July 1902: acquired from the Canon
Greenwell Collection by E. P. Warren; purchased
by MFA from E. P. Warren, September 1904.

From their head-to-head pose and their arm posi-
tion, it appears that these wrestlers are just begin-
ning their match.

60.
Coin depicting two wrestlers (on reverse) (p. 98)
Obverse: Head of Emperor Elagabalus (p. 98)
Roman provincial, minted at Philippopolis, Thrace
Roman Imperial period, about A.D. 218–22
Bronze
Diam. 29.5 mm (1 ³⁄₁₆ in.), weight 14.86 gm
Museum of Fine Arts, Boston. Theodora Wilbour
Fund in Memory of Zoë Wilbour 1984.15

Provenance: By 1983: with Frank Sternberg,
Switzerland (Sternberg auction 13, Zurich,
November 17–18, 1983, lot 851); purchased at
Sternberg auction on behalf of MFA by Jeffrey
Spier; purchased by MFA from Jeffrey Spier,
January 18, 1984.

These wrestlers are also at the beginning of their
match.

61.
Coin depicting wrestlers (on obverse) (p. 98)
Reverse: Youth with a sling (p. 98)
Greek, minted at Aspendos, Asia Minor
Classical period, about 394–380 B.C.
Silver stater
Diam. 24 mm (¹⁵⁄₁₆ in.), weight 10.61 gm
Museum of Fine Arts, Boston. Catharine Page
Perkins Fund 01.5633

Provenance: By 1901: with E. P. Warren; purchased
by MFA from E. P. Warren, 1901.

The left wrestler punches his opponent in the belly
and grabs his left leg—apparently after blocking a
kick to the groin.

62.
Coin depicting athletes drawing lots (on reverse)
(p. 98)
Obverse: Head of Emperor Severus Alexander
(p. 98)
Roman provincial, minted at Baris, Asia Minor
Roman Imperial period, about A.D. 222–35

Bronze
Diam. 34.5 mm (1 ⅜ in.), weight 24.40 gm
Museum of Fine Arts, Boston 1983.3

Provenance: By 1982: with Frank Sternberg, Switzerland (auction 12, November 18–19, lot 692); purchased at auction 12 by Jeffrey Spier; purchased by MFA from Jeffrey Spier, January 12, 1983.

Competitions in combat sports often began with the drawing of lots. Because there were no rankings or seedings, the lot an athlete drew was quite important. The luck of the draw could also be viewed as a form of divine intervention. Here we see one athlete reaching into a vase, while two other athletes read their numbers. A prize crown above and palm branches at the sides of the scene remind us of the winner's rewards.

PANKRATION

63.
Deep cup (skyphos) depicting pankratists (p. 99, details)
Greek, made in Athens
Late Archaic period, about 500 B.C.
Ceramic, black-figure technique; painted by the Theseus Painter
H. 16.2 cm (6 ⅜ in.)
Inscriptions: meaningless inscriptions (on exterior)
The Metropolitan Museum of Art. Rogers Fund, 1906 06.1021.49
Photograph © 2003 The Metropolitan Museum of Art

Pankration, or freestyle fighting, combined elements of boxing and wrestling. Each side of this cup shows fighters grappling with one another, like wrestlers, but with one man preparing to deliver a blow to his opponent, as in boxing. The fighters are heavyweights with bulky bellies. One pair has their hands wrapped with thongs, like boxers. Another athlete and a judge wearing a mantle flank the fighters.

64.
Pseudo-Panathenaic vase (amphora) depicting pankratists (on side B) (pp. vi and 90, details)
Side A: Panathenaic Athena
Greek, made in Athens
Archaic period, about 530–520 B.C.
Ceramic, black-figure technique; painted by the Mastos Painter
H. 60.2 cm (23 ¹¹⁄₁₆ in.)
Museum of Fine Arts, Boston. Henry Lillie Pierce Fund 01.8127

Provenance: By date unknown: W. H. Forman Collection; about 1889, following W. H. Forman's death: in the collections of his sister-in-law, Mrs. Burt, and later of his nephew, Major A. H. Browne; by 1900: with Sotheby, Wilkinson, and Hodge, London (sale of the Forman Collection, part 2, July 2–5, 1900, lot 103); by 1901: with E. P. Warren; purchased by MFA from E. P. Warren, December 1901.

This scene depicts the end of a pankration match between two bulky fighters. The bearded fighter on the left has downed his younger opponent, who signals his surrender by raising a finger in the direction of the judge at the right. Another athlete watches at the left. The pankration ended only when one of the combatants submitted or was incapacitated.

65.
Fragments of a cup depicting pankratists or wrestlers (p. 100)*
Greek, made in Athens
Late Archaic, about 490 B.C.
Ceramic, red-figure technique; painted by Onesimos
H. 10 cm (4 in.)
The Centre Island Collection
Photograph © 2002 The Metropolitan Museum of Art

The participant with the advantage pulls the leg out from under his opponent and tears at or punches his face. The bloody scratches or handprints visible on the youths testify to the violence of ancient sports.

BOXING

66.
Drinking cup (kylix) depicting a boxer (p. 101)
Greek, made in Athens, found near Velzna (modern Orvieto), Etruria
Late Archaic period, about 500 B.C.
Ceramic, red-figure technique; painted by Onesimos
H. 8.8 cm (3 ⁷⁄₁₆ in.)
Inscriptions: "Athenodotos is handsome" (on interior); "handsome" (two times, on interior); "the boy is handsome" (on exterior)
Museum of Fine Arts, Boston. Henry Lillie Pierce Fund 01.8021

Provenance: By date unknown: Alfred Bourguignon Collection (said to be from Orvieto); by 1901: purchased by E. P. Warren from Alfred Bourguignon; purchased by MFA from E. P. Warren, December 1901.

In the center of this cup, a boxer prepares to bind his hands with long leather thongs.

67.
Statuette of a boxer (p. 102, detail)
Roman provincial, probably from Alexandria, Egypt
Roman Imperial period, about A.D. 50–70
Bronze, nipples inlaid with copper
H. 21 cm (8 ¼ in.)
The Cleveland Museum of Art. Leonard C. Hanna, Jr. Fund 1985.137

The pose and hairstyle of this figure help identify him as a boxer. The long lock of hair left on the crown of the head is associated with participants in combat sports. This athlete is stretching out the leather thongs he will later wrap around his hands. The thongs would have been made of a separate strip of metal, which is now missing.

68.
Statuette of a victorious boxer (not illustrated)
Greek
Early Classical period, mid-5th century B.C.
Bronze
H. 10.2 cm (5 in.)
Museum of Fine Arts, Boston. Museum purchase by Contribution 01.7475

Provenance: By 1901: with E. P. Warren; purchased by MFA from E. P. Warren, December 1901.

This youthful athlete carries a strap in his lowered left hand, presumably a leather strap for binding a boxer's hands. He raises his right hand in a gesture that may be a signal of victory or prayer.

69.

Vase (amphora) fragments depicting a boxer (p. 102)
Greek, made in Athens
Archaic period, about 550–525 B.C.
Ceramic, black-figure technique; probably painted by the Painter of Tarquinia RC 6847
H. 10.5 cm (4 ⅛ in.)
The Metropolitan Museum of Art, Gift of Ernest Brummer, 1957 57.12.9a–b
Photograph © 2003 The Metropolitan Museum of Art

This boxer holds his hands up and at the ready. Ancient boxers aimed most of their blows at their opponent's face and head, as this man is clearly ready to do. They also concentrated on defending themselves from potentially devastating blows to the head from the strapped hands of their opponents.

70.

Hand of a boxer (p. 105)
Roman, possibly from Asia Minor
Roman Imperial period, about A.D. 150–220
Bronze
L. 20 cm (7 ⅞ in.)
Museum of Fine Arts, Boston. Gift of Robert E. Hecht, Jr. 1972.900

Provenance: By 1972: with Robert E. Hecht, Jr. (thought to be from Asia Minor and then from a private collection in Switzerland); gift of Robert E. Hecht, Jr., to MFA, September 13, 1972.

In the early days of the sport Greek boxers wrapped their hands and wrists with relatively soft materials, mainly leather. This was intended to protect a boxer's hands, rather than his opponent's face. Later such hand covering was made from harder, more rigid materials. This Roman example shows a boxer's hand covered with leather, sheepskin, and even metal, which must have resulted in devastating blows.

71.

Statue of a fighter fastening a complex headband (p. 105)
Greek
Hellenistic period, 3rd or 2nd century B.C.
Marble
H. 44.1 cm (17 ⅜ in.)
The Metropolitan Museum of Art. Rogers Fund, 1917 17.230.3
Photograph © 2003 The Metropolitan Museum of Art

This athlete is fastening a headband with chin strap, either to protect his cauliflower ears or as an emblem of distinction—one that would securely in place during competition.

72.

Oil jar (lekythos) depicting a grave monument for an athlete (pp. 80 and 104, details)
Greek, made in Athens, probably found in Greece
Classical period, about 450–440 B.C.
Ceramic, polychrome; painted by the Thanatos Painter
H. 31.5 cm (12 ⅜ in.)
Museum of Fine Arts, Boston. Henry Lillie Pierce Fund 01.8080

Provenance: By 1901: with E. P. Warren (bought from Athens); purchased by MFA from E. P. Warren, December 1901.

The shrouded figure at right may represent the deceased. The monument itself is decorated with two statues of athletes holding javelins standing on the corners. One of them also holds a strigil. A boxing match takes place in the pediment below. A discus and a lyre above the monument recall both the physical and the intellectual aspects of the deceased youth's training in the gymnasion.

HORSE RACING

73.

Panathenaic prize vase (amphora) depicting race-horses (side B) (p. 150, detail)
Side A: Panathenaic Athena (p. 151, detail)
Greek, made in Athens
Late Archaic period, about 510 B.C.
Ceramic, black-figure technique; painted by a member of the Leagros Group

H. 63.5 cm (25 in.)
Inscription: "From the games at Athens" (on side A)
The Metropolitan Museum of Art, Rogers Fund, 1907 07.286.80
Photograph © 2003 The Metropolitan Museum of Art

Horse races were very popular events in antiquity. Jockeys riding bareback and tight turns around turning posts must have made for dramatic results. This Panathenaic vase and cat. no. 74 were part of the substantial prize awarded to victors in the equestrian events. This one shows a group of three riders passing a turning post.

74.

Panathenaic prize vase (amphora) depicting race-horses (side B) (p. 108, detail)
Side A: Panathenaic Athena (p. 109, detail)
Greek, made in Athens
Late Archaic period, about 490 B.C.
Ceramic, black-figure technique; painted by the Eucharides Painter
H. 66.3 cm (26 ⅛ in.)
Inscription: "From the games at Athens" (on side A)
The Metropolitan Museum of Art, Fletcher Fund, 1956 56.171.3
Photograph © 2003 The Metropolitan Museum of Art

This prize vase shows one rider looking over his shoulder to see how his competitors are faring.

75.

Trumpet (salpinx) (p. 113)
Greek, probably found at Olympia
Hellenistic or Roman Imperial period, about 3rd century B.C. to 3rd century A.D.
Bone and bronze (13 sections of bone tubing with bronze rings and a bronze bell)
L. 155 cm (61 in.)
Museum of Fine Arts, Boston. Frederick Brown Fund 37.301

Provenance: By 1937: with Joseph Brummer, New York (acquired from a dealer in Paris who in turn acquired it from a Greek who said it was from Olympia); purchased by MFA from Joseph Brummer, April 1, 1937.

The trumpet signaled the start and final lap of the equestrian races. It was also used to announce the arrival of athletes, the start of some events, and the crowning of victors. Contests between trumpeters were included in many Greek athletic festivals. This is the only extant Greek trumpet.

76.
Statuette of a horseman (p. 110)
Greek, probably made and found in Lucania
Archaic period, about 540 B.C.
Bronze
H. 15.4 cm (6 ⅟₁₆ in.)
Museum of Fine Arts, Boston. Museum purchase by contribution 01.7486

Provenance: By date unknown: W. H. Forman Collection; about 1889, following W. H. Forman's death: in the collections of his sister-in-law, Mrs. Burt, and later of his nephew, Major A. H. Browne; by 1899: with Sotheby, Wilkinson, and Hodge, London (sale of the Forman Collection, part I, June 19–22, 1899, lot 54 [said to have been found in a tomb at Grumentum in Lucania in the early 1850s and in 1868 sold at Hotel Drouot with the Fegervary-Pulszky Collection]); by 1901: with E. P. Warren; purchased by MFA from E. P. Warren, December 1901.

Unlike most riders, this one is fully clothed in a tight shirt, short pants, and a cap. The hands of the figure were originally pierced to hold reins.

77.
Statuette of a horse and rider (pp. 106 and 110)
Greek, probably found at Mantineia
Archaic period, about 525 B.C.
Bronze
H. 11.5 cm (4 ½ in.)
Museum of Fine Arts, Boston. Francis Bartlett Donation of 1900 03.993

Provenance: By 1903: with E. P. Warren (bought in London; said to come from Mantineia in Arcadia); purchased by MFA from E. P. Warren, March 1903.

This piece probably commemorated a racing victory. The rider holds the reins in his left hand; his right hand originally held some object, perhaps a palm branch to symbolize his victory.

HORSE RACING COINS (CAT. NOS. 78–82)

Horses were owned and bred by the wealthiest members of society. However, the racehorse was not entered in the name of an individual, but in the name of a city-state. The pride of the cities is expressed in the minting of local coinage. Although the coins feature the riders and the horses, it was the owners who received the crown and prize.

78.
Coin depicting a horse and rider (on reverse) (p. 114)
Obverse: Head of Zeus (p. 114)
Greek, minted at Pella, Macedonia, under King Phillip II
Classical period, about 359–336 B.C.
Silver tetradrachm
Diam. 24 mm (¹⁵⁄₁₆ in.), weight 14.45 gm
Museum of Fine Arts, Boston. Anonymous gift in memory of Zoë Wilbour (1864–1885) 35.101

Provenance: By 1935: Anonymous private collection; anonymous gift to MFA, April 4, 1935.

This coin publicizes a racing victory of Philip II, king of Macedonia and father of Alexander the Great. Philip had several successes in equestrian events at Olympia; in one year he won both a chariot race and a horse race. Because Macedonia was sometimes regarded as being on the fringe of the Greek world, these Olympic victories were especially important to Philip as they confirmed his place—and preeminence—in the Greek world.

79.
Coin depicting a horseman (on obverse) (p. 112, detail)
Reverse: Goat with head turned back (p. 112)
Greek, minted at Kelenderis, Asia Minor
Classical period, about 450–400 B.C.
Silver stater
Diam. 23 mm (⅞ in.), weight 10.59 gm
Museum of Fine Arts, Boston. James Fund 09.284

Provenance: By 1906: with E. P. Warren; purchased by MFA from E. P. Warren, July 12, 1909.

This coin features the *anabates* race, which ended with the horseman dismounting and running to the finish line alongside his horse.

80.
Coin depicting a victorious horseman (on reverse) (p. 112)
Obverse: Head of Apollo (p. 112)
Roman, minted at Rome
Roman Republican period, 67 B.C.
Silver denarius
Diam. 18 mm (¹¹⁄₁₆ in.), weight 3.97 gm
Estate of Emily Townsend Vermeule

A palm branch, symbolic of victory, flies in the wind behind the head of a jockey astride a horse in a "flying gallop."

81.
Coin depicting a rider with two horses (on reverse) (p. 112)
Obverse: Head of Mark Antony (p. 112)
Roman, minted at Rome
Roman Republican period, about 44 B.C.
Silver denarius
Diam. 19 mm (¾ in.), weight 3.72 gm
Museum of Fine Arts, Boston. Gift of Robert E. Hecht, Jr. 67.1027

Provenance: By 1967: with Robert E. Hecht, Jr.; gift of Robert E. Hecht, Jr., to MFA, December 13, 1967.

This coin and cat. no. 82 depict another unusual equestrian event, in which each jockey raced with a pair of horses. The rider was required to switch mounts during the course of the race. This must have been a particularly exciting event.

82.
Coin depicting a rider with two horses (on reverse) (p. 112)
Obverse: Head of Arethusa (p. 112)
Greek, minted at Syracuse, Sicily
Late Archaic period, about 510–485 B.C.
Silver didrachm
Diam. 21 mm (¹³⁄₁₆ in.), weight 8.55 gm
Museum of Fine Arts, Boston. Catherine Page Perkins Fund 00.109

Provenance: By 1900: with E. P. Warren; purchased by MFA from E. P. Warren, 1900.

The outline of the second horse is barely visible.

CHARIOT RACING

83.
Panathenaic prize vase (amphora) depicting a racing chariot (side B) (p. 117, detail)
Side A: Panathenaic Athena
Greek, made in Athens
Late Archaic period, about 500 B.C.
Ceramic, black-figure technique; painted in the manner of the Berlin Painter
H. 62.4 cm (24 ⅜ in.)
Inscription: "From the games at Athens"
(on side A)
Princeton University Art Museum. Bequest of Mrs. Allan Marquand y1950-10
Photograph by Bruce M. White. © 2003 Trustees of Princeton University

This view of a single four-horse chariot (tethrippon) shows the simple and light construction of an ancient chariot. The driver, wearing the traditional long garment of charioteers, stands on a small platform. Grasping four sets of reins and a goad, he leans forward and concentrates on his difficult task.

84.
Vase (amphora) depicting a chariot race
(p. 116, detail)
Greek, made in Athens
Late Archaic period, about 510–500 B.C.
Ceramic, black-figure technique; painted by a member of the Leagros Group
H. 38 cm (14 ¹⁵⁄₁₆ in.)
Courtesy of the Arthur M. Sackler Museum, Harvard University Art Museums. William M. Prichard Fund 1933.54
Photograph by Junius Beebe. © 2003 President and Fellows of Harvard College

This piece captures the chaos and tumult of the chariot race, as four four-horse chariots (tethrippa) surge around a turning post. The artist has taken advantage of the space under the handle by showing a particularly agile charioteer ducking underneath it. Chariot races were undoubtedly full of this sort of improvised, thrilling move as drivers negotiated their way around turning posts and disabled chariots.

85.
Lid of a container (lekanis) depicting a chariot race
(p. 115)
Greek, made in Athens
Archaic period, about 520–510 B.C.
Ceramic, black-figure technique
H. 12.7 cm (5 in.), diam. 40.6 cm (16 in.)
Collection of Shelby White and Leon Levy
Photograph by Sheldan Comfort Collins. © 1990 The Metropolitan Museum of Art

Four chariots race on this lekanis lid. Two of the charioteers reach forward and use their goads on their horses. The white paint on this piece has been preserved, showing the true color of the ancient charioteer's garment.

86.
Mug depicting a chariot race (p. 113, detail)
Greek
Classical period, first half of the 4th century B.C.
Bronze
H. 8.4 cm (3 ⁵⁄₁₆ in.)
Private New England collection

Two four-horse chariots (tethrippa) race around the exterior of this mug, whose handle has been lost. A prize dinos sits atop the finishing post.

87.
Gem depicting a racing chariot (p. 119)
Greek
Classical period, end of the 5th century B.C.
Chalcedony
L. 2.6 cm (1 in.)
Museum of Fine Arts, Boston. Francis Bartlett Donation 23.582

Provenance: By 1920: with E. P. Warren (bought in Athens); purchased by MFA from E. P. Warren, November 21, 1923.

This engraved gem captures a two-horse chariot (synoris) rounding a corner, a difficult maneuver. The flying lower hem of the charioteer's robe indicates that the chariot is moving at high speed. The horses do not move in unison: the one on the far side of the post must move more quickly than the one nearer to it, and the charioteer's pose shows the tension of the moment.

CHARIOT RACING COINS (CAT. NOS. 88–94)

Chariot racing was an especially popular image on coins, primarily because the rulers of the Greek city-states—who oversaw coin production—owned the horses and chariots. The coins functioned as a way to celebrate and announce the victories to a broad public.

88.
Coin depicting a victorious mule-racing chariot (on obverse) (p. 114)
Reverse: Running hare (p. 114)
Greek, minted at Messana, Sicily
Early Classical period, about 480–460 B.C.
Silver tetradrachm
Diam. 27 mm (1 ¹⁄₁₆ in.), weight 17.28 gm
Museum of Fine Arts, Boston. Henry Lillie Pierce Fund 04.462

Provenance: By date unknown: Canon Greenwell Collection; July 1902: acquired from Canon Greenwell Collection by E. P. Warren; purchased by MFA from E. P. Warren, September 1904.

A seated charioteer drives a two-mule chariot. The mule race was part of the Olympic Games for slightly over fifty years in the fifth century B.C. The event was a favorite of the Greeks in Sicily. This coin commemorates a victory of Anaxilas, ruler of Messana, a city in Sicily.

89.
Coin depicting Pelops driving a chariot
(on obverse) (p. 118)
Reverse: The nymph Himera (p. 118)
Greek, minted at Himera, Sicily
Classical period, about 440 B.C.
Silver tetradrachm
Diam. 25 mm (1 in.), weight 17.38 gm
Inscription: "Pelops" (on obverse, at top edge)
Museum of Fine Arts, Boston. Theodora Wilbour Fund in Memory of Zoë Wilbour 2003.67

Provenance: By 1986: said to be with Bank Leu AG, Switzerland; in 1986: said to have been purchased from Bank Leu by Athos Moretti; by 1996: with Numismatica Ars Classica AG, Switzerland (Auction 9, Zurich, April 16, 1996, lot 158); purchased by MFA from Numismatica Ars Classica AG, March 26, 2003.

The inscription at the top of this coin identifies the driver as Pelops, legendary founder of the chariot race at Olympia.

90.
Coin depicting a four-horse chariot (on obverse) (p. 118)
Reverse: Head of the nymph Arethusa (p. 118)
Greek, minted at Syracuse, Sicily
Classical period, about 413–410 B.C.
Silver tetradrachm
Diam. 26 mm (1 in.), weight 17.23 gm
Museum of Fine Arts, Boston. Henry Lillie Pierce Fund 04.556

Provenance: By 1896: Edward Bunbury Collection; 1896: with Sotheby, Wilkinson, and Hodge, London (auction of the Edward Bunbury Collection, London, June 15ff., 1896, lot 462); by date unknown: Canon Greenwell Collection; July 1902: acquired from the Canon Greenwell Collection by E. P. Warren; purchased by MFA from E. P. Warren, September 1904.

The driver of a four-horse chariot (tethrippon) is being crowned by Victory. Yet the race is still on: the horses are moving and the reins are taut. A loose chariot wheel visible below the horses' hooves hints at the dangers of chariot racing. It may also allude to the treachery that caused the legendary King Oinomaos to lose a wheel in his race against Pelops. If so, the victorious charioteer would be Pelops himself.

91.
Coin depicting a four-horse chariot (on obverse) (p. 118)
Reverse: Head of the nymph Arethusa (p. 118)
Greek, minted at Syracuse, Sicily
Classical period, about 413–387 B.C.
Silver dekadrachm
Diam. 37 mm (1 7/16 in.), weight 43.05 gm
Museum of Fine Arts, Boston. Catharine Page Perkins Fund 00.118

Provenance: By 1900: with E. P. Warren; purchased by MFA from E. P. Warren, 1900.

Victory flies in to crown a charioteer, a common motif especially on the coins of Syracuse.

92.
Coin depicting a two-horse chariot (on reverse) (p. 114)
Obverse: Head of Apollo (p. 114)
Greek, minted at Pella or Amphipolis, Macedonia, under King Philip II
Classical period, about 359–336 B.C.
Gold stater
Diam. 19 mm (3/4 in.), weight 8.62 gm
Museum of Fine Arts, Boston. Catharine Page Perkins Fund 00.164

Provenance: By 1900: with E. P. Warren; purchased by MFA from E. P. Warren, 1900.

This coin commemorates a racing victory of Philip at Olympia or Delphi.

93.
Contorniate depicting the victorious charioteer Flavianus (on reverse) (p. 118)
Obverse: Head of Emperor Caligula (p. 118)
Roman, minted at Rome
Roman Imperial period, second half of the 4th century A.D.
Bronze
Diam. 37.5 mm (1 1/2 in.), weight 22.5 gm
Museum of Fine Arts, Boston. Theodora Wilbour Fund in Memory of Zoë Wilbour 68.611

Provenance: By 1949: Henry Platt Hall Collection; 1950: with Glendining & Co., Ltd., London (auction of the H. P. Hall Collection, November 16 ff., 1950, lot 2135); by date unknown: Walter Niggeler Collection; by 1967: with Bank Leu AG, Zurich and Münzen und Medaillen AG (auction of the Walter Niggeler Collection, part 3, November 2–3, 1967, Basel, lot 1592: citing Santamaria Sale, November 1920 [Cantoni], no. 1290; Sambon 1898, Robert 1194); by 1968: with Robert E. Hecht, Jr.; purchased by MFA from Robert E. Hecht, Jr., October 9, 1968.

Flavianus holds a palm branch, the symbol of victory, in his left hand and a whip and wreath in his right. Palm branches decorate the heads of his four horses.

94.
Contorniate depicting the victorious charioteer Gerontius (on reverse) (p. 118)
Obverse: Head of a youth (p. 118)
Roman
Roman Imperial period, second half of the 4th century A.D.
Bronze
Diam. 42.5 mm (1 11/16 in.), weight 44.97 gm
Museum of Fine Arts, Boston. Gift of Mr. and Mrs. Cornelius C. Vermeule III 1998.562

Provenance: By 1950: with A. H. Baldwin & Sons Ltd., London; August 28, 1950: purchased by Cornelius C. Vermeule III from Albert Baldwin; gift of Mr. and Mrs. Cornelius C. Vermeule III to MFA, December 16, 1998.

The leather harness of the charioteer is clearly visible. He holds a palm branch and a whip.

95.
Funerary monument to a charioteer (p. 119)
Roman
Roman Imperial period, about A.D. 130–40
Marble
H. 57.6 cm (22 11/16 in.)
Princeton University Art Museum. Museum purchase, gift of John B. Elliott, Class of 1951 y1989-41
Photograph by Bruce M. White. © 2003 Trustees of Princeton University

A portrait bust of a charioteer fills the front section of this funerary monument. He wears the protective harness of leather straps common to Roman charioteers. Palm trees, symbols of victory, are carved at the front corners and a horse is carved on each side. This monument was probably set up on a road at the edge of a city, so that passersby could see it.

TRAINING GROUNDS

96.

Relief depicting a palaistra scene (p. 141)
Roman
Roman Imperial period, 1st century A.D.
Terracotta
H. 31.5 cm (12 ⅜ in.), l. 40.4 cm (15 ⅞ in.)
Museum of Fine Arts, Boston. Francis Bartlett
Donation of 1900 03.885

Provenance: By 1903: with E. P. Warren (as
Campanian); purchased by MFA from E. P. Warren,
March 1903.

The columns and niches on this plaque, as well as
the bearded herms and prize vases, indicate a
palaistra setting. At the center is a statue of Hermes.

97.

Relief depicting a palaistra scene (p. 140)
Roman
Roman Imperial, 1st century A.D.
Terracotta
H. 40 cm (15 ¾ in.), l. 41 cm (15 ¹³⁄₁₆ in.)
Museum of Fine Arts, Boston. Francis Bartlett
Donation of 1900 03.883

Provenance: By 1903: with E. P. Warren (as
Campanian); purchased by MFA from E. P. Warren,
March 1903.

This plaque, similar in composition to cat. no. 96,
has a statue of Herakles in the central niche. Two
boxers, an athlete cleaning his strigil, and a victor
fill the other spaces.

98.

Herm of the god Hermes (p. 142)
Greek, probably made in Thessaly
Late Archaic period, about 480 B.C.
Marble, from Paros
H. 37 cm (14 ⁹⁄₁₆ in.)
Museum of Fine Arts, Boston. Charles Amos
Cummings Fund 36.218

Provenance: By 1936: with Brummer Gallery, Inc.,
New York (acquired in Paris by Brummer Gallery);
purchased by MFA from Brummer Gallery Inc.,
April 2, 1936.

Hermes was the patron of travelers and merchants,
so the ancient Greeks set up herms, or busts, of him

at crossroads and doorways for protection against
bad spirits. Hermes was also associated with athlet-
ics, particularly wrestling, so herms of him were
often set up in gymnasia and palaistrai. The flaws in
this piece of marble prevented the sculpture from
being finished.

99.

Statue of Hermes (p. 142)
Roman; copy of a Greek original of the late 5th cen-
tury B.C. attributed to a follower of Polykleitos, per-
haps Naucydes of Argos
Roman Imperial period, 2nd century A.D.
Marble
H. 180.3 cm (71 ¼ in.)
The Metropolitan Museum of Art. Gift of the
Hearst Foundation, 1956 56.234.15
Photograph © 2003 The Metropolitan Museum of
Art

In contrast to Herakles, who was famous for his
superhuman strength, Hermes was admired for his
cleverness and for his role as a teacher and
guardian.

100.

Statue of a young athlete (p. 130)
Roman; copy of a late Hellenistic original
Roman Imperial period, mid-2nd century A.D.
Marble
H. 84.5 cm (33 ¼ in.)
The Cleveland Museum of Art. Leonard C. Hanna,
Jr. Fund, and Anonymous gift 1985.79

This boy holds a pair of hourglass-shaped weights
over his shoulder and rests his hand on a punching
bag. Handheld weights (sometimes jumping
weights, as on cat. no. 130) were used for general
conditioning as well as for jumping.

101.

Coin depicting an athlete lifting a weight
(on reverse) (p. 88)
Obverse: Head of Emperor Valerian (p. 88)
Roman provincial, minted at Kyme, Asia Minor
Roman Imperial period, about A.D. 253–60
Bronze
Diam. 30 mm (1 ³⁄₁₆ in.), weight 7.68 gm
Museum of Fine Arts, Boston. Theodora Wilbour
Fund in Memory of Zoë Wilbour 63.1101

Provenance: By 1963: with Robert E. Hecht, Jr.;
purchased by MFA from Robert E. Hecht, Jr.,
September 18, 1963.

This coin and the statuette below (cat. no. 102)
illustrate athletes exercising with a *solos*, a weight
shaped like a ball or round stone. This athlete uses
both arms to lift the large weight over his head. In
front of him is a bird's-eye view of a palaistra.

102.

Statuette of an athlete lifting a weight (p. 16)
Greek
Classical period, about 420 B.C.
Bronze
H. 9.7 cm (3 ¹³⁄₁₆ in.)
Museum of Fine Arts, Boston. Museum purchase
by contribution 01.7487

Provenance: By date unknown: W. H. Forman
Collection; about 1889, following W. H. Forman's
death: in the collections of his sister-in-law, Mrs.
Burt, and later of his nephew, Major A. H. Browne;
by 1899: with Sotheby, Wilkinson, and Hodge,
London (sale of the Forman Collection, part I, June
19–22, 1899, lot 82 [as Hertz sale, lot 576]); by
1901: with E. P. Warren; purchased by MFA from
E. P. Warren, December 1901.

This statuette shows an athlete lifting a small
weight with one hand—either for conditioning or
before a throw.

103.

Drinking cup (kylix) depicting athletes
(p. 139, detail)
Greek, made in Athens
Early Classical period, about 480–470 B.C.
Ceramic, red-figure technique; painted by the
Dokimasia Painter
H. 10.3 cm (4 ⁱ⁄₁₆ in.)
Museum of Fine Arts, Boston. Henry Lillie Pierce
Fund 01.8075

Provenance: By 1901: with E. P. Warren (said to
have been bought in Rome); purchased by MFA
from E. P. Warren, December 1901.

The scene on the inside of this cup shows an ath-
lete who has finished bathing and is dressing. His
toilet kit hangs on the wall behind him. On the
exterior of the cup there are scenes of youths exer-
cising and boxing, while trainers observe.

Oiling the skin was an important part of preparing to exercise. Oil, often covered with a layer of dust, sand, or dirt, kept the skin clean and moist. It was easily removed with a scraper, or strigil. Oil flasks, called aryballoi and alabastra, came in many different shapes, sizes, and materials. Some had handles or chains, for easy carrying. Each athlete carried an oil flask, sponge, and strigil—often tied together—with him to the training grounds or competition area. In vase paintings these toilet kits can often be seen hanging on a wall.

104.
Bronze basin handle in the shape of an athlete (p. 133)
Greek, made in southern Italy
Early Classical period, about 480 B.C.
Bronze
H. 22.5 cm (8 ⅞ in.)
The Cleveland Museum of Art. Purchase from the J. H. Wade Fund 1928.659
© The Cleveland Museum of Art, 2003

This athlete holds an oil flask in his raised left hand. He is ready to pour the oil out onto his left hand and then to spread it on his skin, in preparation for exercising.

105.
Oil flask (aryballos) (not illustrated)
Roman
Roman Imperial period, 1st–2nd centuries A.D.
Glass and bronze
H. 7.3 cm (2 ⅞ in.)
Museum of Fine Arts, Boston. Henry Lillie Pierce Fund 01.8227

Provenance: By 1901: with A. Khayat; purchased by MFA from A. Khayat, November 1901.

106.
Oil flask (aryballos) with a handle and a short chain (p. 133)
Greek, probably found in Boiotia
Hellenistic period, about 300–50 B.C.
Bronze
H. 7.8 cm (3 1/16 in.)

Museum of Fine Arts, Boston. Henry Lillie Pierce Fund 99.480

Provenance: By 1898: with E. P. Warren (acquired in 1898 from Mr. Rhousopoulos, who said it was from Boiotia); purchased by MFA from E. P. Warren, 1899.

107.
Oil flask (aryballos) (p. 133)
Greek
Archaic period, about 6th century B.C.
Bronze
H. 3 cm (1 3/16 in.)
Museum of Fine Arts, Boston. Museum purchase by contribution 01.7520

Provenance: By 1901: with E. P. Warren (bought in Athens); purchased by MFA from E. P. Warren, December 1901.

108.
Oil flask (aryballos) in the shape of a phallus (p. 133)
Greek, made in Athens
Archaic period, about 540 B.C.
Ceramic, black-figure technique; made and signed by the potter Priapos
H. 8.2 cm (3 ¼ in.)
Inscription: "Priapos made it" (on rim)
Museum of Fine Arts, Boston. Gift of Edward Perry Warren 13.105

Provenance: By 1912: with E. P. Warren; gift of E. P. Warren to MFA, January 2, 1913.

109.
Oil flask (aryballos) with a lotus design (not illustrated)
Greek, made in Corinth
Archaic period, about 575–550 B.C.
Ceramic
H. 7.1 cm (2 13/16 in.)
Museum of Fine Arts, Boston. Gift of Edward Robinson 92.2605

Provenance: By 1892: Edward Robinson Collection (purchased in Athens in 1882); gift of Edward Robinson to MFA, February 10, 1892.

110.
Oil flask (aryballos) depicting athletes (p. 133)
Greek, made in Athens, said to have been found in Eretria
Late Archaic period, about 500–490 B.C.
Ceramic, red-figure technique; painted by an imitator of Onesimos
H. 8.6 cm (3 ⅜ in.)
Inscriptions: "Panaitios is handsome" and "Panaitios" (between figures)
Museum of Fine Arts, Boston. Henry Lillie Pierce Fund 98.879

Provenance: By 1898: with E. P. Warren (said to be from Eretria 1897); purchased by MFA from E. P. Warren, 1898.

Around this aryballos athletes are depicted relaxing in a palaistra. An athlete strips the oil from his body with a strigil. More cleaning equipment hangs on the wall. Three pairs of youths and boys stand in conversation; one youth, who is followed by his dog, offers his younger friend a flower.

111.
Oil flask (aryballos) in the shape of an ox head (p. 133)
Greek, made in Athens
Late Archaic period, about 520–500 B.C.
Ceramic, black-figure technique
H. 11.2 (4 7/16 in.)
Museum of Fine Arts, Boston. Catharine Page Perkins Fund 95.55

Provenance: By dates unknown: said to be Albert Barre Collection (cat. no. 354) and Eugène Piot Collection (catalogue, p. 33); by 1892: A. van Branteghem Collection (Hotel Drouot auction of van Branteghem collection, Paris, May 30–31, and June 1, lot 261); by 1894 with E. P. Warren; purchased by MFA from E. P. Warren, 1895.

112.
Oil flask (aryballos) (p. 133)
Greek, made in Athens
Late Archaic period, early 5th century B.C.
Ceramic, black-glaze
H. 12 cm (4 ¾ in.)
Private New England collection

113.
Oil flask (alabastron) in the shape of a hare (p. 133)
Greek, made in Corinth
Archaic period, 6th century B.C.
Ceramic
L. 19.8 cm (7 13/16 in.)
Museum of Fine Arts, Boston. Gift of Henry P.
Kidder 80.574

Provenance: By 1880: H. P. Kidder Collection; gift
of H. P. Kidder to MFA, October 21, 1880.

Hares were often given to athletes as marks of affec-
tion, as on cat. nos. 58 (interior) and 149.

114.
Gem incised with an athlete pouring sand on his
thigh (p. 132)
Etruscan, probably found at Vulci, Etruria
Late Archaic period, about 500–475 B.C.
Sard and gold, set in a gold ring
H. 13 mm (½ in.)
Museum of Fine Arts, Boston. Francis Bartlett
Donation 21.1201

Provenance: By 1920: with E. P. Warren (said to
come from Vulci and to have been owned by
Campanari and later Evans); purchased by MFA
from E. P. Warren, April 7, 1921.

After oiling his skin, an athlete might sprinkle sand
on his body, as this athlete is doing. This dusting or
coating of sand was considered necessary for par-
ticipants in combat sports because it made the skin
less slippery.

115.
Funerary monument for an athlete (p. 138, detail)
Greek, probably made and found in Boiotia
Archaic period, about 550 B.C.
Marble, from Mount Pentelikon near Athens
H. (as reconstructed) 213 cm (84 in.) to feet, 236
cm (93 in.) to base
Inscription: The youth's name, "Tho[i?] …" (at
top, above figure's head)
Museum of Fine Arts, Boston. Gift of Fiske Warren
08.288

Provenance: By date unknown: with E. P. Warren
(said to be from Thebes, 1900); by 1908: Fiske
Warren Collection; gift of Fiske Warren to MFA,
May 28, 1908.

This funerary monument depicts a nude youth as an
athlete: he wears a wreath and carries an aryballos
hanging from a strap or string. He also holds a stalk
with two pomegranates, which could be symbols of
fertility or gifts from admirers. This youth may have
achieved athletic success—he wears an olive wreath,
given to victors at Olympia and Athens.

STRIGILS (CAT. NOS. 116–21)
A metal oil scraper, or strigil, is the most common
attribute of the athlete. After competition athletes
would use a strigil to scrape off the dirt and oil they
had applied before exercising to protect their skin.
Many sculptures and paintings of athletes show
them holding a strigil, designating their athletic
status.

116.
Fragment of a stele depicting an athlete (p. 139)*
Greek
Classical period, late 5th century B.C.
Marble
H. 69.4 cm (27 5/16 in.)
Inscription: "Glaukotas, your mother […] set me in
place for you, to be [a memorial] of your youth" (on
side)
Courtesy of the Michael C. Carlos Museum of
Emory University 2003.4.1
Photograph by Michael McKelvey

Although the lower part of this funerary stele is not
preserved, there are enough clues to identify the fig-
ure as an athlete: he is nude, wears a ribbon given by
an admirer around his head, and carries a strigil.

117.
Drinking cup (kylix) depicting palaistra scenes
(pp. 120–21 and 134, details)
Greek, made in Athens, probably found in Capua,
Campania
Late Archaic or early Classical period, about
500–475 B.C.
Ceramic, red-figure technique, painted by the
Antiphon Painter
H. 9.5 cm (3 ¾ in.)
The Metropolitan Museum of Art. Purchase, 1896
96.18.67
Photograph © 2003 The Metropolitan Museum
of Art

In a palaistra setting, two athletes clean themselves
by scraping the olive oil off their bodies. Another
athlete relaxes, leaning on a turning post. On the
other side of the cup, athletes practice with javelins.

118.
Scraper (strigil) (p. 132)
Italian, said to have been found near Felsina (mod-
ern Bologna)
Late Archaic period, about 500 B.C.
Bronze
L. 22 cm (8 11/16 in.)
Museum of Fine Arts, Boston. Classical
Department Purchase Fund in memory of Miss
Grace Nelson 61.378

Provenance: By date unknown: said to have been
found near Bologna with objects 61.375, 61.376,
61.377, and 61.379 (cat. no. 119); by 1961: with
Münzen und Medaillen AG, Switzerland; pur-
chased by MFA from Münzen und Medaillen AG,
May 10, 1961.

119.
Scraper (strigil) (p. 132)
Italian, said to have been found near Felsina
(modern Bologna)
Late Archaic period, about 500 B.C.
Bronze
L. 18 cm (7 1/16 in.)
Museum of Fine Arts, Boston. Classical
Department Purchase Fund in memory of Miss
Grace Nelson 61.379

Provenance: By date unknown: said to have been
found near Bologna with objects 61.375, 61.376,
61.377, and 61.378 (cat. no. 118); by 1961: with
Münzen und Medaillen AG, Switzerland; pur-
chased by MFA from Münzen und Medaillen AG,
May 10, 1961.

120.
Scraper (strigil) (p. 132)
Greek, made in southern Italy, said to have been
found at Cumae
Late Classical or early Hellenistic period, about
350–290 B.C.
Bronze
L. 27 cm (10 5/8 in.)

Inscription: "Of (or by) Apollodoros" (stamped on back of front part of handle)
Museum of Fine Arts, Boston. Museum purchase by contribution 01.7478

Provenance: By 1901: with E. P. Warren (said to come from Cumae, from Stevens of Naples, from Hoffmann; bought from Ready); purchased by MFA from E. P. Warren, December 1901.

Although a practical object, and one that frequently must have become quite dirty, this strigil is incised with a beautiful vine motif on the handle. The strigil may have belonged to an athlete named Apollodoros.

121.
Drinking cup (kylix) depicting an athlete cleaning up and his dog (p. 139, detail)
Greek, made in Athens
Early Classical period, about 480 B.C.
Ceramic, red-figure technique; painted by the Brygos Painter
H. 7.8 cm (3 ⅟₁₆ in.)
Inscription: "The boy is handsome" (on interior)
Museum of Fine Arts, Boston. Henry Lillie Pierce Fund 01.8038

Provenance: By date unknown: Alfred Bourguignon Collection; by 1901: purchased by E. P. Warren from Alfred Bourguignon; purchased by MFA from E. P. Warren, December 1901.

Here we see an athlete engaged in cleaning up after throwing the javelin. His clothes are draped on a nearby stool. He has wiped the olive oil off his strigil and offers the scrapings to his dog.

APOXYOMENOS STATUES (CAT. NOS. 122–25)
Athletes cleaning themselves became a popular subject for statuary in the fourth century B.C. The theme was given the name *apoxyomenos*, which refers to the act of "scraping off" the oil after exercise. The most often replicated version showed an athlete looking down as he stripped sweaty olive oil from his scraper. A splendid example is a bronze statue that stood in a gymnasion in Ephesos; it is possible that Lysippos, the favorite sculptor of Alexander, created this sculpture. Several fine replicas of it are also notable for their complex poses and tousled hair.

122.
Statuette of an athlete cleaning his scraper (strigil) (pp. 136 and 161, detail)
Roman, probably found at Frascati, near Rome
Roman Imperial period, about A.D. 110–35
Marble
H. (with base) 71.5 cm (28 ⅛ in.)
Museum of Fine Arts, Boston. Henry Lillie Pierce Fund 00.304

Provenance: By 1900: with E. P. Warren (said to have been found in 1896 below Villa Mondragone, at Frascati); purchased by MFA from E. P. Warren, February 1900.

This athlete formerly held a strigil in his right hand and used his left thumb and forefinger to strip away the dirt and oil from his scraper. He is a miniature version of the Ephesos type of apoxyomenos. Cat. no. 123 comes from a full-scale version of the type.

123.
Head of an athlete cleaning his scraper (strigil) (p. 160)
Roman; copy of a Greek original of the second half of the 4th century B.C.
Roman Imperial period, late 1st century B.C. or 1st century A.D.
Bronze
H. 29.9 cm (11 ¾ in.)
Kimbell Museum of Art AP2000.03a
Photograph by Michael Bodycomb 2000. © 2003 by Kimbell Art Museum

This head shows the beauty and expressiveness of major athletic statues. The gaze is concentrated and the hair is tossed about in elaborate oily locks. As in many fourth-century athletic statues, the hair in front is cut short and pushed back. Very few large bronze sculptures have survived from antiquity; being portable and intrinsically valuable, they were generally looted and melted down. The lips were originally overlaid with copper, and the eyes would have been inlaid with precious materials. The head comes from a replica of a statue that was similar in appearance to one found at Ephesos.

124.
Statue of an athlete cleaning himself with a scraper (strigil) (p. 163)
Roman; copy of a Greek original of the late 4th century B.C. similar to the Apoxyomenos by Lysippos
Roman Imperial period, 2nd century A.D.
Marble
H. 190.5 cm (75 in.)
Los Angeles County Museum of Art. William Randolph Hearst Collection 49.23.12
Photograph © 2004 Museum Associates/LACMA

This athlete looks forward as he finishes scraping the underside of his right arm, which would have been held out in front of him. The original sculpture may have been bronze. The majestic statue was well suited to preside over a gymnasion and personify Greek athletic ideals.

125.
Statuette of a young athlete (p. 136)
Greek, made in Tanagra, Boiotia
Early Hellenistic period, late 4th or 3rd century B.C.
Terracotta
H. 29 cm (11 ⅞ in.)
Museum of Fine Arts, Boston. Museum purchase by contribution 01.7816

Provenance: By 1901: with E. P. Warren (bought from Mr. Rhousopoulos); purchased by MFA from E. P. Warren, December 1901.

This terracotta figurine holds a strigil. He also wears a rather large wreath. He is clothed, however, which is unusual for figures of Greek athletes. Perhaps he has completed his bathing and has left the gymnasion.

PHILOSOPHY AND MUSIC (CAT. NOS. 126–30)
Gymnasia and palaistrai were places where male Greek youths received philosophical instruction as well as athletic training. Images of great thinkers, like those below, adorned the spaces in which philosophical discussions took place and may have even inspired discourse. Music was also an important part of Greek education, and musical training was provided alongside athletic training in the gymnasion.

126.

Portrait head of Sokrates (469–399 B.C.) (p. 126)
Roman, probably made and found in Athens; based
on a Greek original of the 4th century B.C. by the
sculptor Lysippos
Roman Imperial period, about A.D. 170–95
Marble, from Mount Pentelikon near Athens
H. 20.4 cm (8 ⁷⁄₁₆ in.)
Museum of Fine Arts, Boston. Frederick Brown
Fund 60.45

Provenance: By 1960: with Byron Th.
Zoumboulakis, Switzerland (said to be from
Athens, perhaps from the Roman Agora, and to be
from the collection of an Eastern European diplo-
mat); purchased by MFA from Byron Th.
Zoumboulakis, February 11, 1960.

The Athenian citizen Sokrates was a teacher and
philosopher. He wrote no treatises, but his thoughts
are preserved in the writings of his followers and
Plato. Many of the dialogues attributed to Sokrates
take place in and around the palaistra and gymna-
sion. Although he took no payment and advocated
no particular school of thought or philosophy, he
did encourage the elite youth of Athens to question
long-held ideas and beliefs.

127.

Portrait head of a philosopher, probably Demokritos
(about 460–370 B.C.) (p. 126)
Roman; based on a Greek original of the
4th century B.C.
Roman Imperial period, about A.D. 50
Marble, from Mount Pentelikon near Athens
H. 39 cm (15 ⅜ in.)
Museum of Fine Arts, Boston. Gift of Heinz Herzer
1972.971

Provenance: By 1972: with Heinz Herzer,
Germany; gift of Heinz Herzer to MFA, November
8, 1972.

128.

Deep cup (skyphos) depicting a young athlete tak-
ing a music lesson (p. 127, detail)
Greek, made in Athens, said to have been found in
Selinus (modern Selinunte), Sicily
Archaic period, about 530–520 B.C.
Ceramic, black-figure technique
H. 10.5 cm (4 ⅛ in.)

Museum of Fine Arts, Boston. Anonymous gift in
memory of Prof. George H. Chase 61.1233

Provenance: By 1961: with Robert E. Hecht, Jr.
(said to be from Selinunte); anonymous gift to
MFA in memory of Prof. George H. Chase,
December 13, 1961.

This scene shows how closely related athletic and
musical instruction were. A youth, identifiable as an
athlete from his strigil and aryballos, stands before
an older seated man. The seated man holds a lyre, a
harplike instrument; evidently he is a music teacher.

129.

Vase (pelike) depicting young athletes jumping
(p. 124, detail)
Greek, made in Athens
Archaic period, about 520–515 B.C.
Ceramic, red-figure technique; painted by
Euphronios
H. 31.1 cm (12 ¼ in.)
Inscriptions: "Aineas," "Kallipides," "Leagros is
handsome," "Smikythion," "Leagros is handsome,
yes indeed!"
Museum of Fine Arts, Boston. Robert J. Edwards
Fund 1973.88

Provenance: By 1972: with Fritz Burki,
Switzerland; purchased by MFA from Robert E.
Hecht; February 14, 1973.

The double-flute in particular was associated with
athletic and martial training. Flute players provided
the rhythm for long jumpers and also for those
practicing athletic dance, as seen on this vase.

130.

Vase (pelike) depicting an athlete (p. 128, detail)
Greek, made in Athens, perhaps found on Rhodes
Archaic period, about 500–490 B.C.
Ceramic, black-figure technique; painted by the
Eucharides Painter
H. 36 cm (14 ³⁄₁₆ in.)
Museum of Fine Arts, Boston. Gift of the family of
Arthur S. Dewing 2004.74

Provenance: By date unknown: W. H. Forman
Collection; inherited from him by Mrs. Burt and
then, about 1889, by A. H. Browne; by 1899: with
Sotheby, Wilkinson, and Hodge, London, auction
of the Forman Collection, June 19–22, lot 316 (per-
haps from Rhodes); 1899: H. de Morgan Collec-

tion (purchased at the Forman auction); American
Art Galleries Sale, March 12–13, 1901, lot 193; by
1954: Collection of a Friend of the Fogg Museum;
loaned by Arthur S. Dewing to MFA, May 22, 1961
(55.61); returned January 18, 1963; loaned by
Arthur S. Dewing to MFA, March 10, 1965 (53.65);
gift of the family of Arthur S. Dewing to MFA, April
21, 2004.

As a trainer observes, an athlete carrying jumping
weights steps or jumps over a discus (or ball) to the
accompaniment of a double-flute. This may depict a
scene of general conditioning rather than preparation
for a particular event.

FEMALES AND THE GAMES (CAT. NOS. 131–36)

Athletic competitions for unmarried girls were held
all over Greece, although the only events in which
girls were allowed to compete were footraces. As
was the case with men, athletic competitions for
girls were part of religious celebrations, for example
to honor Hera at Olympia. There is more evidence
for Spartan girls than for girls of any other region,
because Spartan culture promoted athletic training
for unmarried girls and boys. The costumes and
activities of the girls below make it clear that they
must be athletes.

131.

Vase (stamnos) depicting girls bathing
(p. 135, detail)
Greek, made in Athens, said to have been found in
Campania
Classical period, about 440–430 B.C.
Ceramic, red-figure technique; painted by a member
of the Group of Polygnotos
H. 40.6 cm (16 in.)
Inscription: "Hediste is beautiful" (at the top of the
scene)
Museum of Fine Arts, Boston. Catharine Page
Perkins Fund 95.21

Provenance: By 1893: S. Pascale Collection; by
1895: with E. P. Warren (said to have been found at
Vico in Campania); purchased by MFA from E. P.
Warren, 1895.

Three nude girls stand around a bath basin in a gym-
nasion, cleaning themselves with strigils after exercis-
ing. A female slave brings a garment and an unguent
container (plemochoe); two mirrors hang on the wall.

132.
Drinking cup (kylix) depicting scenes of bathing and exercise (p. 32, detail)
Greek, made in Athens, said to have been found in Campania
Classical period, about 450–430 B.C.
Ceramic, red-figure technique
H. 19 cm (3 ⁹⁄₁₆ in.)
Museum of Fine Arts, Boston. Francis Bartlett Donation of 1900 03.820

Provenance: By 1903: with E. P. Warren (said to have come from a cemetery in Campania); purchased by MFA from E. P. Warren, March 1903.

The outside of this cup shows a discus thrower and a long jumper, each flanked by trainers. The scene on the inside of the cup is much more interesting. Because men and women generally did not exercise or bathe together in ancient Greece, this image can be interpreted as a mythological scene, showing Atalanta, the famous athlete, as she converses and bathes with Peleus, whom she has just defeated in a wrestling match. It may also represent a scene from Spartan life, where young men and women did exercise together.

133.
Bowl (patera) handle in the shape of a female athlete (p. 33)
Etruscan
Hellenistic period, about 3rd century B.C.
Bronze
L. 38.3 cm (15 ¹⁄₁₆ in.)
Museum of Fine Arts, Boston. Francis Bartlett Donation of 1900 03.989

Provenance: By 1903: with E. P. Warren (bought in Rome); purchased by MFA from E. P. Warren, March 1903.

This nude girl, wearing low shoes and carrying a strigil, is surely an athlete. She wears her hair wrapped in a cloth, like the girl on cat. no. 132.

134.
Bowl (patera) handle in the shape of a female athlete (p. 33)
Greek, said to be from Corinth
Archaic period, about 525–500 B.C.
Bronze
H. 18.5 cm (7 ¼ in.)

The Metropolitan Museum of Art. Rogers Fund, 1946 46.11.6
Photograph © 2003 The Metropolitan Museum of Art

This girl wears shorts or a loincloth like those seen on the girl on cat. no. 132. She also wears soft low shoes, like those of the girl on cat. no. 133. She is probably a Spartan; at Sparta girls exercised like men and boys.

135.
Gem depicting a girl running (p. 31)
Etruscan
Early Classical period, about 480–450 B.C.
Sardonyx
H. 13 mm (½ in.)
Museum of Fine Arts, Boston. Henry Lillie Pierce Fund 98.735

Provenance: Date unknown: said to have been seen in Florence by A. J. Evans before its acquisition by Count Tyszkiewicz; by 1897: Count Michel Tyszkiewicz Collection (bought in Naples); 1898: auction of the M. Tyszkiewicz Collection, Paris, June 8–10, lot 260; by 1898: with E. P. Warren; purchased by MFA from E. P. Warren, 1898.

This gem depicts a victor in the girls' running race. She carries a palm branch, perhaps a symbol of victory, as she lifts the hem of her skirt. Etruscan girls competed in footraces fully clothed, while Greek girls wore a shorter garment that left one breast bare.

136.
Two-handled vessel (nestoris) depicting athletes in conversation with girls (p. 35)
Greek, made in Lucania
Classical period, late 5th century B.C.
Ceramic, red-figure technique; painted by the Amykos Painter
H. 49.6 cm (19 ½ in.)
Museum of Fine Arts, Boston. Partial gift of Peter and Mary Lee Aldrich 1998.588

Provenance: By 1982: with Sotheby's, London, auction, December 13–14, 1982, lot 298; by 1996: with Sotheby's, London, auction, December 10, 1996, lot 191 (with note that it was on loan 1988–1994 at the Borchardt Library, La Trobe University, Melbourne); purchased at the 1996 auction by Peter and Mary Lee Aldrich; partial gift of Peter and Mary Lee Aldrich to MFA, December 31, 1998.

Both sides of this vase depict fraternization between male athletes and admiring females. The nude winged figure in the center of one side is Eros, the god of love, whose presence confirms the romantic nature of these interactions.

VICTORS

137.
Oil bottle (lekythos) depicting Victory alighting beside an altar (p. 156)
Greek, made in Athens
Late Archaic period, about 490 B.C.
Ceramic, red-figure technique; painted by the Berlin Painter
H. 24.3 cm (9 ⁹⁄₁₆ in.)
Courtesy of the Arthur M. Sackler Museum, Harvard University Art Museums. Loan from the Estate of Donald Upham and Mrs. Rosamond U. Hunter 4.1908
Photograph by Michael A. Nedzweski. © 2003 President and Fellows of Harvard College

Victory, or Nike, pouring a libation was a popular theme on Athenian vases of the first part of the fifth century. On this bottle and cat. no. 138 the goddess approaches an altar (a small column-like object) carrying a pitcher and a wide, shallow cup. She will pour wine from the pitcher into the cup and then onto the altar in a demonstration of the link between piety and victory.

138.
Vase (amphora) depicting Victory (p. 156, detail)
Greek, made in Athens, perhaps found in Sicily or southern Italy
Early Classical period, about 460 B.C.
Ceramic, red-figure technique; painted in the manner of the Alkimachos Painter
H. 33.2 cm (13 ¹⁄₁₆ in.)
Inscription: "Nikon is handsome"
Museum of Fine Arts, Boston. Catharine Page Perkins Fund 95.20

Provenance: By 1895: with E. P. Warren (said to be probably from Sicily, but perhaps from southern Italy); purchased by MFA from E. P. Warren, 1895.

139.

Fragment of a plaque depicting Victory (p. 157)
Roman
Early Roman Imperial period, 1st century A.D.
Terracotta
H. 23.2 cm (9 ⅛ in.)
Museum of Fine Arts, Boston. Benjamin Pierce
Cheney Donation 88.567

Provenance: By 1888: with Pietro Pennelli; January
6, 1888: purchased by R. Lanciani from Pietro
Pennelli; purchased by MFA from R. Lanciani, 1888.

On this upper portion of a relief, a flying Victory car-
ries a palm branch and a wreath. Originally the scene
contained an athlete somewhere below her, waiting
to be crowned.

140.

Wine-mixing bowl (krater) depicting a victorious
athlete (p. 144, detail)
Greek, made in Apulia
Late Classical, early 4th century B.C.
Ceramic, red-figure technique; painted by the Hearst
Painter
H. 39 cm (15 ⅜ in.)
From the Collection of Peter and Mary Lee Aldrich

A man seated in a chair like a judge offers a ribbon of
admiration to a victorious athlete. The seated man's
elaborate chair, which is cushioned with the skin of a
small feline, and his traveler's hat suggest he is a
hero, perhaps Pelops. The athlete is also about to be
crowned by Victory.

141.

Statuette of a flying Victory (p. 2)
Roman
Early Roman Imperial period, 1st century B.C. to
1st century A.D.
Bronze
H. 16 cm (6 ⅝ in.)
Museum of Fine Arts, Boston. Harriet Otis Cruft
Fund 62.971

Provenance: By 1962: with Mathias Komor, 19 East
71st Street, New York 21; purchased by MFA from
Mathias Komor, November 14, 1962.

This statuette shows a flying Victory alighting upon
a globe. It is based on a sculpture set up by
Augustus, the first Roman emperor, to celebrate his
becoming the sole ruler of Rome.

142.

Coin depicting Victory (on reverse) (p. 38)
Obverse: Eagle flying (p. 38)
Greek, minted at Olympia
Classical period, about 470–440 B.C.
Silver stater
Diam. 26 mm (1 in.), weight 12.09 gm
Museum of Fine Arts, Boston. Henry Lillie Pierce
Fund 04.877

Provenance: By date unknown: Ashburnham
Collection (sale 1895, pl. III, 118); by 1902: Canon
Greenwell Collection; July 1902: acquired from the
Canon Greenwell Collection by E. P. Warren; pur-
chased by MFA from E. P. Warren, September
1904.

143.

Coin depicting Victory (on reverse) (p. 38)
Obverse: Eagle killing a snake (p. 38)
Greek, minted at Olympia
Classical period, about 480–440 B.C.
Silver stater
Diam. 24 mm (¹⁵⁄₁₆ in.), weight 11.97 gm
Museum of Fine Arts, Boston. Henry Lillie Pierce
Fund 04.879

Provenance: By date unknown: Canon Greenwell
Collection; July 1902: acquired from the Canon
Greenwell Collection by E. P. Warren; purchased
by MFA from E. P. Warren, September 1904.

Victory sits on a stepped monument, holding a
staff or javelin. An olive wreath rests on the steps
below her.

144.

Coin depicting a prize table (on reverse) (p. 7)
Obverse: Head of Emperor Caracalla (p. 7)
Roman provincial, minted at Philippopolis, Thrace
Roman Imperial period, about A.D. 211–17
Bronze
Diam. 37 mm (1 ⁷⁄₁₆ in.), weight 25.39 gm
Museum of Fine Arts, Boston. Theodora Wilbour
Fund in Memory of Zoë Wilbour 62.368

Provenance: By 1962: with Münzen und Medaillen,
AG, Switzerland; purchased by MFA from Münzen
und Medaillen, AG, May 9, 1962.

At Olympia the victor's wreaths were displayed on
a beautiful gold and ivory table, designed by a stu-

dent of the sculptor Pheidias. This coin shows ath-
letic prizes, an urn, a palm branch, and a bulky
crown inscribed "Pythia" and filled with five apples
or balls, arranged on and around a table with legs
that end in lion feet.

145.

Fragment of a relief depicting athletic trophies
(p. 146)
Roman, found in Greece
Roman Imperial period, 2nd century A.D.
Marble
H. 32.5 cm (12 ¾ in.), l. 67.7 cm (26 ⅜ in.)
Inscriptions: "Panathenaia," "Isthmia," "Shield
from Argos," "Nemea" (on prizes); "[the son of
Alex]ander of Rhamnous" (at bottom)
The Metropolitan Museum of Art. Rogers Fund,
1959 59.11.19
Photograph © 2003 The Metropolitan Museum of
Art

This relief illustrates in stone the prizes won by a
particular athlete: an amphora from the Panathenaic
Games, a pine wreath from the Isthmian Games, a
shield from games at Argos, and a celery wreath
from the Nemean Games. There may have been a
fifth prize, perhaps from the games at Olympia or
Delphi.

146.

Stele honoring a judge (not illustrated)
Greek, found in Assos, Asia Minor
Hellenistic period, 2nd or 1st century (after 166)
B.C.
Marble
H. 49 cm (19 ⁵⁄₁₆ in.), w. 45.6 cm (17 ¹⁵⁄₁₆ in.), d. 7.5
cm (2 ¹⁵⁄₁₆ in.)
Museum of Fine Arts, Boston. Gift of the
Archaeological Institute of America 84.53

Provenance: 1881–1882: Found at Assos, below
the bouleuterion; gift to MFA from the
Archaeological Institute of America, 1884.

Four cities, including Mylasa and Alabanda, erected
this stele to honor the judge Lanthes, probably for
managing the competitions in civic festivals. At the
top is a triangular pediment with a shield at the
center; below this is a panel giving the judge's
name. The main field is divided into four panels,
each containing a laurel wreath around a disk or

shield noting the name of a city. The laurel wreaths are insignia of honor, here conferred on a judge instead of a victor.

147.
Wreath of olive leaves (p. 146)
Greek, possibly found in western Asia Minor
Late Classical or early Hellenistic period,
4th century B.C.
Gold
Diam. about 16 cm (6 ⁵⁄₁₆ in.)
Museum of Fine Arts, Boston. Arthur Tracy Cabot Fund 67.88

Provenance: By 1966: with Robert E. Hecht, Jr. (said to be from western Asia Minor, perhaps near Miletos); purchased by MFA from Robert E. Hecht, Jr., February 8, 1967.

There was a fashion among Macedonian royalty and elite to be buried with gold foil wreaths, probably reflecting the generalized function of the wreath as an honorific. This wreath of olive leaves is made in two halves, which are joined by a small square knot at the top.

148.
Drinking cup (kylix) depicting athletes and a judge (p. 147, detail)
Greek, made in Athens
Classical period, about 460 B.C.
Ceramic, red-figure technique; painted by the Euaion Painter
H. 11.7 cm (4 ⅝ in.)
Museum of Fine Arts, Boston. James Fund and by Special Contribution 10.181

Provenance: By 1910: with E. P. Warren (bought in London, apparently between 1896 and 1898); purchased by MFA from E. P. Warren, June 2, 1910.

The scenes on the interior and exterior of this drinking cup show older men awarding red and white ribbons to nude boy athletes. The men, who are bearded and wear mantles, are probably the boys' admirers. All the figures wear olive wreaths, except one boy who has a ribbon around his head and carries a branch. An old man with a stick could be a judge or a father.

149.
Vase (amphora) depicting a victorious athlete (p. 6, details)
Greek, made in Athens, probably found in Italy
Late Archaic period, about 490 B.C.
Ceramic, red-figure technique; painted by the Kleophrades Painter
H. 45.4 cm (17 ⅞ in.)
Museum of Fine Arts, Boston. James Fund and by Special Contribution 10.178

Provenance: Said to have been in the possession of Basseggio in Rome and later in the Bammeville and Forman Collections; by date unknown: W. H. Forman Collection; inherited from him by Mrs. Burt and then, about 1889, by A. H. Browne; by 1899: with Sotheby, Wilkinson, and Hodge, London, auction of the Forman Collection, June 19–22, lot 342; by 1910: with E. P. Warren; purchased by MFA from E. P. Warren, June 2, 1910.

This vase shows a much-admired athlete loaded down with prizes and gifts. He carries a walking stick, an aryballos, and a hare. His body is adorned with red ribbons, signs of admiration. On the other side of the vase another youth stands holding a wreath, perhaps to be awarded to the athlete.

150.
Covered drinking cup (kylix) depicting a judge and athletes (p. 149)
Greek, made in Athens
Late Archaic period, about 500 B.C.
Ceramic, black-figure technique
H. 27.3 cm (2 ⅞ in.)
Inscriptions: "The girl is pretty," "The boy is handsome" (twice each)
Museum of Fine Arts, Boston. Catharine Page Perkins Fund 95.16

Provenance: By 1892: A. van Branteghem Collection (Hotel Drouot auction of van Branteghem Collection, May 30–31 and June 1, Paris, lot 21); by 1894: with E. P. Warren; purchased by MFA from E. P. Warren, 1895.

On the cover of this drinking cup, a judge awards red and white ribbons to seven athletes. A flute player accompanies the ceremony.

151.
Deep cup (skyphos) depicting an athlete holding a wreath (p. 28, detail)
Greek, probably made and found in Campania
Late Classical period, about 340–330 B.C.
Ceramic, red-figure technique; painted by the Errera Painter
H. 14.2 cm (5 ⁹⁄₁₆ in.)
Museum of Fine Arts, Boston. Francis Bartlett Donation of 1900 03.822

Provenance: By 1903: with E. P. Warren (said to have come from a cemetery in Campania); purchased by MFA from E. P. Warren, March 1903.

This victorious athlete, an inhabitant of southern Italy, is shown wearing shorts or a loincloth. A proper Greek athlete would have been represented nude, but this custom was not universally adopted outside of Greece, and this athlete probably was a native Italian, perhaps an Oscan.

152.
Statue of a boy athlete (p. 153)
Roman; loosely based on a Greek sculpture of the 5th century B.C.
Roman Imperial period, 2nd century A.D.
Bronze, eyes inlaid with silver
H. 117 cm (46 ⁵⁄₁₆ in.)
Collection of Stuart Pivar

This longhaired boy wears a ribbon around his head and may have originally held a ribbon, or perhaps branches, both of which were given as gifts to admired athletes.

153.
Statue of an athlete (p. 147)
Greek, said to be from Smyrna, Asia Minor; copy of the Diadoumenos sculpture by Polykleitos
Late Hellenistic period, about 100–50 B.C.
Terracotta
H. 29.2 cm (11 ½ in.)
The Metropolitan Museum of Art. Fletcher Fund, 1932 32.11.2
Photograph © 2003 The Metropolitan Museum of Art

This small statue may have been a dedication at a sanctuary. From the position of his arms and hands, he appears to be a copy of a well-known sculpture of an athlete tying a ribbon on his head (the Diadoumenos).

154.
Statue of a young athlete (p. 153)
Roman; copy of a Classical Greek original of about
430 B.C.
Roman Imperial period, 1st or 2nd century A.D.
Marble, from Mount Pentelikon near Athens
H. 116.2 cm (45 ¾ in.)
The Metropolitan Museum of Art. Fletcher Fund,
1926 26.60.2
Photograph © 2003 The Metropolitan Museum of
Art

This statue of a youth wearing a victor's ribbon
around his head was probably set up to commemo-
rate an athletic victory. He may have originally held
a javelin or spear.

155.
Head of an athlete (not illustrated)
Roman
Roman Imperial period, about A.D. 50–75
Marble
H. 37 cm (14 ⁹⁄₁₆ in.)
Museum of Fine Arts, Boston. Francis Bartlett
Donation of 1900 03.754

Provenance: By 1903: with E. P. Warren (bought in
Rome); purchased by MFA from E. P. Warren,
March 1903.

This head of a youth represents an athlete: around
his head he wears both a cord (perhaps to hold his
hair) and a ribbon, presented by an admirer. He may
have been a boxer, as his ears appear swollen.

156.
Gem depicting an athlete (p. 154)
Greek, probably found at or near Eryx, Sicily
Late Hellenistic period, about 2nd to 1st
century B.C.
Sard
H. 1.7 cm (¹¹⁄₁₆ in.)
Museum of Fine Arts, Boston. Francis Bartlett
Donation of 1900 03.1005

Provenance: By 1903: with E. P. Warren (bought
from A. J. Evans, who had it from Eryx in Sicily);
purchased by MFA from E. P. Warren, March 1903.

A victorious runner, holding a palm branch and a
wreath, rests after his race. He rests his hand on a
turning post, perhaps fatigued but savoring his victory.

157.
Statuette of an athletic victor crowning himself
(pp. 9 and 154)
Greek, said to have been found at Kroton, southern
Italy
Early Classical period, about 470 B.C.
Bronze
H. 19 cm (7 ½ in.)
Museum of Fine Arts, Boston. Catharine Page
Perkins Fund 96.706

Provenance: By 1896: with E. P. Warren (said to
come from Kroton); purchased by MFA from E. P.
Warren, 1896.

This nude figure was probably an athlete. Although
much of his right arm is missing, it is likely he was
crowning himself—that is, placing a wreath on his
head, a common gesture for athletic victors (see
also cat. nos. 158 and 161).

158.
Coin depicting an athlete (on reverse) (p. 155)
Obverse: Head of Emperor Caracalla (p. 155)
Roman provincial, minted at Ankyra, Asia Minor
Roman Imperial period, about A.D. 198–217
Bronze
Diam. 30.5 mm (1 ³⁄₁₆ in.), weight 20.30 gm
Museum of Fine Arts, Boston. Theodora Wilbour
Fund in Memory of Zoë Wilbour 61.1126

Provenance: 1961: with Hesperia Art, Philadelphia,
Pa. (said to be from the art market in Turkey); pur-
chased by MFA from Hesperia Art, November 8,
1961.

Here a nude athlete holds a large palm branch and
points to the heavy wreath that he may have just
placed on his head. The coin celebrates Ankyra's
Isopythian Games ("Games Like Those at
Delphi").

159.
Coin depicting a victorious runner (on reverse)
(p. 155)
Obverse: Head of the goddess Juno (p. 155)
Roman, minted at Rome
Roman Republican period, 74 B.C.
Silver denarius
Diam. 18 mm (¹¹⁄₁₆ in.), weight 4.06 gm
Museum of Fine Arts, Boston. Theodora Wilbour
Fund in Memory of Zoë Wilbour 2000.1039

Provenance: By 1997: with Numismatic Ars
Classica, Zurich (sale G, April 10, 1997, lot 1355);
by 2000: with Baldwin's Auctions Ltd., London
and M & M Numismatics Ltd., Washington, D.C.
(The New York Sale, Auction III, New York
Marriott World Trade Center, December 7, 2000,
lot 427); purchased on behalf of MFA at the New
York Sale, Auction III by Antiqua Inc.; purchased
by MFA from Antiqua Inc., January 24, 2001.

Because this runner carries both a palm branch and
fillets, we know he is taking a victory lap.

160.
Coin depicting Agon, the spirit of competition
(on reverse) (p. 159)
Obverse: Head of Emperor Caracalla (p. 159)
Roman provincial, minted at Nicaea, Asia Minor
Roman Imperial period, about A.D. 211–17
Bronze
Diam. 35 mm (1 ⅜ in.), weight 26.60 gm
Museum of Fine Arts, Boston. Theodora Wilbour
Fund in Memory of Zoë Wilbour 1983.6

Provenance: By 1982: with Edward J. Waddell,
Ltd. (auction 1, Barbizon Plaza Hotel, New York,
N.Y., December 9, 1982, lot 111); purchased at
Waddell auction 1 on behalf of MFA by Jeffrey
Spier; purchased by MFA from Jeffrey Spier,
January 12, 1983.

Agon sits on a throne and holds out a prize crown
in his right hand. The vase on the ground in front
of him is likely a prize as well.

161.
Relief depicting a victorious athlete (p. 158)
Roman, probably made and found in the area of
Tarsus, Asia Minor
Roman Imperial period, about A.D. 117–38
Marble
H. 79.5 cm (31 ¼₁₆ in.)
Museum of Fine Arts, Boston. Centennial Gift of
Mr. and Mrs. Charles S. Lipson 67.948

Provenance: By date unknown: said to come from
the Tarsus area, perhaps Soloi-Pompeiopolis; by
1967: Mr. and Mrs. Charles S. Lipson Collection;
gift of Mr. and Mrs. Charles S. Lipson to MFA,
October 11, 1967.

This piece is part of the Hellenistic Greek tradition of portrait busts of heroes on shieldlike roundels. The youthful athlete holds a palm branch decorated with two red ribbons in one hand. With the other hand he reaches up to touch the wreath on his head, perhaps crowning himself or calling attention to his crown. The figure may be a personification of competition.

162.
Stele depicting a victorious boat crew (p. 27)
Greek, made and found in Athens
Roman Imperial period, A.D. 163–64
Marble from Mt. Pentelikon near Athens
H. 80 cm (31 ½ in.), w. 50 cm (19 ¹¹⁄₁₆ in.), d. 24 cm (9 ⁷⁄₁₆ in.)
Inscriptions: The names of the epheboi and victories at the annual festivals in honor of the imperial family
National Archaeological Museum, Athens 1466

This stele illustrates a victorious crew of adolescent rowers wearing cloaks. Their inscribed names are arranged in two teams of twelve each.

FIGURE ILLUSTRATIONS

Fig. 1.
Prize water jar (hydria) depicting Zeus in the form of an eagle abducting Ganymede (p. 21)
Greek, probably made in Mylasa, Asia Minor
Classical period, 4th century B.C.
Bronze
H. 47 cm (18 ½ in.)
Inscription: "Prize from Mylasa of [the games of] Zenoposeidon"
Collection of George D. Behrakis

Fig. 2.
Fish plate depicting a victorious boat crew with marine creatures (p. 27)
Greek, probably made in Canusium, Apulia
Early Hellenistic period, about 320–310 B.C.
Ceramic, red-figure technique; painted by the Bloomington Painter
Diam. 25.4 cm (10 in.)
Private New England collection

Fig. 3.
Pitcher (oinochoe) depicting two athletes sharing a strigil, or scraper, as they clean up (p. 31, detail)
Greek, made in Athens, probably found in Gela, Sicily
Classical period, about 450 B.C.
Ceramic, red-figure technique; painted by the Chicago Painter
H. (with handle) 24.5 cm (9 ⅝ in.)
Inscription: "Alkimachos is handsome"
Museum of Fine Arts, Boston. Francis Bartlett Donation of 1912 13.191

Fig. 4.
Aerial view of the archaeological site at Olympia (p. 36)
© Yann Arthus-Bertrand / CORBIS

Fig. 5.
Plan of Olympia during the Roman period (p. 37)
Modified and reproduced by kind permission of Hirmer Verlag GMBH

Fig. 6.
Drawing of cat. no. 86 by Catherine Alexander (p. 113)

Fig. 7.
Two-handled cup depicting a mature athlete and a boy athlete caressing each other (p. 129, detail)
Greek, made in Athens
Archaic period, about 520 B.C.
Ceramic, black-figure technique
H. 11.4 cm (4 ½ in.)
Museum of Fine Arts, Boston. Gift of E. P. and Fiske Warren, 1908 08.292

Fig. 8.
Drinking cup (kylix) depicting an admirer giving a pomegranate to a boy athlete (p. 148, detail)
Greek, made in Athens
Classical period, about 500–495 B.C.
Ceramic, red-figure technique
H. 10.5 cm (4 ⅛ in.)
Museum of Fine Arts, Boston. James Fund and by Special Contribution 10.193

Fig. 9.
Statue of a victorious runner (p. 155)
Greek, found in the sea near Kyme, Asia Minor
Late Hellenistic or early Roman Imperial period, mid-1st century B.C.
Bronze, eyes originally inlaid in another material
H. 1.54 m (5 ft.)
Izmir Archaeological Museum 9363

CONTEMPORARY PHOTOGRAPHS

Pp. ii–iii:
Mike Hewitt
10,000-Meter Race, 1996 Summer Olympics, Atlanta
© Mike Hewitt / Getty Images

P. 4:
Otto Greule, Jr.
Kristine Lilly, 2002 Women's World Cup Soccer, Seattle
© 2002 Otto Greule, Jr. / Getty Images

P. 8:
Scott Barbour
Tom Hill and German Velazio, Men's Judo, 2000 Summer Olympics, Sydney
© Scott Barbour / Getty Images

Pp. 12–13:
David Cannon
The Olympic Flame, 1988 Summer Olympics, Seoul
© David Cannon / Getty Images

P. 17:
Photographer unknown
Robert Garrett, Discus Gold Medalist, 1896 Olympics, Athens
© Getty Images

P. 19:
John Huet
Chris Huffins, Berkeley, California, 1996
© John Huet 1996

P. 25:
Annie Leibovitz
Dennis Mitchell, ARCO Olympic Training Center, Chula Vista, California
© 1996 Annie Leibovitz / Contact Press Images

P. 41:
Mike Powell
Birgit Clarius, Heptathlon, 1992 Summer Olympics, Barcelona
© Mike Powell / Getty Images

P. 55:
John Huet
Wrestler, Los Angeles, 1999
© John Huet 1999

Pp. 58–9:
Howard Schatz
Stacey Bowers, Triple Jump
Photograph by Howard Schatz from *Athlete* (HarperCollins Publishers, 2002)
© Schatz/Ornstein 2002

P. 63:
Leni Riefenstahl
Nightly Start of the Decathlon, Berlin, 1936
© Leni Riefenstahl

P. 67:
Herb Ritts
Jackie Joyner-Kersee, Point Dume, 1987
© Herb Ritts Foundation

P. 77:
Annie Leibovitz
Mike Powell, ARCO Olympic Training Center, Chula Vista, California
© 1996 Annie Leibovitz / Contact Press Images

P. 83:
Howard Schatz
Breaux Greer, Javelin
Photograph by Howard Schatz from *Athlete* (HarperCollins Publishers, 2002)
© Schatz/Ornstein 2002

P. 86:
Eadweard J. Muybridge
Plate 307. *Throwing an Iron Disk*, from *Animal Locomotion*, vol. 2, *Males (Nude)*, 1885
Collotype
10 1/8 x 10 5/8 in.
Addison Gallery of American Art. Gift of Edwin J. Beinecke Trust 1984.6.75

P. 95:
Wally McNamee
Wrestling, 1992 Summer Olympics, Barcelona
© Wally McNamee / CORBIS

P. 103:
Herb Ritts
Mike Tyson, Las Vegas, 1989
© Herb Ritts Foundation

P. 111:
Darren McNamara
Karen Dixon on Too Smart, 2000 Summer Olympics, Sydney
© Darren McNamara / Getty Images

Pp. 122–23:
Darren McNamara
Men's Team Archery Winners, 2000 Summer Olympics, Sydney
© Darren McNamara / Getty Images

P. 137:
John Huet
Michael Johnson, Barcelona, 1992
© John Huet 1992

GLOSSARY

ageneios (pl. **ageneioi**). Beardless youths, usually between the ages of thirteen and eighteen.

agon (pl. **agones**). An organized contest; an athletic competition. The term Agon also refers to the personification of the games and more generally of the contest.

akon (pl. **akontia**). Light spear or javelin thrown as part of the pentathlon contest; javelin throwing was added to the Olympic Games as a part of the pentathlon in 708 B.C.

akoniti. Literally, "without dust;" a win by forfeit. Initially it referred to a win in a combat event; later it was applied to other events as well.

akrocheirismos. Tactic by which pankration competitors tried to bend back and break their opponents' fingers.

alabastron (pl. **alabastra**). Elongated jar or bottle used to hold oil or perfume. Most often ceramic, it has a rounded, footless bottom and two small handles near the mouth. An alabastron is usually taller and more elongated than an aryballos.

Altis. Literally, "grove" or forest; main sanctuary or sacred area of Olympia, composed of a grove of olive trees and an ash altar.

amphora (pl. **amphorae**). All-purpose, two-handled, lidded jar, usually ceramic, used to store liquids or solids, often food.

anabates. Equestrian event that ended with the horseman dismounting and running to the finish line alongside his horse; also a competitor in the event.

andros (pl. **andres**). Adult male, often shown bearded in artistic depictions; the oldest age division at Greek athletic games.

ankyle. Leather thong or throwing cord used by javelin contestants to aid their throws, probably adapted from a similar device used with spears in hunting and in war; called an amentum in Latin.

aphesis. Literally, "a letting go;" a generic term for the starting line, probably a rope barrier, for footraces and horse races.

apobates. Equestrian event in which armed men repeatedly entered and dismounted from a moving chariot; also a competitor in the event.

apodyterion. Literally, "undressing room;" area in the palaistra where athletes robed and disrobed.

apoxyomenos. Athlete scraping himself with a strigil after exercise or cleaning his strigil. Images of such activities were a popular subject in Greek art, especially during the fourth century B.C.

arete. Virtue, excellence, prowess.

aryballos (pl. **aryballoi**). Small vase for oil or perfume, most often with a spherical, footless body and a single handle; usually ceramic, but sometimes bronze or glass. Athletes often carried aryballoi from a string or strap around their wrists.

askos. Usually a small, low, flat-bottomed ceramic container used to hold liquids; a wineskin.

athletes. Athlete; derived from the words *athlos* and *athlon*.

athlon. Prize of a contest. The plural form also means the contest itself.

athlos (pl. **athloi**). A contest or struggle in war or sport.

athlothetes. Person responsible for organizing and managing games with prizes; judge responsible for punishing fouls and determining victors. See also *Hellanodikes*.

aulos. Flute, usually a double-flute. Flute players often provided music and rhythms for athletes while they trained; they also played at award ceremonies.

balbis. Rectangular area in the stadium, where javelin and discus competitions were held.

black-figure. Vase-painting technique resulting in black figures against a red background. Details inside the figures are usually incised with a metal tool.

bouleuterion. Council house; at Olympia, athletes swore an oath to follow the rules in front of a statue of Zeus in the bouleuterion.

caestus. Roman boxing glove studded with metal that wrapped around the knuckles, with a padded sleeve that protected the entire arm.

contorniate. Late Roman bronze medallion, often decorated with themes related to the amphitheater and circuslike chariot races.

crown games. The four most important Greek athletic competitions, held at Olympia, Isthmia, Nemea, and Delphi.

dekadrachm. Literally, "ten drachmas;" a Greek silver coin equal in value and weight to ten drachmas. See *drachma*.

denarius. Roman unit of money and weight; also a silver coin.

diaulos. Literally, "double-flute" or "double channel;" a footrace measuring two lengths of the stadium (about 365 meters, or 400 yards) introduced in 724 B.C.

didrachm. Literally, "two drachmas;" a Greek silver coin equal in value and weight to two drachmas. See *drachma*.

dinos. Large mixing bowl with rounded bottom and no handles, which must be set on a stand.

diskos (pl. **diskoi**). Discus; a spherical object thrown as part of the pentathlon contest. Typically made of bronze—though sometimes marble, lead, or iron—an ancient diskos could weigh more than 6 kilograms (13 pounds).

dolichos. Longest footrace, introduced to the Olympics in the 720s B.C.; it varied from seven to twenty-four stades, that is, from about 1.6 to 4.8 kilometers (about 1 to 3 miles).

drachma (pl. drachmas). Greek unit of money and weight; also a silver coin.

dromos. Racetrack; a rectilinear space, sometimes with bulging sides, where the footraces were held.

ephebos (pl. epheboi). Greek word for a male youth who had reached puberty. Later it came to mean a youth between eighteen and twenty who was preparing to become a citizen; also an age division at many ancient athletic games.

epinician. Victory ode composed by a poet to honor the winner of an athletic event(s) and performed in public to bring glory to the athlete and his hometown.

erion (pl. eria). Burial mound, where funeral games were held.

euandria (pl. euandria). Male beauty contest.

gymnasiarch. The person responsible for running a gymnasion and supervising its staff.

gymnasion (pl. gymnasia). From the Greek word *gymnos*, or "nude," the training ground where athletes practiced their exercises in the nude.

gymnastes. Trainer specializing in medical therapies.

gymnos. Literally, "nude;" root of the Greek word *gymnasion* and the Latin word *gymnasium*.

gymnotribe (pl. gymnotribai). Athletic trainer who taught specific athletic skills.

halter (pl. halteres). Hand-held weight used by long jumpers, presumably to lengthen their jump; also used by athletes when they exercised.

Hellanodikes (pl. Hellanodikai). Judge in athletic competition who determined victors and also punished athletes for fouls. See also *athlothetes*.

herm. Head or bust of a figure, typically representing Hermes, on a simple shaft.

himas (pl. himantes). Ancient boxing glove; leather thongs wrapped around the hands (sometimes also the wrists and lower arms) of boxers.

hippodrome. Track for horse and chariot races.

hoplitodromos. Armed footrace two stades in length, introduced to the Olympics in 520 B.C., in which participants wore a bronze helmet and greaves (shin guards) and carried a shield; also a competitor in the event.

hydria (pl. hydriae). Vessel for carrying water with two horizontal carrying handles, one on each side, and a third vertical handle on the back of the neck for pouring; usually ceramic, sometimes bronze.

hysplex. A rope or part of a gate that was let down to start a race.

Isthmian Games. Athletic games honoring Poseidon held at Isthmia, on the Isthmus of Corinth, every two years in spring or summer beginning in 581 B.C.; victors received pine wreaths.

kalos. Literally, "handsome one" or "pretty one."

kampter (pl. kampteres). Post used to mark starting and finishing points and the turning areas in footraces and horse races; also called terma.

kanephoros (pl. kanephoroi). Literally, "basket carrier;" girl who carries a basket containing items used to sacrifice animals in a ritual procession.

kleos. Glory, fame, good repute.

kottabos. Party game that involved throwing wine dregs at a target.

krater. Large bowl, usually ceramic, with a foot and two handles, used for mixing wine and water.

kylix. Shallow cup, usually ceramic, with two handles, a stem, and a foot, used to drink wine.

lampadedromia. Torch race held at ancient games as a ritual event, not an athletic contest; especially connected to the Panathenaic Games.

lekanis. Shallow, lidded ceramic container used to hold domestic or personal items or food.

lekythos. Ceramic oil bottle or flask, usually tall and narrow, with a strongly marked foot and elongated neck.

libation. Liquid offering, poured on the ground or on an altar.

louterion. Washbasin.

loutron. Bathing area.

loutrophoros. Tall ceramic vase with two long handles used to carry water for ritual baths, especially those associated with weddings and funerals.

Nemean Games. Athletic games honoring Zeus held at Nemea, in the northeastern Peloponnesos, every other September starting in 573 B.C.; winners received wreaths of wild parsley.

nestoris. Ceramic vase with a globular body and two tall handles.

Nikosthenic amphora. An amphora type developed by the workshop of the Athenian potter Nikosthenes and made for export to southern Italy; its shape, with flat strap handles, imitates Etruscan amphorae.

obverse. The front side of a coin, depicting the principal design.

oinochoe. Ceramic pitcher or jug, usually medium sized, used for liquids.

Olympic Games. Ancient athletic games honoring Zeus held at Olympia, in the region of Elis in northwestern Peloponnesos, about mid-July to mid-August of every fourth year beginning in 776 B.C.; victors received crowns of wild olives. The Olympics were the most prestigious of the four crown games.

paidotribes (pl. paidotribai). General teacher or educator of youth, who also supervised athletic practices.

pais (pl. paides). Boys about twelve years old; youngest class of male athletic competitors.

palaio. Literally, "to wrestle;" root of the Greek word *palaistra*.

palaistra (pl. palaistrai). Literally, "wrestling place," from the Greek word *palaio*, or "to wrestle;" facility where combat athletes and long jumpers practiced.

Panathenaic amphora. Official prize for the Panathenaic Games, characterized by its standardized decoration.

Panathenaic Athena. The type of Athena shown on one side of a Panathenaic amphora; she wears an aegis and a crested helmet and carries a shield in her left arm and a spear in her upraised right hand.

Panathenaic Games. Often called the Panathenaia, this Athens-wide festival was the most important one in Athens.

Panhellenic. Including or involving all Greeks or all of Greece.

pankration. Combat event combining wrestling and boxing in which only biting and eye gouging were not allowed; added to the Olympic program in 648 B.C.

pankratist. Participant in the pankration.

patera. Shallow ceramic or metal bowl; often used to make libations.

pax romana. Literally "Roman peace;" a period of relative peace in the Roman Empire, roughly the first two centuries A.D.

pelike. Ceramic jar used primarily to store liquids or food; much like an amphora, but with a wider, pear-shaped lower body.

pentathlete. A participant in the pentathlon.

pentathlon. Literally, "five contests;" at the ancient games, composed of a footrace, long jump, discus throw, javelin throw, and wrestling, all held on one day; added to the Olympic program in 708 B.C. There were no individual competitions in long jump, discus, or javelin.

periodonikes. A victor in all four crown games.

periodos. Circuit of four crown games, the Olympic, Pythian, Isthmian, and Nemean.

phyllobolia. Custom in which spectators threw leafy branches to athletes to honor their victories.

plemochoe. Shallow, wide, lidded container with a tall foot, used to hold oil or perfume.

polis. City or city-state in ancient Greece. An athlete competed on behalf of his hometown or polis.

psykter. Broad-bodied ceramic vase with a narrow base, used to cool wine by being set in a krater of cold water or snow; its shape was popular for a limited time in the late sixth and early fifth centuries B.C.

Pythian Games. Athletic games honoring Apollo, held every four summers beginning in 582 B.C. at Delphi, in central Greece; victors received crowns of laurel leaves.

pyxis. Small ceramic container with a lid, normally used to hold personal objects or household items.

red-figure. Vase-painting technique resulting in red figures set against a black background; details are added with a paintbrush.

reverse. Back side of coin.

salpinx. Trumpet used to signal the start and final lap of equestrian races, as well as other key moments at the ancient games.

skamma. Pit of sand or softened earth in which jumpers landed and wrestlers fought.

skyphos. Deep bowl or cup, usually ceramic, with two handles, used for drinking.

spherai. Padded boxing gloves tied or bound on with heavy, stiff leather bands.

spondophoroi. Literally "truce bearers;" three heralds who announced the Olympic Truce and the start of each Olympic Games.

stade (pl. stades). Measurement for the distances of footraces; about 180 meters or 200 yards.

stadion (pl. stadia). Stadium where athletic contests were held; also, a footrace one length of the stadium (one stade), which was the only event at the first thirteen Olympic Games.

stamnos. Wide-mouthed, wide-bodied jar, usually ceramic with two handles, which could be used as a mixing bowl or to store foods and liquids.

stater. Greek unit of money and weight; also a gold, silver, or electrum coin.

stele. A tall stone monument or upright slab, usually inscribed with writing or decorated with figures in low relief.

stephanitai. Literally, "crown games."

stlengis. See *strigil*.

strigil. Latin name for a curved metal scraper used by an athlete to remove oil and dirt from his skin after exercise; called a stlengis in Greek, but better known by its Latin name.

symposion (pl. symposia). Drinking party.

synoris. Two-horse chariot race introduced to the Olympic Games in 408 B.C.; also a chariot drawn by two horses; called a biga in Latin.

talent. The greatest unit of value and the heaviest weight in the Greek system; equal to six thousand drachmas. See *drachma*.

terma. See *kampteres*.

tethrippon (pl. tethrippa). Four-horse chariot race introduced to the Olympics in 680 B.C.; also a chariot drawn by four horses; called a quadriga in Latin.

tetradrachm. Literally, "four drachmas;" coin equal in value and weight to four drachmas. See *drachma*.

triakter. Literally, "trebler;" winner of three out of five bouts in the upright wrestling event.

triastes. Triple victor.

tripod. Bowl with three legs, often set over a fire.

votive. Object dedicated in fulfillment of a vow made to a god or hero or in thanks for a blessing received.

zanes. Bronze statues of Zeus that lined the entrance to the stadium at Olympia and were paid for by fines levied on athletes.

SUGGESTED READING LIST

Gardiner, Edward Norman. *Greek Athletic Sports and Festivals*. London: MacMillan, 1910.

Golden, Mark. *Sport and Society in Ancient Greece*. Cambridge: Cambridge University Press, 1998.

Grossman, Janet Burnett. *Athletes in Antiquity: Works from the Collection of the J. Paul Getty Museum*. Exh. cat. Salt Lake City: Utah Museum of Fine Arts, 2002.

Harris, Harold Arthur. *Greek Athletes and Athletics*. London: Hutchinson, 1964.

Hronis, Menelaos. *Olympic Games: 28 Centuries; History—Athletics—Civilization*. Trans. Yiorgos P. Lalazissis. Athens: Lambropoulos, 2003.

Kyle, Donald G. *Athletics in Ancient Athens*. 2nd ed. New York: Brill, 1993.

———. "Winning at Olympia." *Archaeology*, v. 49, no. 4 (1996): 26–37.

Mattusch, Carol C. *The Victorious Youth*. Los Angeles: J. Paul Getty Museum, 1997.

Matz, David. *Greek and Roman Sport: A Dictionary of Athletes and Events from the Eighth Century B.C. to the Third Century A.D.* Jefferson, N.C.: McFarland, 1991.

Miller, Stephen Gaylord. *Arete: Greek Sports from Ancient Sources*. 2nd ed. Berkeley: University of California Press, 1991.

National Archaeological Museum. *Mind and Body: Athletic Contests in Ancient Greece*. Exh. cat. Athens: National Archaeological Museum, 1989.

Neils, Jenifer. *Goddess and Polis: The Panathenaic Festival in Ancient Athens*. Exh. cat. Hanover, N.H.: Hood Museum of Art, Dartmouth College; Princeton, N.J.: Princeton University Press, 1992.

Neils, Jenifer, and Stephen V. Tracy. *The Games at Athens*. Princeton, N.J.: American School of Classical Studies at Athens, 2003.

Percy, William Armstrong, III. *Pederasty and Pedagogy in Archaic Greece*. Chicago: University of Illinois Press, 1996.

Poliakoff, Michael B. *Combat Sports in the Ancient World: Competition, Violence, and Culture*. New Haven, Conn.: Yale University Press, 1987.

Raschke, Wendy J., ed. *The Archaeology of the Olympics: The Olympics and Other Festivals in Antiquity*. Madison: University of Wisconsin Press, 1988.

Reese, Anne C., and Irini Vallera-Rickerson. *Athletries: The Untold History of Ancient Greek Women Athletes*. Costa Mesa, Calif.: Nightowl Publications, 2002.

Roller, Lynn Emrich. "Funeral Games for Historical Persons." *Stadion*, v. 7 (1981): 1–18.

Romano, David Gilman. "Boycotts, Bribes, and Fines: The Ancient Olympic Games." *Expedition*, v. 27, no. 2 (1985): 10–21.

Scanlon, Thomas Francis. *Eros and Greek Athletics*. New York: Oxford University Press, 2002.

———. *Greek and Roman Athletics: A Bibliography*. Chicago: Ares Press, 1984.

Swaddling, Judith. *The Ancient Olympic Games*. 2nd ed. Austin: University of Texas Press, 2000.

Sweet, Waldo E. *Sport and Recreation in Ancient Greece: A Sourcebook with Translations*. New York: Oxford University Press, 1987.

Vanhove, Doris, ed. *Olympism in Antiquity*. Exh. cat. 3 vols. Lausanne, Switz.: Olympic Museum, 1993, 1996, 1998.

Waddell, Gene. "The Greek Pentathlon." *Greek Vases in the J. Paul Getty Museum*, v. 5 (1991): 99–106.

Yalouris, Nicolaos, ed. *The Eternal Olympics: The Art and History of Sport*. New Rochelle, N.Y.: Caratzas Brothers, 1979.

INDEX

Rhetoric (Aristotle), 73, 152
ribbons, *6*, *144*, 145, 146, *147*, *149*, *153*, 155, 175, 185, 189, 190–92
Roman, 15, 36, 76, 126, 130; athletics, 39, 40, 46, 100, 116, 145, 179, 182; coins, 21, 23, 93, 110, 159; sculpture, 132, 138, 142, 152, 157, 162, 176, 189; warfare, 39, 172
Rome, 21, 39, 61, 84, 105, 189
running, *31*, *60*, 61–70, *62–71*, 73, *154*, *155*, 172–73, 188, 191, 192
running tracks, 61, 65, 69, 130

S

salpinx. *See* trumpet
Sanctuary of Zeus, 51–53
scrapers. *See* strigils
Septimius Severus (Emperor), *27*, 172
Severus Alexander (Emperor), *98*, 177
skamma, *73*, 91
Sokrates, 125, *126*, 127, 129, 162, 187
Solon, 129
Sophocles, 48, 119
Sostratos of Sikyon, 99, 100
Sparta, 22, 23, 26, 28, 31–32, *33*, 53, 114, 119, 148, 170, 187, 188
spherai, 100
spondophoroi, 48
stades, 61, 64, 129
stadion, 15, 61, 64, 65, 69, 70, 147, 170
stephanitai, 145
stlengis, 132. *See also* strigils
Strato, 159
strigils, *31*, *33*, 132, *132*, *135*, *136*, *139*, *160*, *161*, 162, 173, 179, 183, 184, 185–86, 187, 188, 192
Sybaris, 91
Sybarites, 148
symposion (pl. symposia), 127, 129
Symposion (Plato), 127
synoris, 114, 181
Syracuse, 65, 148, 159

T

team events, 23, 40
The Team of Horses (Isokrates), 43
Temple of Hera, 36, *37*, 39
Temple of Zeus, 36, 37, *37*, 39, 48, 50, 53, 54, 64, 169
terma, 65
Terme Museum in Rome, 105
tethrippon, 114, 181

Thasos, 21
Theagenes, 21
Theodosius (Emperor), 39
Theognis of Megara, 127
Theokritos, 100
Theseus, 48, 99
Thessaly, 107
Thucydides, 28, 114
torch races, 15, 22, 23, 46, *48*, 70, *71*, 171
trainers, 27–28, 50, *75*, *79*, 97, 99, 100, 126–27, *128*, 129, 130, 148, 173, 174, 175, 177, 183, 187, 188
triakter, 94
triastes, 65
Troizen, 99
Trojan War, 162
Troy, 43
trumpet, 107, 112, *113*, 119, 179

V

Valerian (Emperor), *88*, 183
victors, *6*, 26, 27, 70, 73, 114, *118*, *144*, 145–62, *147*, *149*, *153–55*, *158*, 182, 188–92. *See also* awards to victors
Victory, *2*, *38*, 39, 107, *118*, *144*, *156*, *157*, 159, 169, 172, 182, 188, 189
victory song, 148
Vitruvius, 129, 130, 132

W

weightlifting, *16*, *88*, 157, 183
weights used in jumping. *See* jumping weights
women in sports, 3, 5, 23, 28, 29, 31–34, *31–33*, 39, 114, *135*, 170, 187–88
wreaths, *6*, *9*, 15, *144*, 145, 146, *146*, *154*, 155, 159, 169, 171, 182, 185, 186, 189, 190, 191, 192
wrestling, 15, 22, 27, 31, 43, *44*, 54, 73, 91, *92–98*, *93–97*, 99, 100, 138, 143, 147, 168, 171, 176–78, 183, 188

X

Xenophon, 29, *30*, 61, 175

Z

zanes, 152
Zenoposeidon, 22, 164, 192
Zeus, *21*, 22, 26, 36, 37, *38*, 39, 48, *50*, 50–54, *52*, 64, *114*, 138, 152, 169, 180, 192